Controversy in French Drama

ALSO BY JULIA PREST

Monograph

Theatre under Louis XIV: Cross-Casting and the Performance of Gender in Drama, Ballet and Opera, 2013

Theatre under Louis XIV: Cross-Casting and the Performance of Gender in Drama, Ballet and Opera, 2006

Critical Editions

"La Devineresse ou les faux enchantemens" de Thomas Corneille et Jean Donneau de Visé, ed. Julia Prest, 2007

Molière: "Le Mariage forcé," ed. Julia Prest, Textes Littéraires, 1999

Edited Volume

Corporeal Practices: (Re)figuring the Body in French Studies, ed. Julia Prest and Hannah Thompson, 2000

Controversy in French Drama

Molière's *Tartuffe* and the Struggle for Influence

Julia Prest

CONTROVERSY IN FRENCH DRAMA: MOLIÈRE'S *TARTUFFE* AND THE STRUGGLE FOR INFLUENCE
Copyright © Julia Prest 2014.
Corrected Printing 2014
Softcover reprint of the hardcover 1st edition 2014 978-1-137-34399-4

All rights reserved.

First published in 2014 by PALGRAVE MACMILLAN® in the United States—a division of St. Martin's Press LLC, 175 Fifth Avenue, New York, NY 10010.

Where this book is distributed in the UK, Europe and the rest of the world, this is by Palgrave Macmillan, a division of Macmillan Publishers Limited, registered in England, company number 785998, of Houndmills, Basingstoke, Hampshire RG21 6XS.

Palgrave Macmillan is the global academic imprint of the above companies and has companies and representatives throughout the world.

Palgrave® and Macmillan® are registered trademarks in the United States, the United Kingdom, Europe and other countries.

ISBN 978-1-349-46594-1 ISBN 978-1-137-34400-7 (eBook)
DOI 10.1057/9781137344007

Library of Congress Cataloging-in-Publication Data is available from the Library of Congress.

A catalogue record of the book is available from the British Library.

Design by Scribe Inc.

First edition: January 2014

10 9 8 7 6 5 4 3 2 1

To my parents,
Susan and John

Contents

Acknowledgments	ix
A Note on Translations	xi
Introduction	1
1 The Struggle for Influence: I. The Stakes and Their Protagonists	7
2 What Is a *Faux Dévot*? I. The Hypocrite	35
3 What Is a *Faux Dévot*? II. The Zealot	75
4 What Is a *Vrai Dévot* and Is He a *Véritable Homme de Bien*?	107
5 The Struggle for Influence: II. *Tartuffe* in an Age of Absolutism	137
Conclusion	191
Notes	199
Bibliography	229
Index	241

Acknowledgments

This book has been a long time in the making, and numerous people have helped it along its way. These include my colleagues and friends at Yale University, where the project was begun, and those at the University of St Andrews, where it was completed: my heartfelt thanks to all of you. I am especially grateful to Roy Dilley and Nick Hammond, who read and commented on a draft of the manuscript from their respective and complementary perspectives; to Sarah Townshend, who ably checked numerous references, proofread the manuscript, and found the fabulous image that appears on the cover; to Angela Konrad of Trinity Western University, who tracked down and made available a high-quality version of that image; to Danna Kostroun, who helped me get to grips with Jansenism and who read and commented on Chapter 5; to Russell Goulbourne, who is always ready to respond to any query, however obscure, that I can throw at him; and to Dave Evans and Sam Bootle, who scrutinized and improved upon my translations. Finally, I would like to thank Erica Buchman, Robyn Curtis, and Jen McCall of Palgrave for their patience, good humor, and support throughout the process.

A Note on Translations

In order to ensure that this book is both scholarly and accessible to a wide audience, I have included the original French alongside English translations of all quotations. Quotations from seventeenth-century sources in French are given, wherever possible, with original (and what may sometimes seem eccentric and/or erratic) spelling and punctuation; in all instances, the spelling and punctuation of the source indicated have been retained. All translations into English are my own. These are in no way intended to be exemplary as translations; rather, their purpose is simply to enable any reader who is not well versed in seventeenth-century French to grasp the meaning of what is being said and to have some idea of the manner in which it is being said.

Introduction

The Avignon Festival in 1995 saw the premiere of Ariane Mnouchkine's Théâtre du Soleil production of Molière's *Tartuffe*, in which the eponymous villain featured as a fanatical Muslim cleric. An Islamist Tartuffe also featured in Serdar Bilis's 2004 production of *Tartuffe* at the Arcola Theatre in London. Numerous productions of the late twentieth and early twenty-first centuries have lifted Molière's play out of its original Christian context and successfully recast it in a Muslim one. Is Islam the new Christianity of Western satire? Islam is undoubtedly fertile ground for modern Western satirists, although the fierce controversy provoked by the publication of 12 caricatures of the Prophet Muhammed in the Danish newspaper, *Jyllands-Posten*, on September 30, 2005, that resulted in a series of violent protests around the world and even a number of deaths certainly gave pause for thought.[1] According to Mnouchkine, an Islamist interpretation of Molière's Tartuffe character is the most apposite for a modern French audience, but in other cultural contexts there are other, better options available for the modern director wishing to underline and update the religious dimension of a play that was first performed in 1664.[2]

Unsurprisingly, Mnouchkine's emphasis on fanaticism was picked up by reviewers who in turn reapplied the notion of religious fanaticism to the play's original seventeenth-century context. Barry James writing in *The New York Times*, for instance, noted that "the then-equivalent of today's religious right, well entrenched in the court, saw it as a seditious attack on their kind of fundamentalism."[3] While this is a welcome reminder that neither Christianity nor Islam has a monopoly on fundamentalism, it should be remembered that this charge did not feature as prominently in the original *Tartuffe* controversy of 1664–1669 as that of religious hypocrisy, which has dominated the discussion around it ever since. Yet modern directors such as Mnouchkine have, even as they have allowed themselves to stray from Molière's original text and context, in fact perceived something that has been paid less attention by scholars but that I shall argue was

present in the *Tartuffe* controversy all along: a simultaneous condemnation of fanaticism (or in seventeenth-century parlance, zealotry) as well as hypocrisy. This being the case, James's description of Mnouchkine's Tartuffe as "part Jimmy Swaggart and part ayatollah" is about as close to the mark as a knowingly anachronistic account can be.

Bilis's less political and more overtly comical production of *Tartuffe* also sheds light on an area of the debate that merits further attention. Setting the play in modern Istanbul, Bilis "portrays Turkey as a country torn between Islamic tradition and a Europeanised future."[4] In one particularly witty example, Bilis has the fanatical Orgon take out a prayer mat, while his westernized wife uses the same type of mat for her aerobics. While some reviewers, including Michael Billington in *The Guardian* and Nicholas de Jongh in *The London Evening Standard*,[5] complained that Bilis did not push it far enough, the idea of transposing 1660s France to modern Turkey is nevertheless an inspired one. An understanding of the tension at work in 1660s France between the ultrareforming Catholic *dévots* (Bilis's fanatical Muslims)[6] and the considerably less Catholic *mondains* (Bilis's westernized Turks) is essential in order to grasp the context in which the original controversy unfolded. What modern directors have struggled to bring to contemporary audiences is the more political dimension to the early reign of Louis XIV. All these elements—religious hypocrisy and fanaticism, tensions between conservative and less conservative forms of religion, and the complex dynamics of the early reign of France's most famous king—will be examined in the course of this book.

My first goal in writing *Controversy in French Drama: Molière's* Tartuffe *and the Struggle for Influence* is to provide the first full-length academic monograph dedicated solely to this, the most important controversy in the history of French theatre. In addition to the many articles and chapters that deal with various aspects of the controversy (and to which I of course refer), a number of books make valuable contributions to the field.[7] One such is *Molière et le roi: L'affaire Tartuffe* by François Rey and Jean Lacouture,[8] which offers the most detailed chronological account of the whole controversy from 1664 to 1669 published to date. Firmly grounded in a rich array of primary sources and drawing on the substantial erudition and scholarship of Rey in particular, *Molière et le roi* cannot, however, be considered an academic monograph, owing to the fact that it is presented in the form of a transcription in five acts of a lengthy and sometimes quite personal dialogue between the interviewer (Lacouture) and interviewee (Rey). Other notable volumes dealing primarily with

the *Tartuffe* controversy include Herman Prins Salomon's *Tartuffe devant l'opinion française*,[9] which, despite an excessive and rather prurient obsession with the question of exposed female flesh (which is indeed relevant to the controversy but not quite as central as Salomon suggests) offers considerable insight into the debate from a primarily religious perspective;[10] Robert McBride's *Molière et son premier Tartuffe: genèse et évolution d'une pièce à scandale*[11] (which, as its title indicates, is primarily concerned with the details of the first version of the play) and two older volumes by Francis Baumal, *Tartuffe et ses avatars: De Montufar à Dom Juan*[12] (which discusses earlier models for the Tartuffe character) and *La Genèse de Tartuffe: Molière et les dévots*[13] (which outlines the importance of the role played by the secret *dévot* society known as the Company of the Holy Sacrament). Each of these volumes is important, most of them are now out of print, and none of them is available in English.

Of course, no single volume can reasonably attempt to fill this gap completely, for the subject is too vast and too far-reaching. Drawing on a series of theatrical and nontheatrical writings, including contemporary sermons, treatises and *mémoires*, my aim is to shed new light on the *Tartuffe* controversy in two key ways. First, I shall challenge the very terms of the debate. Critical material relating to the controversy has until now been dominated by the notion of religious hypocrisy and by the supposed dichotomy between the sincere believer (*vrai dévot*) and the hypocrite (*faux dévot*). In this book, I demonstrate that the *vrai-faux* approach is misleading, as the term *faux dévot* encompassed not only hypocrisy but also (sincere) fanaticism. Furthermore, I shall argue that Molière's mention in his preface to the published version of the play of a *véritable homme de bien* (*truly good man*) introduces a significant third term into the debate that hints at an alternative world view. Second, I demonstrate that *Tartuffe* was in and of itself a key locus for the struggle for influence among competing political and religious factions during the early reign of a young king whose authority was in 1664 still precarious. In so doing, I also challenge the assumption whereby the 1669 version of *Tartuffe* must, unlike earlier versions of the play, have been deemed acceptable to the Church simply because the ban on public performances was finally lifted that year. Instead, I proceed on the basis that the final version of the play may yet have contained material that was controversial but that the politico-religious climate had shifted sufficiently between 1664 and 1669 for the king to allow the play to be performed in public despite this.

Chapter 1, "The Struggle for Influence: I. The Stakes and Their Protagonists," sets the early years of Louis XIV's reign in its politico-religious context, focusing particularly on the post-Fronde era and the context of the French Counterreformation, which saw reforming *dévots* opposed to the more worldly *mondains*. I present the key players involved in various struggles to shape the new reign, paying particular attention to two of the key figures of the *Tartuffe* controversy: the young Louis XIV, eager to impose himself, and his former tutor and the future Archbishop of Paris, the blustering and zealous Péréfixe. In Chapter 2, titled "What Is a *Faux Dévot*? I. The Hypocrite," I address the notion of religious hypocrisy, paying particular attention to the roles played by sensuality and sexuality in establishing Tartuffe as a hypocrite. With reference to Bossuet's courtly sermon series, the *Carême du Louvre* (1662), in which the preacher had rebuked the king for his sexual indiscretions, I argue that those who opposed Molière's play were far more concerned about the behavior of France's king at the 1664 *fête* at which *Tartuffe* was given its premiere than with that of Molière's villain.

Chapter 3, "What Is a *Faux Dévot*? II. The Zealot," is the first of two chapters in which I seek to counter widespread misapprehensions regarding the meaning of a key term in the debate. With reference to a variety of contemporary texts I demonstrate that the term *faux dévot* was often applied to zealots, sincere and otherwise, as well as to hypocrites. Sincerity, then, is not the prime issue at stake in the debate. With detailed reference to the text of Molière's play, I demonstrate likewise that Tartuffe is criticized by members of his adopted household as much for his interfering zealotry as for his hypocrisy. In Chapter 4, "What Is a *Vrai Dévot* and Is He a *Véritable Homme de Bien*?," I tackle another key term of the debate and introduce a third term. Cléante's famous description of a *vrai dévot* is—revealingly—one that is made principally by negation, and in this and other contemporary texts we learn that the *vrai dévot* is defined primarily by his invisibility. Yet the absence of any *vrai dévot* from Molière's play world is problematic, particularly when it coincides with the playwright's description of Cléante as a "véritable homme de bien." For Cléante is no orthodox Christian; rather, he belongs in a world that prioritizes matters earthly over matters spiritual.

Chapter 5, my final (and longest) chapter, titled "The Struggle for Influence: II. *Tartuffe* in an Age of Absolutism," is dedicated to a detailed examination of the *Tartuffe* controversy from 1664 to 1669. I demonstrate that the events of 1660s France are no mere backdrop to the theatrical controversy but rather are all part of a

politico-religious struggle involving competing, or at least conflicting, parties. Most significant of all is the Jansenist controversy whose key dates (at least in this phase of its evolution) coincide exactly with Molière's five-year struggle to have the ban on public performances of his play lifted. Just as the simmering tensions over Jansenism provided the principal impulse behind the king's original ban in 1664, so also did the resolution of that religious controversy, with the Peace of the Church in 1669, precipitate the lifting of the ban. Péréfixe, who had simultaneously persecuted the Jansenists as well as Molière and his play, was ultimately sidelined as his former pupil imposed his own authority on the country with increasing conviction. Molière's *Tartuffe*, then, is an integral part not only of the history of Western theatre but also of royal absolutism.

CHAPTER 1

THE STRUGGLE FOR INFLUENCE
I. THE STAKES AND THEIR PROTAGONISTS

We are concerned here with a portion of French history that sits between the two great crises of the *ancien régime*: the Wars of Religion and the Revolution. Or, to put it another way, our period falls between the Renaissance and the Enlightenment, at the time of the French Counterreformation when there was a powerful push in France to enforce the principles set out during the Council of Trent.[1] Although the Tridentine decrees never gained official legal status in France (the Assembly of the Clergy made a declaration of reception of the decrees in 1615, but this was never validated by any French king),[2] their influence was keenly felt. Indeed, according to Jean Calvet, the Counterreformation changed midcentury France more than even the civil wars of the Fronde did.[3] Certainly its influence is difficult to overestimate, and the tension identified by Calvet between the *dévots* (*the devout*) and the *mondains* (*the worldly*) offers a useful framework by which to approach the period. The controversy over Molière's *Tartuffe*, which is our primary concern here, was played out in the 1660s during the early reign of the young Louis XIV, when the tension between devotion and worldliness was at its height. In the context of French Catholic reform, the extent and exact role of religion in daily life was one of the two most pressing issues facing the country at this time. And, as Calvet puts it, the *dévots* were, following the death of Louis XIII, trying to seize the opportunity to "orienter le nouveau règne" (*shape the new reign*) just as the *mondains* "eux aussi prétendaient bien donner le ton au nouveau règne et dominer" (55) (*also hoped to set the tone of the new reign and to dominate it*). Their efforts in this regard are part of what I am calling the struggle for influence.

The other most pressing issue, illustrated graphically but not uniquely by the events of the Fronde, was that of the official balance of political power and the struggle for influence between various parties, including the king and his first minister, the monarchy and the *parlement*, the monarchy and the French Church, the monarchy and Rome, the French Church and Rome, the French Church and the French Church, the monarchy and a series of powerful individuals including noble politicians such as Fouquet, and potential pretenders to the crown in the shape of the king's close blood relatives. The death of Louis XIII in 1643, when his eldest son was not yet five years old, signaled an opportunity for a number of factions,[4] religious, political, and personal, to attempt to influence the direction that France and the future reign would take.[5] If the Fronde was the most conspicuous attempt to change things, pressure was, as we shall see here and throughout this study, being brought to bear in many other ways as well.

As I shall argue, this historical context is no mere backdrop to the *Tartuffe* controversy; rather, the controversy provoked by Molière's play is inextricably bound to contemporary debates about religion and politics (national and individual).[6] More than that, though, I hope to demonstrate that the theatre in general, and *Tartuffe* in particular, became a testing ground and even a battle ground in the struggle for influence between competing movements at a time when the new reign was still taking shape.

Armand de Bourbon, Prince de Conti (1629–1666)

As a means of introducing the context in which this struggle for influence took place, let us take the example of Armand de Bourbon, prince de Conti (1629–1666), whose story touches upon all the principal stakes and debates, as well as most of the individuals, that we shall encounter in the course of this study and who had a personal but checkered relationship with Molière, and even with *Tartuffe*. It should be noted, however, that Conti is not in any way representative of a seventeenth-century French aristocrat; rather, his extraordinarily colorful biography is useful to us precisely because it covers so many different aspects of seventeenth-century France; it offers an unusual microcosm of all the major contemporary tensions and conflicts at work at the same time that it illustrates both the possibility of change (in one individual, at any rate) and, ultimately, the triumph of Louis XIV and traditional, hereditary monarchy. We shall focus here on the

events that are most relevant to the present discussion—namely, the Fronde and Conti's relationship with the monarchy, as well as his religious conversion and subsequent affiliation with the Company of the Holy Sacrament. We shall also touch upon Conti's early encounters with Molière and his attitude toward the theatre, which underwent a complete volte-face.

The youngest child of Henri II, prince de Condé, and Charlotte-Marguerite de Montmorency, the future Conti was born in Paris on October 11, 1629, and had Richelieu as his godfather.[7] A diminutive hunchback, Conti was educated by the Jesuits at the Collège de Clermont, and La Grange and Vivot in the preface to their edition of Molière's complete works state that Conti overlapped in his studies there with Jean-Baptiste Poquelin (the future Molière).[8] Given the uncertainty regarding Molière's education and the fact that he was more than seven years Conti's senior, this is, however, unlikely. Destined for a career in the Church, Conti submitted his thesis at the Sorbonne on July 10, 1646, and on January 10, 1647, he took over the governorship of Champagne and Brie from his father. Conti's shifting roles in the Fronde (or, as some historians prefer, Frondes)[9] illustrate both how significant these rebellions were and how unformed and unfocused the rebels' goals and strategies ultimately proved to be. They also speak of how quickly and easily allegiances might be made and unmade, and of how factions might unite and disunite at will. As will be seen, Conti's two siblings, the prince de Condé (1621–1686, later known as *le grand Condé* in recognition of his exceptional military achievements) and the duchesse de Longueville (1619–1679) also participated actively and erratically in the Fronde.

Stirred up by the agitator, Jean-François Paul Gondi (1614–79), future cardinal de Retz and later Archbishop of Paris, Conti sided with the *parlement* at the beginning of the Fronde in 1648 and was soon made commander of its Parisian troops. After the Peace of Rueil (March 30, 1649), a compromise agreement that brought the first Fronde to an end, Conti made overtures to the court, hoping to be made a cardinal, and was permitted to lead two regiments on the crown's behalf. When he was not put forward for a cardinal's hat, however, Conti reconciled himself with his older brother, Condé (who will reappear in Chapter 5), and his brother-in-law, Longueville, in opposition to the crown. The three men were arrested by order of Anne of Austria on January 18, 1650, an event that John C. Rule describes as being "tantamount to a coup d'état" (Louis XIV 17). The rebellious princes were imprisoned first in Vincennes; on August 29 they were moved to Marcoussis, and on November 15, they were

moved again to Le Havre, where they remained until their release on February 13, 1651. According to a treaty signed with the *frondeurs* on January 30, 1651, Conti was to have married Charlotte, daughter of the duchesse de Chevreuse, but the treaty was retracted in April that year. The unrest continued despite Mazarin's exile, and toward the end of 1651, Conti presided over an insurrectional government in Bordeaux with his older sister, Mme de Longueville, and was involved in the battles of Agen and Miradoux (the latter led by Condé in February 1652). He refused the general amnesty of October 22, 1652, and was declared guilty of *lèse-majesté* on November 13, 1652. On July 20, 1653, he finally submitted and went to Pézenas, to the château de La Grange. This is where he met Molière, who was touring the provinces, and became official patron of Molière's troupe between 1653 and 1656.

If Conti's personal experience of the Fronde was checkered, including as it did a series of successful military operations alongside at least one barefaced change of allegiance and with no obviously coherent agenda to speak of, other participants who were somewhat clearer in their goals were no more successful in achieving them. Orest Ranum neatly summarizes the overall failure of the Fronde thus: "Despite their erudition, patriotism, and articulate perception of alternative forms of government, the Frondeurs never developed a program of reforms subversive to absolute monarchy. Their proposals remained negative, while their profound and justifiable uneasiness came from the fear that their own power and wealth would be reduced, rather than from a vision of an ideal society which they sought to realize."[10] The Fronde's legacy should not, however, be considered null and void. The fact remained that the can of worms that is the nature, extent, and legitimacy (and, one might add, durability) of monarchical power had once again been opened at a time when the future of France was uncertain and when it might, therefore, be particularly open to influence. Without doubt, it left a lasting impression on the young Louis XIV. Most of the hopes for the future of France expressed in the series of antigovernmental pamphlets known collectively as the *Mazarinades* were concerned, as their epithet suggests, primarily with the pernicious and illegitimate nature of Mazarin's person and of his office as first minister and stressed the urgent need to dismiss the cardinal.[11] At the same time, *dévots* did not pass up the opportunity to make other recommendations to the young king with regard to issues as diverse as luxurious waste (which should be abolished) and the tax burden (which should be reduced) or the French people (who should

be listened to) and to insist again and again that a good monarch is a God-fearing monarch.[12]

However, Mazarin was not, in the end, removed from office, and in order to consolidate good relations with the court, Conti, who had by this time contracted syphilis (from which he would eventually die) from another woman, agreed to marry one of Mazarin's nieces. He gave up his ecclesiastical benefits and eventually married Anne-Marie Martinozzi on February 22, 1654, after which he commanded the French army's invasion of Catalonia. He fought successfully for France and was rewarded with the governorship of Guyenne; he enjoyed further military successes and replaced the Grand Condé as Grand Master of France on March 28, 1656. On May 5, 1657, Conti became commander of the French forces in Italy jointly with the Duke of Modena. He came back to France in October 1657 and did not serve again. Conti was awarded the governorship of the Languedoc on February 26, 1660, and took up residence in Pézenas. On November 7, 1659, he passed the governorship of Guyenne to the duc d'Epernon and the position of Grand Master to the duc d'Enghien. Conti became increasingly ill and dictated his will on May 24, 1664; he went back to the château de La Grange, where he died on February 21, 1666. After his death, a number of works were published under Conti's name, including *Les devoirs des grands* (1666) and the antitheatrical *Traité de la comédie et des spectacles selon les traditions de l'Eglise* (1667).

When Conti died, his antitheatrical credentials had been established, and he was, as will be seen, at least tangentially involved in the *dévots'* campaign against *Tartuffe*. Yet only a decade earlier he had been an active supporter of Molière and his troupe. Between 1653 and 1656, Conti received Molière's troupe on a number of occasions and in a number of locations across the Languedoc region. Joseph de Voisin wrote:

> Monseigneur le Prince de Conty avoit eu en sa jeunesse tant de passion pour la Comedie, qu'il entretint long-temps à sa suite une troupe de Comediens, afin de gouster avec plus de douceur le plaisir de ce divertissement: Et ne se contentant pas de voir les representations du Theatre, il conferoit souvent avec le chef de leur troupe, qui est le plus habile Comedien de France, de ce que leur Art a de plus excellent, & de plus charmant. Et lisant souvent avec luy les plus beaux endroits, & les plus delicats des Comedies tant anciennes [sic] que modernes, il prenoit plaisir à les luy faire exprimer naifvement: de sorte qu'il y avoit

peu de personnes qui pussent mieux juger d'une piece de Theatre que ce Prince.[13]

During his youth, His Highness Prince Conti was so passionate about the theatre that for a long time he maintained at his side a troupe of actors in order to enjoy more easily the pleasures of this type of entertainment. Not content simply to see theatrical performances, Conti often discussed the most admirable and delightful aspects of the actor's art with the troupe's director, who was the most talented actor in France. Often, when they read together the most beautiful and delicate excerpts from various plays, old and new alike, he took pleasure in asking this actor to perform them in his natural style. As a result, there were few people better positioned than this prince to evaluate a play.

Conti's appreciation and patronage of the theatre was entirely fitting for a known *bon viveur* or, as some would have said, *libertin*. However, in every *libertin* lies a potential *dévot* (this, certainly, was the hope of every proselytizing Christian at the time), and for reasons that are not entirely clear, Conti began, from 1655, the process of conversion under the auspices of Nicolas Pavillon, Bishop of Alet, and the abbé de Ciron. Pavillon was an acknowledged rigorist who took a particularly hard line against the theatre, condemning not only actors but also those who attended the theatre.[14] Conti's conversion in May 1656 is described in the *Dictionnaire de biographie française* as "aussi complète que sincère" (539) (*as complete as it was sincere*). While we can never in fact know the extent to which Conti's conversion was complete or sincere, we do know that it was taken seriously by all but the most cynical or satirical of Conti's contemporaries, and this is an important reminder of the fact that change *did* take place in seventeenth-century France and that those struggling to influence others did not always struggle in vain. A year after his conversion, Conti wrote from Lyon to the abbé de Ciron, "il y a des comédiens ici qui portaient mon nom autrefois: je leur ai fait dire de le quitter [i.e., son nom], et vous croyez bien que je n'ai eu garde de les aller voir"[15] (*there are some actors here who used to bear my name; I have told them to give it [i.e., my name] up, and you can be sure that I was careful not to go and see them*). What this letter reveals is not only an antagonism between austere religion and the theatre but also, and more important for the present discussion, the fact that an individual's relationship with the theatre was sometimes used as a touchstone for his personal devotion. Conti's active decision not to go see Molière's troupe perform is presented as evidence of his piety; his conscious

disassociation from it represents the completeness of his conversion and rupture with his libertine past. Here, and elsewhere, we see that the theatre was considered to be a yardstick by which one could measure an individual's or a group's religiosity.

Conti's change of heart with regard to the theatre is significant, too, for its move from one extreme to another. For Conti did not simply abstain from seeing Molière's performances postconversion; he also sent the troupe away, thus becoming, from Molière's point of view, an active persecutor of the theatre (a role that he would later consolidate with his antitheatrical treatise). Again, this is perhaps less significant for what it tells us about the vexed relationship between religion and the theatre than for what it tells us about the broader question of whether (and, if so, how) to reconcile matters worldly with matters devout. As Henry Phillips, among others, has demonstrated, this question sat at the heart of the postreformation Church in France.[16]

As the reforming French Church sought, in accordance with Tridentine principles, to reach into every area of daily life, it inevitably encountered resistance from the French people and sparked tensions within the French Church itself. Phillips identifies a particular tension between "the uncompromising and purist perspective of radical Augustinianism and a more flexible Christian humanism which positively assimilated certain values deriving from the world and to which the world was attached, in order better to convert it" (16). This, in turn, led to significant internal divisions between the Christians (considered by many to be laxists) who tried to accommodate the worldly; the zealots who tried to Christianize the world from within, sometimes by means of coercion; and the rigorists, many of whom simply tried to eliminate (or withdraw from) the world completely.

Followers of Saint Augustine and closely associated with Port-Royal, the so-called Jansenists represented the principal proponents of austere antiworldly rigor and were highly controversial throughout the period in question, owing to their inflexibility with regard to matters doctrinal, something that in turn had profound political implications (see Chapter 5). Indeed, Ranum has observed that "the Jansenist moral preoccupations differed little from those of the Company [of the Holy Sacrament], but it became obscured by the theological campaign started by Antoine Arnauld" (*Paris* 231). The Jesuits, meanwhile, were the principal representatives of what was perceived as being the accommodationist tendency in French religion, owing principally to their role as confessors and in particular to their (in)famous use of casuistry—a method dealing with matters of individual conscience not inherently

lax but notoriously open to abuse and that the Jansenist Blaise Pascal famously and viciously satirized in his *Lettres Provinciales* (*Provincial Letters*), published between January 1656 and March 1657. Closely affiliated with Roman (as opposed to Gallican) Catholicism, the Jesuits were the only confessional order in France and thus occupied the privileged position of confessor to individuals in authority, including, of course, the king. Jean Racine (who had, by the time he wrote the account, returned to the Jansenist fold) wrote with regard to the Jesuit influence at court:

> Les jésuites y gouvernaient alors la plupart des consciences. Ils n'eurent donc pas de peine à prévenir l'esprit de la Reine mere, princesse d'une extrême piété, mais qui avait été fort tourmentée durant sa régence par des factions qui s'élevèrent, et qu'elle craignait toujours de voir renaître.[17]

> *At this time the Jesuits ruled over most people's consciences. They did not, therefore, have any difficulty in influencing the Queen Mother, an extremely pious princess who had been plagued during her regency by the rise of various factions and who lived in fear of their reappearance.*

Certainly it seems to have been the case that Louis XIV's confessor from 1654 to 1670, François Annat (1590–1670), encouraged the king's anti-Jansenist inclinations.[18]

Alongside these two factions, a number of *dévot* groups sprung up that sought to implement the principles of the Council of Trent across French society. They also wished to see an end to the war between the French "roi très-chrétien" (*most Christian king*) and the Spanish "roi très-catholique" (*most Catholic king*). The most important of these groups, at least for the present discussion, was the Company of the Holy Sacrament, of which Conti became a member of the Languedoc branch "après bien des difficultés" (*Annales* 168) (*with considerable difficulty*) following his conversion.[19] Founded between 1627 and 1629, the Company of the Holy Sacrament was a secret society composed of a mixture of lay and clerical members (regulars were formally excluded). As Alain Tallon observes, "tout le programme des dévots se résume dans ces mots, contenus dans les statuts: 'opposer la dévotion aux débauches'" (60) (*the whole* dévot *program can be summed up by these words from their statutes: "to offer up devotion in opposition to debauchery"*). For, as one anonymous member of the Company wrote in a letter in 1663, "l'air général du temps est contraire à la piété et à la dévotion" (cited in Tallon 110) (*the spirit of the times runs counter*

to piety and devotion).[20] Once again, it is this tension between being in the world and not being of it, between the *mondain* and the *dévot*, that sits at the heart of the Company's program. Its members saw it as their duty to interfere in matters worldly, and it is in the *Annales* of the Company that the first known reference to Molière's *Tartuffe* is found: At a meeting held on April 17, 1664 (nearly one month before the play was given its first performance), it was agreed that the society would endeavor to have the play banned. While the Company appears not to have come into conflict with Richelieu or Louis XIII, it had been opposed to the ongoing war against Catholic Spain and was considered suspect by Mazarin and Louis XIV during and after the Fronde, when they were seeking to impose greater monarchical authority on the country.[21] Thanks to their extensive network across France, and assuming that they read all the dispatches that were circulated from Paris, members of the Company were among the best informed individuals in France (Tallon 43). Thus, although the *dévots* remained more or less neutral in the major conflicts between Church and state, a climate of incipient absolutism could not tolerate the existence of a powerful network that actively sought to influence the nature of French society. The society's secretive quality only rendered its members more suspect. Tallon summarizes their dilemma and the reason for their failure thus:

> Pris entre l'absolutisme naissant, qui veut garder pour lui seul le contrôle de la société, et des tendances spirituelles qui condamnent le monde, et recommandent même au simple croyant de s'en détacher, les membres de la Compagnie du Saint-Sacrement pouvaient-ils vraiment créer un type chrétien de rapports sociaux? (157)

> *Caught between a period of increasing absolutism of a type that wished to maintain unique control of society and a spiritual movement that condemned the world and recommended that even the most simple believer detach himself from it, the members of the Company of the Holy Sacrament struggled to create a Christian model for social relations.*

The Company was not unpopular only with Louis XIV and Mazarin. Members of the nobility saw their fervent campaign against dueling as an unwelcome infringement of aristocratic rights. The Company also succeeded in treading on the toes of the French *parlements* by its secret policing of French society[22] and on those of the clergy by its interference in matters that the latter considered to be their territory alone.[23] Charles Dufour in the foreword to his *Mémoire pour faire*

connoistre l'esprit & la conduite de la Compagnie establie en la ville de Caën, appellée l'Hermitage deplores the fact

> que de simples Laïques, qui n'ont ni science, ni prudence, ni qualité, entreprennent de conduire les autres, de regler leurs moeurs, & leurs creances, de juger de leur Foy, & de s'establir les arbitres des affaires de la Religion, au lieu & en la place des Evesques qui sont les Princes de l'Eglise, & les Maistres de la Doctrine & de la discipline.[24]

> *that mere laymen, who have neither knowledge nor prudence nor breeding, take it upon themselves to direct others, to regulate their morals and their beliefs, to judge their faith, and to set themselves up as arbiters in matters of religion, thereby assuming the role of bishops who are the princes of the Church and the masters of doctrine and discipline.*

Dufour also complains about the Company's interference in other areas of French life:

> Ces Messieurs croyent avoir droit de se mesler de toutes choses, de s'ingerer dans toutes les actions un peu éclatantes qui regardent la Religion, de s'eriger en Censeurs publics, pour controller & corriger tout ce qui leur déplaist, d'entrer & penetrer dans les secrets des maisons, & des familles particulieres, comme aussi dans la conduite des Communautez Religieuses, pour y gouverner toutes choses à leur gré. (4)

> *These men think they have the right to meddle in all manner of things, and to interfere in anything to do with religion that is even slightly attention grabbing, to set themselves up as public censors, in order to control and correct anything that displeases them, to enter and infiltrate the personal secrets of private family households and likewise to interfere in the running of certain religious communities in order to govern all things as they see fit.*

This is echoed by Guy Patin's letter from September 28, 1660, which describes a level of interference at a domestic level that made its members a good number of enemies:

> Sous le nom de congrégations du Saint Sacrement, ces Messieurs se méloient de diverses affaires . . . ils mettoient le nés dans le Gouvernement des grandes Maisons, ils advertissoient les maris de quelques débauches de leurs femmes . . . se méloient de la politique, & avoient dessein de faire mettre l'Inquisition en France, & d'y faire recevoir le Concile de Trente.[25]

> *In the name of the congregations of the Holy Sacrament, these men became involved in a whole range of affairs. They poked their noses into the running of great households, they warned husbands of their wives' debauchery, and they interfered in politics and were planning to bring the Inquisition to France and to impose the Council of Trent.*

Conti was involved in just such an incident, recorded in the *Annales* for the years 1657–1658, when he provoked a scandal by putting a girl of ill repute into a convent in Bordeaux (*Annales* 178). The *Annales* go on to note that "ce fut là le commencement de la mauvaise humeur qui s'émut contre les dévots, et de la persecution que l'on suscita contre les principales Compagnies du Royaume" (178–79) (*this marked the beginning of a period of antidévot feeling and of the persecution of the principal branches of the Company within the kingdom*).

Despite this, on July 1, 1660, Conti was admitted to the Paris division of the Company of the Holy Sacrament. The *Annales* inform us that the society had sought to resist his admission but were unable to do so since he was already a member of the Languedoc branch. The reasons given for the Company's fears are revealing:

> La Compagnie y étoit très opposée, elle craignoit l'éclat et les suites de cette entrée, elle prévoyoit que c'était là le vrai moyen de la faire découvrir et de la rendre suspecte, mais le zèle de ce Prince et sa persévérance pendant un long temps à désirer cette consolation l'emportèrent sur la résistance de toute la compagnie . . . On ne put rien refuser à ce qu'il voulut absolument par sa haute qualité, mais on prévit bien que ce seroit un écueil où la Compagnie pourroit se briser. (203)

> *The Company strongly opposed Conti's membership. Its members were fearful of a scandal and of the consequences of his admission; this was felt to be the surest way of making the Company known and of casting suspicion upon it. But the prince's zeal combined with his perseverance over a long period of time [in desiring this consolation] eventually overcame the Company's resistance. It is impossible to refuse something that is so fervently wished for by a man of such distinction. But they predicted that this would be a stumbling block that might bring the Company down.*

One wonders exactly why Conti's membership in the Paris division was thought to run the risk of making the society known and of rendering it suspect, particularly given that he was already a member of another branch. Whatever the exact reasons, Conti was clearly considered a liability.

The year 1660 was significant for the Company. It was implicated in a series of scandals (some of these are examined in Chapter 3) and the *Annales* report that when the scandals were discussed at one of their meetings, Conti was very distressed by what was being said about the Company at court. However, he was urged not to take the Company's defense, but instead "par prudence, on le supplia de ne parler nulle part en sa faveur, de peur de la rendre plus suspecte encore qu'elle n'étoit" (*Annales* 209) (*out of prudence, he was asked not to speak in favor of the Company anywhere, for fear of casting further suspicion upon it*). Tempting though it may be to conclude that Conti was a liability because his own personal devotion was suspect, it is more likely that the answer lies with his high (but not, it would seem, sufficiently high) profile and above all with the Company's wish to remain secret. Conti was perhaps no hypocrite, but he was probably indiscreet. Certainly, the *Annales*, while conceding that he achieved many good works (and good works sat firmly at the heart of their agenda), here attribute the Company's decline to the prince. It is suggested both that he brought the company down and that he failed to save it owing to a lack of influence over his uncle-by-marriage, Mazarin:

> Et en effet, selon les apparences, l'entrée de Monsieur le Prince de Conti dans la Compagnie a été le sujet de sa destruction . . . Il ne se trouva pas avoir assez de crédit auprès du cardinal Mazarin, l'oncle de la Princesse, sa femme, pour la soutenir, quand ce ministre voulut la détruire. (*Annales* 203)

> *And indeed, it seems that Conti's admission into the Company was the cause of its downfall. He did not wield enough influence over Cardinal Mazarin, uncle of his wife, the princess, to protect the Company when Mazarin wanted to destroy it.*

And so, on December 13, 1660, all unauthorized meetings of societies that took place without the king's permission and without ratification by the *parlement* were made illegal. It is thought that the president of the Paris *parlement*, Guillaume de Lamoignon, who was himself a member of the Company, succeeded in having the Company's name omitted from the document.[26] But if the Company was not explicitly named, the purpose of the decree was clearly to bring it and its unwelcome interference (a ban on the locking up of women against their will is explicitly mentioned) to its knees.

To an extent, the decree was successful. Although the Company perhaps hoped that the pressure on it would be reduced following the

death of Mazarin on March 9, 1661, the *Annales* indicate that only occasional meetings took place between 1661 and early 1663 and that efforts were intensified to ensure greater discretion. The *Annales* indicate that the police were by this time pursuing the Company's secretary, A. d'Avolé, and in May 1663 the Company felt obliged to ask d'Avolé to refrain from attending its meetings. As Argenson commented a little later, "Le monde étoit si déchaîné contre les dévots" (*Annales* 239) (*The world was raging against the* dévots). It is probably significant that no registers have been found detailing the Company's activities between May 1663 and April 1664. It would seem to have been none other than the news of Molière's upcoming *Tartuffe* that prompted the Company to meet again formally, if fearfully, in April 1664.

Louis XIV's Education

Returning to the question of influencing the direction that a reign might take, the position of preceptor to the dauphin (in this case, the future Louis XIV) was potentially an important one. Certainly the post was much coveted and much disputed. It offered not only the opportunity for personal advancement on the part of the successful candidate but also that of helping to shape the future monarch, and thereby the future of France. Of course, the very choice of preceptor would constitute in and of itself a reflection of the direction that it was hoped the reign would take on the part of those who made the appointment. Following the deaths of Richelieu and Louis XIII in 1642 and 1643, respectively, this decision came to lie in the hands of Anne of Austria and, later, in those of Mazarin. Anne put Mazarin in overall charge of the education of the future king and his younger brother, Anjou, in 1644, and he was sworn into the new position of Superintendent of His Majesty's Education in 1646.[27] Meanwhile a host of candidates put themselves forward for the role of preceptor by submitting treatises on how the young king should be educated.[28]

In 1640, La Mothe Le Vayer (1588–1672) had published *De l'Instruction de Monseigneur le Dauphin*, dedicated to his friend and patron, Richelieu, who had probably requested it as a means of securing for Le Vayer the coveted position of tutor to the dauphin. Le Vayer had once had the reputation of being an avid freethinker but appeared to become somewhat more orthodox when he fell under the patronage of Richelieu from 1633,[29] so much so that he was elected to the Académie Française in 1639. However, following the death of Richelieu in 1642, Le Vayer was passed over by the Queen Mother,

ostensibly because she had resolved not to give the position to a man who was married. Georges Lacour-Gayet speculates that the real reason may have been that the queen was suspicious of his connections with Richelieu (12), but McBride is surely right to conclude that it was Le Vayer's contribution to the burgeoning Jansenist controversy that cost him the position at this stage. Far from being a Jansenist (which, incidentally, would also have lost him the job), Le Vayer's 1641 treatise, *De la vertu des payens*, seemingly written at the request of Richelieu, offered an evident challenge to Jansenist doctrine regarding the absence of human virtue and the need for faith. Le Vayer's suggestion that men can be virtuous without grace was vigorously refuted by Antoine Arnauld (1612–1694) in his *De la nécessité de la foi en Jésus-Christ*, in which Le Vayer was accused of heresy.[30] The controversy was to endure for some considerable time yet (see Chapter 5).

Meanwhile, Antoine Arnauld's older brother, Arnauld d'Andilly (1589–1674), had written one of the more pious offerings, in the form of a *Mémoire pour un souverain* (1643), which contained "a program of political education that called on the king not only to look after his finances and his subjects' welfare in person but also to make God reign in the state."[31] D'Andilly considered himself a strong candidate for the position and in his memoirs claimed that Anne of Austria had even promised him the job. However, as the controversy continued to grow, there was no question of appointing a prominent Jansenist. As Lacour-Gayet puts it, "Le jansénisme fut donc la seule cause de l'exclusion de d'Andilly" (16) (*Jansenism was thus the sole reason for d'Andilly's exclusion*).[32]

If both Le Vayer and d'Andilly were too steeped in controversy and insufficiently orthodox, their unorthodoxy was strongly divergent: Le Vayer was too open and freethinking, while d'Andilly was too closed and doctrinaire. Anne of Austria and Mazarin required somebody with impeccable religious and moral credentials but who was free from the stain of controversy and who did not engage in debates over the finer points of Christian doctrine.[33] The chosen candidate was finally named on May 28, 1644 (three months before Louis turned six), in the *Gazette* (Renaudot 380) as being the abbé Hardouin de Beaumont de Péréfixe (1605–1670). Born in Poitou, Péréfixe was the son of Richelieu's household steward; his parents died when he was young, and Richelieu oversaw Péréfixe's education. He gained an advanced degree from the Sorbonne in 1636 and joined the faculty there a few years later.[34] The *Gazette* reported on June 4, 1644 (Renaudot 407), that Péréfixe had started to give Louis lessons twice daily. In some ways, Péréfixe was a surprising choice:

"'C'est un homme,' disait Mazarin, 'que j'ai mis auprès du roi sans qu'il y songeât et auquel j'ai, après, fait donner plus de quarante mille livres de rente'"[35] (*Mazarin said, "This was a man whom I brought into contact with the king when he was not expecting it and upon whom I have indirectly bestowed an income of more than forty thousand livres"*). Unlike his rivals, Péréfixe had not yet written an educational treatise (or, indeed, anything else). On the other hand, Andrew Lossky claims that "at the time of his appointment Péréfixe was thirty-nine years old and had the reputation of being the most brilliant teacher in Paris."[36]

No doubt aware of the gap in his curriculum vitae, Péréfixe set about writing a treatise entitled *Institutio principis ad Ludovicum XIV*, which was published in 1647 and dedicated to Mazarin. Given that the treatise is in Latin, it must have been used by the dauphin as the basis for Latin translation exercises rather than as a textbook per se. John B. Wolf notes that Péréfixe "had the young Louis translate into Latin the phrase 'I know that the principal duty of a Christian prince is to serve God and that piety is the basis for all royal virtues'" (123).[37] The thrust of the treatise is that a prince must love virtue over all else—that he should be motivated by piety and love God; he should triumph over his passions and thereby be blameless in both his public and his private life. Péréfixe's other educational volume written for the future king (and also dedicated to Mazarin) was an *Histoire du Roy Henry le Grand* (about Louis's grandfather, Henri IV), written in French and not published until 1661, though undoubtedly used as a means of instruction long before then.[38] In the dedicatory epistle to Mazarin, we read how the young Louis had a particular affection for his grandfather and of his wish to use Henry IV as a model (interestingly, Louis XIII is never presented as a model for his son). In Péréfixe's foreword, he notes that only positive examples from the reign will be used and observes that "il faut qu'un Roy fasse ses delices de son devoir, que son plaisir soit de régner" (5) (*a king must take delight in his duty and derive his pleasure from reigning*). The emphasis within the treatise itself is on being a strong, authoritative, and active king. Lacour-Gayet believes that both volumes will have exerted a strong influence on the young king (147), and with this in mind it is interesting to note Péréfixe's observation, included in his foreword to the *Histoire*, whereby Louis wished not to be like "ces Rois faineans de la premiere Race, qui . . . ne servoient que d'Idoles à leurs Maires du Palais" (6) (*the first kings of France, who were indolent and who only served as idols to their superintendents*), which would reappear almost verbatim in Louis's *Mémoires* for 1661.[39]

Lossky has observed that the *Institutio principis* "is not notable for its originality, but it is interesting because the author's precepts seem indistinguishable from those that Mazarin later tried to inculcate in his royal charge" (67). He notes furthermore that "most of these precepts found their way into Louis's own *Mémoires* for the instruction of the dauphin, composed for the most part in the 1660s. Thus Péréfixe's treatise, Mazarin's precepts, and Louis's *Mémoires* together form one coherent whole. Above all the king must honor God and protect His Church. The king must dominate his passions through reason" (67). Péréfixe regularly updated Mazarin on Louis's education and seems to have enjoyed good relations with the cardinal (apart from one moment of hesitation during the latter's exile in 1651—see Lacour-Gayet 143). It is unsurprising, then, that a certain continuity between the two is apparent, especially given that Péréfixe was almost certainly Mazarin's choice. Whether directly or indirectly, it was Mazarin who exerted the greatest influence on the young Louis XIV.

If Mazarin and Péréfixe appear to have shared a common view of kingship, it is possible that Péréfixe was more interested in matters overtly religious than the cardinal. Lacour-Gayet notes that Péréfixe was known to be in the sway of the Jesuits and was therefore anti-Jansenist, and comments that this anti-Port-Royal position may have influenced the direction of the young Louis's religious ideas in a way that would not be shaken (143). Lacour-Gayet suggests, too, that Péréfixe may have encouraged an anti-Protestant feeling in the future king, although none of this is especially surprising given that it was de rigueur for a French king to be anti-Protestant and to be suspicious of any sectarianism that appeared threatening to the unity of the country (as Jansenism seemed to).

As it turned out, the young Louis was to come under the influence (or at least under the tutorship) of both Péréfixe and Le Vayer during his formative years. Le Vayer was summoned to court in 1649 to supervise the education of Louis's younger brother, Philippe duc d'Anjou, and in May 1652, Le Vayer was made preceptor to Louis as well. Péréfixe, meanwhile, had been appointed Bishop of Rodez in June 1648 (although he did not actually go there until 1655).[40] His bishop's duties (even at a distance) took up considerable time, and he was also troubled by ill health. As Lacour-Gayet observes, it is difficult to imagine quite how the educational assignments were divided between one man who was preceptor of both boys and another who was preceptor only to the elder boy. He speculates that Le Vayer supervised Louis's education when Péréfixe was unavailable (19). It is more difficult still to imagine how these two men, coming as they did

from such different backgrounds and with such different approaches, cooperated at all. Moreover, Le Vayer seems to have delegated the teaching of the duc d'Anjou to his own son, the abbé de la Mothe le Vayer.[41] As McBride puts it, "the abbé was not one of those rigorous clerics in the mould of Hardouin de Péréfixe opposed to the theatre. On the contrary, he reveals a satirical humour and jocular good sense in his satire *Le Parasite Mormon* (1650), which makes fun of the pedantic professor of Greek at the Collège de France" (La Mothe, *Lettre* 166).[42] La Mothe Le Vayer (*père*) gave up this function at some point between 1655 and 1658, having written seven treatises, which are notable for their "extrême sécheresse" (Lacour-Gayet 70) (*acute dryness*) and for their nonreligious nature.[43] Péréfixe, for his part, resigned the bishopric of Rodez in 1656, probably to dedicate himself more fully to the education of Louis XIV. This diversity of royal preceptors demonstrates the fact that the young king was subject to a range of influences even at the level of his own private education.

Péréfixe and Le Vayer would encounter one another in the years that followed, first as fellows of the Académie Française (of which Péréfixe became a member in 1654) and later, if McBride is correct in attributing the *Lettre sur la comédie de l'imposteur* to Le Vayer, on opposing sides of the *Tartuffe* controversy (see Chapter 5). It has already been suggested that Louis XIV's *Mémoires* bear the stamp of the influence of Mazarin and Péréfixe. Let us turn now to those *Mémoires*, focusing particularly on the years 1661 and 1662 in order to gain insight into how the young king himself perceived the tensions and, by implication, the pressures that he faced in the early years of his reign.

Louis XIV's *Mémoires*

In Louis's *Mémoires pour l'instruction du dauphin* for the year 1661, he evaluates the state of France in the early years of his reign, touching upon (nearly) all the major issues at stake.[44] While it is theoretically impossible to divide religion from politics at this time given the religious foundations of the French monarchy, it may be useful here to separate the broadly political from the broadly religious issues that Louis discusses. With regard to the former, the king lists "une guerre étrangère . . . ces troubles domestiques . . . un prince de mon sang et d'un très grand nom à la tête des ennemis; beaucoup de cabales dans l'Etat" (*a foreign war, these domestic troubles, a well-reputed prince of my blood leading the enemy, and numerous cabals within the state*), as well as problems with the "parlements encore en possession et en goût

d'une autorité usurpée" (*parlements still possessing and enjoying the authority they usurped*) and the court, where there was "très peu de fidelité sans intérêt" (*very little fidelity without self-interest*). He also mentions "un ministre rétabli malgré tant de factions" (33) (*a minister who had been reinstated despite all the factions*). Some of these issues are regarded as having been resolved by 1661 and are therefore considered retrospectively (doubly so if we take into account the fact that the *Mémoires* for this period were written around a decade postfactum—see Louis XIV 12): the Peace of the Pyrenees, which signaled the end of France's long war with Spain and was signed on November 7, 1659, also included an official pardon for Conti's still rebellious older brother, Condé, who had indeed been leading the enemy. The *parlements* were not quashed after the Fronde (the "troubles domestiques"), but they were certainly more subdued, while the reinstated minister, Mazarin, was to die on March 9, 1661. Louis's famous decision not to take another first minister is often said to have been made upon the advice of Mazarin himself, although the fact that it also complies in many ways with the views repeatedly expressed by many of the *frondeurs* also seems inescapable. We have seen that the most powerful influence exerted on the young Louis XIV was probably Mazarin himself; following the death of the cardinal, Louis sought never to allow any single individual so much influence over him again. Meanwhile, various factions saw the opportunity to exert new influence on the young king. The cabals within the state, while they are more difficult to identify specifically, can thus be said to have persisted at least to the extent that a number of significant factions continued to come into conflict with one another and, as we have seen, to attempt to influence the king in various ways after his personal rule began in 1661. The same might be said of the problems at court.

Two additional noteworthy issues that are essentially political are mentioned under the year 1661. The first is the tendency of the Minister of Finance, Nicolas Fouquet (1615–1680) to

> continuer ses dépenses excessives, de fortifier des places, d'orner des palais, de former des cabales, et de mettre sous le nom de ses amis des charges importantes qu'il leur achetait à mes dépens, dans l'espoir de se rendre bientôt l'arbitre souverain de l'Etat. (Louis XIV 81)

> *continue with his excessive expenditure, to fortify various strongholds, to decorate palaces, to create cabals, and to purchase at my expense various important offices, which he gave to his friends in the expectation of soon being made sovereign arbiter of the state.*

Louis's treatment of the powerful Minister of Finance in 1661 (and after) is worth outlining here given its symbolic status as a rupture with the past (and particularly with Mazarin) and the strong signal that it sent out to any further individuals who might wish to gain too much power or exert too much influence over the country. Fouquet had quite plausibly expected to succeed Mazarin as first minister, but the young king, no doubt spurred on by Colbert, was wary of Fouquet's naked ambition and ostentatious displays of wealth, some of it from dubious sources. On September 5, 1661, only 19 days after Louis had attended a magnificent *fête* at Fouquet's château at Vaux-le-Vicomte (in which no lesser names than Molière and Lully as well as Le Brun and Le Nôtre participated), the king had the minister arrested for embezzlement and put on trial.[45] Contrary to what the *Mémoires* indicate, Fouquet was supported by many prominent French men and women. However, the fact remains that anybody else considering forming cabals or dangerous factions would surely, in the wake of this harsh treatment, have thought twice before doing so.

The second, which Louis describes at considerable length (90–101), concerns a diplomatic incident involving a dispute over precedence between Spanish and French ambassadors in London that year. Contrary to the advice of his counsel, the king wrought from the Spanish not only a humiliating personal apology but also solemn oaths confirming France's enduring superiority in such matters and that no similar incident would ever happen again. These two events together indicated clearly that the king was willing, where expedient, to play hardball. His incipient absolutism was emerging fast.

On matters more overtly religious, Louis wrote that, owing to the machinations of a "secte naissante" (*growing sect*), the Church was "enfin ouvertement menacée d'un schisme" (35) (*finally openly threatened with schism*). The group in question is made explicit later in the *Mémoires* for the same year when Louis writes, "Je m'appliquai à détruire le jansénisme, et à dissiper les communautés où se fomentait cet esprit de nouveauté, bien intentionnées peut-être, mais qui ignoraient ou voulaient ignorer les dangereuses suites qu'il pourrait avoir" (75) (*I pledged to destroy Jansenism and to break up the communities where this spirit of novelty was being stirred up and that were perhaps well intentioned but overlooked or chose to overlook the dangerous consequences that this could have*).[46] And as we shall see in Chapter 5, the Jansenist question was one of the first that Louis was to tackle head on in the 1660s (and one that he was obliged to revisit later in the reign). Although Louis's writing is sometimes deliberately oblique, it is nonetheless clear from the *Mémoires* how important it was for him

to establish and then maintain unity and order within the Church, and to do so with as little recourse to the pope as possible. Part of his stated strategy for achieving this goal was to be the appointment of suitable bishops (78). Given that the question of who was to choose bishops was itself a contentious issue in the ongoing struggle for influence between the Gallican Church and the Church of Rome (Louis nominated his own bishops, and the pope sent them their bulls if and when he approved the candidacy), this is a bid not only to solidify the Church in France but also to assert its relative independence from papal influence. Louis is more explicit with regard to the four individuals on whom he relied most heavily with regard to matters of conscience (sometimes referred to as his "conseil de conscience" [*council of conscience*]):

> Dans ce partage que je fis des emplois, les personnes dont je me servais le plus souvent pour les matières de conscience, étaient mon confesseur, le père Annat, que j'estimais en particulier, pour avoir l'esprit droit et désintéressé, et ne se mêler d'aucune intrigue; l'archêveque de Toulouse, Marca, que je fis depuis archêveque de Paris, homme d'un profond savoir et d'un esprit fort net; l'évêque de Rennes [La Mothe-Houdancourt], parce que la reine ma mère l'avait souhaité, et celui de Rodez [Péréfixe], depuis archevêque de Paris, qui avait été mon précepteur. (45–46)
>
> *As I distributed roles within my entourage, those whom I called upon the most with regard to matters of conscience were my confessor, père Annat, whom I held in particularly high regard for his integrity and selflessness and who did not participate in any kind of intrigue; the Archbishop of Toulouse, Marca, whom I later made Archbishop of Paris, a man who was deeply knowledgeable and clear-sighted; the Bishop of Rennes [La Mothe-Houdancourt], because the queen, my mother, had wished it, and the Bishop of Rodez [Péréfixe], who has since become Archbishop of Paris and who had been my tutor.*

We note the particular reliance on his Jesuit confessor, François Annat, who we know was to be a powerful driving force behind the anti-Jansenist campaign.[47] Louis acknowledges that all kingly actions and decisions should be motivated by a deep respect for God and insists on the importance of his own personal religious devotions (78–79).[48] He also warns his son against religious hypocrisy, both because it is morally wrong and offensive to God and, more interesting for the present discussion, because it cannot be disguised for long and is therefore ineffective as a tool in any case: "L'artifice se dément toujours, et ne produit

pas longtemps les mêmes effets que la vérité . . . A son égard [that of God], l'extérieur sans l'intérieur n'est rien du tout, et sert plutôt à l'offenser qu'à lui plaire" (79) (*Artifice will always reveal itself and cannot produce for very long the same effects as truth. In God's eyes, the exterior without the interior is nothing and serves rather to offend him than to please him*).[49] As we shall see in Chapters 2 and 3, the existence, nature, and effectiveness of religious hypocrisy are three vexed questions that relate directly to the scandal of Molière's *Tartuffe*. Meanwhile, it is no doubt significant that the problems facing the Catholic Church in France are given more attention here than the Protestant problem, for which Louis claims he has a long-term solution in mind (77). Although the Wars of Religion had ravaged France in the sixteenth century, French Protestants had not collectively rebelled during the Fronde and were therefore not seen as an immediate threat. In 1661, Louis XIV was more concerned about his subjects' obedience than their souls.

The *Mémoires* for 1662 discuss two further issues that are pertinent here: the Carrousel that took place that year and the appointment of Péréfixe to the archbishopric of Paris. A propos the Carrousel, Louis writes of the benefits of "plaisirs honnêtes" (*honest pleasures*), which "ôtent à la vertu je ne sais quelle trempe trop aigre" (132–33) (*relieve virtue of a certain harshness*).[50] While Louis's respect for God and for religion is at some profound level indisputable since, to the extent that we can ever know, he seems genuinely to have understood his position as monarch in terms of being God's appointee, we see here another side to his personality and indeed to his notion of kingship: a willingness—wish, even—to embrace worldly pleasures and their political benefits. We also note his wish to attenuate the effects of undiluted virtue. In the context of the tension between the *dévot* and the *mondain*, with which we began this chapter, this is an interesting (if not unusual) claim, and one that will be discussed at greater length in Chapter 2. Of course, Louis, while encouraging his son also to enjoy such pleasures and entertainments, warns that business must always be seen to come before pleasure (135).

Louis did not overlook matters more political and religious, and the *frondeur* Retz's long-awaited resignation from the bishopric of Paris is presented as being in the context of "l'autorité affermie en mes mains qui rendait toutes les cabales inutiles" (137) (*my newly consolidated authority, which rendered all the cabals useless*). This is, in 1662, to overstate the case somewhat, but it does reflect an incipient reality as, in the course of the 1660s, Louis XIV was to tighten his grip on the various cabals that he encountered. It is also a reminder of Louis's

explicit desire to be rid of all "cabales inutiles" (*unwelcome cabals*). Retz was replaced first by Pierre de Marca ("homme d'un savoir et d'un mérite extraordinaires" [137] [*a man of extraordinary knowledge and merit*]), who promptly died, and then by his former tutor, Péréfixe. Louis then deliberates at some length about his choice:

> Je ne fus pas fâché sans doute, mon fils, de reconnaître, par cette marque de mon affection, le soin qu'il avait pris de mon enfance, et il n'y a personne à qui nous devions davantage qu'à ceux qui ont eu l'honneur et la peine tout ensemble de former notre esprit et nos mœurs. Mais je ne me serais jamais déterminé à ce choix, si je n'eusse connu en lui, avec plus de certitude qu'en aucun autre, les qualités qui me semblèrent les plus nécessaires en un poste aussi considérable que celui-là. J'ai très souvent résisté à mon inclination, je le puis dire avec vérité, pour ne faire de cette nature de bien à des personnes à qui j'aurais fait avec plaisir du bien de toute autre sorte, ne remarquant pas en elles ou la capacité ou l'application d'un véritable ecclésiastique. (138)
>
> *I was certainly not displeased, my son, to be able to recognize, by this token of affection, the care that he had taken of my childhood, and there is nobody to whom we owe more than those who have had the honor and the burden of shaping our mind and our morals. But I would never have made this choice if I had not known that he, above all others, possessed the most crucial qualities that such a significant position demanded. I may honestly say that I have very often resisted my impulses in order not to bestow this type of favor on people on whom I would have gladly bestowed an entirely different kind of favor when I did not find in them the capability or the dedication of a genuine ecclesiastic.*

Since we know that Péréfixe was, both chronologically and by order of preference, Louis's second choice for the position, it is important for that choice to be justified at some length. Péréfixe's role in both the *Tartuffe* controversy and the Jansenist debacle will be discussed in detail in Chapter 5.

The Theatre

In the meantime, and in preparation for our examination of the *Tartuffe* controversy in the chapters that follow, we turn to the theatre and in particular to its involuntary function in postreformation France as a touchstone for devotion (or a lack thereof). It will be seen that the French Church never succeeded in convincing en masse either the public or the powers that be (or were) of the theatre's inherent

corruption. As Phillips puts it, "the *querelle du théâtre* in France is in fact a good example of the limitations of the powers of the French Church in the context of lay culture in our period" (*Church and Culture* 64). Phillips, following Marc Fumaroli, concludes that "the enthusiasm of the laity for the theatre, and of the most important members of that laity, was a major obstacle to the success of the Church" (65). One reason for this failure is the fact that the theatre was not formally condemned by the Council of Trent. Indeed, Tridentine tolerance of the theatre fed Roman enjoyment of it, even among many ecclesiastics, and this was a card that Molière was to play shamelessly during the *querelle de* Tartuffe.

And so, while it is true that the Spanish monarchs succeeded in closing the theatres for a time in both the sixteenth and seventeenth centuries (as did Cromwell in Puritan England), there was never any serious likelihood that the theatres would close in France. Phillips comments:

> Despite the refusal of many in the gallican Church to adopt Roman leniency in the domain of theatre, religious moralists could only urge the faithful not to attend public performances of plays. The Church never seriously came near to closing theatres and could do no more than exercise a purely moral influence on individual consciences. While many diocesan rituals included the actor among those refused the sacraments if they did not first renounce their profession (the diocese of Metz included spectators), many more did not. Bossuet, the scourge of Molière, never altered the ritual of his own diocese of Meaux. (*Church and Culture* 299–300)

If closure was not a viable option, one alternative was to attempt to reform the theatre, to rid it of its vulgarity, and to a certain extent this goal was achieved as the bawdy popular farces of the early decades of the seventeenth century were subsumed into the literary, more refined farces of, among others, Molière.[51]

But even self-proclaimed supporters of the theatre such as the abbé d'Aubignac, author of *La Pratique du théâtre* (first published in 1657), would express significant qualms about the inclusion of religion and religious topics in the theatre. In a later addition to his volume, d'Aubignac wrote:

> Je ne dy pas seulement qu'une piece entiere qui seroit contre la mauvaise devotion seroit mal receuë, mais je pretens qu'un seul vers, une seule parole qui meslera quelque pensée de religion dans la Comedie

blessera l'imagination des Spectateurs, leur fera froncer le sourcil et leur donnera quelque degoust. Nous en avons veu l'experience en des poemes que l'on a depuis peu representez, et nous le scavons encore par la lecture d'un autre, fait avec beaucoup d'art et d'esprit contre la mauvaise devotion [*Tartuffe*]; celuy-la mesme que l'on avoit fait voir au public où l'on avoit depeint le caractere d'un Impie chastié severement par un coup de foudre [*Le Festin de Pierre*], a donné beaucoup de peine aux gens de bien et n'a pas fort contenté les autres.[52]

> *I'm not saying only that a whole play that is critical of false devotion would be undesirable, but moreover that a single line or a single word that mixes religion with theatre would offend the spectators' sensibilities and make them frown with repulsion. We have seen this happen in the case of some plays that were performed recently, and we know it, too, from reading another, composed with considerable skill and wit, that attacks false devotion [*Tartuffe*]. We have also seen it in the case of a play that was performed in public and in which the wicked man is severely chastised by lightning [*Le Festin de Pierre*], which caused considerable consternation among the pious and did not really please the others either.*

Interestingly, d'Aubignac's main objection is to religious theatre *in performance*. He writes, "Les pieces de cette qualité peuvent estre leüs avec plaisir et mesme avec fruit, mais elles ne peuvent estre joüées publiquement sans produire les mauvais effets dont nous avons parlé" (331) (*These kinds of plays may be read with pleasure and even fruitfully, but they cannot be performed in public without producing the pernicious effects that we have discussed*). His is a particularly interesting point of view given that one solution to the theatrical dilemma that had been put forward was to promote religious drama, which might (in theory, at least) be used to edify its audience (Chill 163). According to Emmanuel Chill, these hopes had, however, been (more or less) abandoned by the 1660s, as the *dévots'* idea that they could achieve a genuinely Christian society was waning.

What is particularly fascinating about the arguments put forward against the theatre is the fact that a blanket charge of immorality often obscured bigger and more far-reaching arguments about the theatre's potential for moral instruction. The theatre was in some ways a rival to the Church, and as Phillips, among others, has observed, this rivalry was compounded (and not, as some hoped, alleviated) by the emphasis in contemporary dramatic theory in defense of the theatre on moral instruction. As Phillips puts it, "the Church could not be expected to look with indifference upon a secular space which seemed to arrogate to itself a task which was properly and traditionally theirs" (*Church*

and Culture 61). He writes, for instance, about the Sorbonne's anxiety that "religious problems might be discussed by an organisation not authorised and constituted by the Church" (181).[53] A 1660 sonnet by Antoine Godeau, Bishop of Grasse (and later Vence) is revealing in its paradoxical attitude toward the power, role, and utility of the theatre:

> Le théâtre jamais ne fut si glorieux,
> Le jugement si [sic] joint à la magnificence,
> Vne regle seuere en bannit la licence,
> Et rien n'y blesse plus ny l'esprit, ny les yeux.
> On y voit condamner les actes vicieux,
> Mal-gré les vains efforts d'vne injuste puissance,
> On y voit à la fin couronner l'innocence,
> Et luire en sa faveur la justice des Cieux.
> Mais en cette leçon, si pompeuse & si vaine,
> Le profit est douteux, & la perte certaine,
> Le remede y plaist moins que ne fait le poison;
> Elle peut reformer vn esprit idolâtre,
> Mais pour changer leurs mœurs, & regler leur raison,
> Les Chrestiens ont l'Eglise, & non pas le theatre.[54]

> *Never has the theatre been so glorious,*
> *In it we find both good judgment and magnificence,*
> *A harsh ruling has banished licentiousness,*
> *And nothing there offends our spirit or our eyes anymore.*
> *Vicious acts are condemned in the theatre,*
> *For all the vain efforts of unjust authority,*
> *Innocence is always crowned at the end,*
> *And is promoted by the light of heavenly justice.*
> *But the benefits of this pompous and vain teaching,*
> *Are doubtful, while the dangers are certain.*
> *The antidote is less enjoyable than the poison;*
> *While it can reform an idolatrous mind,*
> *In order to change people's morals and regulate their reason,*
> *Christians have the Church and not the theatre.*

While Godeau's conclusion is emphatic in its clarity, his tribute to the state of French theatre is also striking.

Given that the claims put forward in defense of the theatre were arguably as compelling as those made against it, it is perhaps unsurprising to find a woman known for her devotion regularly attending the theatre. As one biographer puts it, Anne of Austria was "passionately fond of the theatre," and even during her year of mourning following the death of Louis XIII, she continued to go to the theatre, but sat

hidden behind her ladies "for the sake of decency" (Kleinman 184). During the negotiations and preparations for the marriage of Louis XIV and Marie-Thérèse, the French court traveled to Saint-Jean-de-Luz, where they had to occupy themselves for a month. Drawing on the Montpensier *Mémoires*, Ruth Kleinman explains how "Anne took advantage of these weeks to indulge her two greatest passions: every day she visited churches and afterward saw Spanish plays" (270). For Anne, it would seem that there was no conflict between her religion and her favorite pastime.

However, the queen's predilection did not pass without criticism. The priest of Saint-Germain de l'Auxerrois (and parish priest of the Louvre) objected to it, claiming that Anne was setting a bad example to the rest of the French court and to French society more generally. In collaboration with seven theologians from the Sorbonne, he produced a document in 1647 in which it was declared that to frequent the theatre was a sin. Anne was sufficiently perturbed by their protestations to ask Péréfixe, then abbé de Beaumont, to investigate the matter in consultation with another group of theologians from the Sorbonne. Péréfixe returned with a declaration in which "il fut prouvé par dix ou douze autres docteurs, que, présupposé que dans la comédie il ne se dise rien qui pût apporter du scandale, ni qui fût contraire aux honnêtes mœurs, qu'elle était de soi indifférente et qu'on pouvoit l'entendre sans scrupule"[55] (*it was proven by ten or twelve scholars that, on condition that nothing is included in a play that could cause scandal or that runs counter to good morals, the theatre is in itself morally neutral and one may go to the theatre without hesitation*). Anne was reassured.

Meanwhile, another powerful force, in the shape of Mazarin, complained that Anne was spending too much time on her devotions and even suggested that the *dévots* (many of whom openly disapproved of her intimate relationship with the cardinal)[56] were deliberately keeping her occupied in order that she have less time to spend with him. Just as *Tartuffe* was to become a pawn in the conflict between *dévot* and *mondain* factions, so in a similar fashion was Anne of Austria a site of conflict between Mazarin and the *dévots*. Anne's love of theatre crystallized the fundamental conflict between *mondain* and *dévot*, while her unassailable devotion made it impossible to resolve the matter.

In the particular case of Molière, it should be remembered that during the bitter, more personal but less political controversy over *L'Ecole des femmes*, the Queen Mother agreed to have *La Critique de l'Ecole des femmes* dedicated to her, and Molière noted in the preface

to the published edition that she "ne dédaigne pas de rire de cette même bouche dont elle prie si bien Dieu" (Pléiade I, 485) (*does not consider it beneath her to laugh with the same mouth with which she makes her prayers to God*), thereby proving that "la véritable dévotion n'est point contraire aux honnêtes divertissements" (Pléiade I, 485) (*true devotion and honest entertainment are not mutually exclusive*). While Anne of Austria cannot have disapproved of *L'Ecole des femmes*, it has often been suggested that she did disapprove of *Tartuffe*. The allegation stems principally from a distorted sense of the exact nature of her personal morality and also from a line in Rochemont's pseudonymical *Observations sur une comédie de Molière, intitulée "Le Festin de Pierre"* (1665), in which a propos of *Tartuffe* we read of "le déplaisir que cette grande Reine en a témoigné" (Pléiade II, 1219) (*the displeasure that it caused this great queen*). But this is refuted in turn by the anonymous and infinitely more measured author of the *Lettre sur les observations d'une comédie du sieur Molière, intitulée "Le Festin de Pierre"* (1665), who notes that "cet Observateur . . . fait parler la Reine mère; mais l'on fait souvent parler les grands sans qu'ils y aient pensé. La dévotion de cette grande et vertueuse Princesse est trop solide, pour s'attacher à des bagatelles, qui ne sont de conséquence que pour les tartufles" (Pléiade II, 1232) (*this observer speaks for the Queen Mother; but people often speak on behalf of the royal family without their having any say in it. The devotion of this great and virtuous princess is too secure for her to be interested in such trifles, which are only of interest to the Tartuffes of this world*). In the following chapters, we shall examine exactly what and who these "tartufles" might be.

Chapter 2

What Is a *Faux Dévot*?
I. The Hypocrite

Molière's *Tartuffe* was premiered on the evening of May 12, 1664, in a makeshift theatre at Versailles before Louis XIV and his court. It is commonly understood to be a play about religious hypocrisy, the controversy it provoked owing to the alleged possibility that its audience might subsequently be unable to distinguish *off stage* between a hypocrite and a true believer. The particular concern was that true believers might be mistaken for hypocrites and that the reputation of the Church might thereby be unjustly tarnished or even seriously damaged. The debate is typically couched in terms of *vrais* and *faux dévots*, who correspond to true believers and religious hypocrites, respectively. In the course of the controversy, Molière also established a rhetorical correspondence between opponents of his play and the *faux dévots* it supposedly denounces, arguing—ingeniously but quite unfairly—that to oppose his play was in practice tantamount to an admission of personal religious hypocrisy. These assumptions and arguments will be reexamined and challenged (or at least nuanced) in the course of this book. In this chapter, I shall outline the origins of the *vrai-faux* paradigm that has dominated discourse regarding the *Tartuffe* controversy from 1664 onward, before turning my attention specifically to the notion of the *faux dévot*, focusing on its primary meaning as a religious hypocrite. (Its additional meaning, as a religious zealot, will be examined in Chapter 3.) That the character Tartuffe is some kind of religious hypocrite is not in dispute, although a brief examination of some contemporary views on religious hypocrisy will reveal that the concept is more multifaceted and highly complex than is sometimes acknowledged.[1] It will be seen that Tartuffe's

hypocrisy is revealed primarily by means of his sensuality, which is incompatible with the austere lifestyle that he preaches but does not himself practice. The nature of Tartuffe's weaknesses in this way aligns him with the enduring literary trope of the lascivious cleric that is as old as satirical literature itself. This is not to say that Tartuffe is wholly unoriginal or that he does not resonate with the people and events of 1660s France, for he emphatically does. Here, however, my aim is to begin to unpick the notion of the *faux dévot* and to focus on the role that sensuality plays in establishing personal hypocrisy.

I shall argue furthermore in favor of some surprising and striking parallels between Tartuffe's sensuality and that of the young Louis XIV at the time of the play's premiere at Versailles and during the first two decades of the king's personal reign.[2] While Jerry Kasparek lists Tartuffe's faults as being "ambition, greed, pride, [and] lust,"[3] Burke lists the principal failings of which Louis XIV was accused by his contemporary critics as "the king's ambition, his lack of moral scruple and of religion, his tyranny, his vanity, and his military, sexual and intellectual weaknesses."[4] The overlap is considerable, and like Tartuffe, Louis XIV's reputation was based more on his image than on his actual person; Tartuffe, meanwhile, has to perform his role and his religion in a way that is not dissimilar to Louis's performance of kingship and religion. In both cases, there exists a tension between a public image and a (more) private reality. While the question of Louis's adultery has received adequate attention,[5] its centrality to the *Tartuffe* controversy has been underestimated, and the insights it brings to the discussion have been largely overlooked. While I am emphatically not suggesting that the character or role of Tartuffe is in any way modeled on the king, I shall demonstrate that just as Tartuffe's sensuality made the *dévots* uncomfortable in 1664, so also—and more significantly, as well as more enduringly—did Louis XIV's. Among other reasons, then, Molière's play was met with hostility in *dévot* circles because it coincided, temporally and temperamentally, with a *mondain* and overtly sensual Louis. In Chapter 1, the general context of the early reign and some of its struggles were outlined; here the specific context of May 1664 and the significance of the courtly *fête* during which *Tartuffe* was premiered will be emphasized, as will the related controversy over the king's mistresses. Both controversies are understood to be touchstones in the struggle for influence.

Vrai-Faux Model

Molière himself advanced what was rapidly to become the enduring *vrai-faux* model when he wrote in his preface to the published edition of *Tartuffe* in 1669, "J'ai mis tout l'art, et tous les soins qu'il m'a été possible pour bien distinguer le personnage de l'Hypocrite d'avec celui du vrai Dévot" (Pléiade II, 92) (*I have done everything within my power to distinguish clearly between the character of the hypocrite and that of the* vrai dévot). Other contemporary sources that are commonly cited in support of this approach include, notably, the official, anonymous account of the 1664 *fête*, *Les Plaisirs de l'île enchantée*, at which *Tartuffe* was given its courtly premiere;[6] Rochemont's pseudonymical *Observations sur une comédie de Molière, intitulée "le Festin de Pierre"*; and the *Ordonnance de Monseigneur l'archevêque de Paris* of August 11, 1667, condemning the play in the strongest possible terms.[7] A later prominent example is to be found in Bourdaloue's sermon *Sur l'hypocrisie*.[8] I would like to briefly revisit each of these sources, as well as the lesser-known *Sentimens de l'Eglise & des SS Peres pour servir de discussion sur la Comedie et les comediens* by père Coustel, in order to begin to problematize the *vrai-faux* model.[9]

The official account of Louis XIV's *fête* surely ranks as the most balanced among contemporary views on *Tartuffe*, for it neither condemns the play nor entirely overlooks its explosive potential:[10]

> Le soir [du 12 mai] Sa Majesté fit jouer une Comédie nommée *Tartuffe*, que le Sieur de Molière avait faite contre les Hypocrites; mais quoiqu'elle eût été trouvée fort divertissante, le Roi connut tant de conformité entre ceux qu'une véritable dévotion met dans le chemin du Ciel, et ceux qu'une vaine ostentation des bonnes œuvres n'empêche pas d'en commettre de mauvaises; que son extrême délicatesse pour les choses de la Religion, ne put souffrir cette ressemblance du vice avec la vertu, qui pouvaient être prises l'une pour l'autre. (597)

> *In the evening, His Majesty arranged for a performance of a play called* Tartuffe, *by Molière, in which the playwright satirizes hypocrites. Although the play was found to be very entertaining, the king noted such a considerable overlap between those whose true devotion sets them on the path to heaven and those for whom a vain display of good deeds does not prevent them from committing bad deeds as well that his extreme delicacy with regard to matters of religion could not condone this close resemblance between vice and virtue, which could be mistaken one for the other.*

At first sight, this appears to conform to the *vrai-faux* model according to which true and false devotion are dichotomized and yet resemble one another closely (and it is of course the close resemblance that requires the would-be clear distinction suggested by dichotomy). Critics typically seize upon the opposition of good and bad works and of vice and virtue—their likeness and their potential for confusion. But the distinction being made is in fact rather more subtle: It is between the good works resulting from true devotion (*une véritable dévotion*) and those motivated by a vain ostentation that will either taint those good works or exist alongside bad ones (it is not entirely clear which). So while it is true that the importance of motivation is upheld here, it is not absolutely certain whether the authors of ostentatious good works are calculating hypocrites with another agenda entirely or simply misguided zealots. We are also reminded of the crucial fact that seemingly good works are not an infallible gauge of sincerity of heart.[11]

In his highly partisan account, Archbishop Péréfixe claimed in 1667 that Molière's play (now called *L'Imposteur*) was "d'autant plus capable de nuire à la Religion, que sous prétexte de condamner l'hypocrisie, ou la fausse dévotion, elle donne lieu d'en accuser indifféremment tous ceux qui font profession de la plus solide piété" (Pléiade II, 1168) (*all the more likely to cause harm to religion, owing to the fact that, while claiming to condemn hypocrisy, or false devotion, the play provides grounds to accuse indiscriminately all who profess the most steadfast piety*). Here there is no mention of a close resemblance between the most steadfast piety and false devotion; rather, the suggestion is that Molière's portrayal of hypocrisy might provide grounds ("donner lieu") for accusing true devotion *as well*. Nor does Péréfixe even state explicitly that such grounds (or even the accusations themselves) would be false—only that they would spring from a portrayal of false devotion. And does the conjunction *ou* imply that hypocrisy and false devotion are one and the same, or does it hint at some slippage between the two?

For Bourdaloue, in his fascinating sermon *Sur l'hypocrisie*, the question of a close resemblance reappears.[12] For him, when true or false religion is mocked, both are almost always implicated:

> Comme la fausse dévotion tient en beaucoup de choses de la vraie, comme la fausse et la vraie ont je ne sais combien d'actions qui leur sont communes; comme les dehors de l'une et de l'autre sont presque tout semblables, il est non-seulement aisé, mais d'une suite presque nécessaire,

que la même raillerie qui attaque l'une intéresse l'autre, et que les traits dont on peint celle-ci défigurent celle-là. (II, 235)

Since false devotion is in many ways dependent on true devotion, since the true and false varieties have who-knows-how-many acts in common, and since the external appearance of one and the other is almost identical, it is not only likely but also almost inevitable that the satire of one affects the other and that the characteristics that are used to portray the former discredit the latter.

In many respects, this quotation *does* conform closely to the *vrai-faux* paradigm, stressing as it does the external similarities between the two, although the repeated use of *presque* (*almost*) also suggests that the similarities, like their transferability, are not absolute. False devotion looks very much like true devotion because it behaves very much like true devotion (visiting the sick, giving money to the poor, and so forth). Once again, then, we are faced with the uncomfortable admission that a person's deeds (*actions*) do not necessarily make known his sincerity or otherwise.[13]

Another later example is found in Coustel's *Sentimens*:

Sous pretexte de ruiner la fausse devotion, il [Molière] represente les brutalitez de son Tartufe avec des couleurs si noires, & il luy fait advancer des maximes si detestables, que la corruption du Coeur humain ne manquera pas de les faire appliquer, non à un Tartufe de Theatre; mais à un veritable homme de bien. (66)

On the pretext of condemning false devotion, Molière represents his Tartuffe's wickedness with such intensity and has him pronounce such repugnant teachings that the corruption of the human heart will not fail to apply these not to a Tartuffe in the theatre but to a real-life man of religion.

The logic of this argument is difficult to follow and runs directly counter to Molière's claim to have made his *faux dévot* so unequivocally *faux* that there is precisely no possibility of confusion. Coustel goes on to make the interesting observation whereby any minor fault committed by a sincere *dévot* will align him with Tartuffe:

Ainsi cette piece expose les personnes les plus pieuses à une raillerie & à une censure inevitable, & sur l'idée qu'on aura de ce faux devot, on prendra occasion de les traiter impitoyablement pour la moindre faute qu'on leur verra faire, & de les mettre en parallele avec Tartufe. Que

> si on leur voit faire quelque action de pieté & de vertu, on dira que ce fourbe & cet hypocrite en faisoit encore de plus surprenantes. (66)

> *And so this play exposes the most pious individuals to inescapable mockery and criticism, and, based on the idea people have of this faux dévot, they will take the opportunity to be merciless with regard to the slightest indiscretion that the pious might commit and to associate them with Tartuffe—to the point where, if they are seen to do something pious and virtuous, people will say that the treacherous and hypocritical Tartuffe was even more remarkable in his good deeds.*

To admit that *vrais dévots* are capable of mistakes is an interesting strategy, but what Coustel is most concerned about is, once again, the uncomfortable fact that seemingly good deeds are no guarantee of sincerity—something that is not highlighted in Molière's play (the audience does not actually see Tartuffe visiting the sick or giving money to the poor) and for which Molière cannot justifiably be blamed. The problem, seemingly, is less that Molière's comic and exaggerated portrayal of false devotion might tarnish the audience's perception of off-stage true devotion than the inescapable fact that while false devotion will often give itself away, what appears to be evidence of true devotion can never be absolutely confirmed as such in real life. No man can see into another man's heart; only God can do this.

Bossuet had addressed this very question in a sermon on March 13, 1661, in which he commented:

> Quelque soin que prennent les hommes de démêler le vrai d'avec le faux, si celui dont il est écrit "qu'il éclaire tout homme venant au monde" n'envoie une lumière invisible sur les objets et l'intelligence, jamais nous ne ferons le discernement.[14]

> *However careful men are in their attempts to disentangle the true from the false, if the one about whom it is written that "he enlightens every man that comes into the world" does not cast his invisible light on the objects under scrutiny and on people's understanding, we shall never be able to make that distinction.*

And as Bourdaloue observed later in his sermon *Sur la vraie et la fausse piété*, "on entre dans les hôpitaux, on visite des prisons, on console des affligés, on soulage des malades, on assiste des pauvres; et tel peut-être qui fait voir sur cela plus d'assiduité et plus de zèle, est celui qui exerce moins la miséricorde chrétienne" (II, 219) (*people visit*

hospitals and prisons, they comfort the afflicted, they relieve the sick, they help the poor; and yet he who appears most assiduous and zealous in these acts is perhaps also the one who is least inclined toward Christian forgiveness). Indeed, it is even possible for an individual to engage in "une apparence de piété qui le trompe lui-même" (II, 216) (*a pious façade that is self-deceiving*).[15] It is owing to the risks inherent in attempting to distinguish between sincerity and hypocrisy that Bourdaloue, following Saint Augustine's recommendation not to judge prematurely (this should be left to God at the Final Judgment),[16] elects to focus in his sermon not on hypocrisy itself but instead on the pernicious effects of *perceived* hypocrisy.

Rochemont in his *Observations* had complained precisely about the external similarities between the hypocrite and the (*vrai*) *dévot* in his attack on Molière's play. Yet in so doing, he also offers one of the most convincing arguments in favor of the potential (and greater) visibility in a *theatrical* portrayal of either or both:

> L'hypocrite et le dévot ont une même apparence, ce n'est qu'une même chose dans le public, il n'y a que l'intérieur qui les distingue, et afin *de ne point laisser d'équivoque, et d'ôter tout ce qui peut confondre le bien et le mal*, il [Molière] devait faire voir ce que le Dévot fait en secret, aussi bien que l'hypocrite. Le dévot jeûne, pendant que l'hypocrite fait bonne chère, il se donne la discipline et mortifie ses sens, pendant que l'autre s'abandonne aux plaisirs et se plonge dans le vice et la débauche à la faveur des ténèbres: l'homme de bien soutient la Chasteté chancelante, et la relève lorsqu'elle est tombée, au lieu que l'autre, dans l'occasion, tâche à la séduire, ou à profiter de sa chute. (1215–16, original emphasis)

> *The hypocrite and the* dévot *look the same and behave the same in public. They are only distinguishable by what is on the inside, and in order not to leave any room for doubt and to remove anything that could fail to differentiate between good and evil, Molière should have shown what both the* dévot *and the hypocrite do in secret. The* dévot *fasts while the hypocrite eats well; he practices mortification while the hypocrite indulges in sensual pleasures and gives himself over to vice and debauchery under cover of darkness; a good man comes to the aid of chastity when it is under threat and sets it back on course; a hypocrite, when the opportunity arises, helps it fall or takes advantage of that fall.*

Rochemont is right to observe that the audience never sees any of the possible *dévots* alone, just as they never see Tartuffe alone, either. But he is also right to suggest, one assumes unwittingly, that the

theatre is in a privileged position with regard to the vexed question of hypocrisy since its conventions dictate that what is spoken alone—notably, in the revelatory monologue (of which there are of course none in this particular play)—be understood as sincere. The theatre thus offers greater scope for the general audience to witness the true, private motivations of individuals than does real life, and in that sense Rochemont's complaint, although ungenerous in the extreme, is perhaps not invalid. The question of who any (*vrai*) *dévot* in the play in question might be is discussed in Chapter 4, where the principal problem is revealed not to be the fact that we never see any *vrai dévot* acting in private but more fundamentally that there are simply no *vrais dévots* in the play at all. Meanwhile, Molière does establish Tartuffe's hypocrisy, not by his behavior when alone, but by accounts and representations of his behavior *in private*, away from Orgon but witnessed by other members of the household. If the epistemological reliability of the theatrical monologue is absent from *Tartuffe*, Molière gives us the next best thing, and for the cooperative audience member there remains no doubt that Tartuffe is a hypocrite.

Tartuffe's Hypocrisy

It is the outspoken servant, Dorine, who in I.4 first characterizes Tartuffe as a sensualist in both physique and behavior.[17] He is "gros et gras, le teint frais, et la bouche vermeille" (I.4.234) (*round and fat, with a ruddy complexion and red lips*), and the previous evening,

> . . . Fort dévotement il mangea deux perdrix,
> Avec une moitié de gigot en hachis (I.4.239–40)

> *Most devoutly, he ate a brace of partridge*
> *And half a leg of minced lamb.*

And then,

> Pressé d'un sommeil agréable,
> Il passa dans sa chambre au sortir de la table,
> Et dans son lit bien chaud, il se mit tout soudain,
> Où sans trouble il dormit jusques au lendemain. (I.4.245–48)

> *A pleasant sleepy feeling came over him;*
> *He left the table and went to his room,*

Straight into his warm bed he went
And slept soundly until morning.

The humor of these lines depends on the shared assumption that there is something incongruous about Tartuffe's behavior. Dorine makes this explicit in her ironic use of the word *dévotement*, the suggestion being of course that one cannot eat this much food or sleep that long and that comfortably in a way that is truly *dévot*.[18] Tartuffe is clearly guilty of gluttony and sloth. By extension, he is thus also guilty of hypocrisy, because his behavior is perceived to be incongruous with what he is supposed (in both senses of the word) to believe and with his role as a director of conscience. A crucial but unanswerable question is whether his hypocrisy is operative only at an external level (a discrepancy between his words and his actions) or also at an internal level (a discrepancy between his behavior and his hidden personal belief). This in turn points toward a bigger question: How can one tell the difference between a sincerely devout person (a *vrai dévot*) and an accomplished hypocrite (a *faux dévot* or, in Marc Escola's terms, a *(vrai) faux dévot*) when their external behavior is, by definition, the same? As Escola rightly reminds us, the answer is that, in the absence of an omniscient narrator (or, we should add, a revelatory monologue) one cannot.[19] Such a distinction is easily made in a novel and can be made in a theatrical monologue or, as Rochemont suggested, in staged scenes depicting an individual alone (or thinking himself to be alone); it is, however, impossible in real life. It is for theatrical, as well as theological, reasons, then, that Tartuffe must be a *(faux) faux dévot*: someone whose external behavior belies what that person is assumed to believe.[20]

Within these parameters of incomplete and problematic legibility, it is another aspect of Tartuffe's sensuality that establishes him most compellingly as a *(faux) faux dévot*: his sexual desire for, and pursuit of, Elmire.[21] In III.3, Elmire is quick to remind Tartuffe of his supposed lack of interest in worldly sensuality when she comments first, "Vous n'aimez rien des choses de la terre" (929) (*You are not interested in earthly matters*), and then, "Rien ici-bas n'arrête vos desirs" (932) (*Nothing from this world gets in the way of your heavenly aspirations*). Tartuffe famously tries to reconcile his sensuality with his profession and faith, but what emerges most forcefully is, in his own words, his human weakness (1009) and the fact that a man is made of flesh (1012). Of course, Tartuffe's notorious use of Jesuitical casuistry in his attempt to set aside the accusation of hypocrisy brings another dimension to that hypocrisy, in the form of the abuse of religious

methodology. Tartuffe may genuinely be unable to control his own sensuality, but his abuse of casuistry is knowing and calculated.

Later, when Tartuffe seeks concrete (i.e., fleshly) evidence of Elmire's supposed love or, rather, desire for him in IV.5, he is motivated not only by his lust but also by his own first-hand experience of the frequent discrepancy between words and actions, between image and reality—the same discrepancy that Elmire had, if more discreetly, highlighted in their previous encounter. And who better than Tartuffe to deliver a clear lesson on the unreliability of the spoken word?

> Nos vœux sur des discours ont peine à s'assurer (1460)
> Et je ne croirai rien, que vous n'ayez, Madame,
> Par des réalités su convaincre ma flamme. (1465–66)

> *Words alone are not enough to validate an agreement*
> *And I will believe nothing, Madame, until you have,*
> *With firm evidence, convinced me of your favor.*

If this is the moment at which, within the limits of *bienséance*, Tartuffe is at his most sexually aroused, it is also one of the most provocative at an epistemological level. Tartuffe is inviting the audience to seek truth not in discourse but in the physical (in both the bodily and the material sense) actions that take place behind closed doors. For Tartuffe (and he is well placed to know), private behavior is a far more accurate gauge of any reality than words or reputation. Just as he knows that his austere reputation (as perceived by Orgon and Mme Pernelle at any rate) belies his keen sensuality, so also does he doubt the sincerity of those around him—and rightly so.[22]

Louis XIV's Hypocrisy

While Tartuffe uses religion to achieve his personal ambitions in a piece of comic drama, a similar strategy is recommended in all seriousness and with some important caveats to Louis XIV by Pierre Le Moyne, who promotes the notion of "piété par interest" (*political piety*) and observes with striking cynicism that

> il n'y a point de frein plus propre à manier les Peuples que la Religion. Ce frein les rend souples à toutes leurs charges: il leur adoucit toutes leurs corvées: il leur fait prendre sans violence toutes les routes que l'on veut: il les accoustume à une obeïssance libre & sans contrainte.[23]

there is no check on the behavior of the people more effective than religion. This renders them compliant in all their works; it lessens their drudgery; it makes them accept their lot uncomplainingly; it accustoms them to a form of obedience that is free and without constraint.

However, for this religious tool to be effective, Louis XIV, like other monarchs, must serve as an example to his people and must not fall prey to hypocrisy: "Il faut que sa vie religieuse sans fard, soit une leçon de religion à ses peuples" (52) (*His religious life laid bare must be a lesson in religion to his people*). Otherwise, Le Moyne warns, the French people will become libertines and atheists and there will be anarchy and schism in the kingdom. As we saw in Chapter 1 (and as will be discussed at greater length in Chapter 5), the threat of schism was in no way vain, and is intimately bound to the story of *Tartuffe*.

Citing the case of King David, Le Moyne issues a special warning to his king regarding the risks of giving in to sensuality, noting that few princes escape this particular weakness (162–63). He then gives the example of Louis XIV's grandfather, Henri Le Grand (about whom, we remember, Péréfixe had written a sanitized history for the edification of his royal pupil), who was a great prince but with an excessive penchant for the female sex (212). Senault, too, had warned of the dangers of royal mistresses, commenting that "dés que le Prince s'attache au service d'une Maistresse, il cesse d'estre Souverain; & descendant de son Thrône, il se met en quelque façon sous les pieds de celle qu'il aime. Il est impossible d'estre prudent & d'estre amoureux" (*Le Monarque* 243–44) (*as soon as a prince pledges himself to the service of a mistress he ceases to be sovereign, and, stepping down from his throne, he places himself, as it were, at the feet of the woman he loves. It is impossible to be prudent when in love*). Senault continues, highlighting the particular dangers of a married monarch taking a mistress: "S'il est marié, le scandale & le péché sont encore bien plus grands; & outre le mauvais exemple qu'il donne à tout son Estat, il met la division dans sa famille, en donnant une Rivale à sa femme, & il autorise l'adultere en le commettant" (245–46) (*If he is married, the scandal and the sin are even greater. In addition to the bad example he sets to his whole state, he sows division within his family by giving his wife a rival; he authorizes adultery by committing it himself*). These were prophetic words, as this is exactly the situation in which Louis found himself in 1664. Louis's inappropriate attention to his brother's new wife, Henriette d'Angleterre (known as Madame), as early as 1661 had led to the introduction of Louise de La Vallière, one of his sister-in-law's maids of honor, as a decoy, but it was not long before Louis and

La Vallière embarked on a sexual relationship that would last several years, produce several bastard children, and cause considerable tension within Louis's family, particularly between the king and his disapproving mother. While Marie-Thérèse was pregnant with the dauphin (born November 1, 1661), the king's liaison with La Vallière was kept secret from the queen and others; with the royal succession seemingly secure, the time bomb of the inevitable revelation of their relationship ticked on, and Louis and Louise became increasingly indiscreet and their liaison became widely known at court. While adultery was undoubtedly a common feature of court life, the liaison was met with disapproval from a number of quarters, and several individuals even attempted to intervene.[24]

It was widely acknowledged, then, that French kings, who were theoretically supposed to be beyond reproach and close to God, needed to be vigilant with regard to their sensual—and in particular, their sexual—inclinations. Yet at the same time, as Georges Couton reminds us, the French monarchy had, from François I onward, with the exception of Louis XIII, also promoted the notion and political utility of the "cour galante" (*La chair* 55) (*gallant court*). A king's sexual prowess was of course a sign of his virility, and as Abby Zanger has argued, as the son of a king (Louis XIII) who had taken a dangerously long time to produce an heir, owing partly to his preference for reproductively sterile relationships with other men, it was politically expedient for the young Louis XIV to assert his own sexual potency.[25] However, Couton suggests that the extramarital liaisons of François I and Henri IV, among others, provoked less scandal than those of Louis XIV; he notes in the responses to Louis's adultery a new bitterness and surmises that "la conduite de Louis XIV avec ses maîtresses, et surtout Montespan, a pratiqué une ponction grave et durable sur le capital moral dont bénéficiait le roi" (*La chair* 214–15) (*Louis XIV's behavior with his mistresses, and especially with Montespan, made a serious and lasting dent in the king's moral capital*). Conflicting images were in fact repeatedly put into the service of the king's image. By virtue of his seemingly miraculous conception, for instance, Louis XIV was *dieudonné* (*God-given*), and by virtue of his status as French monarch, he was of course *le roi très-chrétien* (*most Christian king*), but he was quickly likened to a number of mythological divinities as well—notably, to Apollo. According to Francis Assaf's subtle account of contemporary conceptions of kingship, Bossuet's view, which was broadly christlike (or christomimetic), was in conflict with the more modern, juricentric view that allowed Louis XIV more leeway to separate his political persona from his private body.[26] Although

this coexistence of Christian and pagan imagery was not inherently incongruous to the seventeenth-century mindset, which could accommodate the reality of the Christian God alongside the figurative use of mythological divinities, the two did come into conflict when they were put to different uses in the service of different messages. It was, of course, on the subject of love that the two diverged most radically, for the type of Christian love modeled on God's love for his Church and on Christ's or a priest's love for his flock that Louis XIV was supposed to feel for the French people could hardly be more different from the type of sensual erotic love commonly experienced by his mythological models. Throughout his reign, Louis XIV was both the *roi soleil* (*sun king*), in relation to Apollo, and the *roi très-Chrétien* (*most Christian king*), in relation to God, sometimes simultaneously but usually independently. From the mid-1680s, he became more closely associated with the Christian God, but in the 1660s, the mythological comparisons were used more frequently and were in many ways more apt.

THE *CARÊME DU LOUVRE* (1662)

As a means to deepen our understanding of how the *dévots* viewed the sensual Louis XIV at this time, we turn to the twelve extant texts from Bossuet's sermon series that took place between February 2 and April 7, 1662, known as the *Carême du Louvre*, which predates *Les Plaisirs de l'île enchantée* by little more than two years. Bossuet is warmly described in the *Annales* of the Company of the Holy Sacrament, of which he was a prominent member, in the following terms:

> L'abbé Bossuet, depuis évêque de Condom et précepteur de Mgr le dauphin, et enfin évêque de Meaux. C'étoit un des ecclésiastiques les plus zélés et les plus exemplaires de la Compagnie, et il a toujours conservé ses pieux sentiments malgré son élévation et l'air de la Cour. (*Annales* 209–10)

> *Bossuet later became Bishop of Condom and tutor to the dauphin and finally Bishop of Meaux. He was one of the most zealous and exemplary ecclesiastics of the Company, and he retained his piety despite his success and despite the atmosphere at court.*

An unabashedly reforming *dévot*, Bossuet, who in 1662 was only a humble priest from the diocese of Metz, occupied an interesting position vis-à-vis the king, over whom he had no formal ecclesiastical authority

or influence.²⁷ It was Bossuet who took it upon himself, more than any other, to attempt to bring his errant David to repentance.

From Bossuet's point of view, kingly sin had repercussions that went far beyond a question of reputation. Its most devastating implications were twofold: In the first instance, it was a question of personal salvation, and as will be seen, Bossuet appears to have been genuinely and continually concerned about the state of Louis XIV's soul, repeatedly warning him not only about the dangers of sin but also of an imperfect repentance; in the second instance, it was a matter of concern for the whole of France, for the state might receive God's punishment by proxy in the form of war and especially famine. The stakes, therefore, were extremely high, and so in 1662, when preaching before the young king for the first time, Bossuet did not shy away from difficult or uncomfortable subject matter. Quite the reverse: Spurred on by the urgency of the matter at hand and bolstered by the authority imputed to him by the austerity of the Lenten season as well as his own extraordinary audacity, he tackled the troublesome sensual appetites and desires of the French court and king in some strikingly bold and direct ways.²⁸

Bossuet's *Sermon du mauvais riche* (delivered on March 5, 1662), for instance, is clearly a response to the court's evident penchant for lavish festivities. In it, Bossuet compares his protagonist, an "homme de plaisirs et de bonne chère" (*man of pleasures and good food*), with "le pauvre Lazare, qui mourait de faim à sa porte" (93) (*poor Lazarus, who was dying of hunger on his doorstep*). He comments that the poor ask only for "le superflu, quelques miettes de votre table, quelques restes de votre grande chère" (106–7) (*what's unwanted, a few crumbs from your table, the leftovers from your feasting*). It is, he claims, scandalous that some inhabitants of France should eat to excess while others, after a particularly harsh winter, endure a famine.²⁹ Furthermore, he insists that the former are in some way directly responsible for the plight of the latter: "Ce riche inhumain . . . a dépouillé le pauvre Lazare, parce qu'il ne l'a pas revêtu; . . . il l'a égorgé cruellement parce qu'il ne l'a pas nourri . . . Et cette dureté meurtrière est née de son abondance et de ses délices" (105) (*This inhuman and wealthy man has made poor Lazarus naked because he has not clothed him; he has cruelly bled Lazarus dry because he has not fed him; and this murderous callousness stems from his excesses and his pleasures*). In 1664, the official account of *Les Plaisirs de l'île enchantée* would fly in the face of Bossuet's position on the question of food and famine by emphasizing precisely some of the elements that the preacher had condemned, including *bonne chère* (*good food*), *abondance* (*abundance*) and *délices*

(*delights*), each of which features as a positive attribute in the account of the first day of the *fête* (see Pléiade I, 534). Bossuet's literal and metaphorical use of food in his sermons is thus in marked contrast to the self-conscious use of excess soon to be adopted by the king; as Jean-Marie Apostolidès argues, "de l'opposition entre rareté dans le royaume et surabondance à la cour naît le mythe de la surpuissance du roi qui peut seul se permettre de telles dépenses ostentatoires"[30] (*the myth of an ultrapowerful king who alone could afford such ostentatious expenditure was borne of the opposition between scarcity in the kingdom and superabundance at court*). In other words, "Versailles offre aux privilégiés une surabondance de mets, alors que la carence alimentaire (pour ne pas parler de famines qui déciment périodiquement les villages) est le lot quotidien d'une partie des vingt millions de Français" (Apostolidès, "Spectacle" 27) (*Versailles offered the privileged a superabundance of dishes when food shortages (not to mention the famines that periodically decimated villages) were the staple of a good many of France's twenty million people*).

More audacious still is Bossuet's seemingly unflinching attack on the king's sexual sin. It happened that the sermon series coincided with a crisis in the relationship between Louis XIV and Louise de La Vallière: On February 24 or 25, 1662, after a fight with her royal lover, La Vallière fled the court and sought refuge in a convent in Chaillot. Her request was refused, and the king himself went to retrieve her. Whenever the exact moment that Bossuet became aware of the king's adultery, it is abundantly clear that his knowledge of this particular sin inflects a good number of these sermons. One of Bossuet's most frequent devices for approaching this delicate subject was with reference to the Bible's most famous adulterer, David—a great king, guilty of sexual sin but ultimately brought to repentance and thereby to further greatness.[31] Although the use of such figures allowed the preacher more scope to broach difficult topics by seeming to do so indirectly, these were nonetheless widely understood and could sometimes be very hard hitting indeed. One instance of particular force is when Bossuet, casting himself as David's prophet, Nathan (who himself tended to adopt the veil of parable when speaking of delicate matters to his king), spells out his technique in the sermon delivered on February 26 (i.e., following La Vallière's flight and retrieval), *Sur la prédication évangélique*, in the presence of the king:

> Nathan lui parle. Nathan l'entretient, et il entend si peu ce qu'il faut entendre, qu'on est enfin contraint de lui dire: Ô prince! c'est à vous

qu'on parle; parce qu'enchanté par sa passion et détourné par les affaires, il laissait la vérité dans l'oubli. (*Le Carême* 83)

> *Nathan speaks to him. Nathan addresses him and the king is so lacking in understanding that finally Nathan is obliged to say to him, "Oh, prince! This story is for you!" Bewitched by his passion and distracted from his work, the king had forgotten the truth.*

The moment when Bossuet adopted the direct speech of the prophet apostrophizing his king ("Ô prince! c'est à vous qu'on parle") is when Louis XIV reportedly lowered his head—one assumes in shame or, at the very least, discomfort. Another favorite biblical reference for Bossuet and throughout the seventeenth century was to Mary Magdalen, also known for her sexual sin and subsequent repentance. In the light of what we know about La Vallière's religious and moral scruples, the hope that she, like Mary, would repent and turn to God seemed quite plausible. Bossuet's sermons also explain why all this should matter:

> ils [les rois] donneraient au Dieu vivant un trop juste sujet de reproche, si, parmi tant de biens qu'il leur fait, ils en allaient encore chercher dans les plaisirs qu'il leur défend, s'ils employaient contre lui la puissance qu'il leur accorde, s'ils violaient eux-mêmes les lois dont ils sont établis les protecteurs. (*Le Carême* 237–38)

> *Kings would give the living God all too genuine cause for reproach if, in the wake of all the blessings he showers upon them, they looked for further satisfaction among the pleasures that he does not permit them, or if they used against him the very power that he gives them, if they themselves broke the laws that they are in place to protect.*

Such behavior is reprehensible in the all-seeing eyes of God, worthy of divine punishment and possibly, therefore, damnation. Behind Bossuet's evident concern for Louis XIV's soul, we can also detect his concern for the well-being of his country. As indicated, it was thought that the sinful semiprivate behavior of France's king would be met with national disasters such as famine and lost wars.

Bossuet, then, is at least as concerned with religious hypocrisy as is Molière—considerably more so, in fact. In the sermon on *L'intégrité de la Pénitence*, given on March 31, 1662, he gives examples of sinners who did not enjoy the benefits of a genuine repentance or whose repentance came too late (Antiochus, King Saul, and Judas). It is

remarkable that, for Bossuet, even a divinely appointed king such as Louis XIV might be insincerely—or at least incompletely—penitent. This is a theme to which he would return again and again as the king persisted in his sexual sin. It is also one that reflects seventeenth-century debates regarding the nature of penitence and particularly the distinction between attrition and contrition, the former being borne of an incomplete repentance rooted in a fear of divine punishment and hellfire, the latter borne of genuine remorse founded in a deep love of God.[32] Most critics and historians agree that Louis's personal faith bore the marks of fearful superstition.[33]

In the same sermon, Bossuet offers quite a nuanced discussion of different types of religious hypocrisy, including one that seems to be a form of self-casuistry:

> Ainsi, par une étrange illusion, au lieu que la conversion véritable est que le méchant devienne bon, et que le pécheur devienne juste, il [le pécheur] imagine une autre espèce de conversion, où le mal se change en bien, où le crime devienne honnête, où la rapine devienne justice. (*Le Carême* 221)[34]
>
> *And so, by a strange illusion, in place of a real conversion where the bad man becomes good and the sinner becomes righteous, the sinner imagines another kind of conversion where evil becomes good, crime becomes lawful, and plundering becomes fair.*

What Bossuet condemns here is precisely the process by which Tartuffe tries to convince Elmire that he can reconcile their anticipated adultery with religious principles. Earlier in the sermon series, Bossuet had asked rhetorically, "Des vices cachés en sont-ils moins vices?" (*Le Carême* 138) (*Is hidden vice any less of a vice?*). While a contemporary proverb held that "péché caché est à demi pardonné"[35] (*a hidden sin is half forgiven*), Tartuffe states categorically that "ce n'est pas pécher que pécher en silence" (IV.5.1506) (*to sin in silence is no sin at all*),[36] confidently reasserting the importance of appearance as a guarantor of reputation, based on the knowledge that reputation and reality are not one and the same:

> . . . Le mal n'est jamais que dans l'éclat qu'on fait;
> Le scandale du monde est ce qui fait l'offense. (IV.5.1504–05)
>
> *Any harm lies only in the scandal that is created;*
> *It is other people's reactions that make it an offense.*

This is indeed the crux of the matter: Both Bossuet and Tartuffe know that sincerity of heart is impossible to prove but that private actions are generally a better gauge of authenticity than formal rhetoric.

If Molière invited his courtly audience in 1664 to question the credibility of the external signs of Christianity, Bossuet had warned much the same audience of the same thing two years earlier.[37] Indeed, one of his descriptions of a sinner sounds uncannily like Tartuffe:

> Ce pécheur . . . pour éviter de se cacher, tâche plutôt de cacher son crime sous le voile de la vertu, ses trahisons et ses perfidies sous le titre de la bonne foi, ses prostitutions et ses adultères sous l'apparence de la modestie. (*Le Carême* 220)
>
> *This sinner, in order to avoid having to hide away, tries instead to hide his crime under cover of virtue, his betrayal and his treachery under the guise of good faith, and his prostitution and adultery under the appearance of modesty.*

Given Bossuet's concern about Louis's sensual and *mondain* inclinations, and particularly his extensive engagement with the notion of *plaisirs* (*pleasures*) in his opening sermon on the purification of the Virgin Mary, in which he opposes spiritual and mortal pleasures, Louis's *fête* may be understood as an act of defiance on the part of the king. And given the title of the *fête*, it is particularly striking to read Bossuet's declaration in one sermon: "Je veux arracher ce cœur de tous les *plaisirs* qui l'*enchantent*" (*Le Carême* 76, my emphasis) (*I want to wrench this heart away from all the pleasures that bewitch it*).[38] Indeed, the very question of pleasure is problematic. In Péréfixe's *Henry le Grand*, he put forward the notion of a form of political, professional pleasure, discreetly noting that "il faut qu'un Roy fasse ses delices de son devoir, que son plaisir soit de régner" (5) (*a king's delight must be in his duty; his pleasure must be in reigning*). Meanwhile in the constitition of the Caen branch of the Company of the Holy Sacrament, the idea of *plaisir* is explicitly rejected. Their sixth point reads: "De fuir toutes les choses délicieuses, mesme de ne rien faire ny rien désirer par le motif du plaisir, n'en admettant aucun s'il n'est conjoint justement à la nécessité ou à la condescendance au prochain, ou à la santé du corps, ou au relâche et délaissement de l'esprit" (Tallon 160) (*To avoid all delights, to do nothing and desire nothing for pleasure, to accept no pleasure unless it is in order to meet the needs of or help another, or unless it helps maintain a healthy body or gives rest to the mind*). This could helpfully be compared to what Louis XIV writes

in his *Mémoires* about the efficacy of "plaisirs honnêtes" (132) (*honest pleasures*), which include the fact that "ils délassent du travail . . . servent à la santé" (132) (*they relieve us from work and are good for our health*). Louis's comment whereby these types of pleasure, which explicitly include theatre, "ôtent à la vertu je ne sais quelle trempe trop aigre" (132–33) (*relieve virtue of a certain harshness*), is particularly interesting in that it puts a limit on the desirability of pure virtue. For Bossuet and those of his ilk, Louis's *fête* would epitomize all that was wrong about his pleasure-seeking court at the same time that it signaled the unwelcome direction that the reign seemed to be taking.

THE *FÊTE* (1664)

Les Plaisirs de l'île enchantée officially took place over three days, between May 7 and 9, 1664, on the grounds of Louis XIV's country retreat at Versailles. The entertainment continued unofficially in the days that followed, and *Tartuffe* was given its first performance toward the end of the court's stay. The *fête* was a vast operation requiring the skills of hundreds of performers and artisans and to which some six hundred guests were invited. It was overseen by the duc de Saint-Aignan, about whom Cardinal Chigi wrote later in 1664:

> Le duc de Saint-Aignan occupe une grande place dans le crédit du roi; elle ne lui vient pas de son immixtion aux affaires publiques, mais de la part qu'il prend aux divertissements de la cour, dont il est le promoteur et l'organisateur. C'est de ce seigneur que le roi se sert pour connaître ce qu'on pense de lui à la cour.[39]

> *The Duke of Saint-Aignan is highly esteemed by the king; this is owing not to his involvement in public affairs but rather to his role as chief organizer of court entertainment. The king consults Saint-Aignan when he wants to know what people think of him at court.*

In the text of the official account of the *fête*,[40] we read that "le Roi commanda au Duc de Saint-Aignan . . . qui avait déjà donné plusieurs sujets de Ballet fort agréables; de faire un dessein" (Pléiade I, 522) (*the king asked the Duke of Saint-Aignan, who had already provided several delightful subjects for court ballets, to oversee this* fête). Saint-Aignan's position and his frequent participation in the gallant genre of court ballet places him (and this *fête*) firmly in the *mondain* tradition. The theme of the *fête* was taken from cantos VI and VII of Ariosto's *Orlando furioso*, which narrate Roger's sojourn with his knights

on the island belonging to the magician, Alcine. Although Ariosto's original may be classified as a Christian epic, it serves principally as a frame for a *fête* whose moral thrust is undeniably hedonistic. Indeed, the overarching theme of the *fête* and at least some of its purpose is, as its title suggests, pleasure. The opening words of the official account read as follows: "Le Roi voulant donner aux Reines et à toute sa Cour le plaisir de quelques Fêtes peu communes" (Pléiade I, 521) (*The king wanted to provide the queens and all his court with the pleasure of some unusual festivities*). It was the inaugural event for Versailles, whose renovation had only recently begun and was to last for decades. The château, initially a relatively modest hunting lodge, is formally introduced in the opening paragraph of the official account, where it is described as "une Maison de Campagne" (*a country house*) in a location "à quatre lieues de Paris" (Pléiade I, 521) (*four hours from Paris*). The account continues: "C'est un Château qu'on peut nommer un Palais Enchanté, tant les ajustements de l'art ont bien secondé les soins que la Nature a pris pour le rendre parfait: Il charme en toutes manières, tout y rit dehors et dedans, l'or et le marbre y disputent de beauté et d'éclat" (Pléiade I, 521) (*It is a château that could be called an enchanted palace since the art of man has so ably assisted nature in making it perfect. It is charming in every way, everything inside and outside the house is filled with laughter, and its gold and marble vie with each other in beauty and radiance*). In keeping with the theme of the *fête*, Versailles is established as a magical, beautiful, and impressive place; it is a palace given over to laughter. The pleasure-seeking, *mondain* message could hardly be clearer.

For all its emphasis on pleasure, *Les Plaisirs de l'île enchantée* was certainly not apolitical. The fact that we read toward the end of the official account of these having been festivities "où les soins infatigables de Monsieur de Colbert s'employèrent en tous ses divertissements, malgré ses importantes affaires" (Pléiade I, 597) (*to which the indefatigable Colbert has contributed despite having pressing business to deal with*) clearly places the *fête* also within the broader context of Colbert's burgeoning grand scheme to establish an official, public image of the young king that was grandiose and heroic. This was the inaugural *fête* of the reign, and one that was intended to eclipse Fouquet's fated 1661 *fête* that had been followed so swiftly by his arrest. In this context, the *fête* was particularly timely given that public opinion with regard to the ongoing trial of Fouquet had begun to turn, somewhat, against Colbert and the king.[41] The *fête* was political in other ways, too. We saw earlier that it was formally dedicated to Louis's mother, Anne of Austria, and to his wife, Marie-Thérèse (the two queens).

Rey notes that the widely held notion whereby the *fête* was secretly dedicated to La Vallière, who had given birth to the king's child in December 1663,[42] is absent not only from official accounts, as one would expect, but also from contemporary private accounts (Rey and Lacouture 70).[43] Kathleen Wine, meanwhile, notes that *Les Plaisirs de l'île enchantée* marked the moment at which Louise de La Vallière was formally established as Louis's *maîtresse en titre* ("*Le Tartuffe*" 141). While the transition may not have been quite as official as Wine suggests, she is certainly right to observe that La Vallière's increasing prominence, and Louis's dwindling discretion, will have conferred a "highly charged atmosphere" on the whole event.

However, the official account is keen not to lose sight of the king's political role, and we read that in the opening procession on the evening of May 7, a richly adorned d'Artagnan, representing the king, carried a shield bearing the inscription *Nec Cesso, nec Erro* (*I do not cease, I do not err*). As the official program explains, this and other similar indicators "faisant allusion à l'attachement de sa Majesté aux affaires de son Etat, et la manière avec laquelle il agit" (Pléiade I, 522) (*referred to His Majesty's commitment to matters of state and to his modus operandi*). But as Wine puts it so neatly, the inscription in fact "denies the errors Louis is about to reenact" ("Honored Guests" 82). On the first day, the king himself played the role of Roger. The theme of gallantry and even of infidelity is introduced early on in the verses for the Marquis de Villequier, representing Richardet, which read:

> Personne comme moi n'est sorti galamment
> D'une intrigue où sans doute il fallait quelque adresse,
> Personne à mon avis plus agréablement
> N'est demeuré fidèle en trompant sa Maîtresse. (Pléiade I, 526)

> *Nobody has emerged so gallantly as I have*
> *From a situation that no doubt required some skill.*
> *Nobody, in my opinion, has more agreeably*
> *Remained faithful when cheating on his mistress.*

The verses for the marquis de La Vallière, brother of Louise, who featured as Zerbin alongside prominent members of the older nobility, promote love and allude to royal love:

> Quelques beaux sentiments que la gloire nous donne
> Quand on est amoureux au souverain degré,
> Mourir entre les bras d'une belle Personne
> Est de toutes les morts la plus douce à mon gré. (Pléiade I, 526)

> *Whatever noble feelings our sense of glory gives us*
> *When we are in love to a sovereign degree,*
> *To die in the arms of a beautiful woman*
> *Is to my mind the most pleasing of all deaths.*

While the reference may not have been legible to members of the foreign courts to which the official account of the *fête* was later sent, members of Louis's own court, well trained in the art of deciphering punning references to court gossip (embodied here in the word *souverain*), would have had no difficulty picking it up, particularly given the identity of the individual with whom they are associated. The motto linked to the marquis, likewise, read *Hoc juvat uri* (*What a pleasure to be enflamed by him*) and was similarly intelligible to those in the know (Pléiade I, 529).

Interestingly, these thinly veiled allusions are followed by a lengthy and open compliment to the king's wife, Marie-Thérèse, in praise of political marriage and in which Apollo, no less, salutes "le charmant object qu'Hymen y fait régner" (Pléiade I, 529) (*the beautiful object that Hymen has put on the throne*) as well as "le nom glorieux d'Epouse de LOUIS" (530) (*the glorious name of Louis's wife*). Later in the first day, further compliments were made to the queen, with particular reference to the fact that she had already produced an heir (533).[44] This, of course, is the principal purpose of a dynastic marriage: to ensure continuity of the line. In that sense, Marie-Thérèse had fulfilled her function, and the political marriage that led to the birth of the dauphin can be couched rhetorically and gallantly in terms of love. A mistress's function, on the other hand, is to give and receive pleasure and to testify to the king's gallantry and virility. While this coexistence of references to the king's love affair and to his wife seems tactless, it accurately reflects the situation in which Louis found himself juggling the necessities and benefits of a political and broadly religious marriage to someone of whom he was evidently fond (if not passionately so) with a drive to pleasure and self-indulgence that could, at least in part, also be exploited for political capital.[45] The fact that the references to the queen are explicit while those to La Vallière are veiled, however thinly, maintains a veneer of formal decency that may have paradoxically allowed the king more leeway to indulge his more dubious inclinations. Meanwhile, the fact that on the first day the marquis de La Vallière won the *course de bague* (*running at the ring*) is certainly convenient and probably uncoincidental; the fact that his prize was a lavishly bejewelled sword presented to him by the Queen Mother must have been uncomfortable, to say the least.

The second day of *Les Plaisirs* was given over primarily to the première of a new *comédie-ballet* by Molière, with music by Jean-Baptiste Lully, commissioned for the event and based on Moreto's *El Desden con el Dedsen* (published in Madrid in 1654): *La Princesse d'Elide*.[46] The Spanish source for the play may have been chosen in honor of the two Spanish queens; certainly the theme and tone of Molière's adaptation are very much in keeping with the pleasure-seeking, amorous spirit of the *fête*. *La Princesse d'Elide* has often been read as an apology for Louis XIV's relationship with Louise de La Vallière, and in view of its context, this is certainly a credible interpretation. As will be seen, the play not only appears to condone the phenomenon of a king in love (and even a king's extramarital love affairs) but also seeks to square it with his kingly qualities.

The opening musical *intermède* sets the tone of the *comédie-ballet* and anchors it firmly within the context of courtly gallantry and the pursuit and indulgence of love. The opening sung *récit*, in the tradition of those that were commonly used in court ballets, urges young women of the court precisely to give in to love, a theme that will provide the driving force of the play's plot:[47]

> Quand l'Amour à vos yeux offre un choix agréable,
> Jeunes beautés laissez-vous enflammer.
> Moquez-vous d'affecter cet orgueil indomptable,
> Dont on vous dit qu'il est beau de s'armer:
> Dans l'âge où l'on est aimable
> Rien n'est si beau que d'aimer. (Pléiade I, 536)

> *When love offers you a pleasing opportunity,*
> *Young beauties, allow yourselves to burn with passion.*
> *Do not affect an invincible pride*
> *That some say it is good to adopt.*
> *When you are of an age that is lovable*
> *Nothing is more beautiful than to love.*

The second stanza addresses the phenomenon of disapproving opponents of youthful lovemaking:

> Soupirez librement pour un amant fidèle,
> Et bravez ceux qui voudraient vous blâmer;
> Un cœur tendre est aimable, et le nom de cruelle
> N'est pas un nom à se faire estimer:
> Dans le temps où l'on est belle,
> Rien n'est si beau que d'aimer. (Pléiade I, 536)

> *Sigh openly for a faithful lover,*
> *And defy those who would like to condemn you.*
> *A tender heart is lovable, and to be called cruel*
> *Is no way to be appreciated.*
> *When you are young and beautiful,*
> *Nothing is more beautiful than to love.*

The agenda is set, and Molière-Lully's *comédie-ballet* is established less as a light-hearted, gentle response to the general concerns expressed by the likes of Senault and Le Moyne than as a vigorous, if indirect, riposte to the more specific complaints voiced by the king's mother, courtly *dévots*, and even Bossuet. Interestingly, the question of blame is raised and again dismissed in the summary of the opening scene of the play, which features "Euryale Prince d'Ithaque amoureux de la Princesse d'Elide, et Arbate son Gouverneur, lequel indulgent à la passion du Prince, le loua de son amour *au lieu de l'en blâmer*, en des termes fort galants" (Pléiade I, 543, my emphasis) (*Prince Euryale of Ithaca, who is in love with the Princess of Elide, and Arbate, his tutor, who is indulgent of the prince's passion, praises him for his love* instead of condemning him, *in the most gallant of terms*). More specifically, when Arbate is invited explicitly to comment on his master's amorous pursuit, he responds at length:

> Moi vous blâmer, Seigneur, des tendres mouvements,
> Où je vois qu'aujourd'hui penchent vos sentiments;
> Le chagrin des vieux jours ne peut aigrir mon âme
> Contre les doux transports de l'amoureuse flamme,
> Et bien que mon sort touche à ses dernier Soleils,
> Je dirai que l'Amour sied bien à vos pareils:
> Que ce tribut qu'on rend aux traits d'un beau visage
> De la beauté d'une âme est un clair témoignage,
> Et qu'il est malaisé que sans être amoureux
> Un jeune Prince soit et grand et généreux:
> C'est une qualité que j'aime en un Monarque,
> La tendresse du cœur est une grande marque,
> Et je crois que d'un Prince on peut tout présumer
> Dès qu'on voit que son âme est capable d'aimer.
> Oui cette passion de toutes la plus belle
> Traîne dans un esprit cent vertus après elle,
> Et tous les grands Héros ont senti ses ardeurs. (I.1.15–32)

> *How could I blame you, my lord, for the tender movements*
> *That I see are stirring in your heart?*

> *The sadness of old age cannot harden my soul*
> *Against the sweet transports of an amorous flame.*
> *And although I am in the winter of my life,*
> *I believe that love is most becoming in people like you,*
> *That to pay tribute in this way to a beautiful face*
> *Is clear evidence of the beauty of one's soul,*
> *And that it is difficult for a young prince*
> *To be great and generous unless he is in love.*
> *Love is a quality that I appreciate in a monarch;*
> *Tenderness of heart is a sign of greatness,*
> *And I think that one can expect anything from a prince*
> *When one sees that his soul is capable of love.*
> *Yes, this passion, the most beautiful of all,*
> *Brings to an individual one hundred virtues,*
> *And all great heros have felt its fervor.*

Not only, according to Arbate's view of kingship, is an amorous king exempt from the weakness that is sometimes associated with being in love; his inclination is also evidence of other kingly qualities, including greatness, generosity, and a hundred virtues. Indeed, according to him, an inclination toward erotic love is a prerequisite for any king who is to become a great hero.[48] This was not a view shared by Senault or Le Moyne—still less by Bossuet.

Although Euryale and Arbate are concerned with a nonadulterous form of love, the question of royal adultery and even of bastard children does also feature in the play, where it is treated with good-humored flippancy.[49] The comic character, Moron, played by Molière, observes in I.2 to the prince, Euryale:

> Vous êtes né mon Prince, et quelques autres nœuds
> Pourraient contribuer au bien que je vous veux:
> Ma mère dans son temps passait pour assez belle,
> Et naturellement n'était pas fort cruelle;
> Feu votre Père alors, ce Prince généreux,
> Sur la galanterie était fort dangereux,
> Et je sais qu'Elpénor, qu'on appelait mon Père,
> A cause qu'il était le mari de ma Mère,
> Contait pour grand honneur aux Pasteurs d'aujourd'hui
> Que le Prince autrefois était venu chez lui,
> Et que durant ce temps il avait l'avantage
> De se voir salué de tous ceux du village. (I.2.251–62)

> *You were born my prince, and some other ties*
> *Might also play a part in the goodwill that I feel toward you:*

> *In her day, my mother was thought to be beautiful*
> *And was naturally not cruel.*
> *Your late father, a generous prince, was then*
> *Most dangerous in his gallantry,*
> *And I know that Elpénor, who was known as my father*
> *Because he was my mother's husband,*
> *Proudly told the local shepherds*
> *That the prince had once come to his house*
> *And that at this time he had had the honor*
> *Of being greeted by all the villagers.*

Even some of the female characters vaunt the power of love and appear unconcerned by polygamy (or perhaps serial monogamy), as when Cynthie observes, "Les Dieux même sont assujettis à son empire: On nous fait voir que Jupiter n'a pas aimé pour une fois; et que Diane même dont vous affectez tant l'exemple n'a pas rougi de pousser des soupirs d'amour" (II.1) (*The gods themselves are subject to love's empire; we are told that Jupiter loved more than once and that even Diana, whose example you claim to follow, was not ashamed to utter sighs of love*). The god(dess) to whom a sacrifice is made as reported in II.4 and who confirms the princess's change of heart at the end of the play (V.4) is Venus, and the play ends with a song in praise of the pleasures of erotic love. We could hardly be further away from the *dévot* principles expounded by Bossuet to many of the same people in 1662.

While it would be wrong to read the *comédie-ballet* as a straightforward *roman à clé*, its resonances with the real-life Louis XIV are impossible to ignore, particularly when one considers that it is, with its opening and closing songs and in its *fête* context, strongly reminiscent of the coded, gossiping genre of court ballet.[50] Indeed, the king's liaison with La Vallière had already featured far less discreetly in some of Benserade's openly gallant *ballets de cour*—notably, in the *Ballet des Arts* (performed in January 1663), in which, in the opening entry, La Vallière had played a shepherdess to Louis's shepherd. Although Benserade's verses written for the king insist that his pleasure will never take precedence over more important matters, those written for Mlle de La Vallière invite the spectator to speculate on what is clearly by this time an open secret:

> Elle a dans ses beaux yeux vne douce langueur,
> Et bien qu'en apparence aucun n'en soit la cause,
> Pour peu qu'il fût permis de foüiller dans son cœur,
> On ne laisseroit pas d'y trouuer quelque chose.[51]

> She has in her beautiful eyes a sweet langor,
> And although there is no apparent cause,
> If we were permitted to search her heart,
> We would be sure to find something in there.

In the final entry of the same ballet, Benserade had returned to the idea, writing in the verses for La Vallière, now playing an Amazon:

> [Je] ne conte pas moins qu'Alexandre & Cesar,
> En me figurant des Esclaues
> A la suite de vostre Char. (II, 624)

> *When imagining the slaves*
> *Who follow behind your chariot,*
> *I see no lesser figures than Alexander and Caesar.*

Given that Louis XIV was often likened to Alexander and Caesar, there is no doubt that Benserade is alluding to their liaison.

If the first day of *Les Plaisirs* was offered up in particular praise of Queen Marie-Thérèse and the second in praise of erotic love in all its guises, the third day, still loosely within the conceit of the Ariostean theme, praised the Queen Mother. The characters of Célie and Alcine draw particular attention to Anne of Austria's handling of the Fronde (which had come to an end more than a decade earlier), with the latter offering the following account:

> Disons qu'au plus haut point de l'absolu pouvoir,
> Sans faste et sans orgueil sa grandeur s'est fait voir;
> Qu'aux temps les plus fâcheux, sa sagesse constante,
> Sans crainte a soutenu l'autorité penchante;
> Et dans le calme heureux, par ses travaux acquis,
> Sans regret la remit dans les mains de son Fils. (Pléiade I, 592)

> *Let us say that at the high point of absolute power,*
> *Without ceremony and without pride, her greatness was made plain,*
> *That in the most difficult times, her unflagging wisdom*
> *Fearlessly buttressed sovereign authority when under attack,*
> *And that, having brought about a welcome peace,*
> *Without regret, she placed that authority in the hands of her son.*

Anne is also recognized for her "zèle si connu pour le culte des Dieux" (Pléiade I, 592) (*her renowned zeal for worshipping the gods*)—a reference to her piety that sits somewhat uncomfortably in the context of

this hedonistic *fête*.⁵² The prolongation of the *fête*, including a brief mention of the first performance of *Tartuffe* and its ban, cited toward the beginning of this chapter, is outlined in the final pages of the account, which concludes much as it began, with the notion of pleasure. We read that in these festivities "chacun a marqué si avantageusement son dessein de plaire au Roi; dans le temps où Sa Majesté ne pensait elle-même qu'à plaire" (Pléiade I, 598) (*everybody clearly demonstrated his intent to please the king at a time when His Majesty himself was thinking only of pleasing others*).

The Struggle

Molière's battle to be permitted to perform his masterpiece in public was long, drawn out, and immensely frustrating (and is discussed at length in Chapter 5); Bossuet's battle to have Louis XIV stop giving his extramarital performances in the semiprivacy of his own court was even more so. In June 1664, Olivier Lefèvre d'Ormesson tells of how rather than forsaking Louise de La Vallière, Louis "n'avoit point fait ses dévotions à la feste" (*did not perform his devotions at Easter*) that year.⁵³ When asked by his brother (a notorious sodomite and therefore also guilty of sexual sin) if he was planning on taking communion, "il [Louis] luy avoit dit que non et qu'il ne feroit pas l'hypocrite comme luy, qui alloit à la confesse parce que la reyne mère le vouloit" (Ormesson 148) (*Louis said no and explained that he would not become a hypocrite like his brother, who went to confession simply because the Queen Mother wanted him to*). If Bossuet's call to a full repentance had not taken hold, it is possible that his call to eschew hypocrisy had made some impact on the king.⁵⁴ But there was still a very long way to go.

Bossuet was invited by the ailing Queen Mother to preach again at the Louvre for Advent 1665, the year after *Tartuffe* received its premiere, as Molière was rewriting the play and fighting to have the ban on public performances lifted (having meanwhile given the public his *Festin de Pierre*). It was during this series that Bossuet gave a sermon, *Sur le jugement dernier*, in which he not only denounces religious hypocrites but also refers to them specifically as *faux dévots*:

> Mais de tous les pécheurs qui se cachent, aucuns ne seront découverts avec plus de honte que les faux dévots et les hypocrites. Ce sont ceux-ci, Messieurs, qui sont des plus pernicieux ennemis de Dieu, qui combattent contre lui sous ses étendards. Nul ne ravilit davantage l'honneur de la piété que l'hypocrite, qui la fait servir d'enveloppe et de couverture à sa malice . . . Nul donc ne trouvera Dieu juge plus sévère que

l'hypocrite, qui a entrepris de le faire en quelque façon son complice. (Bossuet VIII, 121–22)

But of all the sinners who hide away, none will be found to be more shameful than the faux dévots *and hypocrites. These people, gentlemen, who fight against God under his own banners are God's most pernicious enemies. Nobody offers a greater insult to the honor of piety than the hypocrite who uses it as a cloak to conceal his malice. Nobody therefore will find God to be a harsher judge than the hypocrite who has tried in some way to make God his accomplice.*

In 1665, the expression *faux dévots* could not have failed to resonate with the ongoing controversy surrounding Molière's play. But Molière was not Bossuet's concern, and Bossuet was to remain curiously silent on the *Tartuffe* question for thirty years. What is most striking about this sermon series is the emphasis placed on true penitence and on the extraordinary effort required in order to achieve it. In the sermon *Sur la divinité de Jésus-Christ*, given on December 6, 1665, he declared that "pour produire un repentir sincère, il faut renverser son cœur jusqu'aux fondemens, déraciner ses inclinations avec violence, s'indigner implacablement contre ses foiblesses, s'arracher de vive force à soi-même" (Bossuet VIII, 195) (*to bring about sincere repentance, a man must shake up his heart to its core, brutally uproot his proclivities, rage inconsolably against his own weaknesses, and take himself by brute force*). He also spelled out that a failure to do so would lead to a miserable damnation.

Bossuet was invited again, after the Queen Mother's death, to preach at court, in Saint-Germain for Lent 1666, when he renewed his audacious condemnation of the king's dangerous behavior. This time, however, he also attacked the complicity of the confessor or director who is too quick to let his penitent off the hook. In a sermon preached on April 11, *Sur la haine de la vérité*, Bossuet declared:

> Voici les jours de salut, voici le temps de conversion dans lesquels on verra la presse autour des tribunaux de la pénitence . . . Cherchez-y des amis et non des trompeurs, des juges et non des complices, des médecins charitables et non pas des empoisonneurs. Ne vous contentez pas de replâtrer où il faut toucher jusqu'aux fondemens . . . Ne cherchez ni complaisance, ni tempérament, ni adoucissement, ni condescendance. (Bossuet IX, 434)

> *Now is the time for salvation, for conversion, a time when people will crowd around the seat of judgment. Look there for friends and not deceivers, for*

> *judges and not accomplices, for benevolent doctors and not poisoners. Do not be content to paint over your faults when they need to be stripped bare. Do not seek indulgence or relief, nor comfort or mercy.*

While their ultimate concerns diverge radically, we note that with regard to this question too there is significant overlap between Bossuet and Molière, at least to the extent that both are aware of the existence of laxist confessors and spiritual directors.⁵⁵ Even Le Moyne's conciliatory *La Dévotion aisée* (first published in 1652 but reissued during the *Tartuffe* controversy in 1668) ends with a strongly worded note about choosing a spiritual director:

> Il y a des Guides ignorans & sans habitude dans le Païs . . . il y en a de temeraires qui se font des routes de leurs erreurs, & se perdent avecque ceux qui les suivent. Il y en a de vains, qui aiment mieux s'égarer avecque bruit, qui aiment mieux se perdre & avoir des spectateurs de leur perte . . . Il y en a mesme d'inhumains & de cruels, qui tirent les voyageurs à l'écart, afin de les égorger plus seurement, & d'en avoir toute la dépouille . . . Il n'est pas moins dangereux de se tromper au choix des Guides, qu'aux choix des chemins.⁵⁶

> *In France, ignorant, inexperienced directors are to be found. There are reckless directors who persist in their errors and who lead their followers astray; there are vain directors who would rather stray conspicuously, who would rather fall down and be seen. There are even inhuman and cruel directors who tempt others away from the straight and narrow in order to be certain of bleeding them dry and taking all the spoils. It is just as dangerous to choose the wrong director as to choose the wrong path.*

For Molière, the phenomenon of dubious directors was above all a valuable source of comic satire, which he exploited by making Tartuffe an accomplished but flawed casuist in his attempted seduction of Elmire. For Bossuet it is a matter of the highest importance, since a lax confessor risks maintaining the king in a state of incomplete penitence, thereby endangering his royal soul and his country.

On May 13, 1667, the Parisian *parlement* registered the letters patent that created a peerage for La Vallière and the king's illegitimate daughter, Marie-Anne, who was thus publically recognized (Couton, *La chair* 82–83).⁵⁷ Although Bossuet had reason to hope that the king might now give up La Vallière,⁵⁸ rumors about the king's interest in Mme de Montespan had been circulating as early as November 1666. This liaison, which began sometime in 1667, was considered even more culpable since *both* parties were married. It was a double

adultery. Bossuet's efforts continued, and in 1669, now Bishop of Condom designate, in recognition of the role he played in the conversion from Protestantism of the great military leader, Turenne, Bossuet was invited to Saint-Germain between November 1 and December 25 to preach the Advent sermons. Bossuet tried again to tackle the king's obvious weaknesses and the obstacles to his salvation. Again, he revealed his preoccupation with the dangers of an improper penitence, warning ironically, "Risquez tout; faites d'un repentir douteux le motif d'un crime certain" (Bossuet VIII, 194) (*Risk everything; make an unsure repentance the motive for a certain crime*).

Louis's scandalous relationship with Montespan endured, and every year the tension mounted as the moment in the Christian calendar approached when sinners had to offer up a genuine repentance, vowing sincerely never to sin again, or make a sacrilegious communion (or no communion at all, the option that Louis chose in 1664 and felt obliged to follow on other occasions too), knowing that such a promise was impossible to keep. In 1675 Bossuet's outraged concern seems finally to have been shared by some of those less zealous and less courageous than he, and the situation reached a crisis point when Mme de Montespan was refused the Easter absolution on Maundy Thursday (April 11, 1675), first by the curate, Lécuyer, and then by the priest, Thibaut, at Versailles. Père La Chaise, who had been the king's confessor for only a few weeks, gladly deferred authority on this most delicate of matters to Bishop Bossuet, now preceptor to the dauphin, who upheld the decision of his ecclesiastical colleagues. Bossuet then famously engineered the separation of the lovers and became the king's de facto spiritual director. As Pentecost approached, when Louis XIV was proposing to take communion, Bossuet wrote a particularly poignant letter urging the king to ensure that he was now genuinely free from sin.[59] The king received communion at Pentecost on June 2 in his army camp,[60] and Bossuet continued to provide support and guidance to both parties, even likening the new, improved Louis XIV in a letter dated July 1675 to a reformed Henri IV, now "le modèle d'un roi parfait" (*Lettres de Bossuet* 92) (*the model of a perfect king*). But what seems to have been a genuine crisis of conscience on the king's part was in the event short-lived: the lovers entered into a written correspondence after Pentecost and began to meet again and were that summer once again involved in a sexual relationship.[61] The death of the recently converted Turenne, on whom France relied heavily for her military successes, that same summer was perceived by many as a divine punishment for the return to royal adultery (see Couton, *La chair* 143).

Meanwhile, the political dimension to these events should not be overlooked, and Couton speculates that both Colbert and Louvois, in an attempt to avoid any radical change in politico-religious outlook, as well as Bossuet's ecclesiastical rivals, La Chaise and the Archbishop of Paris, now Harlay de Champvallon, encouraged Montespan's return to court (*La chair* 141–42). And indeed, the feared radical shift did not take place until the 1680s, when an aging Louis, following the death of his first wife and a secret marriage to the pious Madame de Maintenon, seems finally to have renounced all extramarital affairs and to have taken more seriously his remit as the most Christian king. The major politico-religious event of the 1680s was of course the Revocation of the Edict of Nantes in 1685, of which Bossuet also thoroughly approved. But the extent to which Bossuet can be credited with any success with regard to the question of the royal mistresses remains open.

Louis XIV's *Mémoires*

It is interesting to consider Louis XIV's semiofficial view on the matter as given in his *Mémoires*. We know that Louis XIV understood the importance of maintaining a solid, scandal-free reputation; he informed the dauphin in his *Mémoires* for the year 1667 in terms that are more political than religious:

> Les rois, qui sont les arbitres souverains de la fortune et de la conduite des hommes, sont toujours eux-mêmes les plus sévèrement jugés et les plus curieusement observés . . . un souverain ne saurait mener une vie trop sage et trop innocente . . . le seul moyen d'être vraiment indépendant et au-dessus du reste des hommes est de ne rien faire ni en public, ni en secret, qu'ils puissent légitimement censurer. (Louis XIV 256)
>
> *Kings, who are the sovereign arbiters of the fortune and behavior of men, are always those who are the most harshly judged and intensely scrutinized. A sovereign cannot lead a life that is too prudent or too innocent. The only way to be truly independent and beyond the reach of the rest of mankind is to do nothing in public or in secret that others could legitimately criticize.*

The use of the word *secret* is particularly interesting. We remember that Tartuffe, in his attempts to convince Elmire to submit to an extramarital affair, insists upon his personal discretion and ability to keep a secret, hoping this to be the last practical and rhetorical obstacle to be overcome before she submits to his advances. Yet Louis's

view on the matter as expressed in the *Mémoires* is not, seemingly, that any sin will be known to God, who is all-seeing, but rather that it will become known more broadly. He writes that "c'est une des plus grandes erreurs où puisse tomber un prince de penser que ses défauts demeurent cachés, ni qu'on se porte à les excuser" (Louis XIV 256) (*one of the greatest mistakes that a prince can make is to think that his faults will remain hidden or that they will be forgiven*). Louis has been writing in imprecise terms about the faults committed by kings, but it is surely no coincidence that this passage is followed by the incomplete fragment on Louise de La Vallière and the perils of taking mistresses, which Longnon coyly includes in his edition of the *Mémoires* "en raison des remarques judicieuses qu'il renferme et qui complètent ce que Louis XIV vient de dire au sujet de la conduite du roi de Portugal" (257n24) (*because of the judicious remarks that it contains and that complement what Louis XIV has just said about the behavior of the King of Portugal*).

On the question of his mistresses, Louis XIV mentions his recent ennoblement of a certain M. L (i.e., Mademoiselle de La Vallière) and his legitimization of their daughter. He is clearly hesitant about mentioning the matter at all, writing "j'aurais pu sans doute me passer de vous entretenir de cet attachement dont l'exemple n'est pas bon à suivre" (Louis XIV 258) (*no doubt I could have refrained from speaking about this relationship, which offers an example not to be followed*), but he explains that the dauphin may thereby learn from his mistakes as well as from those of others already mentioned in the *Mémoires*.[62] He revisits the notion whereby a prince should always be a perfect model of virtue alongside that of how his "faiblesses . . . ne sauraient demeurer cachées" (Louis XIV 258) (*weaknesses cannot remain hidden*), a remark that suggests Louis had originally hoped to be more discreet than he in fact was. In a semijustificatory section that is characterized more by pragmatism than absolutism, he recommends, in the event of any deviation, two precautions to reduce its impact: first, that any time spent in pursuit of love should not be at the expense of the time needed to fulfill the obligations of a good and hardworking monarch; and second, that in surrendering his heart, a king should not surrender his wisdom and judgment, and that the source of his pleasure should never be permitted to speak to (and thereby attempt to influence) a monarch about matters of state (259). In modern parlance, he insists on business before pleasure, and on the separation of the two. Here too, one of the reasons relates to the question of secrecy, but with an additional gendered dimension, for "le secret ne peut être chez [les femmes] dans aucune sûreté" (259) (*secrets are*

not safe with women). Louis equivocates between an insistence on the necessity of following his recommended precautions and an admission of how difficult this is to accomplish, and the fragment concludes with the hyperbolic assertion that the failure to follow these precautions has led to thrones being overthrown, provinces being ruined, and whole empires being destroyed (260). If the fragment is surprising in its honesty and its lucidity, its eventual omission from the *Mémoires* is no surprise either.[63] To admit to this much human weakness, even in a work that is surprisingly open about Louis the man, was too dangerous. Louis's ambivalence toward this particular aspect of his life also indicates that the various tensions that were entrenched in it were still not resolved.[64] Yet it should also be noted that the issue is at least as much a pragmatic one for Louis (the need to ensure that good decisions are made at the level of the state) as one of hypocrisy (the need to uphold a solid and virtuous reputation).[65]

THE *DEUS EX MACHINA*

For similar reasons, Molière appears to have added the famous *deus* (or *rex*) *ex machina* to the fabric of his *Tartuffe* at much the same time that he opted to emphasize the weaknesses in Tartuffe's performance of devotion, between 1664 and 1667. The playwright's efforts to distinguish unambiguously between true and false devotion (at least to the point that Tartuffe's hypocrisy is indisputable—the clarity of his portrayal of true devotion will be debated in Chapter 4) by making him, in Escola's terms, an indisputable *(faux) faux dévot*, were presented as a response to the repeated allegations outlined at the beginning of this chapter. The *deus ex machina* on the other hand is principally an attempt to invoke the rhetorical and practical power of the authority of the king in the face of any challenges to that authority. From Molière's point of view, the challenge came in the form of a ban on the play that was in place despite the king's own personal support; for Louis XIV, the challenge came in the form of opposition to the king's personal behavior—notably, here (but not by any means exclusively), with regard to his mistresses. The constructed Louis XIV who intervenes at the end of *Tartuffe* and saves Orgon's family from ruin at the eleventh hour is exemplary in his kingly qualities, particularly with regard to his judicious perspicacity.[66] As the Exempt explains to Orgon in V.7:

> Nous vivons sous un Prince ennemi de la fraude,
> Un Prince dont les yeux se font jour dans les cœurs,

Et que ne peut tromper tout l'art des Imposteurs.
D'un fin discernement, sa grande âme pourvue,
Sur les choses toujours jette une droite vue. (1906–10)

We live under a prince who is an enemy of fraud,
A prince whose eyes see right into people's hearts
And who cannot be taken in by any imposter's art.
His great soul is endowed with a keen discernment,
And he always sees everything with perfect clarity.

Molière's Louis, it turns out, was in control of the situation all along and now is able by means of his sovereign power to break the contract made between a mistaken Orgon and Tartuffe. The references to the Fronde in the play are also deeply significant. Molière's Louis has the power and authority to forgive Orgon's secret offense (a reference to the papers Orgon had kept, belonging to a rebellious *frondeur* friend of his) on the basis precisely of Orgon's loyalty to the crown during the Fronde: "C'est le prix qu'il donne au zèle qu'autrefois / On vous vit témoigner, en appuyant ses droits" (1939–40) (*It is his reward for the zeal with which you formerly defended his rights*). This Louis is thus all-seeing, all-knowing, and all-powerful; he is capable of clemency where appropriate—specifically here, in recognition of evidence of loyalty to his kingly authority. Molière's *deus ex machina* thus offers an ingenious response to any form of opposition to the king, to his support of the play or to his personal behavior, though one that in practice was unsuccessful until the real king had been able to establish his own authority by other, more effective means. While the fictitious, constructed Louis XIV could hypothetically be anything his image makers wanted as long as they retained narrative control over their work and as long as no alternative image was put forward, the real-life Louis XIV sometimes suggested such alternatives. There was a constant risk that the reality of the flawed, real Louis would undermine the fiction of Molière's constructed, godlike Louis (the irony being, of course, that it was the flawed Louis who supported the play).[67]

Conclusion

We have seen that Tartuffe is indeed a hypocrite and that his hypocrisy is revealed to the theatre audience largely owing to his ill-concealed sensuality, his gluttony and sloth, and above all his lust, which are understood to be incongruent with his status as a lay director of conscience. In the same way that the character of Tartuffe emerges as

contradictory and thereby hypocritical, so also does the person of Louis XIV embody a number of contradictions or tensions between his official image as Christian king and his personal behavior. In the 1660s and 1670s, these tensions were made apparent notably, though not exclusively, in the unconcealed and persistent existence of the king's mistresses, culminating in what has been termed his *crise d'érotisme* (*crisis of eroticism*) in the late 1670s.[68] But it is another element of Tartuffe's hypocrisy that ultimately sheds more light on the discussions provoked by the scandal of royal adultery. Mme de Maintenon's letter to Mme de Saint-Géran, dated July 1676, in which she comments on the 1675 crisis, is revealing at a number of levels:

> Je vous l'avois bien dit, madame, que M. de C[ondom] [i.e., Bossuet] joueroit dans toute cette affaire un personnage de dupe! Il a beaucoup d'esprit, mais il n'a pas celui de la cour . . . Il vouloit les convertir; et il les a raccommodés.
> C'est une chose inutile, madame, que tous ces projets; il n'y a que le père de La Chaise qui puisse les faire réussir; il a déploré vingt fois avec moi les égarements du roi; mais pourquoi ne lui interdit-il pas absolument l'usage des sacrements?[69] Il se contente d'une demi [*sic*] conversion. Vous voyez bien qu'il y a du vrai dans les *petites lettres*. Le père de La Chaise est un honnête homme; mais l'air de la cour gâte la vertu la plus pure, et adoucit la plus sévère.[70]

> *I told you, Madam, that Bossuet would play the role of dupe in this matter! He has a good mind, but he does not understand the mind of the court. He wanted to convert them, and he has reconciled them.*
> *All these projects, Madam, are in vain. Only La Chaise could make it work; more than a dozen times he has bemoaned the king's behavior to me. But why does he not refuse point blank to give the king the sacraments? He makes do with a half conversion. You can see that there is truth in the* Petites Lettres. *La Chaise is a good man, but the air of the court infects even the purest virtue and attenuates the most strict.*

Maintenon spells out both the unique authority of the position of king's confessor ("il n'y a que") and La Chaise's particular failure to meet the obligations that this authority demands. And the result is precisely what Bossuet had repeatedly warned about: an incomplete conversion, an imperiled soul (and an imperiled country). The allusion to the *petites lettres* is to Pascal's *Lettres provinciales*, in which, as we have seen, the tendency toward laxism among Jesuit confessors (and directors) had been vigorously and satirically denounced in the 1650s.

Molière's own denunciation was more *mondain*, more entertaining and made, from the playwright's point of view at least, outside the context of the Jansenist controversy. Yet, in their different ways, Molière, Maintenon, Bossuet, and Pascal all understood that laxism was itself both a form of hypocrisy and, more dangerously, one that promoted hypocrisy in others. While Tartuffe actively abuses casuistical reasoning in order to seek sexual gratification, La Chaise and his ilk more passively (but equally culpably) appear to have hidden behind the role of the confessor as a keeper of secrets not in order to prevent the king's sexual sin from becoming known (for it already was) but rather to avoid having to confront Louis XIV about it. Louis XIV in turn was, up to a point, able to hide behind the silent authority of the laxist (for cowardice was a form of laxism as far as the *dévots* were concerned) confessor, first Annat and then La Chaise.[71] This was a case not quite of the emperor's new clothes, then, but of the king's dirty sheets. We know that Annat was zealous in his anti-Jansenism, but his position vis-à-vis the king's personal behavior and salvation is less well known.[72] Saint-Simon, meanwhile, provides an interesting description of La Chaise's annual attack of anxiety with regard to the royal confession:

> La fête de Pâques lui causa plus d'une fois des maladies de politique pendant l'attachement du roi pour Mme de Montespan. Une entre autres, il lui envoya le P. Dechamps en sa place, qui bravement refusa l'absolution.[73]

> *On more than one occasion during the king's liaison with Mme de Montespan, the Easter festival compelled La Chaise to succumb to a strategic political illness. One year he sent Dechamps to the king in his stead and Dechamps bravely refused the king absolution.*

This anecdote is confirmed by Chamillart, editor of de Sourches's *Mémoires*, who notes that, the king having returned to Paris following his victories at Gand and Ypres in 1678, La Chaise stayed in Lille, claiming to be ill:

> Soit qu'il le fût effectivement, soit qu'il ne voulût plus donner l'absolution au Roi qui, malgré toutes les paroles qu'il lui avoit données, ne vouloit point rompre son commerce avec Mme de Montespan. En l'absence de son confesseur, le Roi envoya quérir le P. de Champ, lequel, après un long tête-à-tête avec lui, ne voulut point le confesser, parce qu'il ne vouloit pas lui donner l'absolution.[74]

> It is unclear whether he really was ill or whether he did not want to give absolution to the king, who despite all his promises refused to renounce his relationship with Mme de Montespan. In the absence of his confessor, the king sent for Dechamps, who, after a long discussion, did not wish to hear his confession, because he did not want to give him absolution.

If La Chaise was no Tartuffe, his behavior is in marked contrast with that of Bossuet, who demonstrated quite extraordinary audacity in the face of royal sin, and even, as we have just seen, of Dechamps, who, according to Chamillart, refused to take on the position of royal confessor following Annat's death (Sourches 209n2).[75] While it is true that the confessor was bound by the secrecy of the confessional, he was also duty bound to withhold absolution when circumstances demanded it, as these did. Saint-Simon's use of the expression "maladies de politique" (*strategic political illness*) underlines the fact that this was a triumph of politics (and diplomacy) over religion (and salvation). Among the ecclesiastics who had the king's ear, then, the fundamental conflict at work was not between the *dévot* and the *mondain* but between the zeal of the reforming *dévot* and the hesitancy of the pragmatic moderate.

Meanwhile, we saw that in 1664, Louis XIV elected to circumvent his own hypocrisy by not taking communion, but that he also pursued his general tendency toward indulging his own sexual sin—notably, by becoming involved in a scandalous double adultery with Mme de Montespan that lasted from 1667 to 1680. The ban on public performances of *Tartuffe* was lifted, uncoincidentally, at a highpoint in this personal scandal but before it took a nastier turn with the Affair of the Poisons. The extent to which Bossuet (and by extension the *dévot* program) may be said to have triumphed is debatable. At a personal level, the king had finally freed himself from the yoke of adultery, although it is possible, as Couton suggests, that while royal appearances were saved, the same might not be said of their souls. This view was put forward by at least one contemporary of the king, the duchesse d'Orléans, who observed on August 11, 1686, that the nonadulterous Louis XIV "se figure être dévot parce qu'il ne couche plus avec des jeunesses" (*thinks he is now devout because he no longer sleeps with young women*).[76] Louis could never definitively prove the veracity of his own personal religious beliefs for the simple reason that they are invisible. Louis XIV could only clearly demonstrate his *false* devotion. Even in his dotage, then, we cannot be sure of Louis XIV's beliefs, since his apparent status as *vrai dévot* might only in fact have been the successful performance of what Escola has termed a

(vrai) faux dévot. At a national level, meanwhile, the *dévot* program was undoubtedly boosted by the Revocation of the Edict of Nantes, aimed at promoting unity within France and the Catholic Church more broadly. On the other hand, even the more pious Louis XIV did not implement anything approaching the level of moral and spiritual reform that the *dévots* had once hoped for.[77] And it is surely significant that Bossuet raised the issue of laxist spiritual directors in his *Oraison funèbre* for Marie-Thérèse in 1683, in which he condemned the pernicious influence of "nos flatteurs parmi lesquels il faudroit peut-être compter des directeurs infidèles que nous avons choisis pour nous séduire" (Bossuet XII, 532) (*our flatterers, including perhaps dishonest directors whom we have chosen to seduce us*). While the original *Tartuffe* affair had long been resolved, and the question of the king's sexual sin was finally resolved with Louis's secret marriage to Mme de Maintenon in October 1683, the broader problem of religious hypocrisy inevitably persisted.

Chapter 3

What Is a *Faux Dévot*?
II. The Zealot

In Chapter 2, we examined the question of religious hypocrisy, focusing on the figures of Tartuffe and Louis XIV. In the present chapter, we shall focus on another key aspect of Tartuffe's character—one that is both related to and distinct from his hypocrisy: his zealotry or, in modern parlance, fanaticism. Although religious zealotry was a feature of counterreformation France and still in evidence in the 1660s, Tartuffe's zealotry has been somewhat overlooked since and its importance in the controversy underestimated. I hope to redress this imbalance here by reasserting the nature and significance of Tartuffe's performance of zealotry and by examining the extent to which zealotry and hypocrisy were (and were not) perceived as being coterminous. Among other sources, I shall draw on the insights of the great preacher Louis Bourdaloue (1632–1704), whose sermons are not the staple diet of moliéristes[1] but do, I believe, shed considerable light on the *Tartuffe* controversy. I am using the term *zealotry* here to describe a type of religiosity that tends toward conspicuousness, owing to its particular concern with the lives and souls of others. The zealot is a proselytizer; he seeks to change the world around him via his encounters with the people around him. The most subtle type of encounter would be through fervent prayer, though more commonly the zealot is identified as such by his delivery of audacious, hectoring sermons or, if he is a lay person, by boldly offering his opinions in his capacity as lay spiritual director or self-appointed advisor and sermonizer. Often the zealot is controlling and highly critical, and sometimes, as was the case with some members of the Company of the Holy Sacrament, he intervenes directly by means of coercion. Owing to his

tendency to concern himself with the behavior and salvation of others, the zealot naturally leaves himself open to the accusation of the type of hypocrisy that is more concerned with the speck in another's eye than with the beam in his own. Lay members of the Company in particular were often described as hypocrites, owing to their tendency to interfere in the lives of others, though most of its members were probably sincere in their intentions.

Tartuffe, as will be discussed, is a hypocrite and an imposter who has adopted the cloak of the zealot in order to further his own interests. Tartuffe pretends to practice physical mortifications (see his references to his hair shirt and scourge in III.2), while he is also an accomplished casuist as seen in his encounters with Elmire and in the arguments he presents to Orgon in order to persuade him to part with his *cassette* and its compromising contents. In this combination of different and in some cases incompatible traits, Tartuffe is unique and of course he owes this privileged position to his status as a satirical creation. Via a single character, Molière not only portrays the generic religious hypocrite but also mocks the extremism of the self-mortifiers, the interfering zealotry of the type associated with the Company of the Holy Sacrament, and the casuistical laxism of some Jesuits. In a letter to a Jansenist sympathizer, Racine wittily summed up how the play was open to interpretation depending on one's own personal affiliation and prejudices: "On vous avait dit que les jésuites étaient joués dans cette comédie, les jésuites au contraire se flattaient qu'on en voulait aux jansénistes"[2] (*You were told that it is the Jesuits who are satirized in this play; the Jesuits, on the other hand, claimed that it is the Jansenists*).

The common tendency among critics, however, has been to treat Tartuffe's zealotry simply as evidence of his hypocrisy, thereby eliding the two elements.[3] This trend is unsurprising given that Molière himself, as the *Tartuffe* controversy wore on, boldly implied that his zealous opponents (many of whom must have been sincere in their faith and in their opposition to his play) were hypocrites since no sincerely devout individual could possibly object to his work. As Molière, inspired by an observation made by the Prince de Condé, puts it in his second petition to the king in 1667, opponents of the play object to this piece of theatre in particular because "celle-ci les attaque, et les joue eux-mêmes, et c'est ce qu'ils ne peuvent souffrir" (Pléiade II, 194) (*this one attacks and satirizes them, which they cannot bear*). In his first petition of 1664, Molière explicitly presents his comedy as one that denounces hypocrites, whom he then goes on to describe interchangeably as "ces Gens de bien à outrance" (*these excessive do-gooders*)

and "ces Faux-Monnayeurs en dévotion" (*dévotional counterfeiters*) who try to "attraper les Hommes avec un zèle contrefait, et une charité sophistique" (Pléiade II, 191–92) (*trap men with their false zeal and sophistic love*). While this was an ingenious polemical strategy made at various critical points during the controversy, a similar point of view is also presented in the body of the play itself. It would seem that, for Molière, it is the point at which the zealous *dévot* becomes indiscreet that sincere fervor and hypocrisy are no longer distinguishable (Bénichou 279). Yet the distinction is an important one, for it is Tartuffe's zealotry that caught Orgon's attention and interest in the first place, while it is this same zealotry (more even than his hypocrisy) that makes Tartuffe particularly unpopular among the other members of Orgon's household.

Tartuffe's Zealotry

In our search for evidence of his zealotry, we must attempt to set aside our foreknowledge of Tartuffe's hypocrisy. It is commonplace to assert that Tartuffe's character, and therefore his hypocrisy, is established in the opening scene of the play. However, what is established (or at least complained about) just as ardently is the fact that the power and control Tartuffe exerts over the household is illegitimate and, above all, that his extreme censoriousness is intrusive and unwelcome. Damis refers to Tartuffe as "un Cagot de Critique" (*a sanctimonious censor*) who has come into the house and usurped power therein (I.1.45–46); Damis complains that family members cannot indulge in any entertainment without Tartuffe's consent (I.1.47–48). Dorine, similarly, complains about Tartuffe's arrogation of power and his controlling, critical inclinations: "S'il le faut écouter, et croire à ses Maximes, / On ne peut faire rien, qu'on ne fasse des crimes, / Car il contrôle tout, ce Critique zélé" (I.1.49–51) (*If he is to be listened to and his maxims believed, everything is a crime, for this zealous critic controls everything*). Tartuffe's appropriation of patriarchal power in the house is criticized not only because it rightfully belongs to Orgon but also because Tartuffe is a usurper of social status or class: Damis refers to him as a "Pied plat" (*a provincial country bumpkin* [I.1.59]), and Dorine speaks of his status not only as an unknown figure but also as a poorly dressed beggar with no shoes (I.1.63–64); for Dorine, it is scandalous that such a man should overstep his lowly rank and take it upon himself to "contrarier tout, et de faire le Maître" (I.1.61, 65–66) (*contradict everything and take on the role of master*) in a

household belonging to the Parisian upper bourgeoisie. This would be the case regardless of whether or not he were a religious hypocrite.

It is only when Mme Pernelle insists that things would be an awful lot better if Tartuffe's pious orders were followed that Dorine retorts with the accusation of hypocrisy: "Il passe pour un Saint dans votre fantaisie; / Tout son fait, croyez-moi, n'est rien qu'hypocrisie" (I.1.69–70) (*Your view of his saintliness is pure fantasy; believe me, he is nothing but a hypocrite*). Dorine's allegation is supported a few lines later by the suggestion that Tartuffe is jealous of Elmire (I.1.84). Were this to be true (and we later find out that it is), it would indeed indicate hypocrisy on his part since the motive is morally dubious and incongruent with Tartuffe's assumed role as spiritual director. But at this early point in the play, Tartuffe's alleged hypocrisy takes shape by way of an explanation for his excessive severity with regard to social calls to the house and various *divertissements*. And so, while his outward severity is an indisputable fact (even Dorine and Pernelle agree on this), Tartuffe's hypocrisy is in I.1 still only a hypothesis. Mme Pernelle is quickly established as a ridiculous character, owing in no small part to the fact that she was, in 1669, played by a male actor, the limping Louis Béjart, wearing an outmoded costume and speaking in falsetto—and this in a play in which all the other female characters were played by female actors.[4] However, her observation whereby he is not the only person to condemn all these visits (I.1.86) is true both at the level of the play (the neighbors, *mauvaises langues* that they are, *are* no doubt gossiping about the succession of carriages and servants appearing chez Orgon)[5] and in the context of counterreformation France, when disapproval of conspicuous worldliness was not in short supply. In the contrasting accounts of Tartuffe given by Dorine and Mme Pernelle, we see the comic and polemical potential of the figure of the religious hypocrite rubbing shoulders somewhat uncomfortably with the social reality of the religious zealot whose outward style Tartuffe has, in large part, adopted. Within the play, the difference is one of interpretation, and Dorine's will of course turn out to be correct, where Pernelle's is misguided. But in 1660s France, it was more a matter of one's position on the vexed question of the extent to which worldly pursuits that had not been decontaminated by religion were considered acceptable. In a delightfully satirical speech, Dorine expounds on the case of their neighbor, Orante: While she concedes that Orante does now live a life of austerity, Dorine observes that this was not always the case—that "elle est Prude, à son corps défendant" (I.1.124) (*she is a prude only against her will*). Dorine suggests that this kind of volte-face is not unusual:

> Ce sont là les retours des Coquettes du temps.
> Il leur est dur de voir déserter les Galants.
> Dans un tel abandon, leur sombre inquiétude
> Ne voit d'autre recours que le métier de Prude. (I.1.131–34).[6]

> *This is what old coquettes do later on.*
> *It is difficult for them when their suitors disappear.*
> *Finding themselves abandoned, their dark disquiet*
> *Can see no alternative but the life of a prude.*

But even here, Dorine's principal complaint about her neighbor is less that she is a hypocrite per se and more that she seeks zealously to impose her newfound (and, moreover, hypocritical) principles on those around her:

> . . . La sévérité de ces Femmes de bien,
> Censure toute chose, et ne pardonne à rien;
> Hautement, d'un chacun, elles blâment la vie,
> Non point par charité, mais par un trait d'envie
> Qui ne saurait souffrir qu'une autre ait les plaisirs,
> Dont le penchant de l'âge a sevré leurs désirs. (I.1.135–40)

> *These do-gooders, in their severity,*
> *Condemn everything and forgive nothing;*
> *Out loud, they blame the lives of all around,*
> *Not out of charity, but out of envy,*
> *For they cannot bear to see others enjoy the pleasures*
> *That they no longer desire in their old age.*

Although we have no reason to doubt Dorine's interpretation of Orante's behavior, it should be noted that Orante's status as a hypocrite can only ever remain a hypothesis, since it is based on an attribution of personal motives, which are of course invisible and are not developed any further in the course of the play. As with the earlier discussion of Tartuffe, it is only Orante's critical censoriousness that is an established fact. Meanwhile, Mme Pernelle's personal view on Orante's life of austerity is that it is exemplary (I.1.118); the outward manifestation of Orante's life is not, then, in dispute; Dorine and Pernelle diverge radically in their interpretation only of Orante's motives and with regard to her exemplarity. In response to Dorine's diatribe, Pernelle can only reiterate the reforming agenda to which she subscribes by insisting that Tartuffe's constraints are for the good of their collective (and individual) souls:

> Que pour votre salut vous le [Tartuffe] devez entendre,
> Et qu'il ne reprend rien, qui ne soit à reprendre.
> Ces Visites, ces Bals, ces Conversations,
> Sont, du malin Esprit, toutes inventions. (I.1.149–52)

> *For the sake of your salvation, you should listen to Tartuffe,*
> *For he condemns nothing that should not be condemned.*
> *These visits, balls, and conversations*
> *Are all inventions of the devil.*

As we saw in Chapter 2, prelates whose sincerity was never seriously called into question, such as Bossuet (who was a member of the Company of the Holy Sacrament) and Bourdaloue (who was not), also warned of the dangers of these same worldly pleasures and pursuits. While the warning is unwelcome among Orgon's family, owing no doubt partly to the fervor with which it is expressed as well as to the individual articulating it, it is not in and of itself unusual or unorthodox. Indeed, in 1660s France, the religious zealot was a far more common phenomenon than the religious imposter (Tartuffe coming from the provinces and pretending to qualify as a religious director); the proportion of religious zealots to religious hypocrites is impossible to establish, but it is essential when reading *Tartuffe* in context to acknowledge that the two are not necessarily one and the same, whatever Molière may have suggested. If the figure of the hypocrite ultimately leaves a stronger impression at the end of this scene (and of the whole play), it is probably because, being so at odds with himself, he is more at home—and therefore more compelling—in comic drama than the zealot, who, if misguided, may yet be sincere.

This is not to suggest, however, that the zealot, sincere or otherwise, cannot be a comic figure. McBride points out that Henri Bergson's comic *raideur*, as outlined in his seminal piece on comic theory, *Le Rire*, in which he argues that laughter is provoked by the spectacle of rigidity in a human (and supposedly flexible) context, "fuses automatically with the *raideur* of the rigorist *dévot* attached to the supra-empirical order." McBride concludes that "dogmatism about anything, whether it be about the necessity of practising truthfulness and integrity or about the non-existence of the supernatural, is irremediably comic because man presumes to dogmatize in areas where humility, hesitation and doubtfulness are seen to impose themselves" (*Sceptical* 57, 216). While this is to overstate the case somewhat (*nothing* is irremediably comic) and to do so with more than a hint of anachronism, given that dogmatism was in some ways essential to the

fundamental structures of the *ancien régime*, McBride's basic point is undoubtedly still useful. Bergson's observation whereby "un vice souple serait moins facile à ridiculiser qu'une vertu inflexible"[7] (*it would be more difficult to ridicule a flexible vice than an inflexible virtue*) is even closer to the mark. Certainly, as Bergson has demonstrated, much of Molière's comic drama is built upon the inflexibility of the monomaniac, and while Orgon is the leading monomaniac of *Tartuffe*, the eponymous character, at least in his (over)performance of zealotry (and rigorism) shares some of his inflexibility. Take Tartuffe's long-awaited entrance on stage in III.2, for instance, in which his opening words refer to the accoutrements of Christian self-mortification (the hair shirt and scourge); these lines are steeped in comic potential owing to their invocation of an inflexible and supposedly hidden form of religious practice pronounced in the context of a private home, in the presence of an unashamedly worldly servant. Likewise, while not necessarily comic per se, given that the drive to counter the excessive exposure of female flesh was a central tenet of a number of French Catholic Reform groups at the time,[8] Tartuffe's legendary request that Dorine cover her exposed breast with a handkerchief is likewise potentially highly comic, particularly given that its zealous expression of rigorist principles occurs in an incongruous environment.[9] However, Tartuffe's inflexibility is ultimately very different from Orgon's. Orgon is consistently inflexible in his obsession, at least until his eyes are finally opened in IV.7, whereupon his instinct is to adopt the same inflexibility, but now in an inverted form: "Je renonce à tous les Gens de bien" (V.1.1604) (*I'm giving up on all good people*). Where Orgon's *raideur* is thus an integral part of his character, Tartuffe's performance of zealous rigor is not endowed with the same comical thrust (at least, not for the same reasons), because it is in no way as consistent or integrated. In that sense, Tartuffe's hypocrisy and the exposure thereof attenuates the comic potential of his performance of rigorist *raideur* and its zealous application.

Returning to the impression formed of Tartuffe prior to his appearance on stage, we must examine Orgon's description of how he first met his future spiritual director as well as Cléante's response to that description. By this time, the satirical portrait of Tartuffe's zealous rigorism has been developed alongside that of his hypocrisy, and Dorine in particular provides material for both dimensions to his portrait. We learn in I.2, for instance, that one of Tartuffe's particular complaints was with regard to the mixing of the sacred and the profane. Dorine tells Cléante:

> Le traître, l'autre jour, nous rompit de ses mains,
> Un Mouchoir qu'il trouva dans une Fleur des Saints;
> Disant que nous mêlions, par un crime effroyable,
> Avec la Sainteté, les parures du Diable. (207–10)

> *The other day the traitor tore up*
> *A handkerchief that he found inside a* Lives of the Saints,
> *Saying that we were committing a terrible crime by mixing*
> *The devil's ornaments with a holy book.*

It seems that the women of the house are guilty of having used a popular religious book (Pedro de Ribadeneyra's *Flos sanctorum*, 1599, translated into French in 1640) in order to smooth out a wrinkled handkerchief (Pléiade II, 1397n27). If Tartuffe's reaction sounds excessive (and its effect correspondingly comic), it is nonetheless consistent with a movement within French Catholic Reform that opposed any overlap between matters sacred and secular. This vignette, then, evokes rigorism and zealotry but not necessarily hypocrisy. On the other hand, flagrant inconsistencies between Tartuffe's role and his personal behavior also emerge in the same speech. Dorine's account of how Tartuffe, seated at the table in pride of place, eats enough for six and accepts from his deluded host the tastiest morsels (I.2.191–94) before belching (loudly, one imagines), is intended primarily to establish Orgon's blindness with regard to the true nature of his protégé. But it also anticipates the more famous account of Tartuffe's gluttony in I.4. This, as we have seen, is compelling evidence of at least some level of religious hypocrisy.

Orgon, of course, is utterly taken in, as demonstrated in the famous scene of his repeated utterances of "et Tartuffe?" (*and Tartuffe?*) and "le pauvre Homme!" (*poor man!*) (I.4). He then informs his brother-in-law of his own first impressions of Tartuffe, which, we note, were made at church:

> Chaque jour à l'Eglise il venait d'un air doux,
> Tout vis-à-vis de moi, se mettre à deux genoux.
> Il attirait les yeux de l'assemblée entière,
> Par l'ardeur dont au Ciel il poussait sa prière:
> Il faisait des soupirs, de grands élancements,
> Et baisait humblement la terre à tous moments;
> Et lorsque je sortais, il me devançait vite,
> Pour m'aller à la Porte offrir de l'Eau bénite.
> . . .
> Je lui faisais des dons; mais avec modestie,
> Il me voulait toujours en rendre une partie,

C'est trop, me disait-il, c'est trop de la moitié,
Je ne mérite pas de vous faire pitié:
Et quand je refusais de le vouloir reprendre,
Aux Pauvres, à mes yeux, il allait le répandre. (I.5.283–98)

Every day at church, he would meekly
Drop to his knees right opposite me.
He attracted the attention of the whole congregation
With the ardor with which he prayed to heaven.
He would sigh and groan,
Humbly kissing the ground over and over again.
And as I left, he would quickly overtake me
In order to offer me holy water at the door.
. . .
I gave him alms; but in his modesty
He always wanted to give me some back.
It's too much, he'd say, too much by half.
I do not deserve to inspire pity in you.
And when I refused to take back the money,
He'd distribute it among the poor right in front of me.

Again, these lines have often been used as clear evidence of Tartuffe's hypocrisy, but this interpretation is in need of nuancing, as there is nothing here that automatically indicates hypocrisy. Rather, Tartuffe's external behavior is that of a religious zealot. René Pommier points out, for instance, that Tartuffe going down on both knees is a sign of his zeal: "L'usage était de ne mettre, pour prier, qu'un genou en terre. La prière à deux genoux n'était pratiquée, en signe d'humilité, que par un petit nombre de dévots particulièrement zélés" (86) (*It was customary when praying only to place one knee on the ground. Only a small number of particularly zealous* dévots *would pray on both knees, as a sign of humility*).[10] Indeed, Pommier notes that Tartuffe's behavior corresponds to a practice that had been quite widespread and had not completely disappeared by the 1660s but was becoming considerably less fashionable (118). One component of Molière's satirical portrait here is surely that Tartuffe's excess is, like the ruff that Sganarelle wears in *Le médecin malgré lui*, outmoded. Pommier notes that Tartuffe's sighings and outpourings correspond to a form of worship known as *l'oraison jaculatoire* (*ejaculatory prayer*), which was practiced by only the most ardent and committed *dévots* (Pommier 89). Although the Gospels, along with many other prominent religious authorities, are suspicious of ostentatious displays such as these because their motives may be dubious (see Mt 6:5–6), the form has been embraced at various moments in the history of Christianity, usually at times of threat

or, as in the case of the Counterreformation, renewal. The dilemma of the zealous *dévot* who elected to express his devotion in such exuberant fashion was how both to appear (externally) and to remain (internally) humble before God and man. We shall return to this question later, in our examination of the 1660 scandals of the Company of the Holy Sacrament in Caen, but here it is important to note that, as far as Orgon is concerned, Tartuffe succeeds in performing simultaneously the modest attitude expected of a good Christian and the expansive form of worship adopted by some particularly intense zealots. Neither the fact that Tartuffe attracted the attention of all people present nor the fact that his donations to the poor were seen by Orgon is compelling evidence of insincerity—only of conspicuousness. And while visibility of this sort undoubtedly jarred with certain Christian precepts, the two are not absolutely mutually exclusive.

Orgon's description of Tartuffe's apparent gentleness as well as his humility and modesty should also give us pause for thought. Taken out of context, the aforementioned description could indeed be that of a genuinely pious yet zealous man who achieves the rare and oxymoronic feat of reconciling Christian humility with Christian fervor. Even in the context of the play, Orgon's use of "humblement" (*humbly*) does not function in quite the same way as did Dorine's "dévotement" (*devoutly*) in I.4 (see Chapter 2). Where Dorine's usage is patently and heavily ironic, Orgon's is not (it could only be ironic as a choice on the part of Molière, not on the part of the character of Orgon himself); more significantly and more subtly, the term *dévotement* contained within itself a hint of sarcasm, given the debates that were taking place over the nature and qualities of the *dévot* and the degree to which *dévot* was and was not coterminous with *chrétien* (*Christian*).[11] While the words *doux* (*gentle*), *humblement* (*humbly*), and *modestie* (*modesty*) could, like any other, potentially be used in an ironic sense, they usually evoked genuine Christian qualities. Their irony, then, is generated by the audience member who is by this point in the play fully aware of Orgon's lack of good judgment and increasingly suspicious of the sincerity of Tartuffe's devotional ostentation.

Orgon's description of Tartuffe's behavior within the household functions in a similar way:

> Je vois qu'il reprend tout, et qu'à ma Femme même,
> Il prend pour mon honneur un intérêt extrême;
> Il m'avertit des Gens qui lui font les yeux doux,
> Et plus que moi, six fois, il s'en montre jaloux.
> Mais vous ne croiriez point jusqu'où monte son zèle;

Il s'impute à péché la moindre bagatelle,
Un rien presque suffit pour le scandaliser,
Jusque-là qu'il se vint l'autre jour accuser
D'avoir pris une Puce en faisant sa prière,
Et de l'avoir tuée avec trop de colère. (I.5.301–10)

I see that he corrects everything, and vis à vis my own wife
He takes an acute interest in my honor.
He warns me when people make eyes at her,
And he is six times more jealous of her than I am.
You would not believe quite how zealous he is:
He considers the slightest trifle to be a sin,
The smallest thing is enough to scandalise him,
And the other day he accused himself
Of having found a flea when he was at prayer
And of having killed it with excessive anger.

By this stage, little doubt remains of which Tartuffe might be given the benefit, and it is increasingly certain that Tartuffe's intentions toward Elmire (and, by extension, Orgon) are not honorable. However, the behavior and discipline of married women was a central tenet of Catholic reform, and it was not unheard of at this time for the more zealous wing of the Church to make similar reports to *dévot* husbands regarding their wives. The group that was most notoriously associated with this practice was the Company of the Holy Sacrament, which, while almost certainly misguided at times (arguably another form of hypocrisy, as we saw in Chapter 2), was not fundamentally hypocritical. To police the behavior of another's wife was not irreconcilable with religious sincerity; to attempt to seduce her was. But we are not at that point yet. Orgon's description of Tartuffe's zealousness (we note his use of the word *zèle*) with regard to his having accidentally killed a flea is a positive account of a phenomenon similar to that described and bitterly complained about by Damis and Dorine in I.1, and to an extent we are once again faced with a divergence of interpretation. But there are two notable differences: first, the nature of the alleged crimes or sins; and second, the identity of the alleged sinner. Here the crime is trivial and has been committed by Tartuffe himself. The size of the creature in question is obviously intended to reflect the unimportance of the event; the incident with the flea may also be a reference to one Saint Macaire, a member of the Desert Fathers, whose story had been written by the prominent Jansenist Arnauld d'Andilly in the mid-seventeenth century. In a 1566 treatise, one Henri Estienne had invited his readership to mock Macaire for

having (allegedly) spent seven years of penitence in the wilderness for having killed a flea (see Pléiade I, 1398n39).[12] Yet even here, there is a potential shred of legitimacy in the notion that Tartuffe is attempting to overcome his own personal anger. This in turn leads us to note the interesting fact whereby it is in this instance his own failings that Tartuffe's severity is supposedly targeting. As we shall see in what follows, the preacher, Bourdaloue, among others, was critical of the type of personal devotion and zealotry that was harsher with regard to others than to oneself. Of course, given what we now know combined with what we strongly suspect about the character of Tartuffe, there is little doubt that Tartuffe's self-scourging is anything more than a strategic attempt to impress Orgon. And this will become irrefutable in III.6 when Tartuffe, whose initial attempts to woo Elmire have been overheard by Damis, achieves the extraordinary feat of convincing Orgon of his good nature by accusing himself of utter worthlessness and infamy.

Further clues have of course been provided in the form of Tartuffe's teachings. Orgon's famous account of these is multilayered in its significance:

> Qui suit bien ses leçons, goûte une paix profonde,
> Et comme du fumier, regarde tout le monde.
> Oui, je deviens tout autre avec son entretien,
> Il m'enseigne à n'avoir affection pour rien;
> De toutes amitiés il détache mon âme;
> Et je verrais mourir Frère, Enfants, Mère, et Femme,
> Que je m'en soucierais autant que de cela. (I.5.273–79)

> *Anyone who follows his teachings finds a deep peace,*
> *And looks at the world as if at a dungheap.*
> *Yes, I am a changed man thanks to him.*
> *He teaches me to feel affection for nothing,*
> *He detaches my soul from all friendships,*
> *And I could see my brother, children, mother and wife all die*
> *Without being the slightest bit upset.*

As many critics have observed, Orgon's words include a number of biblical allusions. The image of the dungheap is inspired by Saint Paul (Phil 3:8) and is one that was commonly invoked in seventeenth-century France, particularly among followers of Saint Augustine. A personal detachment from the world to the point of indifference toward one's nearest and dearest is found in the Gospels (notably

Lk 14:26; also Mt 10:37) and was, likewise, commonly expounded as a principle in contemporary religious writings. To a degree, then, Tartuffe's teachings and Orgon's espousal of them is quite orthodox and unsurprising for any *dévot* inclined toward rigorism or zealotry.[13] But Orgon, in his evident attachment to Tartuffe rather than to God, has spectacularly missed the point, and the way he speaks of his family is supposed to be shocking, particularly in a bourgeois comedy that, by definition, is concerned above all with the domestic sphere. If Orgon's words are simultaneously biblically inspired and shocking, this opens up some space to oppose the devout sphere with something different—something worldly but, above all, human. This comes, discreetly, in the form of Cléante's sarcastic response: "Les sentiments humains, mon Frère, que voilà!" (I.5.280) (*What humane sentiments, my brother*).[14] As William Howarth puts it, Cléante does not exclaim, "'What a travesty of Christian doctrine!,' but 'What a travesty of human feeling!'"[15]

Cléante's Response

For Cléante, who has been listening to Orgon's affectionate tribute to his spiritual director, there is no doubt that Tartuffe is a hypocrite, and he asks Orgon with evident exasperation, "Hé quoi! Vous ne ferez nulle distinction / Entre l'Hypocrisie, et la Dévotion?" (331–32) (*What? You make no distinction between hypocrisy and devotion?*). But in his speech on how to make that crucial distinction, it is important to note the emphasis Cléante places on ostentation and zealotry as evidence of supposed hypocrisy. Cléante notes, for instance, that there are *faux dévots* just as there are *faux braves* (men who are wrongly known for great bravery) and that the method by which they give themselves away in both instances is their noisy ostentation. Just as, Cléante explains, the *vrais braves* are not those who shout about it, so also are the "bons et vrais Dévots" (*good and true* dévots) not those who draw attention to themselves (I.5.326–30). Alongside Cléante's oft-repeated metaphors about the differences between the mask and the face, the phantom and the human being, and real and counterfeit money, all of which are standard images used to contrast authenticity and inauthenticity, sits a call for moderation grounded in reason that imposes limits on everything and declares that even the most noble cause can be spoiled "pour la vouloir outrer, et pousser trop avant" (I.5.343–45) (*by a wish to take it too far*). For Cléante, then, as Francis Lawrence has noted, "ostentation should in itself be taken as a sign of falsity" ("*Tartuffe*" 141). The argument appears to run even deeper

than that, for what Cléante is suggesting is not simply that such a display is an outward sign of inner falsehood, a means of distinguishing the hypocrite from his authentic counterpart, but also that it constitutes in itself the essence of that same falsehood. The *dévot* may be false simply because his devotion is so far reaching (or, in Cléante's eyes, excessive) and not necessarily because he is a hypocrite in the ordinary sense of the term. The dangerous implication of this point of view is that *all* zealotry, even for God's cause, sincere or otherwise, is (or is liable to be) false.[16]

Warming to his theme, Cléante pursues this idea in a long speech in which he ostensibly provides a lesson in how to differentiate between true and false devotion. In an important disclaimer, aimed no doubt at placating opponents of the play in order to have the ban lifted, Molière has Cléante allow, in theory at least, for the existence of perfect *dévots* (355) or "Dévots de cœur" (382) (*heartfelt* dévots), who are contrasted with "ces Dévots de Place" (361) (*public* dévots). He even addresses the question of zeal(otry) by opposing the saintly fervor of true zeal with the superficiality of fake zeal. In theory, then, a form of zealotry might exist that is authentic and laudable, which brings us back to the problem of how to distinguish one from the other. If it is impossible to see into another's heart, is it perhaps easier to disentangle the true type of zeal from the false? On the question of zeal, it is surely significant that no external features of the favored variety are provided—only a value judgment based on its unsurpassed nobleness and beauty. Given that zeal tends, almost by definition, to result in behavior and acts that are visible to those around, this is a little surprising, particularly when Cléante is able to expound at length on the type of zeal that he is denouncing:

> Ces Gens, qui par une âme à l'intérêt soumise,
> Font de Dévotion métier et merchandise,
> Et veulent acheter crédit, et dignités,
> A prix de faux clins d'yeux, et d'élans affectés.
> Ces Gens, dis-je, qu'on voit d'une ardeur non commune,
> Par le chemin du Ciel courir à leur fortune;
> Qui brûlants, et priants, demandent chaque jour,
> Et prêchent la retraite au milieu de la Cour:
> Qui savent ajuster leur zèle avec leurs vices,
> Sont prompts, vindicatifs, sans foi, pleins d'artifices,
> Et pour perdre quelqu'un, couvrent insolemment,
> De l'intérêt du Ciel, leur fier ressentiment;
> D'autant plus dangereux dans leur âpre colère,
> Qu'ils prennent contre nous des armes qu'on révère,

Et que leur passion dont on leur sait bon gré,
Veut nous assassiner avec un fer sacré. (I.5.365–80)

These people whose souls are motivated by gain
And who turn devotion into a career and a commodity,
Who want to buy credit and favors
With their false looks and affected gestures.
These people, I tell you, whom we see with exceptional enthusiasm
Earning their living from selling the path to heaven,
And who preach withdrawal in the middle of the court
Who know how to square their zeal and their vices,
They are hasty, vindictive, faithless, full of artifice,
And to bring someone down, they impudently cover
Their proud resentment with heavenly concerns,
They are all the more dangerous in their bitter anger
Because they use against us weapons that we respect,
And because, in the fervor that earns them so much respect,
They want to assassinate us with a sacred sword.

Cléante's account is dense and rich in references to a host of different problems and issues that we must attempt to unpack here. Given that the hypocritical imposter who adopted the cloak of religion for personal gain was not a common type in 1660s France, Cléante's suggestion to the contrary is therefore somewhat misleading and may be based in polemical intent or, more probably, in a deep skepticism with regard to individuals who make a profession of religion. The account of those who urge withdrawal in the middle of the court might indeed encompass the hypocrite who does not practice what he himself preaches, but it might also include prelates such as Bossuet, whose job it was, when invited to preach at court, precisely to remind a group of compromised courtiers of the dangers of their worldly existence. And how exactly is one to tell false looks from real ones, or affected gestures from natural ones? Similarly, the exceptional enthusiasm that Cléante condemns is not necessarily hypocritical; indeed the zealous Christian seeks precisely to surpass himself—to be exceptional in his ardor.

A zealot may indeed be considered a hypocrite if he knows how to square his zeal with his vices, and this was of course the charge leveled at the abuse of Jesuitical casuistry, although the Jesuists were more commonly charged with the crime of laxist accommodation than with any excess of *zèle*. It is also exactly what Tartuffe will proudly announce to Elmire that he is able to do in order to justify his seduction of her and her complicity therein. When we encounter something marginally

more tangible in Cléante's description, we gain some further insight into his objections to the zealot and into his tendency to oppose all forms of religious zealotry, regardless of motivation. Cléante's zealous *faux dévots* are hasty and vindictive, and they try to bring down others by their bitter anger. It is the *faux dévot*'s zeal with regard to others that seems to trouble Cléante, and here his objection once again has less to do with the hypocrisy of the zealot's condemnation of those around him than with the severity of the judgment. In this way, Cléante's view, though more detailed and more deeply cutting, is not far removed from that of the majority of Orgon's household, as exemplified by Dorine and Damis. At the same time, Cléante does claim to be upset by the abuse of religion, which certainly denotes skillful manipulation on the part of the abuser if not undeniable hypocrisy. What is most important, then, about this portion of Cléante's speech is his blurring of the signs of authentic zealotry with apparent indicators of hypocrisy and the value judgments that he applies to both (*faux, affectés, insolemment,* and so forth). Given that we understand this speech to have been written with considerable care in the context of a bitter controversy, Cléante's failure to distinguish between conventional religious hypocrisy and religious zealotry is perhaps odd, though surely no oversight on the part of our playwright.

The two become more entangled still when Cléante attempts to define the *vrai dévot*. For all Cléante's claims that he is easily able to identify them, what is most striking about Cléante's *vrais dévots* is that they are described negatively, in terms of what they are not. And what they are not is zealous:

> Ce ne sont point du tout Fanfarons de vertu,
> On ne voit point en eux ce faste insupportable,
> Et leur Dévotion est humaine, est traitable.
> Ils ne censurent point toutes nos actions,
> Ils trouvent trop d'orgueil dans ces corrections,
> Et laissant la fierté des paroles aux autres,
> C'est par leurs actions, qu'ils reprennent les nôtres.
> L'apparence du mal a chez eux peu d'appui,
> Et leur âme est portée à juger bien d'autrui;
> Point de cabale en eux, point d'intrigues à suivre;
> On les voit, pour tous soins, se mêler de bien vivre.
> Jamais contre un Pécheur ils n'ont d'acharnement.
> Ils attachent leur haine au Péché seulement,
> Et ne veulent point prendre, avec un zèle extrême,
> Les intérêts du Ciel, plus qu'il ne veut lui-même. (I.5.388–402)

> *They do not boast about their virtue,*
> *They do not display an ounce of that unbearable ostentation,*
> *And their devotion is flexible and humane.*
> *They do not censor all our actions, for*
> *They see too much pride in such corrections.*
> *Leaving such arrogant words to others,*
> *They modify our actions by their own example.*
> *The appearance of evil counts for little with them,*
> *And their souls are inclined to think well of others.*
> *They do not form cabals, nor do they conspire;*
> *Their only concern is to live righteously.*
> *They never hound a sinner,*
> *They hate only the sin,*
> *And do not seek to take up, with an excess of zeal,*
> *The interests of heaven more than heaven itself would wish.*

This definition by negation and the absence of such examples from the play are discussed in Chapter 4; here we are concerned above all with the religious zealot and what was found to be so objectionable about him. For there is nothing that is inherently and indubitably hypocritical about the counterexample set out by Cléante here; the extent to which a genuine Christian was permitted to judge others was (and still is) a matter of some debate since the Bible teaches both that the ultimate (and final) judgment rests with God alone and that Christians should encourage and sometimes even reprimand others in the case of perceived poor behavior. Certainly the model proposed by Cléante is Christlike in its modesty, loving attitude, and emphasis on exemplarity, and it is true that the allegation of cabals and intrigue implies a level of dubiousness that might be equated with hypocrisy. However, Cléante's use of the terms *cabale* and *intrigues* hints at a judgmentalism of his own (one man's cabal is another's group, just as one man's scheming may be another's good works), as does his description of their unbearable ostentation. If not a judgment, then the latter is certainly an opinion, even if it may have been a majority opinion. What was hinted at earlier becomes blindingly obvious here—namely, that Cléante objects above all to the zealot's judgment of and interference in the lives of others. This, for Cléante, is tantamount to religious hypocrisy. As Bénichou puts it, "c'est au point où le zèle dévot devient indiscret que la ferveur sincère et l'hypocrisie cessent de se distinguer" (279) (*it's at the point where devotional zeal becomes indiscreet that sincere fervor and hypocrisy can no longer be distinguished*). What Cléante appreciates and therefore equates with true devotion is not sincerity per se but rather something that is tolerant and accommodating.

For Cléante, it is simple: *Vrais dévots* are those who do not seek to impose themselves on others. Yet, as Bénichou recognizes, it is (by the standards of seventeenth-century France, at least) hardly an edifying position to accuse anybody who seeks to censor vice of being a sinner himself (280). Cléante's *vrai dévot* may lead a good life, founded on Christian principles, but it must be a discreet and personal existence: "On les voit, pour tous soins, se mêler de bien vivre" (I.5.398) (*Their only concern is to live righteously*). Cléante's *vrai dévot* must not seek to change the world around him directly; he may lead by example only and must not exhibit any outward manifestations of his faith, however sincere, that could be considered ostentatious or eye-catching. The idea in the last aforementioned couplet that the zealot, in his extreme zeal, is more preoccupied by God's interests than God himself is intriguing: Surely there are no limits to God's concern. Cléante, who is commonly described as the *raisonneur* of the play and preaches a philosophy of moderation, is surprisingly immoderate in his condemnation of Christian zealotry. He finally concludes that Tartuffe is not, according to his definition, a *vrai dévot* and says to Orgon, "C'est de fort bonne foi que vous vantez son zèle, / Mais par un faux éclat je vous crois ébloui" (406–7) (*You praise his zeal in good faith, but I believe you are dazzled by a false display*). Once again, the suggestion is both that a good form of *zèle* might hypothetically exist (though it is significant that no convincing examples of it are given) and yet that the falseness inherent in the (bad) zealot's outward ostentation (*éclat*) is tantamount to religious hypocrisy.

Although Cléante's failure to distinguish between conventional hypocrisy and what he considers to be the hypocrisy inherent in zealotry is problematic, Molière was not alone in regarding excessive zealotry as a form of false devotion. Le Moyne's *La Dévotion aisée* chimes with much of what Cléante says, both in its commitment to moderation and proportion and in its portrait of what devotion is not: "On en a fait un Phantôme décharné, qui fait le Caresme toute l'année, qui met le vendredy-Saint à tous les jours" (4) (*It has been turned into an emaciated ghost who practices Lenten devotions all year round and for whom it is Good Friday every day*). Le Moyne declares that "les severitez excessives ne sont pas moins scandaleuses que les indulgences mal ménagées" (5) (*such excessive severity is no less scandalous than overindulgence*). Like Cléante, Le Moyne perceives zealotry and austerity as evidence of false devotion, but here the nuance is a little different—and the difference is significant, for Le Moyne appears to be warning against a *misguided* form of devotion and not necessarily an insincere one.[17] However, as we shall see in Chapter 4, Le

Moyne and Molière are approaching the matter from sharply different angles: Where Le Moyne is a throwback to the Christian humanism of the first part of the century (and, to his critics, a clear example of Jesuitical laxism), Cléante seems to be looking in an altogether different direction. La Mothe Le Vayer, for his part, is somewhat more aware of the difference between zealotry and hypocrisy but arrives at the same broad conclusion as Cléante. In his *De la dévotion*, we read:

> Plût à Dieu, que nous eussions moins de sujet de remarquer, combien le spécieux prétexte du zèle de la Réligion, couvre au tems, où nous sommes, de dangereuses intentions. Mais quand ces mêmes intentions ne seroient pas si mauvaises, un zèle inconsidéré n'est jamais agréable à Dieu.[18]

> *Would to God that we had less cause to notice how often these days the specious pretext of religious zeal hides dangerous intentions. But even if these intentions are not very bad, a reckless zeal is never pleasing to God.*

The Company of the Holy Sacrament

Molière's merging of the zealot with the hypocrite is ingenious not only because it served his polemical interests when he could accuse all zealous opponents of his play of hypocrisy but also because it elided the problem inherent in the figure itself. For the Christian zealot was faced with what turned out to be an intractable and unsolvable dilemma: how to be discreet. In the constitution of the Caen branch of the Company of the Holy Sacrament, which was a particularly fanatical branch of this zealous society, the eighth item has each member agree "de faire ce que je pourray avec un *zèle discret* pour empescher que Dieu ne soit offensé, son saint nom blasphémé, ny le prochain déchiré par médisance ou calomnie" (Tallon 160, my emphasis) (*to use discreet zeal to prevent God from suffering any offense, to prevent his holy name from being taken in vain, and to stop any individual from being ripped apart by malicious gossip or calumny*). However, the discreet zealot is surely an oxymoron, and the chances of him achieving the aims stated here discreetly seem very remote indeed. The Company's solution, of course, was to operate in secret. Its secrecy was thus intended to allow the Company's members to resolve the conundrum that sat at the heart of the French Counterreformation—namely, how to be in the world but not of it and how to bring devotion to the world without being contaminated by *le mondain*.[19] We read in the *Annales*:

> Le secret consiste à ne point parler de la Compagnie à ceux qui n'en sont pas, de ne rien dire de ses œuvres ni de sa police, de ne nommer jamais les particuliers qui la composent, et de ne la faire connoître au dehors en quelque façon que ce soit.
> Et la fin de ce secret, c'est de donner moyen d'entreprendre les œuvres fortes avec plus de prudence, de désappropriation de succès, et moins de contradictions. Car l'expérience a fait connoître que l'éclat est la ruine des œuvres, et la propriété, la destruction du mérite et du progrès en vertu. (*Annales* 195)

> *Secrecy is maintained by never speaking of the Company to anybody who is not a member, by saying nothing about its works or its policing, by never naming individual members, and by never making its business known in any way in the outside world.*
> *The aim of this secrecy is to enable members to undertake significant works with more prudence, with a lack of concern for success and fewer contradictions. For experience has taught us that recognition ruins good works and propriety; it destroys merit and limits virtue.*

Perhaps the Company did in this way achieve their goal of fewer contradictions between acts and motives, but these were impossible to eliminate completely.

It was seen in Chapter 1 that the Company's zealous involvement in the world made it many enemies. Even when the details of the Company and of its membership did remain secret, this in no way ensured that its activities remained discreet. Quite the contrary, in many instances. The most notorious examples of the Company's indiscretion took place in 1660 in Caen, followed by copycat incidents in Argentan and Sées. Tallon explains that a member of the Company named Bernières was an ardent practitioner of the mystical tradition of "oraison mentale" (*mental prayer*), which, rather than using set prayers, encouraged a dialogue between the individual and God. He initiated the members of the Ermitage de Caen into the practice, and it was this that provoked the scandals of 1660, when some youths, trained by Bernières, claimed to have received warnings from God about the pernicious influence of the Jansenists (Tallon 91). The most reliable account of the episode, and the one that made it known in France at the time (see Baumal, *Genèse* 131), is that attributed to an ecclesiastic named Charles Dufour, a priest in the diocese of Rouen, in the shape of his *Mémoire pour faire connoistre l'esprit & la conduite de la Compagnie establie en la ville de Caën, appellée l'Hermitage*. Dufour's narrative is powerful and sometimes ironic, but it is not satirical. Rather, it is a lamenting denunciation of the abuses

of something that he considers to be fundamentally good: the Christian impulse behind one's daily acts.

The opening sentence of the *Mémoire* explains that "il y a en la ville de Caën une Societé de Personnes devotes, qui se donnent le tiltre de Compagnie du saint Sacrement; mais que l'on appelle communement l'Assemblée de l'Hermitage" (1) (*in the city of Caen there is a society of the devout called the Company of the Holy Sacrament, though it is more commonly known as the Assembly of the Hermitage*). The author goes on to explain that the society is linked with other such companies around France, that about half its members are Jesuits, and that they share a strong aversion to Jansenists. He laments the degeneration of a society that was set up as a force for good and singles out for particular regret the lay status of many of its leading lights and the fact that, despite not having any official royal, ecclesiastical, or legal authority, it is nonetheless extremely well supported and inappropriately powerful.[20] He notes that "on peut asseurer avec verité que cette Compagnie a degeneré en une cabale, & en une faction dangereuse & pernicieuse" (4) (*we can be absolutely sure that this Company has degenerated into a cabal and into a dangerous and pernicious faction*).

The particular incident that provoked Dufour to write his *Mémoire* took place on February 4, 1660, when a group of young fanatical members of the Ermitage entered the town of Caen, shouting with all their might that all the local priests but two were "fauteurs de Jansenistes & excommuniez" (17) (*excommunicated Jansenist sympathizers and troublemakers*). Four of the youths, we are told, were sent to prison and fined, and then sent back to their families; the other, deemed to be a hypochondriac, was sent home immediately (18). The *Mémoire* records that copycat incidents took place shortly thereafter, first in Argenton (where priests made a model of the Virgin Mary stamping on a dragon labeled *flagellum Jansenistarum*), and then in Sées (27–28). For Dufour the incidents represented a telling symptom of a wider problem fueled by misguided fanaticism. In his foreword, he explains that he has been moved to speak out "comme on voit que le temps ne modere point les fougues de leur zele indiscret" (np) (*because it is evident that time has in no way tempered the fire of their indiscreet zeal*). One wonders if the principal problem for Dufour, who is, unlike Cléante, Le Vayer, or Garaby, a committed ecclesiastic, is the zeal itself or its lack of discretion—the motive or its method. Later, Dufour reminds his reader of the extreme dangers of this type of zeal by commenting that it is widely understood to have been "un faux zele de la Religion, qui a armé les mains parricides de trois furies infernales, contre deux des meilleurs de nos Roys" (21)

(*a false religious zeal that armed the parricidal hands of three furies from hell against two of our greatest kings*). This reference to the assassination of Henris III and IV during the Wars of Religion is intended to shock the reader and perhaps also hints at the fact that Dufour hoped his text might be read by key members of the French Court. It also suggests that there is in Dufour's mind a difference between indiscreet zeal and false zeal, if only because the former refers to an (unfortunate) outward manifestation while the latter refers to a (misguided) motive. As we have seen, Cléante tends to elide the two.

For Tallon, the Caen controversy was the symptom of the Company's spiritual failure: "La division entre un intérieur anéanti et un extérieur mondain conduit à un mysticisme inspiré, qui, loin de rester caché, veut se traduire par des actes concrets, qui revendiquent leur origine, c'est-à-dire la volonté de Dieu" (98) (*The divide between internal renunciation and a worldly exterior leads to a type of inspired mysticism that, far from remaining hidden, wants to make itself known in concrete acts that speak of their source—that's to say, the will of God*). This is precisely the problem of discretion. For the Norman poet and member of the Académie de Caen, Garaby de la Luzerne, who was hardly well disposed toward orthodox religion generally, the Caen episode was further evidence of the pernicious effects of religiously inspired fanaticism. As he explains, his bitingly satirical poem *Les Pharisiens du temps ou le dévot hypocrite*[21] was directly inspired by what he saw (or heard about) in Caen. However, the particular incident involving the unfortunate young men, whom he refers to as poor madmen, is of less interest to him than the broader, related problem of the zealous *dévot*. On the question of the incident involving the young men, he comments that "leur cervelle me semble un peu trop de guinguois / Pour les oser placer au rang de ces narquois" (65) (*their brains seem to me to be too unhinged for us to deride them along with the others*). For Garaby, they are mentally, even comically, unstable and can be dismissed as mere "Harlequins du dévot bastelage" (65) (*Harlequinesque buffoonish* dévots). Garaby's satire and ill-concealed contempt is reserved, rather, for the hypocritical *dévot*, both of the conventional variety and of the zealous variety that concerns us particularly here. He comments in his poem, "O! que de telles gens souvent le zèle faux / Dans la Religion a fait naistre de maux!" (56) (*Oh, how often has the false zeal of such people bred harm within religion!*). We note that his complaint here is that the zeal is false rather than that it is indiscreet—and also that it is the cause of misfortune in others (as in the case of the misguided and mentally unsound youths). Like Cléante (but before him), Garaby understood ostentatious religion to be an indicator of

false religion, and zealotry was thus equated with religious hypocrisy. We read in his poem, for instance, that "le plus ignorant, par son seul zèle habile, / Opine froidement, ainsi qu'en un Concile: / Fait le rude examen des actions d'autruy" (53) (*the most ignorant man, skilled only in zeal, coolly pronounces as though in a Council and harshly examines the actions of others*) and, later, that "n'approuvent rien d'autruy, présument tout d'eux-mêmes / Tout nouveau en conduite, en prières, en zèle, / Ils ne vont qu'aux Béats d'impression nouvelle" (64) (*condoning nothing in others, they are utterly assured of themselves; as newcomers to spiritual direction, to prayer and to zeal, they only make an impression on the gullible*). We see that what the satirists, moderate skeptics, and conventional Christians, including even some rigorous Jansenists,[22] agreed on is the fact that religious zealotry was potentially dangerous. They differed on the question of whether or not *all* religious zealotry was *inherently* harmful.

Bourdaloue

Given the vexed nature of zealotry, it is perhaps no surprise that even fervent preachers such as Bourdaloue were wary of this tendency.[23] In his discussion of true and false forms of personal devotion, Bourdaloue warned against anything too extreme, eccentric, or eye-catching:

> La dévotion doit être prudente, et on peut bien lui appliquer ce que saint Paul a dit de la foi: *que votre service soit raisonnable.* Ce n'est donc point l'esprit de l'Evangile, que par une dévotion outrée nous nous portions à des extrémités qui choquent le bon sens, ou à des singularités qui ne sont propres qu'à faire parler le monde. Mais le mal est que cette prudence, qui est un des caractères de la dévotion, n'est pas toujours le caractère des personnes dévotes. (*Pensées de la vraie et de la fausse dévotion* IV, 373)
>
> *Devotion must be prudent, and we may usefully apply to it what Saint Paul said of faith:* Let your service be reasonable. *It is not, then, in keeping with the spirit of the Gospels to adopt a type of excessive devotion that pushes us to extremes that jar with good sense or to adopt idiosyncrasies that only serve to provide a talking point. The problem is that this prudence, which is one of the characteristics of devotion, is not always a characteristic of the* dévots.

And with regard to the zealot's relationship with the world, Bourdaloue criticizes the type of behavior that was commonly associated with the Company of the Holy Sacrament:

> C'est assez que nous ayons un certain zèle de discipline et de réforme, pour nous attribuer le pouvoir de juger de tout, pour usurper une supériorité que ni Dieu ni les hommes ne nous ont donnée et pour faire la loi peut-être à ceux dont nous devons la recevoir. Car un laïque s'érigera en censeur des prêtres, un séculier en réformateur des religieux, une femme en directrice, et que sais-je de qui? tout cela, parce que, sous couleur de piété, on ne s'aperçoit pas qu'on veut dominer. (*Sur la sévérité évangélique* I, 135)
>
> *A certain zeal for discipline and reform seems to be the basis for some people to assert their authority to judge everything and to usurp a position of superiority that neither God nor man has given them, and even to preach to those who should perhaps be preaching to them. Thus a layperson becomes a censor of priests, a secular becomes a reformer of people in religious orders, a woman becomes a spiritual director, and goodness knows what else. All this because, under cover of piety, people do not realize that their purpose is to dominate.*

Bourdaloue is troubled by the lack of conformity to standard hierarchical structures within the Church and society more generally (the references to lay persons and to women are especially revealing here) and an inappropriate wish to judge and to dominate—charges that, as we have seen, were repeatedly leveled at the Company. What is particularly interesting for the present discussion is the suggestion of how easy it is to fall into this type of behavior and the seemingly commendable motives that can generate it (discipline and reform). It only requires a certain zeal for these worthy aims to be distorted—and not, we note, a false zeal. If Bourdaloue is indulging in a degree of understatement, it remains the case that the zeal he identifies here is not altogether condemned; instead he issues a warning regarding the potential pitfalls of this type of attitude.

Similarly, in his sermon on zeal, Bourdaloue praises the right kind of religious zeal but indicates that a series of checks must always be in place, owing to its potential for misapplication: "Il n'est rien de plus sublime, ni même de plus héroïque, dans l'ordre des vertus chrétiennes, que le zèle du salut et de la perfection du prochain" (*There is nothing more sublime, or even more heroic, among Christian virtues than a zeal for salvation and the perfection of one's neighbor*), but it must be "soutenu et autorisé, parce que sans cela il est vain et sans effet; épuré et réglé, parce que sans cela il est défectueux et faux; adouci et modéré, parce que sans cela il est odieux et rebutant" (I, 376) (*steady and authorized, otherwise it is vain and ineffectual; it must be pure and regulated, otherwise it is defective and false; it must*

be gentle and moderate, otherwise it is odious and repellent). Zeal, then, is a powerful but dangerous tool, only to be wielded by the most careful and skilled initiates. Above all, a zeal for the reform of others must always be a consequence of a constant and vigilant zeal for self-correction: "Mesurez le zèle que vous avez pour les autres sur le zèle que vous devez avoir pour vous-mêmes. C'est par nous-mêmes, Chrétiens, que doit commencer ce zèle de correction et de réforme, que la vue des intérêts de Dieu a coutume de nous inspirer" (I, 376) (*Measure the zeal that you have for others against the zeal that you should have for yourselves. Fellow Christians, this zeal for correction and reform, which is inspired in us by our concern for God's work, must begin with ourselves*). This, for Bourdaloue, is the key to avoiding falling into the trap of hypocrisy.

Without that essential check in place, members of Bourdaloue's flock run the risk of participating in the scandal of those whose zealotry has led them straight into hypocrisy (or, perhaps, in some cases, whose hypocrisy has led them toward zealotry):

> Des gens qui voudraient rétablir l'ordre partout ailleurs que dans leurs personnes et dans leur conduite; des laïcs corrompus et peut-être impies, qui prêchent sans cesse le devoir aux ecclésiastiques, des séculiers mondains et voluptueux, qui ne parlent que de réforme pour les religieux; des hommes de robe pleins d'injustices, qui invectivent contre le libertinage de la cour; des courtisans libertins, qui déclament contre les injustices des hommes de robe: des particuliers d'une conduite déréglée, qui cherchent des moyens pour remettre ou pour maintenir la règle dans l'état, mais à qui l'on pourrait bien dire ce que Jésus-Christ disait à ces femmes de Jérusalem: *Nolite flere super me, sed super vos ipsas flete*; Ne pleurez point sur moi, mais sur vous-mêmes. (I, 378)

> *Those who would like to put everything right except with regard to themselves and their own behavior; corrupt and perhaps impious laymen who constantly sermonize ecclesiastics; worldly and voluptuous seculars who speak only of reforming the holy orders; unjust lawyers who rage against the libertinage of the court; courtly libertines who rant about the injustices of the lawyers; unruly individuals who look for ways to establish or maintain order within the state but to whom one might well say what Jesus Christ said to the women of Jerusalem*: Nolite flere super me, sed super vos ipsas flete; *weep not for me but for yourselves.*

For Bourdaloue, not all zealots are incontrovertible hypocrites, but it would appear that zealotry appeals to those who are quick to condemn

others and slow to attend to their own shortcomings. In individuals lacking charity (or love), zeal is used as a pretext to criticize others:

> On appelle zèle de la gloire de Dieu, zèle du salut des âmes, zèle de la vérité et de la pure doctrine, ce qu'il y a dans la médisance de plus outrageux et de plus calomnieux. Bien loin d'en avoir quelque peine, on s'en fait un mérite devant Dieu, et l'on s'en glorifie devant les hommes. (*Instruction sur la charité* IV, 232)

> *The most excessive and defamatory scandalmongering passes for a zeal for the glory of God, a zeal for the saving of souls, or a zeal for truth or true doctrine. Far from being troubled by this, people make a virtue of it before God and take pride in it before men.*

Religious zeal, then, is to be treated with extreme caution, as its attempts to promote Catholic reform can, within a Christian context, become very heavy-handed and even work as a gateway to or outlet for religious hypocrisy.

There is, on the other hand, one particular framework in which Bourdaloue positively encourages zeal among his flock: in their encounters with behavior and individuals that appear to be operating outside the Christian framework. Here it is not so much a question of reforming Christian practice according to Tridentine principles as simply confronting the sinner. Interestingly, Bourdaloue, in his rhetorical strategy, anticipates the counterargument against employing zeal to this end:

> Vous me direz qu'un zèle vif et ardent, tel que je tâche de vous l'inspirer contre le libertinage et contre le vice, bien loin de guérir le mal, ne servira souvent qu'à l'irriter. Quand cela serait, Chrétiens . . . votre indifférence pour Dieu n'en serait pas moins criminelle, et en mille rencontres le zèle ne vous obligerait pas moins à vous déclarer . . . Aussi ce zèle que je vous demande étant un zèle de charité, qui n'a rien d'amer, qui n'est ni fier ni hautain, qui aime le pécheur et l'impie, en même temps qu'il combat l'impiété et le péché, il y a tout sujet de croire qu'il sera efficace et d'en attendre le fruit que l'on se propose. (*Sur le zèle pour la défense des intérêts de Dieu* II, 170)

> *You will say to me that a quick and ardent zeal of the kind that I try to inspire in you in the face of libertinage and vice, far from curing these ills, will only serve to provoke them. Even if that is the case, Christians, your indifference toward God will be no less culpable, and in a thousand encounters this zeal will still require you to speak up. Moreover, this type*

of charitable zeal that I promote, having no bitterness and being neither proud nor haughty, loves the sinner and the ungodly just as it fights impiety and sin. There is every expectation, therefore, that it will be successful and bear the fruits that I have outlined.

Here, too, the good Christian's zeal must be properly motivated and grounded in charity or love. But it is interesting to note that in this context, Bourdaloue warns not against an excess of zeal but a shortage or absence of it. If the wrong kind of zeal is common, the right kind is, in Bourdaloue's view, not only imaginable but also, in some situations, vital. Bourdaloue even addresses the question of discretion, permitting "tant de discretion qu'il vous plaira, pourvu que le vice soit corrigé, pourvu que le scandale soit réparé, pourvu que la cause de Dieu ne succombe pas" (II, 170) (*as much discretion as you wish as long as vice is corrected and scandal rectified, and as long as God's cause does not suffer*). However, Bourdaloue positively encourages indiscretion if it is required to further the fundamental Christian cause:

> Vous me direz que votre zèle fera de l'éclat et du bruit; mais pourquoi donc en faire, si ce n'est pour empêcher ce que vous savez être un véritable désordre . . . est-ce prudence d'éviter l'éclat, quand l'éclat est nécessaire, et qu'il peut être avantageux? Faudra-t-il que le libertinage, qui règne dans votre maison, sous ombre que vous ne voulez pas éclater, y soit tranquille et dominant? . . . mais cet éclat troublera la paix: Qu'il la trouble, répond saint Augustin. (II, 171)
>
> *You will say to me that your zeal will be conspicuous and indiscreet; but why go down that path unless it is to prevent what you know will be real depravity? Is it prudent to avoid being conspicuous when it is necessary and when it can be useful? Should the libertinage that reigns in your house under cover of the fact that you do not wish to draw attention to yourself remain undisturbed and dominant? But this will cause upset. Let it cause upset, says Saint Augustine.*

Discretion, then, is a virtue within a Christian context and with regard to one's fellow Christian, but it is a vice in the context of an individual or group that is operating according to altogether different criteria. For Bourdaloue, the zealot is to be gentle in his drive to reform Christianity from within but vigorous in his drive to defend it from any external and fundamental threat.

Don Juan in *Le Festin de Pierre*

The type of libertinage or vice that must, according to Bourdaloue, be countered by the right kind of zeal is best represented in Molière's theatre by the figure of Don Juan. *Le Festin de Pierre*[24] was given its first performance during the *Tartuffe* controversy on February 15, 1665, and is best understood in that context.[25] As the anonymous author of the *Lettre sur les observations d'une comédie du sieur Molière, intitulée "Le Festin de Pierre"* (1665) observed, addressing Molière directly, "A quoi songiez-vous, Molière, quand vous fîtes dessein de jouer les tartufles? si vous n'aviez jamais eu cette pensée, votre *Festin de Pierre* ne serait pas si criminel" (Pléiade II, 1231) (*What were you thinking of, Molière, when you decided to portray the Tartuffes? If you had never had this idea, your* Festin de Pierre *would never have been so scandalous*). Comparisons have often been made between Tartuffe's calculating religious hypocrisy, which is sustained until he reappears at the end of his play in a new (or perhaps old) incarnation, and that adopted by Don Juan only in the final act of his play. It has also been suggested that a useful comparison could be made between Tartuffe as *faux dévot* and Don Juan as *faux libertin* in the sense that both individuals abuse their professed outlook on life in order to suit their personal needs and desires.[26] Moreover, there does appear to be something overly zealous in Don Juan's performance of libertinage, just as there is in Tartuffe's performance of devotion. Leclerc comments:

> Il ne me paraît pas impossible que . . . Molière ait voulu porter un coup, en passant, aux faux-libertins qui risquaient, par leurs excès, de compromettre et de discréditer les vrais libertins, ceux qui poursuivaient alors la tradition humaniste et libérale de Montaigne . . . Il aurait fait du dom [*sic*] Juan odieux et parasite le symbole de ses adversaries et du Dom Juan éclairé et hardiment rationaliste celui de ses amis. (57–58)

> *It does not seem impossible to me that Molière wanted, in passing, to take aim at the false libertines, who, by their excesses, ran the risk of compromising and discrediting true libertines, those who were then following the liberal humanist tradition of Montaigne. He may have had the odious and parasitical Don Juan symbolize his opponents while the enlightened and boldly rationalist Don Juan symbolized his friends.*

The type seems to have persisted later into the seventeenth century, as Madeleine de Scudéry, for her part, notes in one of her *Nouvelles Conversations de morale*:

Je connois parmi les gens du monde des hipocrites en mal, qui sont les plus blasmables de tous, & les plus bizarres, pour ne pas dire les plus foux. Ce sont . . . de ces jeunes gens sans discernement & assez emportez, qui croyent que pour estre estimé homme d'esprit, & homme de la Cour, il faut paroistre libertin, se moquer de ceux qui vivent avec bienséance, & qui afféctent de paroistre plus déréglez qu'ils ne le sont naturellement.[27]

Among the worldly I know some who pretend to be bad, and these are the most culpable hypocrites of all and the oddest, not to mention the maddest. They are insensitive and quite undisciplined young men who think that in order to be considered a wit and a courtier they must be seen to be libertines, to mock those who live in a seemly manner. They try to appear more disorderly than they really are.

If, as will be suggested in Chapter 4, Molière was in the course of the *Tartuffe* controversy hinting at the merits of individuals who subscribed to a worldview that was not exclusively or necessarily Christian, it is possible to see in *Le Festin de Pierre* a reminder of the potential pitfalls of an outlook that is too zealously nonconformist or one that is selfishly rather than ideologically motivated.[28] We remember that when, finally disabused with regard to Tartuffe, Orgon declared, "Je renonce à tous les Gens de bien" (V.1.1604) (*I'm giving up on all good people*), Cléante, who as we have seen is hardly orthodox in his views (see also Chapter 4), advised him to "laissez aux libertins ces sottes conséquences" (V.1.1621) (*leave that sort of foolish response to the libertines*). For Cléante, both explicit libertinage and zealous devotion were forms of excess to be avoided. The notion of excessive libertinage would certainly make sense of d'Aubignac's rather curious observation with regard to audience response to *Le Festin de Pierre*: D'Aubignac noted that "le caractère d'un impie châtié sévèrement par un coup de foudre, a donné beaucoup de peine aux gens de bien et n'a pas fort contenté les autres" (330) (*the wicked man severely chastised by a thunderbolt caused considerable consternation among the pious and did not really please the others either*). If the others are the libertines, it may indeed be that they are displeased with this excessive and therefore unflattering portrait of their philosophy. For although Don Juan is (as Monsieur Jourdain will never be) a *gentilhomme* (*gentleman*), he is not in any way a *gentil homme* (*gentle man*).

More interesting still, however, is the effect on our libertine of the type of zealotry that Bourdaloue encouraged. For, as Constant Venesoen points out, several zealots feature in *Le Festin de Pierre*,

each trying to convert Don Juan and save his imperiled soul, just as Bourdaloue would have wished.[29] Venesoen makes the point that Cléante has condemned precisely this kind of *zèle*; Cléante has "une éthique de la tolérance qui enfreint et même contredit tout le zèle agressif et militant dont Dom Juan est devenu l'objet" (550) (*an ethic of tolerance that infringes upon and even contradicts the aggressive, militant zeal of which Don Juan has become an object*). It is certainly helpful to consider Don Juan, who is not an entirely sympathetic character even to a modern audience, as an object of hard-line proselytizing. Venesoen's suggestion that Elvire's portrayal, particularly in IV.6, is satirical, is thought provoking if not entirely convincing, and he is certainly right to observe that Elvire's language verges on parody in its extensive use of the vocabulary of repentance (e.g., "Je ne demande qu'assez de vie pour pouvoir expier la faute que j'ai faite, et mériter, par une austère pénitence, le pardon de l'aveuglement où m'ont plongée les transports d'une passion condamnable" (IV.6) [*I only ask for the time to atone for the sin that I have committed and to earn, by an austere penance, forgiveness for the blindness that the raptures of a guilty passion plunged me into*]). A propos of Don Juan's much-debated fake "conversion" in Act V, Venesoen concludes that the scenes featuring hypocrisy, first with Don Louis (V.1) and then with Don Carlos (V.3), seal the victory for the *dévots* (554). What we see, then, is that the type of zealotry that is singled out for approval by Bourdaloue but included in a quasi blanket condemnation by Cléante and equated by Molière with religious hypocrisy can lead in turn to the more overt kind of religious hypocrisy that was discussed in Chapter 2. In this instance, zealotry is dangerous not because it can lead to hypocrisy on the part of the zealot but, fascinatingly, because it can lead to hypocrisy on the part of the proselytizee. According to this reading, it is not only Don Juan who is culpable; it is also those sincere zealots who have forced him into this situation in the first place.

Conclusion

In the course of this discussion, we have seen that the character of Tartuffe is both a hypocrite in the ordinary sense of the term and a zealot, to the extent that the form of religious practice that he adopts much of the time is that of a zealot, notably in his excessive preoccupation with the behavior of others. It was noted that complaints in the Orgon household about Tartuffe are at least as concerned with his zealous disapproval of their behavior as with his own hypocrisy and that Tartuffe's outward zealotry is firmly established in the first

scene of the play at the same time that his hypocrisy is (only) strongly implied. It was seen that many of the complaints about Tartuffe could equally have been leveled at the sincere zealot and that similar complaints were indeed made about the activities of, among others, the Company of the Holy Sacrament. We may conclude, then, that the notion of religious zealotry is, in the context of seventeenth-century France, inherently ambiguous and problematic. While Molière's ingenious but disingenuous elision of zealot and hypocrite in the course of the *Tartuffe* controversy is not shared by all his contemporaries, even Bourdaloue was aware of the dangers of zealotry and of the potential for it to lead to certain forms of religious hypocrisy. A reforming zealot, then, is not necessarily a hypocrite in the ordinary sense of the term (though he could well be). If, on the other hand, the notion of false devotion is understood to encompass misguided devotion as well as hypocrisy, as it clearly did for some, then the zealot is likely to qualify. In that sense, a sincere zealot might legitimately be termed a *faux dévot* on the basis of his lack of good judgment rather than on his actual hypocrisy. Meanwhile, the special attention paid by Bourdaloue to the need for zealotry in the face of individuals who patently do not conform to orthodox religious precepts is significant both because it might, as in the case of Don Juan, lead to more conventional hypocrisy on the part of the object of zealous attention under duress and, especially, because it implicitly acknowledges the significance of the contemporary threat posed by alternative world views. If Don Juan's excessive form of libertinage is condemned in *Le Festin de Pierre*, it will be seen in Chapter 4 that Cléante's far gentler nonconformist tendencies are seemingly, albeit discreetly, praised by the playwright.

Chapter 4

What Is a *Vrai Dévot* and Is He a *Véritable Homme de Bien*?

We have seen that the key terms of *vrai* and *faux dévot*, with which the *Tartuffe* controversy is commonly framed, are notoriously slippery and that their meaning does not simply turn on a question of hypocrisy or sincerity but is partly dependent on individual viewpoints on matters moral and religious. One type of *faux dévot*, the zealot, discussed in Chapter 3, emerged as being particularly open to interpretation since his zealotry is, for some people, clear evidence of his fundamental falsehood, while for others, in some contexts, it is compelling evidence of an authentic love of God. Still others treat the zealot and his methods with an interesting combination of suspicion and respect. Yet the *dévot* is unambiguous at least to the extent that *all* types of *dévot* are, by definition, perceived within a religious context. And although *dévot* was a term often applied, approvingly or disapprovingly, to lay persons working within the world and beyond the strict confines and structures of the established Church, particularly in the case of members of the Company of the Holy Sacrament, the *dévot's* framework was irrefutably Christian. If not always operating strictly *intra ecclesiam*, the *dévot's* moral standpoint was grounded in the principles set out at the Council of Trent, which had at its heart the reform and stability of the Catholic Church across Christendom.

In the preface to the published edition of *Tartuffe* (1669), Molière famously wrote:

> J'ai mis tout l'art, et tous les soins qu'il m'a été possible pour bien distinguer le personnage de l'Hypocrite d'avec celui du vrai Dévot . . . Mon Scélérat . . . ne fait pas une action qui ne peigne aux Spectateurs

le caractère d'un méchant Homme, et ne fasse éclater celui du véritable Homme de bien, que je lui oppose. (Pléiade II, 92)

> *I have used all my art and taken every possible precaution to distinguish clearly the character of the hypocrite from that of the* vrai dévot. *My scoundrel does not do anything that does not reflect, in the eyes of the spectator, the character of a wicked man or enhance the character of the truly good man to whom he is opposed.*

In attempting to understand this oft-cited passage, we shall address two major questions in the present chapter: First, where and who is the *vrai dévot* in Molière's *Tartuffe* (and the *vrais dévots* more generally in the controversy that the play provoked); and second, is he, as the majority of critics have assumed, the same as the *véritable homme de bien* (*truly good man*) to whom Molière also refers?[1] In the course of our discussion, not only shall we address the notion of the *vrai dévot*, but we shall also introduce another concept into the debate: the *homme de bien* (*good man*). For many writers of the seventeenth century, a *(vrai) dévot* and an *homme de bien* were coterminous, simply because it was, for those writers, impossible to conceive of genuine goodness or morality coming from any source other than a Christian God. However, as André Lévêque explains, *l'homme de bien* is one of those expressions open to interpretation depending on who was using it and when it was applied.[2] At the beginning of the seventeenth century, the term still evoked the morality of humanism more than any Christian morality, but gradually, as the century wore on, and partly in response to the sharpening of key notions of Christian morality that took place under the influence of Jansenism, "l'expression prend un sens religieux de plus en plus prononcé" (Lévêque 625) (*the expression took on an increasingly religious dimension*). By Molière's time, an *homme de bien* was more commonly used to designate an individual in Christian rather than in *mondain* or humanist terms, and it is significant that Molière's own Don Juan explains to Sganarelle that he has decided to feign a religious conversion by playing "le personnage d'homme de bien" (*Festin de Pierre* V.2) (*the character of a good man*). But a degree of ambiguity inevitably remained, and it is this ambiguity that I believe Molière exploited and subtly emphasized by the use of the crucial word *véritable* (*truly*), as will be discussed in what follows.

This inherent ambiguity is even more pronounced when the *homme de bien* is spoken of in relation to the *honnête homme*.[3] Even some religiously inclined authors tried to bring the two categories together: the abbé Goussault, in the preface to his *Portrait d'un honneste homme*,

for instance, commented that "plus on est Homme de bien, plus on est honneste Homme"⁴ (*the more one is a good man, the more one is an* honnête homme). But these attempts to Christianize *honnête* precepts or to *honnêtify* Christian ones could not conceal the fact that the underlying moralities at play were very different. As Lévêque observes dryly, the injunction "'Souffrez-vous reciproquement les uns les autres et passez-vous mutuellement vos imperfections' n'est pas tout à fait le: 'Aimez-vous les uns les autres' de l'Ecriture" (630) (*'Bear with one another and let your mutual imperfections pass' is not quite the 'Love one another' of the Bible*). For this crucial reason, such attempts at reconciliation were roundly rejected by *dévots* such as Bossuet and Bourdaloue, who insisted instead on the irreconcilable differences between the two models. It is perhaps unsurprising that it was the non-*dévot* authors—religious moderates such as the abbé de Goussault and particularly the *mondains* themselves—who were most eager to highlight useful overlaps between the two categories. Michel de Marolles, for instance, notes in his *Mémoires*:

> Il y a si peu de différence entre l'honnête homme & l'homme de bien, qu'ils se peuvent confondre aisément l'un avec l'autre; quoiqu'à le bien prendre, l'on puisse être homme de bien, sans être si fort honnête homme; mais il est impossible d'être honnête homme, sans être homme de bien.⁵

> *The difference between the* honnête homme *and the* homme de bien *is so slight that they can easily be mistaken for each other, even though, strictly speaking, one can be an* homme de bien *without being much of an* honnête homme. *But it is impossible to be an* honnête homme *without being an* homme de bien.

Yet in his attempt to emphasize the overlap between the two, Marolles in fact underscores the fact that for all their external similarities, the *honnête homme* and the *homme de bien* are not one and the same. Similarly, the chevalier de Méré, the most important contemporary theorist of *honnêteté*, comments revealingly on a fortuitous overlap between Christian morality and the morality of the *honnêtes gens*:

> Je prends garde aussi, que la devotion et l'honnêteté vont presque les mêmes voïes, et qu'elles s'aident l'une à l'autre. La devotion rend l'honnêteté plus solide et plus digne de confiance; et l'honnêteté comble la devotion de bon-air et d'agrément . . . De sorte que l'honnêteté n'est pas inutile au salut, et qu'elle y contribuë extrêmement, mais la devotion en est la principale cause.⁶

> *I am careful also to ensure that devotion and* honnêteté *follow almost the same path, that they help each other along. Devotion makes* honnêteté *more solid and more trustworthy, while* honnêteté *enhances devotion with its pleasing appearance and charm. The result is that* honnêteté *has a significant role to play in salvation, even if devotion is its principal source.*

For all the lip service that he pays to the useful and welcome reciprocity between these two modes of morality, it is abundantly clear that the variety put forward by Méré is fundamentally secular and *mondain*. The separation, even if incomplete, of a moral code of conduct from the question of salvation means that the stakes of its morality are entirely different: Where Christian morality is concerned above all with the afterlife (via an individual's relationship with God), *honnête* morality is concerned primarily with the here and now (via an individual's relationship with other human beings). This calls to mind the dictum "extra ecclesiam nulla salus" (*outside the Church there is no salvation*). Both the *honnête homme* and the *homme de bien* might agree on this principle, but the *honnête homme* is less pressingly concerned with the question of salvation. As Lévêque explains, the religious ideal of the *homme de bien* corresponds to the *mondain* ideal of the *honnête homme*, as defined by Méré (625). They are both ideals, but moving in very different directions; for all their external similarities, the two are in fact worlds apart. What is at work beneath these coexisting terms overlaps with the debate outlined in Chapter 1 regarding the question of the place of the world in religion and of religion in the world; however, whereas any legitimization of a worldview that did not have God at its center was anathema to the Counterreformation, we do encounter in these debates concerning the *homme de bien* and especially the *honnête homme* a degree of slippage that allows for the possibility that God might not be the only yardstick by which morality could be measured and that orthodox religion might not be the only guardian of morality. Worse still, the suggestion also existed whereby other types of morality might have a legitimate existence of their own.

The *Vrai Dévot*

In Chapter 2, it was noted that the *vrai* and the *faux dévot* (of the hypocritical rather than the zealous variety) share many external characteristics. Both are likely to be seen to conform to the expectations of a good Christian life: They go to Church, they visit the sick, and so on. For this reason, it is notoriously difficult to distinguish between a *vrai dévot* and an accomplished *faux dévot*, because what sets them

apart is invisible. While the true *dévot* remains tantalizingly undetectable, it was seen that hypocrisy can become legible when, for instance, a *dévot* is caught attempting to seduce a married woman or when a Christian king is known to have succeeded in doing so. Meanwhile the fervent hope that true devotion could be equally legible was expressed repeatedly, even by the relatively moderate Le Moyne, who wrote:

> Il luy faut des actions qui luy soient propres, parce que la vie devote a sa forme & ses principes, qui la distinguent de toutes les autres vies; & par consequent elle doit avoir des actions proportionnées à cette forme, & ajustées à ces principes. (*Dévotion* 159)

> *It must have acts that mark it out, because the devotional life has its structure and its principles that distinguish it from all others. And so it must have acts that are in line with this structure and are congruent with its principles.*

Yet this is evidence of wishful thinking rather than any concrete demonstration of what those acts might be. In pursuing his attempt at distinguishing between the actions of the devout from those of others, Le Moyne returns again to the key question of motivation, of purity of intention, which, as we know, is invisible. While, judged by his own standards, Le Moyne is no doubt right to note that "les Vertus qui manquent de cette couleur, quelques parées & quelques esclatantes qu'elles soient d'ailleurs, ne peuvent estre agreables au Dieu des Vertus" (*Dévotion* 184) (*virtues that lack this color, however ornate or dazzling they might be, cannot be pleasing to the God of virtue*), the fact remains that he has been unable to define or describe what that color might be.

In an interesting twist, it is in the context of the weak would-be believer who is put off for fear of being mistaken for a *hypocrite* (and not the other way around) that Bourdaloue dares to put forward not a series of defined *acts* but a series of semidefined *qualities* that distinguish one from the other:

> C'est une lumière . . . c'est un or pur qui se sépare sans peine de tous les autres métaux . . . Une humilité sans affectation, une charité sans exception et sans réserve, un esprit de douceur pour autrui et de sévérité pour soi-même, un désintéressement réel et parfait, une égalité uniforme dans la pratique du bien, une soumission paisible dans la souffrance, tout cela est au-dessus des jugements mauvais. (*Sur l'hypocrisie* II, 240)

> It is a light. It is pure gold that can be easily distinguished from all other metals. It is unaffected humility, indiscriminate and unreserved charity, a spirit of gentleness toward others and of severity toward oneself, a true and perfect selflessness, a consistent impartiality in the practice of good, a peaceful submission in the face of suffering. All this is beyond reproach.

But of course, these qualities, like Le Moyne's color, are characterized primarily by their internal motivation and are far less easy to discern than the acts that, as he has already observed, are no guarantee of true sincerity. This is clearly a source of frustration for Bourdaloue, who asks, precisely, "Pourquoi la vraie dévotion est-elle si peu connue, et pourquoi, au contraire, connaît-on si bien la fausse?" (*Why is true devotion so obscure while false devotion is so well known?*). His answer denounces ostentation and puts its finger back on the problem of discretion (discussed in Chapter 3):

> C'est que la vraie dévotion se cache, parce qu'elle est humble; au lieu que la fausse aime à se montrer et à se distinguer. Je ne dis pas qu'elle aime à se montrer ni à se faire connaître comme fausse; bien loin de cela, elle prend le dehors de la vraie: mais elle a beau faire, plus elle se montre, plus on en découvre la fausseté. Voilà d'où vient que le monde juge communément très-mal de la dévotion: car il n'en juge que par ceux qui en ont l'éclat, qui en ont le nom, la réputation: or, ce n'est pas toujours par ceux-là qu'on en peut former un jugement favorable et avantageux. (*Pensées diverses sur la dévotion* IV, 372)

> *It is because true devotion is humble and hides itself away, whereas false devotion likes to be seen and to be noticed. I do not mean that it likes to be seen or known to be false; far from it, for it adopts the appearance of true devotion. But this is all in vain, for the more it is on display, the more its falseness is uncovered. This is why the world generally has such a low opinion of devotion: because the world judges those whose devotion is conspicuous, who call it devotion and who are reputed to be devout. And it is not always from these people that others may form a favorable or advantageous opinion of devotion.*

For Tallon, as we saw, this was precisely the dilemma that the *dévots* of the Company of the Holy Sacrament faced and that led to the scandals in Caen. The problem of discretion was certainly a real and tantalizingly paradoxical one; but the greater problem when attempting to establish a case of true devotion beyond doubt lay with the impossible fact that *any* act, discreet or otherwise, might be grounded in hypocrisy or performed by a hypocrite. It then becomes an uncomfortable

game of probability, of *likely* truths rather than absolute truths: The hypocrite is likely to give himself away eventually, while the truly devout individual will tend toward a type of discretion that may yet be uncovered (though the hypocrite may of course offer up a sincere repentance while the discreet *dévot* may have wanted to be discovered all along). Above all it becomes a matter of personal opinion, a best guess based on one's own prejudices and preconceptions.

While the task is impossible and the Final Judgment can only justly be left in God's hands, this has never prevented people from forming opinions with regard to the hypocrisy, sincerity, or ambiguity of those around them based to a large extent on their own personal views on what might be deemed offensive to God (and the extent to which it even matters). The characters in Molière's *Tartuffe* frequently express an opinion with regard to the moral status of the other characters' codes and conduct, just as critics from 1664 onward have sought time and again to pin down the morality of those same characters. In particular, they have sought to identify likely candidates for the label *vrai dévot* in the wake of Molière's famous assertion, cited earlier: "J'ai mis tout l'art, et tous les soins qu'il m'a été possible pour bien distinguer le personnage de l'Hypocrite d'avec celui du vrai Dévot" (*I have used all my art and taken every possible precaution to distinguish clearly the character of the hypocrite from that of the* vrai dévot). If the hypocrite in question here is undoubtedly Tartuffe, his authentic counterpart on the other hand has proven to be highly elusive.[7] As many critics have observed, it is possible to argue that both Orgon and Mme Pernelle are *vrais dévots*, in the sense that they are sincere—even if misguided—in their faith. However, the seventeenth century took a dim view of the self-righteous self-deceiver, as this mother and son surely are.[8] Bossuet, for instance, denounces as hypocrites those who convince themselves (wrongly) of their own sincerity, while, as we have seen, Bourdaloue condemns those who are taken in by their own hypocrisy, as well as those who are taken in by that of others.[9]

Meanwhile, Cléante invites Orgon explicitly to distinguish between true and false devotion. Yet his famous bipartite speech that purports to portray first the *faux* and then the *vrai dévot* in fact offers a portrait of the *faux dévot* and then a portrait of the *vrai dévot*, based largely on what he is not—that is, a zealot (see also Chapter 3):

> Ce ne sont point du tout Fanfarons de vertu,
> On ne voit point en eux ce faste insupportable,
> Et leur Dévotion est humaine, est traitable.
> Ils ne censurent point toutes nos actions,

> Ils trouvent trop d'orgueil dans ces corrections,
> Et laissant la fierté des paroles aux autres,
> C'est par leurs actions, qu'ils reprennent les nôtres.
> L'apparence du mal a chez eux peu d'appui,
> Et leur âme est portée à juger bien d'autrui;
> Point de cabale en eux, point d'intrigues à suivre;
> On les voit, pour tous soins, se mêler de bien vivre.
> Jamais contre un Pécheur ils n'ont d'acharnement.
> Ils attachent leur haine au Péché seulement,
> Et ne veulent point prendre, avec un zèle extrême,
> Les intérêts du Ciel, plus qu'il ne veut lui-même. (I.5.388–402)

> *They do not boast about their virtue,*
> *They do not display an ounce of that unbearable ostentation,*
> *And their devotion is flexible and humane.*
> *They do not censor all our actions, for*
> *They see too much pride in such corrections.*
> *Leaving such arrogant words to others,*
> *They modify our actions by their own example.*
> *The appearance of evil counts for little with them,*
> *And their souls are inclined to think well of others.*
> *They do not form cabals, nor do they conspire;*
> *Their only concern is to live righteously.*
> *They never hound a sinner,*
> *They hate only the sin,*
> *And do not seek to take up, with an excess of zeal,*
> *The interests of heaven more than heaven itself would wish.*

Unlike Bourdaloue, then, Cléante makes the reassuring claim that the distinction is easy to make. But this is a definition by negation, and his examples of evidence of true devotion are considerably less concrete than his counterexamples.[10] While Cléante's *faux dévot* has many recognizable traits, including his "faste insupportable," his "corrections," his "intrigues," his "acharnement," and his "zèle extrême," the *vrai dévot* is discreet almost to the point of being invisible. Indeed, it is his near invisibility that seems to be the *vrai dévot's* defining characteristic.

The author of the *Lettre sur les observations d'une comédie du sieur Molière, intitulée "Le Festin de Pierre"* (1665), clearly aware of this problem, seeks in his *Apostille* to "prouver qu'il est impossible de jouer un véritable dévot, quand même on en aurait dessein, et que l'on y travaillerait de tout son pouvoir" (Pléiade II, 1239) (*prove that even if one wanted to and even if one went to considerable lengths to do so, it is impossible to play a truly devout person*). The strategically eccentric

suggestion is that Molière cannot be guilty of having failed to portray a *véritable* (or *vrai*)[11] *dévot* in his play (as alleged by Rochemont), because the task is impossible. The initial explanation is tantalizingly tautologous: "Si l'on représente ce que fait un véritable dévot, l'on ne fera voir que de bonnes actions; si l'on ne fait voir que de bonnes actions, le véritable dévot ne sera point joué" (Pléiade II, 1239–40) (*If one were to portray what a truly devout individual does, one would show only good works; if one showed only good works, the truly devout person would not be portrayed at all*). Further on it emerges that the author is putting forward much the same argument that we have already examined—namely, that the truly devout person is by definition discreet:

> Je vous dirai . . . que les véritables dévots ne sont point composés, que leurs manières ne sont point affectées, que leurs grimaces et leurs démarches ne sont point étudiées, que leur voix n'est point contrefaite, et que, ne voulant point tromper, ils n'affectent point de faire paroître que leurs mortifications les ont abattus. Comme leur conscience est nette, ils en ont une joie intérieure qui se répand jusque sur le visage. S'ils font des austérités, ils ne les publient pas; ils ne chantent point des injures à leur prochain pour le convertir; ils ne les reprennent qu'avec douceur, et ne le perdent pas dans l'esprit de tout le monde. (Pléiade II, 1240)

I tell you that the truly devout are not self-conscious, their behavior is not affected, their facial expressions and their manner of walking are not studied, their voices are not put on, and, not wanting to mislead others, they do not pretend to show that their mortifications have worn them out. Since they are of clean conscience, they have an internal joy that can be seen even on their faces. If they practice self-denial, they do not shout about it; they do not yell insults at their neighbor in order to convert him; they gently reprimand him and do not damage his reputation among others.

As Herman Prins Salomon wittily puts it, "c'est l'homme de bien négativement idéal" (47n2) (*it's the negatively ideal good man*). For, as was the case with Cléante's aforementioned portrait, this is a definition primarily by negation. Yet one external indicator is mentioned: the internal joy that will somehow be manifest on an individual's face. For Bourdaloue, then, this elusive indicator is a light; for Le Moyne, it is a color; and for the anonymous author of this *Lettre*, it is a facial expression or aura. Yet on the same page, the same author admits how similar a *vrai* and *faux dévot* are in external appearance and resorts to

the familiar but flawed argument whereby it is by a person's deeds that he may be judged:

> Je sais que si les vrais et faux dévots paraissaient ensemble, que s'ils avaient un même habit et un même collet, et qu'ils ne parlassent point, on aurait raison de dire qu'ils se ressemblent; c'est là justement où ils ont une même apparence, mais on ne juge pas des hommes par leur habit ni même par leurs discours: il faut voir leurs *actions*, et ces deux personnes auront à peine commencé d'agir, que l'on dira d'abord: voilà un véritable dévot; voilà un hypocrite. Il est impossible de s'y tromper. (Pléiade II, 1240, my emphasis)

> *I know that if some* vrais *and* faux dévots *appeared alongside each other wearing the same clothing and the same collar, and if they remained silent, it would be true to say that they look alike. Under those circumstances they do look the same. But we do not judge men by their clothing or even by what they say. We must examine their actions. And these two types would only have to begin doing things and we would immediately say, "That one is truly devout; that one is a hypocrite." It is impossible to mistake the two.*

But here again it is never made clear what exactly those actions are, and it is in fact all too possible to mistake the two.

Returning to Cléante's attempts at making the difference between true and false devotion clear, Lionel Gossman has observed that "what he distinguishes among the actual manifestations of piety . . . is not the true and the false; it is the obviously false and the possibly true."[12] Yet the doubt seems to extend even further, to both good and bad deeds, since Cléante's notion whereby true *dévots* lead by example is followed by the observation that the appearance of evil counts for little with them. If seemingly bad deeds are not necessarily taken as such, it is because appearances, both good *and* bad, are unreliable.

While Cléante struggles to come up with reliable evidence of true devotion, he does manage to name a series of supposedly exemplary *dévots*: Ariston and Périandre, then Oronte, Alcidamas, Polydore, and Clitandre (I.5.385–86), who are precisely the individuals described by the counterexamples discussed earlier. According to the *Lettre sur la comédie de l'Imposteur* (1667), Cléante's list featured in the opening scene of the play in the 1667 version. Its function is clearly important, as it is discussed rather laboriously in the *Lettre* and at considerable length:

> Pour un exemple de bigoterie qu'elle [la Vieille] avait apporté, il [le Frère de la Bru] en donne six ou sept, qu'il propose, soutient et prouve

l'être de la véritable vertu. Nombre qui excède de beaucoup celui des bigots allégués par la Vieille: pour aller au-devant des jugements malicieux ou libertins, qui voudraient induire de l'aventure qui fait le sujet de cette pièce qu'il n'y a point ou fort peu de véritables gens de bien, en témoignant par ce dénombrement, que le nombre en est grand en soi, voire très grand, si on le compare à celui des fieffés bigots, qui ne réussiraient pas si bien dans le monde s'ils étaient en si grande quantité. (Pléiade II, 1171–72)

> *For every example of a bigot put forward by the old woman [the Mme Pernelle figure], the daughter-in-law's brother [the Cléante figure] provides six or seven that he proposes, maintains, and proves are examples of true virtue. These far exceed the number of bigots cited by the old woman. Anticipating the malicious or libertine judgments whereby the subject of the play means that there are no, or very few, truly good people in the world, it is shown that the number of good people is high, indeed very high, when compared with these out-and-out bigots, who would not make their way so easily in the world if there were many more of them.*

For the author of the *Lettre*, this naming of exemplary individuals is not an attempt to distinguish clearly between *vrais* and *faux dévots*; rather, it is intended to underline the very existence of genuinely moral individuals and to indicate that they far outnumber the opposition (who are simply termed *bigots*). The fundamental question at play is what constitutes moral behavior in the eyes of different characters, and the divergence is between the "bigots" so warmly praised by La Vieille-Mme Pernelle (who include Tartuffe and a female neighbor, Orante, who, as we saw in Chapter 3, only behaves with sexual decency now that her old age prevents her from doing anything else) and Cléante's six or seven (in the final version in I.5, six names are given) examples of true virtue. But if Mme Pernelle's examples are not to be taken seriously, what are we to make of Cléante's?

It is surely significant that alongside two names that could indeed be those of Cléante's peers (Oronte and Clitandre) sit those of three Greek philosophers: Alcidimas (a sophist) and the stoic, Ariston de Chios, are mentioned by Diogenes Laertius in his *Lives of the Philosophers*, while Périandre is mentioned by Plutarch in his *Banquet of the Seven Sages*.[13] The type of devotion suggested by these names hardly corresponds to that of orthodox Christianity. Meanwhile, Jacqueline Plantié has made an interesting, if not absolutely convincing, case for an interpretation whereby Ariston and Périandre designate, respectively, François de Sales (who had been beatified in 1661 and was to be canonized in 1665) and Jean-Pierre Camus, Bishop of Belley. Calvet

is certainly correct when he comments that our examples are not presented with precision—that they are shadows with shadowy names (70).[14] Whether generic or not, and whatever philosophy or moral code they are associated with, what is most significant about these examples is that they are not only discreet but actually *absent* from the stage and from the immediate world of *Tartuffe*. Louis Veuillot asks, "Où donc sont les 'dévots de cœur,' les vrais gens de bien dont le contraste serait indispensable . . . J'ai beau regarder: ni Périandre, ni Polydore, ni aucun de ces parangons de vertu ne se montrent; ils restent dans la coulisse"[15] (*where are these* dévots de cœur, *the authentic good people with whom the comparison is supposed to be indispensable? I look in vain for them. Neither Périandre nor Polydore, nor any of the other paragons of virtue, appears on stage; they remain in the wings*). The numerical superiority that the author of the *Lettre* emphasizes is ineffective in the glaring absence of these named individuals. And as we have seen, the claim whereby Cléante maintains and proves the authenticity of their virtue is severly undermined by the fact that they are defined almost exclusively in negative terms. They cannot, therefore, act as a foil or even a counterexample to our villain.

Cléante

Who else, then, is opposed to Tartuffe and might qualify? If we approach the play in terms of its marriage plot, Valère is Tartuffe's rival for the hand of Mariane. It is to Valère that the final words of the play refer, stressing a way of life that prizes generosity and sincerity that is certainly opposed to Tartuffe's model, in both its sincerity and its secular leanings.[16] But the most plausible candidate and the name most frequently put forward as the *vrai dévot* of the play is of course Cléante himself. Yet critical opinions of Cléante diverge wildly, particularly with regard to his religious standing, and the principal reason for this is surely that he cannot be made to fit the *vrai-faux* model that is usually applied. Michael Hawcroft has recently summarized the different prevailing views of Cléante and his defense of devotion (83–85). Hawcroft notes that Molière needed Cléante to be someone who would "strike audiences as a sincerely and conventionally devout man of his times" and asserts that "most [critics] think that he does constitute the adequate defender of the play that Molière says he sought to make him" (83).[17] Hawcroft cites Calder, for whom Cléante "illustrates, through both the soundness of his arguments and the modesty of his behaviour, how a good and honest man should behave" (83–84), and Lawrence, who notes "how often the words of

Cléante resemble those of Christ: distrust of ostentatious devotion, forbearance before the sins of others, toleration of sinners but not sin, opposition to Tartuffe's hypocrisy as Christ opposed the Pharisees" (83). Hawcroft also mentions Scherer, who sees combined in Cléante human wisdom and a *dévot* who practices the Christian virtues of moderation, charity, and forgiveness (84), while Ferreyrolles, "who also sees Cléante as the representative of true religion in the play," is mentioned in a footnote (84n15). To this list, we might add, notably, John Cairncross, who writes emphatically, "Il y a en effet un chrétien modèle, mais il est seul. C'est Cléante"[18] (*There is indeed an exemplary Christian, but he is the only one. It is Cléante*).

But Hawcroft's lineup is in need of nuancing. In the case of Calder, for instance, a false analogy is drawn between qualities that most of us admire today and religious conviction. A "good and honest man" is not necessarily a man of religion; rather, those are qualities associated with the *honnête homme*. Lawrence and Scherer cast Cléante's qualities in a more religious light, but here too they are drawing on the false assumption that personal integrity is evidence of religious conviction. In particular, when Scherer calls Cléante "un dévot intelligent" (*an intelligent* dévot), he betrays his anachronistic approach to the question as well as his attempt to squeeze Cléante into a mold that does not fit.[19] Cairncross, whom Hawcroft does not cite at this juncture, goes on, revealingly, to qualify Cléante's supposedly exemplary form of Christianity with "Malheureusement, le christianisme qu'il professe approche dangeureusement du déisme" (896) (*Unfortunately, the Christianity that he professes is dangerously close to deism*). This is no mere detail; it is, from a seventeenth-century perspective, an entirely different form of morality.

A more subtle and accurate evaluation of Cléante's hypothetical status as a *vrai dévot* is given by Richard Parish, who points out, "Cléante does not in any respect constitute the positive correlative of which Tartuffe is the deformation; the 'true' Tartuffe would in all good faith be devoted to prayer, fasting, mortification of the flesh, chastity, almsgiving, and so forth. The counterpoint offered by Cléante represents an entirely false complementarity easily emptied of conviction; his recipe for *dévotion*. . . is spiritually insubstantial even in the context of the most urbane traditions of counter-reformation belief and practice."[20] If Cléante and Tartuffe are (dramatically) opposed, they are not (devotional) opposites.[21]

Some critics have tried to squeeze Cléante into the more flexible model of the Christian humanist, thereby retaining the *vrai/faux dévot* dichotomy *and* accounting for Cléante's undeniable humanist

tendencies. The most committed proponent of this view is Plantié, who casts Cléante as a follower of François de Sales. While it is true that de Sales in his best-selling *Introduction à la vie dévote* (first published in 1608 and reissued several times in the course of the seventeenth century) attempted to reconcile being in the world with religious devotion, it is also the case that "he still retains, in modified form, the Pauline antithesis of the world and God" and "his concessions serve only to palliate what is a predominantly Christian rather than humanist attitude to life" (McBride, *Sceptical* 69). And as Plantié herself admits, by the 1660s the tendency toward attempting to reconcile humanism and devotion was dwindling,[22] and Christians were faced instead with a starker choice between, broadly, rigorism on the one hand and laxism on the other (918).[23] This context may also shed light on one of the most famous lines of the play: "Ah! Pour être dévot, je n'en suis pas moins homme" (III.3.966) (*Ah! I may be a* dévot, *but I am still a man*),[24] which may not, as is usually understood, be evidence of hypocrisy so much as a gently satirical reference to a form of religion or religious practice that was no longer acceptable.

We noted in Chapter 3 a rejection of religious zealotry in both Cléante's outlook and that put forward by Le Moyne in his *La Dévotion aisée*. But where Le Moyne's explicit aim was to try to bring the lost and the hesitant back into the fold, Cléante seems to dispense with God and the Church altogether. Indeed, while Cléante is often praised for the emphasis he places on reason (and he is of course frequently labeled a *raisonneur*), the abbé de Gerard roundly rejects such an approach in a Christian context:

> Il n'y a rien de si dangereux pour la Religion que ces raisonneurs. C'est étre d'une presomption outrée de s'entêter sur des choses qui sont au de-là de la Raison, & c'est être d'une temerité indiscrete de preferer les lumieres de la terre aux lumieres du Ciel, & ainsi nous pouvons dire, que si souvent nous croions peu, c'est que pour l'ordinaire nous raisonnons trop.[25]

> *There is nothing more dangerous for religion than these* raisonneurs. *It is an outrageous presumption to obsess about things that are beyond Reason and impertinently inquisitive to prefer earthly insights to heavenly ones, and so we can claim that if we often lack belief, it is because we tend to reason too much.*

Cléante's morality is thus far removed from anything that Tartuffe is drawing on. Rather, he belongs in a different moral universe altogether.

Garaby de la Luzerne

In order to appreciate Molière's failure to oppose the *faux dévot* with his authentic, religious counterpart, one may compare his work with that of a close contemporary who also produced a satirical portrait of the *faux dévot*, which he would describe as "mon Tartuf, aisné de celuy de Molière de sept à huit ans" (Garaby, *Satires* 52) (*my Tartuffe, seven or eight years older than Molière's*). Garaby's *Les Pharisiens du temps ou le dévot hypocrite* was mentioned briefly in Chapter 3, where it was seen that his own portrait also combined elements of traditional religious hypocrisy (his *dévot* is a glutton and a sensualist, also a miser and a usurer) with religious zealotry (to the extent that he is ostentatious in his devotion and displays a far greater concern for the behavior of others than for his own). In contrast with Molière's play, Garaby's satire of the early 1660s was expected to reach only a limited audience in Normandy and above all to be read in private.[26] The extent to which its portrayal of religious zealotry-cum-hypocrisy is daring and provocative may be demonstrated, for instance, by the fact that at one point Garaby rhymes "dévotisme" (*dévotion*) with "puta[i]nisme" (*prostitution*) (*Satires* 62). Indeed, Garaby displays here, and even more so in some other of his writings, a scathing and deeply skeptical attitude toward religion that is far removed from anything that Molière would even hint at. If Molière was accused of being a freethinking *libertin*, that Garaby really was a freethinker (and provocateur) is in little doubt. In his *Sentiments Chrestiens* (1654), when writing on hypocrisy, Garaby takes the opportunity to comment that all strains of religion, whether sincere or otherwise, are at odds with common sense (or reason):

> Soient vrays ou faux, tous les Mysteres
> Ont cela de commun qu'aucun,
> Quoy que par maximes contraires,
> N'est bien avec le sens commun. (9)

> *Whether true or false, all the mysteries*
> *Have this fact in common: that none of them,*
> *While contradictory in terms of their maxims,*
> *Is reconcilable with common sense.*

While in the same work Garaby notes that all religions (he is probably referring only to different strains of Christianity, although it is just possible that he is also referring to Judaism and/or Islam) "s'accordent

en la confession d'une puissance souveraine gouvernante de toutes choses" (16) (*recognize a sovereign power that governs all things*), he also points out the problem inherent in the fact that "chaque Religion prend l'affirmative: se dit la vraye à l'exclusion de toute autre" (11) (*every religion affirms that it is right to the exclusion of all others*). Although Garaby was not alone in making them, such assertions are radical, for they strike at the heart of a society based on the notion that absolute truth (and truths) existed. Garaby then goes on to uphold the more innate virtue of the *honnête homme* in comparison with religious hypocrisy:

> L'honneste homme fait ce qu'il doit, & par ce motif seul qu'il le doit. Penses-tu, Hypocrite, que Dieu se soucie de ton exterieur feint, de ta posture de devot estudiée? qu'il aime plustost d'estre loüé en long qu'en court habit, en noir qu'en gris ou blanc? nenni. Il s'arreste aux coeurs; considere ta preud'hommie, & void si tu es homme de bien moral premier que traistre Chrestien, c'est à dire dementant la vertu que ta Religion te recommande. Autrement tu n'es qu'un pipeur, & ta fade pieté n'est que moquerie. (*Sentiments* 19)

> *The* honnête homme *does what is right and for the simple reason that it is right. Do you think, oh hypocrite, that God is concerned by your false appearance, your studied pretense of devotion? Do you think that he would rather be worshipped in a long (and not a short) gown, by someone dressed in black (and not in grey or white)? Not a bit of it. He is interested only in people's hearts. Consider your pomposity and see if you are first and foremost a good, moral man and not a Christian traitor who belies the virtue that your religion requires of you. If not, you are nothing more than a sham and your lukewarm piety is a travesty.*

What is implied here is that religion tends toward hypocrisy, whereas the *mondain* ethic of *honnêteté* tends toward a natural, instinctive morality.

Given the provocative and controversial nature of Garaby's views on religion and his clear preference for a form of morality centred around the individual man (rather than the indivisible God), it is all the more surprising that in *Les Pharisiens du temps ou le dévot hypocrite* he allows space—albeit only a few lines—for what appears to be authentic—even perhaps laudable—faith. Before embarking on his lengthy character assassination of the (*faux*) *dévot*, Garaby issues a disclaimer:

> Je n'entends pas dévot de ces gens sans cabale,[27]
> Qui, sur la preud'hommie appuyant leur morale,

Suivent tout simplement les loix que Jésus-Chrît,
Dans son saint Evangile à ses enfans prescrit. (*Satires* 52)

By dévot *I do not mean those who have not formed a cabal,*
And whose morality is grounded in their precepts,
Those who simply follow the laws that Jesus Christ
Prescribed to his followers in the holy Gospels.

And later on he complains about the fact that the *dévots* "estoufant toutefois la vertu la plus belle / Que Jesus Christ enseigne à son people fidelle, / J'entends la charité qui se doit au prochain" (54) (*stifle the most beautiful type of virtue that Jesus Christ taught his faithful flock, by which I mean the charity that we should show others*). For Garaby, the principles taught by Jesus Christ are indeed commendable, and the very act of naming Christ in the poem sets it in a rather different context from Molière's *Tartuffe* (from which, as will be seen, all direct references to God, Christ, or heaven are omitted). However, Garaby is scornful of organized religion, and his (admittedly lukewarm) praise for the Christlike believer is followed immediately by the biting observation that "ce monde là n'est bon, en ce temps de finesse, / Qu'à fournir d'auditeurs le Prône de la Messe" (*Satires* 52) (*in these sensitive times, such people are only good for listening to sermons*). If Christ's teachings are commendable in Garaby's eyes, something has gone seriously awry with his Church. The principal reason for this becomes clear later in the poem, when we read that "la Cabale y souscrit, par la seule raison / Que l'Eglise avec elle a tant de liaison" (53) (*the cabal subscribes to this for the simple reason that it is closely involved with the Church*). The message he conveys is that the Company of the Holy Sacrament is, thanks to the Church's complicity, contaminated and contaminating, while the Christlike believer is left listening sincerely but rather foolishly to a series of long, boring sermons.

A More Secular World

Where Garaby's attack on false devotion is thus considerably more biting than Molière's, the fact that he allows for the existence, albeit only slimly fleshed out, of the Christlike Christian renders it on that front at least less threatening than Molière's otherwise more anodyne play. This may in turn go some way toward explaining the conundrum of why *Tartuffe* was banned while *Le Festin de Pierre*, which features as its protagonist an avowed atheist who actively defies God and, worse still, whose ultimate sin is to feign a religious conversion, was only censored but never banned. The performance and especially

the publication history of *Le Festin de Pierre* is the most complicated of all Molière's plays, and a full account of it lies far beyond the scope of the present study.[28] The extent to which *Le Festin* was considered more or less threatening than *Tartuffe* is certainly debatable, as is the extent to which the *dévots* triumphed in their attempts (if such there were) to have the play banned. While one hesitates to pronounce on whether the fact that *Le Festin de Pierre* was given only a single performance run in Molière's lifetime indicates a triumph (or failure) for either the pro- or antitheatricalists, the simple fact that while the ban on public performances of *Tartuffe* remained firmly in place *Le Festin de Pierre* was performed 15 times at the Palais-Royal is surely telling.

Although Don Juan's blatant rebuttal of traditional Christian values and beliefs must, when taken at face value, have been extremely shocking for the broadly Christian theatre audience and even for some of its more *mondain* members, the play may in fact have more redeeming features than *Tartuffe*. It is true that Sganarelle's defense of Christianity is woefully inadequate, but Don Juan's (im)morality is not established in opposition to Sganarelle's but rather to that of the genuinely devout individual (notably in the shape of his father, Don Louis, and, to a lesser extent, the noble pauper who refuses to swear for money in III.2, and also Done Elvire). Ultimately, however, Don Juan meets his match when he meets his maker. Where, as we have seen, Cléante's series of named *dévots* are strikingly absent from *Tartuffe*, the audience at *Le Festin de Pierre* witnesses first the noble outrage (IV.4) and then the tender joy (V.1) of Don Louis in the face of his son's appalling behavior and subsequent (supposed) conversion. If Don Louis's rapture is in the event unfounded, it is no less an expression of the sincere elation felt by the father of the returning prodigal son. This is a world, then, in which Christianity exists and in which the struggle is a relatively clear-cut one between Christian and atheist, or God and the devil. Although Elvire's own repentance as expressed in IV.6 has led at least one critic to suggest that it might be a parody (see Chapter 3), for all its excess there is no reason to doubt the sincerity of Elvire's penitence or that of her wish that Don Juan also repent in order that his soul be saved.

Here too lies an important difference in relation to *Tartuffe*. For all its religious subject matter, the stakes of *Tartuffe* remain fundamentally terrestrial: Orgon runs the risk of losing his house, his family, and his reputation. And significantly, it is the king's representative (and not even the king himself), the *rex ex machina* and not the *deus ex machina*, who intervenes at the eleventh hour to set things right again. Similarly, the king intervenes in some very practical ways: by sending

Tartuffe to prison and by doing so just in time to prevent Orgon's house from being taken over by bailiffs. In *Le Festin de Pierre*, it is Don Juan's soul that is at stake, and Done Elvire is right to anticipate with dread "le cruel déplaisir de vous voir condamné à des supplices éternels" (IV.6) (*the cruel torment of seeing [you] condemned to eternal damnation*). This is a job for a *deus* (and just not a *rex*) *ex machina*, who intervenes by means of the statue who prompts the Don's rapid descent into the burning fires of hell, a scene that is described in vivid terms in a contemporary account of the stage machinery required for the play: "L'ombre entre, qui voyant qu'il persiste dans sa méchante inclination, le fait abîmer dans un gouffre, précédé des éclairs et du Tonnerre, tout le Théâtre paraît en feu" (Pléiade II, 1245) (*The specter enters and, upon seeing that he is persisting in his evil ways, plunges him into an abyss. There is thunder and lightning, and the whole stage appears to be on fire*).

Although it is not difficult to see why those susceptible to taking offense at theatrical portrayals of religion and/or atheism would not have liked the play, *Le Festin de Pierre* is no apology for *libertinage*. D'Aubignac's observation, cited in Chapters 1 and 3—that the play had caused considerable consternation among the pious and had not really pleased the others either—suggests as much and gives credence to the notion that an additional dimension at play may have been the portrayal of the *faux libertin*. The Don's punishment, however, represents above all a dramatic reassertion of Christian precepts and seems to indicate the welcome "truth" that God will always triumph. The story of *Tartuffe*, on the other hand, suggests something rather different.

It is ironic that in what he claimed were his attempts to render his play more acceptable to orthodox religion, Molière may in fact have achieved the opposite. In the second petition to the king, outlining the changes made between 1664 and 1667, Molière notes that he has "déguisé le Personnage sous l'ajustement d'un Homme du Monde" (Pléiade II, 193) (*disguised the character in the clothing of a man of the world*). The 1667 Tartuffe character, renamed Panulphe, now wears a small hat, a large wig, a large collar, a sword, and lace all over his coat (193); it is likely that his 1664 predecessor wore the reverse of this: the semiecclesiastical dress of the "petit collet" (*small collar*), commonly adopted by lay members of the *dévot* faction.[29] Whereas Tartuffe's costume in 1664 was sufficiently ecclesiastically reminiscent as to render comparison with the clergy plausible, Panulphe's 1667 costume is unequivocally secular and, with its copious lace and sword, evokes the aspiring bourgeoisie or minor nobility. Panulphe

thus becomes an imposter (as reflected in the new title of the play)—a layman claiming religious authority—rather than a more conventional religious hypocrite. While this choice softened the issue of religious hypocrisy among ecclesiastics or semiecclesiastics, it may have heightened its apparent condemnation of lay directors and of lay interference in matters spiritual, something with which the Company of the Holy Sacrament was, as we have seen, closely associated. More significantly, a secular Tartuffe-Panulphe also situates the play in a more secular universe. And as Tartuffe (both the person and the play) became more secular, they may both have become more insidiously threatening to a society that was still inextricably bound up in religious principles and structures.

As Couton reminds us, "le respect, même simplement extérieur, des lois de Dieu et de l'Eglise est déjà un certain hommage rendu à la sainteté de ses préceptes par les lâches qui n'ont pas le courage de les observer" ("Réflexions" 413) (*even when those cowards who do not have the courage to observe them appear to respect the laws of God and the Church, it is a tribute to the holiness of those precepts*). If Tartuffe is religious, then religion still exists—or, rather, if religious hypocrisy exists, then religion still exists. This is a point that had been made earlier in the seventeenth century by Jean-Pierre Camus, who, in his *Sermon sur l'hypocrisie* (published in 1615), enjoined his flock, "Soyez hypocrites!" (*Be hypocrites!*), since "plusieurs voulans contrefaire les deuots, le sont deuenus reellement & sainctement" (*many people in their attempts to feign devotion have become real and holy* dévots). He laments the fact that "la Vertu [est] si vilipendee, qu'à peine se trouue-il [quelqu'un] qui la veuille contrefaire"[30] (*virtue is so reviled that there is barely anybody who wants to imitate it*). Indeed, as Couton has shown, many seventeenth-century writers maintained that religious hypocrisy, while a sin, could still be of some marginal benefit, depending on the motive and the consequences ("Réflexions" 405, 413). And we have already seen that *faux dévots* are capable of good works, for that is an essential part of their disguise. It would seem, then, that a complete absence of religious hypocrisy would indicate an absence of religion. Tartuffe-Panulphe the imposter has not done away with religion entirely, but his new lay status dispenses with any immediate need for the Church, which in turn represents one dangerous step in the wrong direction.

Likewise, Molière also claimed later in his preface to have "retranché les termes consacrés, dont on aurait eu peine à lui [Tartuffe] entendre faire un mauvais usage" (Pléiade II, 93) (*cut out all the consecrated terms that would have been repugnant when misused by*

Tartuffe). But might not this also be precisely part of the problem? As Plantié notes, "'Dieu' is used only eleven times in the play and nearly always in expressions and formulae that are without religious signification" (926). "Le ciel," on the other hand, with its more neutral connotations, is used quite frequently.[31] It was of course widely understood that it was wholly inappropriate for God to feature in a comic drama. Indeed, this was something that even protheatricalists such as Chappuzeau and d'Aubignac did not dispute. Samuel Chappuzeau noted near the beginning of his *Théatre François* that God's name should never be pronounced in a laughable context and that playwrights should be especially vigilant in keeping it separate from comic drama and plays featuring love plots.[32] We know that Molière offended by writing a comedy that dealt with matters religious (his 1664 *Tartuffe*); it is possible that he in fact made matters worse by attempting to render that same comedy less offensive (his 1667 *L'Imposteur*) by eliminating (or at least reducing) all explicit usage of religious terminology. Molière conformed to the requirement that God be excluded from comic drama, but His absence may also do Him a disservice, particularly in a comedy as topical as this and one that is, by the standards of the day, so lifelike. Molière's onstage world is recognizably a comic version of that known to his theatre audience; if God is absent from one, might not the implication be that He is absent from the other as well?

Beyond the Play

Having noted the striking absence of *vrais dévots* (as well as *vraie dévotion* and God himself) from Molière's play, it should nevertheless be noted that Molière acknowledges their existence beyond the play world when he writes in his preface:

> C'est aux vrais Dévots que je veux partout me justifier sur la conduite de ma Comédie; et je les conjure . . . de ne point condamner les choses avant que de les voir; de se défaire de toute prévention, et de ne point servir la passion de ceux, dont les grimaces les déshonorent. (Pléiade II, 92)

> *It is* vrais dévots *everywhere whom I wish to convince of the innocence of my play; and I beseech them . . . not to condemn anything before seeing it, to rid themselves of all prejudice, and not to serve the fury of those who dishonor them with their grimacing.*

Molière appears to be seeking approval for his play not so much from Louis XIV (whose personal approval he appears always to have had) but particularly from influential *vrais dévots*, claiming that an appreciation of theatre is not incompatible with true devotion. And the playwright may genuinely have failed to see an incompatibility that had only relatively recently been sharpened in the tense climate of the Counterreformation during the post-Fronde era. Although antitheatrical Christian sentiment dates back at least as far as the Church Fathers, it is also the case that pious individuals such as Bossuet, who had deigned to visit the theatre earlier in the century, now felt obliged to condemn it. The 1660s was a decade of renewed antitheatrical sentiment, as evidenced most notably by the publication of Conti's *Traité de la comédie et des spectacles, selon la tradition de l'église* (1667) and Pierre Nicole's *Traité de la Comédie et des Spectacles* (1667). There is no doubt, then, that the theatre had become a touchstone for the broader debate regarding the reconcilability or not of a worldly existence and a religious one. Indeed, Nicole says as much in the opening sentence of his *Traité de la comédie*:

> Une des grandes marques de la corruption de ce siècle est le soin que l'on a pris de justifier la Comédie, et de la faire passer pour un divertissement qui se pouvait allier avec la dévotion. Les autres siècles étaient plus simples dans le bien et dans le mal . . . Mais le caractère de ce siècle est de prétendre allier ensemble la piété et l'esprit du monde. (Thirouin 32)
>
> *One of the great indicators of the corruption of our times is the care taken to justify the theatre and to claim that it is a form of entertainment that is compatible with devotion. In former times, the distinction between good and bad was clearer. But a characteristic of the current century is the wish to unite piety and worldly concerns.*

For Nicole, a would-be Christian's attitude toward the theatre reveals the extent to which he is able to perceive and act upon the fundamental difference between good and evil. Any individual attempting to reconcile a love of God with a love of the theatre is guilty of bringing two worlds together that should be kept apart. Theatre is no mere detail, then; it is evidence of where one sits on the sliding scale from *dévot* to *mondain* (or worse), something whose implications for Nicole and the converted Conti extended into the realm of personal salvation, no less.

Meanwhile, in a stroke of provocative genius, Molière in his 1669 preface places the *vrais dévots* who are at least potentially supportive of his play in opposition to those who oppose it (Pléiade II, 91–96). But to cast his opponents (most of whom appear to have been zealots rather than hypocrites) as Tartuffes, while rhetorically ingenious, clouds the issue, for to the extent that we can ever know, the play divided the *dévots* not into sincere believers and hypocrites but along other lines. The anti-Tartuffe faction was composed largely of antiworldly zealots (many of whom must have been sincere in their beliefs), while the pro-Tartuffe factions included those who genuinely saw no incompatibility between the theatre and their religious integrity and those who chose to overlook any such incompatibility, as well as those who were not religiously inclined at all. There were thus hypocrites and nonhypocrites on both sides of the divide. Between them sat the king, who for all his personal appreciation of the play was sufficiently politically astute to do what he could to avoid stirring up the troubled waters of contemporary religious controversy and tension.

THE *VÉRITABLE HOMME DE BIEN*

We have demonstrated that sincerity is not the principal issue at stake in the *Tartuffe* controversy; neither is it only a question of the position of worldly matters within a religious climate (or vice versa). While Molière's petitions and preface allow for the existence of true devotion (even if he comes dangerously close to equating this with approval of his play), we have seen that examples of it are sorely lacking in the play. We must ask ourselves in what moral universe this work in fact takes place. Returning to Molière's preface, we notice that, when alluding more specifically to Tartuffe's on-stage foil, Molière writes, significantly, not of a *vrai dévot*, but of a *véritable homme de bien* (*truly good man*) (Pléiade II, 92). The majority of critics have assumed that there exists either a complete overlap or a very close correspondence between the categories of *vrai dévot* and *véritable homme de bien* in Molière's discourse. But I would like to suggest that the designation *véritable homme de bien* denotes for Molière here a third category that may sometimes sit outside the *dévot* paradigm: *vrai* or *faux*. I also argue that it is in this slippage between a *vrai dévot* and a *véritable homme de bien* that we find a value judgment and the suggestion of an alternative worldview that was perhaps more threatening to the religious establishment than Molière's portrayal of religious hypocrisy or its own internal divisions. As with Molière's *vrai dévot* of the same preface, it is not stated explicitly to whom he is referring, but

the words "que je lui oppose" (Pléiade II, 92) (*to whom he is opposed*) in the second instance indicate that (in contrast with what I have argued regarding the absent, hypothetical *vrai dévot*) the *véritable homme de bien* does appear in the play. And the person in question must surely be Cléante, whose religiously ambiguous morality, which is "humaine" and "traitable" (see I.5.390) (*humane and flexible*), is here condoned by the playwright and singled out, albeit discreetly, as being something other than orthodox devotion. The slippage in this same paragraph of the preface, as Tartuffe is labeled first a hypocrite, in opposition to the hypothetical *vrai dévot*, then a *scélérat* (*villain*), and finally, when opposed to a *véritable homme de bien*, a *méchant homme* (*a bad man*), is also revealing. Although in his case it is clear that it is the same character that is being referred to in all instances, we note that he too comes to be described in terms that are more worldly than religious. A *méchant homme* is the opposite of an *honnête homme* (or here a *véritable homme de bien*), and he too sits outside a specifically religious paradigm. Molière's universe, then, is subtly slipping beyond one that is religious by default.

The respective connotations and ambiguities of the terms *dévot*, *homme de bien*, and *honnête homme* were discussed at the beginning of this chapter. If the *homme de bien* was by the 1660s generally conceived of in terms of a Christian morality, the same is not necessarily true of Molière's *véritable homme de bien*. It is possible that the crucial qualifier *véritable* is being used precisely to indicate that true, *véritable* morality lies (or can lie) beyond the ordinary *homme de bien* and possibly, therefore, outside a religious framework. Certainly this interpretation seems to be borne out in this instance by the fact that Tartuffe, the *faux dévot*, is pitted not against any genuine *vrai dévot* (who would be an *homme de bien*) but rather against Cléante, the *véritable homme de bien*. As was seen in Chapter 3, Cléante's morality is of a type more likely to appeal in an age in which tolerance and moderation are prized than at a time when society was still built on clear hierarchies, themselves founded on absolute truths. Alongside the famous and almost paradoxical notion of a form of devotion that is humane and flexible, Cléante's preferred type of morality as he professes it to Orgon is perhaps best summarized by the notion that its prononents' only concern is to live righteously (I.5.398). The notion of *bien vivre* alludes to a form of personal integrity within the context of social relations that is fundamentally secular, *honnête*, and unconcerned with higher matters. Similarly, if we judge Cléante not by his description of true devotion but by his own behavior in the play, we note that his attempts to intervene when the domestic affairs of the

household appear to be going awry (with regard not only to the character of Tartuffe but also to the related question of Orgon's choice of marriage partners for his children and Orgon's social reputation more generally), while commendable and perfectly reasonable, are in practice quite ineffectual.

Yet the use of the term *véritable* suggests that Cléante's morality is superior even to that of the conventional, religiously grounded *homme de bien*. The play, then, teaches us that piety does not necessarily equate with genuine goodness, for it may encompass the hypocritical zealotry of a Tartuffe and/or the sincere but misguided zealotry of Mme Pernelle or Orgon. In the absence of nonzealous devotion, Cléante's more unassuming morality, that of the *honnête homme*, is discreetly offered as an alternative both in the play and especially in Molière's preface. The opposition in this instance is not between good and bad devotion, but between good, moral, delicate secularism (the *véritable homme de bien* à la Cléante) and bad, immoral, vigorous religion (the *faux dévot* à la Tartuffe).

This notion that Cléante is the custodian of true morality is also put forward in the *Lettre sur la comédie de l'Imposteur* (1667), in which Cléante is described as both "un véritable honnête homme" and someone who promotes an "excellente morale" (Pléiade II, 1181) (*excellent moral code*). Whereas I have argued that there is a significant difference between the absent, hypothetical *vrai dévot* and the identifiable *véritable homme de bien* of Molière's preface, there appears to be an almost complete overlap between Molière's *véritable homme de bien* and the *véritable honnête homme* of the *Lettre*, not least because both are describing the same person, Cléante. Both are *véritables* in implicit opposition with some hypothetical non-*véritable* variety of *homme de bien*, and both are described in explicitly non-*dévot* terms. While Molière's *véritable homme de bien* allows greater scope for the existence of true morality among some orthodox Christians, the *véritable honnête homme* seems more radical in its secularity.

The author of the *Lettre* does engage briefly with the notion of devotion, when, having commented that Cléante's observations in I.5 are "des réflexions très solides sur les différences qui se rencontrent entre la véritable et la fausse vertu" (1174) (*some very solid reflections on the differences between real and false virtue*), he goes on to note how "le Frère de la Bru commence déjà à faire voir quelle est la véritable dévotion, par rapport à celle de M. Panulphe" (1171) (*the daughter-in-law's brother is already beginning to demonstrate what real devotion is, in comparison with that of Panulphe*). Yet here too we note first the use of the term *vertu* (*virtue*), which tends to denote a more

secular form of morality than Christian virtue, and the subsequent use of the qualifier *véritable* (and not *vraie*) when the word *dévotion* does appear. The suggestion is that the oxymoronic *véritable dévotion* being put forward in opposition to that of Tartuffe, as it is described in the *Lettre*, is not his exemplary opposite but rather something quite different. If Cléante's model is secular and tolerant, and if it is judged by Molière and by the author of the *Lettre* to be *véritable*, it is in contrast not only to Tartuffe's hypocritical form of religious devotion but also to any truly authentic examples of religious devotion (of which, as we have seen, there appear to be none in the play). Crucially, then, it is in comparison not only with the *faux dévot* that the *vrai dévot* suffers, but also with the *véritable homme de bien*.

My reading of the slippage between a *vrai dévot* and a *véritable homme de bien* in the *Tartuffe* controversy is supported by an examination of definitions of the terms in seventeenth-century dictionaries. In both Furetière's dictionary and that of the Académie Française, the terms *dévot* and *dévotion* are, as one would expect, defined within a religious context.[33] Significantly, in both dictionaries, the word *véritable* is given a wholly secular context. In Furetière, the first example after the definition of *véritable* as "qui est vray, qui dit verité" (*that which is true, that which is truthful*) is "Un *véritable* homme d'honneur tient sa parole" (*A true man of honor keeps his word*), while in the *Dictionnaire de l'Académie Françoise* we find "Un homme est véritable dans ses paroles" (*A man is true in what he says*). Furetière's "véritable homme d'honneur" (*true man of honor*) is thus closely aligned with Molière's "véritable homme de bien" (*truly good man*) and the *Lettre's* "véritable honnête homme" (*true* honnête homme). None of them has anything to do with going to church or even, it would seem, with God. But all are associated with telling the truth. We find similar nuances in Richelet's dictionary (he includes among his definitions of *dévotion* a secular form of personal devotion toward another individual, but only after devotion to God and the saints).[34] These are of course the same dictionaries in which the word *dévot* is tainted by the notion of the *faux dévot*, with Tartuffe as its primary example, and in that sense, Molière's enemies were right to fear the corruption of the *vrai* by the *faux*.[35] But what is most threatening of all is the underlying, if subtle, sense that there is a closer alignment in the dictionaries between secularism and truth than between devotion and truth—and a closer alignment in Molière's preface and in the *Lettre* between secularism and morality than between religion and morality. This being the case, it is no wonder that *Tartuffe* was (and continued to be, even after the ban was lifted) felt so threatening in certain religious circles.[36]

Molière uses the term *véritable* on two other occasions during the *Tartuffe* controversy. The first (which comes chronologically before the example we have just examined) is in the second petition to the king in 1667. Here the playwright laments the fact that "les Gens que je peins dans ma Comédie" (*the people whom [he has] portrayed in [his] comedy*) have succeeded in taking in "de véritables Gens de bien, qui sont d'autant plus prompts à se laisser tromper, qu'ils jugent d'autrui par eux-mêmes" (Pléiade II, 194) (*truly good people, who are all the more inclined to be taken in because they judge others by their own standards*). This seems to be a reference to Lamoignon, president of the Parisian *parlement*, who had, in the king's absence, just put the ban back in place after a single performance of the revamped *L'Imposteur*. We know from the Boileau-Brossette correspondence (see also Chapter 5) that Molière had met with Lamoignon to discuss the matter, and it is plausible to think that Molière is sincere in describing him as a *véritable homme de bien*. Lamoignon's is a particularly interesting case, for he had been a keen member of the Company of the Holy Sacrament but had needed to side with Mazarin and the young Louis XIV in 1660 when all such secret societies were banned. He was, then, a *dévot*, sincere as far as we know, zealous yet reasonable where some of his *dévot* colleagues were not. With this information in mind, the distinction that Molière appears to be drawing in this instance is between the uncompromising zealots of the now banned Company and the more measured attitude of Lamoignon, who is, nonetheless, still closely linked to these (mainly sincere) zealots whom Molière insists on likening to Tartuffe. Here too, then, the *véritable*-ness is about moral integrity and a lack of misplaced zealotry rather than sincerity of belief.

The other example, this time in the preface, appears also to refer to Lamoignon and his ilk. Here Molière laments the fact that the hypocrites have managed to "jeter dans leur parti de véritables Gens de bien, dont ils préviennent la bonne foi, et qui par la chaleur qu'ils ont pour les intérêts du Ciel, sont faciles à recevoir les impressions qu'on veut leur donner" (Pléiade II, 92) (*enlist to their cause some truly good people, prejudicing the good faith of these people whose enthusiasm for heaven's best interests makes them very impressionable*). These individuals are taken in owing to their religious convictions, and it is their very integrity that makes them naïve and vulnerable to the influence of Molière's hypocrites. So in the case of Lamoignon, the *véritables gens de bien* are opposed to the anti-Tartuffian *dévots* who are labeled *faux dévots* or *hypocrites* or *Tartuffes* not because they are necessarily insincere but because their zealotry is perceived as being misplaced.

Conclusion

Returning to the questions with which we began, my contention is that in his preface Molière briefly compares his hypocrite, Tartuffe, with a hypothetical *vrai dévot*. I have argued that there are no *vrais dévots* in Molière's *Tartuffe* and that those who are named in passing and whose function, according to the *Lettre sur la comédie de l'Imposteur*, is to counter this very charge serve in practice only to underline their absence from the play world and an absence of authentic Christianity and even of God in the play (and perhaps, therefore, beyond). This appears to have been particularly the case in the 1667 version of the play, in which Tartuffe is recast as Panulphe and given a more secular identity (whereas the 1669 Tartuffe is more like the 1664 original). Although it was notoriously difficult for an authentic *dévot* to make his presence felt onstage or off given that he was expected to be discreet and modest, the slippage between Molière's absent *vrai dévot* and the description of Cléante as a *véritable homme de bien* in Molière's preface (alongside Molière's description of Tartuffe first as a *hypocrite* and then as a *méchant homme*) hints at a worldview that discreetly challenges religion's monopoly on morality at a time when the Church was striving to tighten her grip on it. Mme Pernelle's complaint to Cléante—namely, "Sans cesse vous prêchez des Maximes de vivre, / Qui par d'honnêtes Gens, ne se doivent point suivre" (I.1.37–8) (*You are constantly preaching the kind of principles that should not be followed by good folk*)—is thus more perceptive than it may first appear: The use of the verb *prêcher* (*to preach*) indicates that Cléante is, in her view, putting forward an alternative to the Christian-based teaching of her preferred preachers, while the description of the content of his "sermons" as "Maximes de vivre" suggest, not inaccurately, that he is more concerned with a facile view of how to lead one's daily terrestrial life than with anything that might go beyond it. While the extent to which her conception of *honnêtes gens* is Christian is debatable, Pernelle is right also to observe that Cléante's morality is very different from her own. Commenting on this opening scene, Pommier observes that "on sent que deux morales, deux conceptions de la vie s'opposent ici, celle austère et rigoriste de Madame Pernelle et celle beaucoup plus souple et beaucoup plus tolérante de ceux qui sont en face d'elle" (27) (*we sense two forms of morality, two opposing conceptions of life, here: Mme Pernelle's austere and rigorist approach and the far more supple and tolerant morality of those who are opposed to her*). Meanwhile, in Garaby de la Luzerne's satire, we saw that the *vrais dévots* still had their place, in church, even if Garaby himself had little

time for them. But while Molière's minority group, which he labels the *véritables gens de bien*, can be *dévots*, they are, if so, liable to be duped by ill-advised zealots (as is the case for Lamoignon, according to Molière). Meanwhile, the fact that the *véritable homme de bien* with the most integrity remains the fictional Cléante, who calls for moderation, for a form of devotion that is not *dévot* at all but *humaine* and *traitable*, and whose interventions in the play are largely ineffectual, is, I believe, more discreetly but ultimately more profoundly threatening than Orgon's blindness or Tartuffe's imposture. The real scandal of *Tartuffe* is not that the Church might include religious hypocrites (for that was a widely known, if unwelcome, fact) or even that their portrayal on stage would inevitably tarnish the reputation of sincere Christians in real life; rather, it is, above all, that genuine goodness might be beginning to escape the confines of the Church and that the type of morality being proposed, while externally similar to that professed by Christians, was of a fundamentally different variety.

CHAPTER 5

THE STRUGGLE FOR INFLUENCE
II. *TARTUFFE* IN AN AGE OF ABSOLUTISM

It was seen in Chapter 1 that the newly incumbent Louis XIV was faced with a number of potential threats to the stability of his country and a number of fronts on which he would seek to assert his kingly authority. Above all, Louis had to avoid what was understood to be a genuine threat of schism within the Church. Although the Jansenist controversy and the *Tartuffe* controversy are not one and the same, they are intimately bound up in chronology and context and, crucially, to the extent that one needed to be resolved before the other could be. For, as will be seen, the crucial moments in the unraveling and subsequent resolution of the Jansenist controversy in the 1660s coincide almost exactly with the unraveling and subsequent resolution of the *Tartuffe* affair. The two controversies also involved two of the same protagonists: the Archbishop of Paris, Péréfixe, and Louis XIV himself. According to Salomon, Bazin was probably the first critic (in 1848) to note the relationship between the Peace of the Church and the lifting of the ban on *Tartuffe*.[1] In *Molière et le roi*, Rey himself has more recently and for the most part very convincingly pushed the link further than anybody else. While my own reading is indebted to Rey's, my emphasis is on interpreting those events via the notion of what I have called throughout this book the struggle for influence in the early reign of Louis XIV. I shall suggest not only that *Tartuffe* became entangled in some of the most pressing matters of state in 1660s France but also that it became in and of itself a matter of state, a locus for a power struggle between competing factions and, for some, perhaps, a symbol of resistance. The vital role played by the notorious former *frondeur* and rebel Condé in the *Tartuffe* controversy

is particularly interesting in this regard. For, although overstated, E. Thierry's suggestion, warmly recalled by Coquelin, whereby Condé, "n'ayant plus de champs de bataille, gardait le théâtre pour y décider encore la victoire" (Coquelin 6) (*having no more battle fields, held on to the theatre as the place where the war might still be won*), is not entirely void of truth and will be given due consideration in the forthcoming discussion.

In our chronological account, we must begin with the Company of the Holy Sacrament. The fact that the society, which was now illegal and, in Paris at least, barely functional, chose Molière's *Tartuffe* as one of its rare projects speaks tellingly of the significance of the play and of the symbolic capital that it would rapidly accrue.[2] As indicated in Chapter 1, the first recorded mention of *Tartuffe* is not in any theatrical or courtly source but rather in a note in the records of the Company, dated April 17, 1664, indicating that the society would endeavor to prevent the play from being produced.[3] Even before its first performance, then, *Tartuffe* was a testing ground for the dwindling power of a committed and fanatical religious group that, we believe, yet enjoyed the support of such powerful people as the Queen Mother (who was not a member) and Conti (who was). The account in the *Annales* reads as follows:

> On parla fort ce jour-là de travailler à procurer la suppression de la méchante comédie de *Tartuffe*. Chacun se chargea d'en parler à ses amis qui avoient quelque credit à la Cour pour empêcher sa représentation, et en effet elle fut différée assez longtemps, mais enfin le mauvais esprit du monde triompha de tous les soins et de toute la résistance de la solide piété en faveur de l'auteur libertin de cette pièce, qui sans doute a été puni de toutes ses impiétés par une très malheureuse fin. (*Annales* 231)
>
> *That day we spoke eagerly about obtaining a ban on the pernicious play* Tartuffe. *Each one took it upon himself to speak to any influential contacts he might have at court in order to prevent the play from being performed. Indeed, it was postponed for quite some time, but eventually the harmful spirit of the world triumphed over all the care and resistance of a solid piety in favor of the libertine author of the play, who no doubt was punished for all his impiety when he met a very sticky end.*

We note that the failure of their mission is expressed in terms of a failure of piety to triumph over the harmful spirit of the world—but also that the (divine) punishment meted out to the libertine playwright (who, of course, was taken ill onstage in 1673 and died without

receiving the last rites) indicates an ongoing belief that God will triumph in the end.[4]

The Jansenist controversy, meanwhile, may be traced back to the posthumous publication of Jansen's *Augustinus* in 1640 and its subsequent proscription by the pope in 1643 on the basis that it violated a papal ban on discussions relating to the thorny question of grace.[5] Theological debates about grace sat at the heart of the conflict between Protestants and Catholics in particular, and silence on the matter was seen to be crucial in maintaining unity within the Catholic Church at this delicate time of reform and renewal. The matter prompted much theological wrangling in France, fueled by Pope Innocent X's bull *Cum Occasione*, published in 1653 and received at the Sorbonne in 1657, in which he condemned five propositions from *Augustinus* as heretical. Throughout the 1650s, a series of individuals, some more prominent than others, spoke out by submitting theses, treatises, or other publications in support or condemnation of *Augustinus*. Its supporters became known as Jansenists. Although the matter appears at first sight to have been theological, its political dimension was inescapable for at least two reasons. The first is neatly set out by Daniella Kostroun in the following terms:

> Coinciding with the political upheaval of the Fronde, the conflict at the Sorbonne [over *Augustinus*] prompted the regency government to regard Jansen's supporters, many of whom were also supporters of Cardinal de Retz (Archbishop of Paris, 1654–62)[6] as factious agitators set out to undermine the French church from within. When Louis XIV came to power in 1661, he maintained the regency government's profound animosity toward the so-called Jansenists and, with the encouragement of his Jesuit confessors, made it his priority to drive them out of France. ("Formula" 491)

For all their alleged links with prominent *frondeurs* (many of which in fact dated from after the Fronde), the associates of Port-Royal, where the majority of so-called Jansenists were based, were no rebels in any ordinary sense of the term. Certainly, they considered themselves to be obedient and faithful Christians. Yet their relationship with authority, and in particular with what might be termed "absolute" authority, was an intricate one, and one that would prove to be incompatible with Louis's incipient absolutism (and, indeed, with papal or even ecclesiastical absolutism). In that sense, the Jansenists were at this point, as our examination of Louis's *Mémoires* suggested, more threatening to the unity of France than the Protestants.

On the same day that Louis XIV passed the writ banning secret societies and heralding the demise of the Company of the Holy Sacrament, he also met with representatives from the Assembly of Clergy to inform them of his wish to tackle Jansenism (Tallon 22). Then, on April 29, 1661, one of Louis's first acts of personal rule was to issue a decree requiring that all French clergy sign the formulary drawn up in 1657 condemning the five propositions taken from Jansen's *Augustinus*. As Kostroun puts it, "this request for signatures marked the most invasive attempt by the Bourbon monarchs to regulate their subjects' consciences and to rival the Church as a mediator with God" (*Feminism* 105). It also marked a shift in emphasis away from matters doctrinal in favor of a debate regarding the complex relationship between authority, obedience, and an individual's own conscience. Sedgwick summarizes the dilemma faced by the Jansenists in April 1661: "The dictates of conscience had to be weighted against fear of schism. All those known as Jansenists regarded themselves as true Catholics, obedient to the Church. But in their minds the immediate question was whether there were limits to its authority. The issue was particularly sensitive because the authority of the Church was strongly backed by that of a king who did not tolerate opposition" (108). As far as Louis XIV was concerned, the fear of schism weighed most heavily. But while he could legitimately demand outward obedience from all his subjects, he soon discovered that he could not demand that every individual conscience submit to his will.

In the course of their multiple attempts at resolving the conundrum in order that all Jansenists fulfill the papo-monarchical demand that they sign the formulary, both sides drew on an ingenious distinction between *droit*, which was a matter of faith concerned with doctrine and discipline, and *fait*, which was a matter of fact concerned with people and books. The Church was considered infallible in matters of faith, which emanated from divine law, but not in matters of fact, which depended on fallible human beings. While this intricate distinction allowed some individuals to sign with mental reservations and others to sign with written caveats, it failed at this point to resolve the matter when it was subsequently required that all signatures be entirely free from qualification.

On the one hand, then, religion afforded the young Louis considerable support in his efforts to calm and unite his country around the central figure of the monarch: Louis relied on a reciprocal relationship with the Church for his monarchical legitimacy and understood the imperative that he avoid a schism. Yet at the same time that organized religion was a source of legitimation, it was also a source of

contestation, to the extent that the efforts of, notably, the Company of the Holy Sacrament to subvert conventional hierarchies and power structures (owing to their unconventional methods of intervention) represented a threat to would-be absolute monarchy. Similarly, while there could not have been any groups less likely to take up arms against the crown than those associated with Port-Royal, they represented a more insidious threat to a monarch who demanded absolute submission, and their invocation of matters that by definition must finally remain between an individual's conscience and God alone represented an intriguing and insurmountable area of resistance. Louis thus found himself in an impossible situation, caught between the need to avoid schism and that of imposing his will on all his subjects.

First Stage: 1664

The Ban

The courtly context in which Molière's *Tartuffe* was given its first performance, on May 12, 1664, was discussed in Chapter 2. The precise nature of the negotiations that led to a ban on public performances of the play is, along with the names of the individuals involved, beyond that of Louis XIV himself—uncertain. We know that the Parisian division of the Company of the Holy Sacrament campaigned for a ban on performances of *Tartuffe* and that it took some credit for having maintained a ban for several years. The majority of critics agree that its members played some part in persuading Louis XIV to issue his injunction against the play, although the degree to which the Company can justifiably take responsibility for it is debatable. In the same way that Molière's satirical portrayal of *dévot* behavior in *Tartuffe* cannot be aligned with a single, identifiable group, be it the Company, the Jansenists, or the Jesuits, so also is it the case that the pressure brought to bear on the young king cannot be linked with a single group. The possibility that members of the Company and other outraged *dévots* put pressure on Anne of Austria to support a ban (or even that Anne herself was the driving force behind it) has often been put forward. Certainly a case could be made for *Tartuffe* falling into the category of plays that could cause scandal or run counter to good morals and that were condemned by her theological advisors at the same time that the theatre itself was considered an innocent diversion (see Chapter 1). But we saw, too, that during the *querelle de L'Ecole des femmes*, the Queen Mother agreed to have *La Critique de l'Ecole des femmes* dedicated to her. If Anne of Austria was indeed in favor

of a ban on the play, it would have been for much the same reasons that her son agreed to one: namely, to avoid rocking the *dévot* boat at a time when the unity of the Church was very precarious, and not because she considered the play to be inherently immoral. The problem with the play was that it was controversial, not that the controversy was justified.

Archbishop Péréfixe's stunning intervention in the *Tartuffe* controversy in 1667 in the form of his extraordinarily heavy-handed *ordonnance* is well known and will be discussed in what follows. However, there is good reason to think that Péréfixe played a greater part in the original ban in 1664 than is usually attributed to him. Brossette notes that it was Péréfixe who convinced the king of the need for a ban on *Tartuffe*: "M. de Péréfixe, archevêque de Paris, se mit à leur tête [de la cabale des dévots], et parla au Roy contre cette comédie. Le Roy, pressé là-dessus à diverses reprises, dit à Molière qu'il ne falloit pas irriter les dévots qui étoient gens implacables" (*Correspondance* 563) (*Péréfixe, Archbishop of Paris, appointed himself leader of the cabal and spoke out against the play to the king. The king, pressed on the matter on several occsions, told Molière that he should not aggravate the* dévots, *who were a ruthless lot*). This is confirmed by a report in the *Annales* of the Company of the Holy Sacrament detailing a meeting that took place on May 27, 1664, in which "on rapporta que le roi, bien informé par M. de Péréfixe, archevêque de Paris, des mauvais effets que pouvoit produire la comédie de *Tartuffe*, l'avoit absolument défendue" (*Annales* 232) (*it was reported that the king, who had been informed by Péréfixe, Archbishop of Paris, of the pernicious effects that the play* Tartuffe *could have, had banned it completely*). Whether or not Péréfixe acted as an intermediary for the *dévots* from the Company or for the *dévots* more generally, or whether he was acting simply in his capacity as the newly incumbent Archbishop of Paris and member of the king's Council of Conscience is less important than the idea that one should not aggravate the *dévots* and the question of the pernicious effects that the play could allegedly produce. Given that the Company of the Holy Sacrament was officially disbanded (and unofficially dwindling), the *dévots* that one should not provoke would appear to be of a broader kind. In the reported conversation between king and playwright, Louis does not pass any judgment on the form or content of Molière's play; rather, he explains to the playwright the reasons why the ban must remain in place. Similarly, the pernicious effects invoked by Péréfixe may refer not only to those that would be stirred up among audience members viewing the play itself but also to those that would result within *dévot* circles were the play to be

performed in public. In Chapters 2 and 4, we examined the dangers of allowing true and false devotion to become confused in the minds of Molière's theatre audience; here we are more concerned with the dangers of a potential outcry within religious circles in response to the public performance of *Tartuffe*. Louis's ban, then, represented not his condemnation of the play but rather his political shrewdness during this period of high religious tension.

The significance of the politico-religious context, and specifically of the Jansenist controversy, in the king's decision to ban the play is made clear in the way that the event was reported in the *Gazette* on May 17, 1664. Indeed, the first mention of *Tartuffe* in the *Gazette* is not even to describe the play or its first performance but simply to praise Louis XIV for banning it.[7] Moreover, the main thrust of this article is concerned with the recent edict aimed at forcing the Jansenists to submit to papal and kingly authority once and for all:

> Cette semaine, on a ici publié l'Edit vérifié au Parlement le 29 du Passé, le Roy y tenant son Lit de Justice: par lequel Sa Majesté ordonne . . . que les Bulles . . . qui condamnent les cinq Propositions tirées du Livre de Ianssénius, seront publiées par tout le Royaume, & enjoint à tous Ecclésiastiques, Séculiers & Réguliers, de signer le Formulaire qui fut dressé le 17 Mars 1657, par l'Assemblée générale du Clergé de France, ainsi qu'il est plus amplement porté par cet Edit: qui montre combien ce Grand Monarque est soigneux de retrancher toutes semences de division dãs l'Eglise, & qu'aucun de ses Prédécesseurs n'en porta jamais plus glorieusement le Titre de Fils Ainé, qu'il le soutient par cette delicatesse qu'il témoigne pour tout ce qui la regarde, comme il le fit encor voir n'aguéres, par ses défenses de représenter vne Piéce de Théatre intitulée l'*Hypocrite*,[8] que Sa Majesté, pleinement éclairée en toutes choses, jugea absolument injurieuse à la Religion, & capable de prodüire de tres-dangereux effets.[9]

> *This week we published an edict verified in the Parlement on the 29th of last month. There the king held his Bed of Justice, in which he decreed that the bulls condemning the five propositions taken from Jansen's book be published across the kingdom; he enjoined all ecclesiastics, both secular and regular, to sign the formulary drawn up on March 17, 1657, by the Assembly General of the French Clergy as it is amplified in this edict, all of which shows the extent to which the king is at pains to remove any seed of division within the Church and that none of his predecessors ever bore more gloriously the title of its eldest child. We witness the sensitivity that he displays toward anything to do with the Church, as we saw recently in the case of a play called* The Hypocrite, *which His Majesty, highly perceptive*

in all matters, judged to be an insult to religion and capable of producing some very dangerous consequences.

Louis XIV's motive for passing what has been described as "the strongest edict yet against Jansenism" (Kostroun, *Feminism* 142) is clearly stated here as being the wish to eliminate all potential sources of division within the Church. The king's commitment to the Church and his fulfillment of his title of eldest son thereof is further exemplified by his ban on *Tartuffe* (referred to here as *L'Hypocrite*). That the two events are closely linked is abundantly clear from the way they are presented.

It has been widely understood that the elements of the play that allegedly render it an insult to religion are the same that make it capable of producing some very dangerous consequences and that both have to do with the infamous distinction (or lack thereof) between true and false devotion as well as the simple fact of portraying religious hypocrisy on stage. Although it is certain that a number of his *dévot* contemporaries did consider the play to be an insult to religion for those reasons, it is unlikely that Louis XIV himself did, and the *Gazette's* account is usually understood to be disingenuous on this particular point. But might not the term *injurieuse* (*insulting* or *an insult*) be taken in the sense of a broader threat in the same way that the dangerous consequences that follow might refer at least as much to the dangers of further controversy between religious parties with regard to their respective views on *Tartuffe* as to the dangers inherent in the play itself? If so, the account is more faithful to what we understand to have been Louis's view than it first appears. The long-term threat to the Church of the exposure of hypocrisy within its ranks was not negligible, but it was the suggestion of alternative worldviews that the Church would find infinitely more troublesome. What Louis XIV needed to avoid more than anything else in 1664 was not the exposure and propagation of the possibility that there might be hypocrites within the ranks of professed *dévots* (which would hardly constitute news, in any case) or even the confusion of external manifestations of devotion in the minds of the Parisian theatre audience; rather, he needed to keep a lid on the tensions and wranglings that were bubbling among devotees of the French Church itself. In other words, Louis needed to minimize controversy.

This is not to say that this was not a difficult decision for the king to take. It is not clear from Brossette's aforementioned account of how the king was pressed on the matter on several occasions whether or not this was by Péréfixe or Molière (or both). Certainly we know

that Molière would petition the king repeatedly on the matter for as long as the ban remained in place, and Loret's *Lettre en vers* of May 24, 1664, speaks of the playwright's multiple trips to Fontainebleau (where the court was now stationed) to appeal to the king:

> Toutefois, un Quidan m'écrit
> (Et ce Quidan a bon esprit)
> Que le Comédien Molière,
> Dont la Muze n'est point asniére,
> Avoit fait quelque plainte au Roy,
> Sans m'expliquer trop bien pourquoy,
> Sinon que sur son *Hypocrite*,
> Piéce, dit-on, de grand mérite,
> Et trés-fort au gré de la Cour,
> Maint Censeur daube nuit et jour.
> Afin de repousser l'outrage,
> Il a fait coup sur coup voyage,
> Et le bon droit reprézenté
> De son travail persecuté.
> Mais de cette plainte susdite
> N'ayant pas sceu la réussite,
> Je veux encor être en ce cas
> Disciple de Pithagoras,
> Et sur un tel sujet me taire,
> Ne sçachant le fonds de l'afaire,
> Qu'on poura dire en temps et lieu.[10]

> *Somebody wrote to me*
> *(And this somebody has a good head)*
> *To say that the actor, Molière,*
> *Whose muse is not stupid,*
> *Had complained to the king*
> *But did not really tell me why*
> *Except that his* Hypocrite,
> *A play said to be of great merit*
> *And very well received at court,*
> *Is constantly sneered at by the censors.*
> *In order to drive away the insult,*
> *He has made several journeys*
> *In order to defend*
> *His persecuted work.*
> *But with regard to this complaint,*
> *Not knowing the result,*
> *I want to remain in this instance*
> *A disciple of Pythagorus*

And be silent on the matter,
Not knowing the details
That I may learn in due course.

Loret is no lobbyist, but he represents another take on the affair: broadly, that of *mondain* society, which evidently shared some of Molière's frustration with the suppression of a play that had been well received by most of the French court. While the *Gazette* was an official publication, Loret's *Lettre en vers* was permitted more freedom to put forward alternative positions that were no doubt also known to (and perhaps even, in some ways, shared by) the king. We note that the king is not mentioned directly and that the ban is attributed only to a number of censors. Where the *Gazette* credits Louis XIV with the ban, Loret tactfully absolves him from it. His support of Molière in the face of his "persecution" is not provocative as such, but it does represent a useful reminder of the fact that Molière was not alone among the French in wanting the ban to be lifted and in failing to understand if (and why) it needed to be introduced in the first place.

Cardinal Chigi

Meanwhile, we know that Molière subsequently took *Tartuffe* to a number of private residences, where his troupe read or performed the play. One particularly interesting example of a projected reading of the play brings another area of religious controversy into the equation, in the shape of France's relations with Rome. The relationship between the Vatican and the Gallican Church was strained, owing to France's wish for further independence from Rome and to an ongoing power struggle between the various popes and Louis XIV for authority over the French clergy.[11] The pope's claims of infallibility were regarded with deep suspicion in France, as they were understood to be in conflict with Louis XIV's own aspirations to absolutism.[12] However, Louis and the popes shared a common cause in their condemnation of Jansenism, and this in turn led each party at different points to invoke the other's authority when expedient. During the Jansenist controversy in 1664, for instance, Louis XIV wrote to the pope to ask him to demand that the formulary be signed. In so doing, Louis was accepting papal jurisdiction over his subjects. In February 1665, the pope duly issued the bull *Regiminis apostolici* and, when faced with four rebellious French bishops, expected to judge them on his authority alone. Louis eventually had to give in to his own logic, though the judgment was never completed, owing to Pope Alexander VII's

death (Phillips, *Church and Culture* 108–9). The balance of power and professed power between the two of them at different moments in this matter was intriguing, to say the least.[13] Most of the time things remained tense. In order, ostensibly, to ease the ongoing tensions with the pope, Louis XIV had sent the duc de Créqui to Rome in June 1662, charged, among other things, with winning over the pope's nephew, Cardinal Chigi. In August 1662, a series of major clashes took place between Créqui's French retainers and the local Corsican guards, and on August 20 the guards attacked Créqui's wife's carriage, killing one of her pages, before going on to besiege the French embassy and even firing at the ambassador himself. When news of this reached Louis XIV, he was enraged. The papal nuncio (one Piccolomini)[14] was promptly expelled from Paris, and a long, drawn-out set of recriminations, attempts at settling scores, and negotiations ensued.[15] In a treaty signed in Pisa on February 12, 1664, Louis obtained a number of measures he wanted from Pope Alexander VII, including the promise of a visit from a nuncio extraordinary bearing the pope's excuses. That summer, the pope's nephew, Cardinal Flavio Chigi, duly came to France to present the papal apologies.[16] Chigi's disembarkation at Marseille coincided almost exactly with the première of Molière's *Tartuffe*.[17]

It is a well-known fact that Molière invokes Chigi in his first petition to Louis XIV, reminding the king of "l'approbation encore de Monsieur le Légat, et de la plus grande partie de nos Prélats" (*the approval of the legate and of the great majority of [our] prelates*), and of the "lectures particulières que je leur ai faites de mon Ouvrage" (Pléiade II, 192) (*the private readings that [he had] given them of [his] work*). Indeed, Chigi's alleged approval of *Tartuffe* is mocked by Rochemont, in his *Observations sur une comédie de Moli*ère, who writes that "L'Italie a des vices et des libertés que la France ignore . . . il semble à l'entendre parler qu'il [Molière] ait un Bref particulier du Pape pour jouer des Pièces ridicules, et que Monsieur le Légat ne soit venu en France, que pour leur donner son approbation" (1216) (*Italy has vices and liberties of which France is unaware. From hearing him speak, it would seem that Molière has a personal papal brief to perform ridiculous plays and that the legate has come to France just to approve them*). In the *Lettre sur les observations d'une comédie du sieur Molière, intitulée "Le Festin de Pierre,"* meanwhile, Molière's supporter comments on Rochemont's attempts at using Chigi to discredit the playwright: "Comme il [Rochemont] n'ignore pas qu'il [le Légat] a ouï lire *le Tartufle*, et qu'il ne l'a point regardé d'un œil de faux dévot, il se venge, et l'attaque en faisant semblant de ne parler

qu'à Molière" (1233) (*Since Rochemont knows that the legate heard a reading of* Tartuffe *and that he did not respond to it as a* faux dévot *would, he is taking his revenge and attacking the legate by pretending to attack only Molière*). In view of Molière's claims, it is hardly surprising that the majority of critics, contemporary and modern, have surmised that the playwright did indeed perform (or read) the play to Chigi during his visit. However, this turns out not to have been the case.

Chigi was received by the king in Fontainebleau between July 28 and August 9, 1664. During this period, four theatre troupes were present at the château: the Spanish and Italian troupes as well as those of the Hôtel de Bourgogne and the Palais-Royal (i.e., Molière's troupe). We know that Chigi saw at least one performance of *La Princesse d'Elide*; the first performance of Corneille's tragedy, *Othon*; and two Italian premieres, one of which may have been the famously scurrilous *Scaramouche ermite*. However, there is no compelling evidence that Molière read *Tartuffe* to the legate or to any of his associates in Fontainebleau. Rather, plans were put in place for Chigi to hear a private reading of the play in Paris at the Palais Mazarin on the evening of August 9 after his triumphal entry into the city. In a letter to Hugues de Lionne written that day, the marquis de Bonneuil, who was accompanying Chigi on his travels, reported:

> Nous avions pris heure ce soir de faire lire en particulier à Molière sa comédie dont il avait passion, et lequel le roi avait eu la bonté de l'envoyer ici pour cet effet. N'ayant pu néanmoins, par cet accident, réussir ce dessein, et craignant d'interrompre les plaisirs de Sa Majesté . . . Molière part demain à trois heures du matin, pour se rendre de bonne heure à Fontainebleau et recevoir les ordres du roi. (cited in Rey and Lacouture, 119)

> *We had set aside some time this evening to hear Molière read in private the play that he is so agitated about, and the king had been so good as to send Molière to us for this purpose. Owing to Chigi's ill health, however, we were unable to accomplish this mission, and, anxious not to interrupt His Majesty's entertainments, Molière will leave tomorrow morning at 3:00 a.m. in order to reach Fontainebleau in good time to receive the king's orders.*

It appears to have been with no small amount of chutzpah that Molière claimed (or at least strongly implied) that the reading had in fact taken place, particularly in a document addressed to the king, who would surely have known the truth of the matter. On the other hand, when Molière writes of the nuncio's approval of the play, one

might understand this to have been implicit in his very wish to see it. More interesting still is the part that the king reportedly played in this attempted reading. If it is true that the king sent Molière to Paris in order precisely that he might read the play to Chigi, this gives further credence to the hypothesis whereby scandal had to be avoided (we note the more discreet location chosen for the reading, away from the attention of the court at Fontainebleau)—but not the play itself.

Roulé, *Le Roi Glorieux* (1664)

At the same time that Molière was negotiating to read *Tartuffe* to Chigi, the priest of Saint Barthélemy, Pierre Roulé (d. July 8, 1666),[18] was composing his extraordinary tract, *Le Roi glorieux au monde, ou Louis XIV, le plus glorieux de tous les rois du monde*.[19] The 91-page piece was printed without formal approval or a royal privilege at the front of a 691-page *summa theologica*.[20] The whole work was dedicated to the king, who received the hefty tome in early August 1664. Most moliéristes are familiar with the paragraphs in which Molière and his play are mentioned,[21] but it is useful to examine the piece in its entirety in order to gain a better understanding of it and its context. Exactly what prompted Roulé to write and then to submit such an ill-judged piece is unclear. At the time, Roulé had been a priest at Saint Barthélemy for 25 years. A member of the Faculty of Theology at the Sorbonne, Roulé became, in 1630, the philosophy teacher of the future Grand Arnauld, a leading Jansenist. Following the Jansenist crisis of 1655–1657 (involving the publication of Pascal's *Lettres provinciales*, Antoine Arnauld's explusion from the Sorbonne and the reception at the Sorbonne of the papal bull condemning Jansenism), Roulé became the hired agent—essentially a spy—of Mazarin and Séguier charged with reporting from within the Assembly of Priests in Paris and the Faculty of Theology (Rey and Lacouture 112). Roulé was himself a *conducteur des âmes* (*spiritual director* or *director of conscience*) and had published his experiences in this capacity two years prior to the first performance of *Tartuffe*.[22] Although Roulé cannot have seen or read *Tartuffe*, he must have heard about it, possibly at the meetings of the Company of the Holy Sacrament, of which he may have been a member. But none of this accounts for the nature and tone of this extraordinary diatribe in which Roulé reveals himself to be a zealot and a fanatic of the highest order.

Although *Le roi glorieux* is anomalous in its tone, a reading of the whole pamphlet reveals that Roulé's agenda is very closely aligned with that of the Company of the Holy Sacrament: He is anti-Protestant,

anti-Jansenist, antiblasphemy, and antiduelling but pro-Rome and pro–directors of conscience. One of Roulé's more outspoken projects in the tract is the conversion to Catholicism of the Protestant maréchal de Turenne (1611–1675), a great solider who had initially rebelled during the Fronde but went on to serve as one of the most important factors in the defeat of the rebellious princes. Roulé admits that Turenne is an accomplished soldier but goes on to point out that "[il] n'est point de la religion véritable et catholique, qu'il faut nécessairement professer pour estre agréable à Dieu et se sauver" (10) (*he is not of the true, Catholic faith, which is essential in order to be pleasing to God and to be saved*), stating explicitly his wish that Turenne convert (11).[23] This cannot have endeared Roulé to Turenne (who was Louis XIV's consultant on military strategy throughout the 1660s, as well as an active participant in the wars against Spain), and Lacroix even speculates that it was Turenne who had the volume suppressed (Roulé xiv).

Neither can it have endeared Roulé to Louis XIV, particularly when he goes on to speak on behalf of the king with regard to the Protestant question, noting that "Sa Majesté voudroit bien les [French Protestants] bannir tous de son royaume, et n'estre point obligée à entretenir le traité de ses prédécesseurs, touchant la liberté de conscience" (36) (*His Majesty would like to ban all French Protestants from his kingdom and not be obliged to maintain the treaty on freedom of conscience established by his predecessors*). Although this is prescient to the extent that Louis XIV was, some twenty years later, to overturn the Edict of Nantes, this was not, as we have seen from the king's own *Mémoires*, his policy in the 1660s. If Roulé's enthusiastic approbation of the anti-Jansenist policy being pursued by the king (22) was more acceptable, to praise him in similar terms for the destruction of Protestant churches was a highly risky strategy.

Even at the points where Roulé's prose most closely resembles more conventional forms of encomium, he loses control of his own text, his hyperbole coming dangerously close to blasphemy on a number of occasions, such as when he describes the king as "un Dieu visible" (57; see also 48–49) (*a visible God*). Praising a supposedly superlative king was of course a notoriously tricky enterprise, but Roulé in his extraordinary hyperbole is singularly inept and singularly unaware of his inadequacies. There are times when Roulé manages to avoid blatant excess, as when he compliments Péréfixe, writing of Louis's tutor as "des mieux entendus et éclairés" (15) (*a most learned and enlightened man*) who went to the Sorbonne and subsequently became Archbishop of Paris. While these words are no more fulsome

than those used by Louis a propos of Péréfixe in his *Mémoires*, they can hardly have pleased the archbishop when they featured in a tract that was so powerfully discredited by its tone elsewhere.

While Roulé's attempts at praise border on the ridiculous, the full force of his venom is reserved for the author of *Tartuffe* in a curious piece written ostensibly in praise of the king's treatment of play and playwright. According to Roulé, Louis has gone to Fontainebleau after committing

> une action héroïque et royale, véritablement digne de la grandeur de son cœur et de sa piété, et du respect qu'il a pour Dieu et pour l'Eglise, et qu'il rend volontiers aux Ministres employés de leur part pour conférer les graces nécessaires au salut. Un homme, ou plustost un demon vestu de chair et habillé en homme, et le plus signalé impie et libertin qui fust jamais dans les siècles passes, avoit eu assez d'impiété et d'abomination pour fair [*sic*] sortir de son esprit diabolique une pièce . . . à la derision de toute l'Eglise, et au mépris du caractère le plus sacré et de la function la plus divine, et au mépris de ce qu'il y a de plus saint dans l'Eglise, ordonnée du Sauveur pour la sanctification des âmes, à dessein d'en rendre l'usage ridicule, contemptible, odieux. Il méritoit, par cet attentat sacrilége [*sic*] et impie, un dernier supplice exemplaire et public, et le fust mesme avant-coureur de celuy de l'Enfer, pour expier un crime si grief de lèze-Majesté divine, qui va à ruiner la religion catholique, en blasmant et jouant sa plus religieuse et sainte pratique, qui est la conduite et direction des âmes et des familles par de sages guides et conducteurs pieux. Mais Sa Majesté, après luy avoir fait un sévère reproche, animée d'une forte colère, par un trait de sa clémence ordinaire, en laquelle il imite la couleur essentielle à Dieu, luy a, par absolution, remis son insolence et pardonné sa hardiesse démoniaque pour luy donner le temps d'en faire penitence publique et solonnelle toute sa vie. Et, fain d'arrester, avec success, la veuë et le débit de sa production impie et irreligieuse, et de sa poésie licentieuse et libertine, elle luy a ordonné sur peine de la vie, d'en supprimer et déchirer, étouffer et brûler tout ce qui en estoit fait, et de ne plus rien faire à l'advenir de si indigne et infamant, ny rien produire au jour de si injurieux à Dieu, et outrageant à l'Eglise, la religion, les sacremens, et les officiers les plus nécessaires au salut . . . fait atteinte à . . . la reverence deuë aux sacremens, qui sont les canaux de la grâce que Jésus-Christ a méritée aux hommes par sa mort en la croix, à la faveur desquels elle est transfuse et répanduë dans les âmes des fidèles qui sont saintement dirigés et conduits. Sa Majesté pouvait-elle mieux faire contre l'impiété et cet impie que de luy témoigner un zèle si sage et si pieux, et une execration d'un crime si infernal? (33–35)

a heroic and royal act, one truly worthy of the greatness of his heart and of his piety, one worthy of the respect that he has for God and for the Church and that he willingly offers to those ministers who are busy working to distribute the various qualities necessary for salvation. A man, or rather a demon dressed in human flesh and clothing, the most remarkable sinner and libertine that ever existed has been impious and wicked enough to create from his devilish mind a play that derides the whole Church and mocks its most sacred nature and most divine function, one that mocks what is most holy in the Church, what has been commanded by the savior for the sanctification of souls, in order to make it ridiculous, contemptible, and odious. For this sacrilegious and impious attack, he deserved to be made an example of and executed publicly, to be burned before burning in the fires of hell, in order to atone for such a heinous example of divine lese majesty, which seeks to bring down the Catholic religion by condemning and mocking its most religious and holy practice—namely, the spiritual guidance of souls and families undertaken by wise and pious directors. But His Majesty, who was deeply angered, having severely reprimanded him, then demonstrated his customary clemency (in which he imitates the essential characteristics of God), then absolved him, pardoned his insolence and his devilish effrontery in order that he spend the rest of his life in public and solemn penitence. In order to prevent performances of this impious and irreverent work with its licentious and libertine script, His Majesty ordered him, on pain of death, to suppress, destroy, obliterate, and burn all evidence of the play and never again to produce anything as unworthy, ignominious, or so insulting to God, the Church, religion, the sacraments, and the officers necessary to salvation, and never to challenge the respect due to the sacraments, which are the channels by which Christ bestows his grace on mankind through his death on the cross and by which this grace is transmitted and spread among the souls of the faithful, who benefit from saintly guidance. What more could His Majesty have done in response to this impious sinner than demonstrate such wise and pious zeal while cursing such an infernal crime?

To attribute Louis's motive for the ban on the play to piety and a love of God and the Church is conventional enough and resonates with the *Gazette's* account of the same events. But Roulé's vicious attack on the playwright and, in a different way, his wholly inaccurate account of the king's response to the play are astonishing in their audacity and their bald effrontery. It is worth remembering that the suggestion that Molière be publically executed, that he be burned at the stake before burning in hell, is, while undoubtedly hyperbolic, no idle project, for one Claude Lepetit, author of a satirical ode to the Virgin Mary, had been burned alive at the Place de Grève in Paris as recently as September 1, 1662.

Meanwhile, the attribution of clemency as a character trait of the king is not in and of itself offensive or even inaccurate (Louis XIV, like any shrewd politican, knew how to use clemency for political ends), but the astonishingly inaccurate account of the king's thoughts and deeds, on the other hand, is. Roulé's heavy-handed criticism of the evils of a play that we know was personally appreciated by the king is tactless, while the priest's pronouncement of what an appropriate response might have been is profoundly ill judged. In view of the legate's approving wish to hear Molière's *Tartuffe*, there is, however, a delicious irony in the fact that Roulé writes at some length (25–31) about Cardinal Chigi's visit to France, which was then under way. Roulé praises both king and pope and notes with pride that Chigi has been received in France in a suitably welcoming and respectful manner, concluding that "Monsieur le Légat n'a rien à souhaiter de plus" (29) (*the legate could not have wished for more*). In fact, we know that the one additional thing that Chigi did wish for was precisely a reading (or better still performance) of the play that Roulé will, a few pages later, condemn in no uncertain terms.[24]

The official response to Roulé's offering is not documented, although the scarcity of extant copies may hint at its suppression. The most useful indication, alongside Molière's first petition, comes in the form of Roulé's own foreword to another work, *Le Dauphin*, which came out in autumn that same year, in which he wrote:

> Je puis sans doute, par ignorance, avoir fait bien des fautes, mais vénielles, parce que non volontaires. Quand même elles seraient grandes et sans excuses, sensibles et évidentes, on me doit faire la grâce entière de les attribuer à mon affection plutôt qu'à quelque autre défaut dont on me fasse criminel, car je ne le suis véritablement pas; n'ayant rien fait en cet ouvrage, non plus qu'en tous les autres précédents, que par un pur amour et passion d'hommage et de respect envers Leurs Majestés, sans aucune vue d'intérêt, et, en vérité, même sans volonté quelconque de nuire à personne.[25]

> *I may, out of ignorance, have committed some faults, but only venal ones, because they were involuntary. Even if they were grave and inexcusable errors—palpable, obvious ones—people should have the good grace to attribute them to my affection rather than to any other fault of which it might be alleged I am guilty. For I am really not guilty; I have done nothing in this work, nor in any of my earlier works, that does not stem from pure love and a passion driven by veneration and respect toward Their Majesties, entirely without self-interest and, in truth, even without any wish to damage anybody.*

It is probable, then, that Roulé was reprimanded either by Louis XIV or by Péréfixe. And one prime reason for the reprimand would have been that his pamphlet fanned the flames of a fire that was by no means extinct. On the other hand, Rey remarks that *Le Roi glorieux* and its contents were a boon for Molière because they gave him new ammunition with which to pursue his goal and ask anew that the work be performed in the form of his first petition to the king (Rey and Lacouture 116).

First Petition (1664)

Molière's petition (or *placet*) will have been read to the king sometime in August 1664, and it is clear that it was written in response to a defamatory pamphlet.[26] Molière writes of "un Livre composé par le Curé de . . ." (*a book written by the priest of . . .*") that had been presented to the king. He picks up the key terms of Roulé's libel:

> Ma Comédie, sans l'avoir vue, est diabolique, et diabolique mon cerveau; je suis un Démon vêtu de chair, et habillé en Homme; un Libertin; un Impie, digne d'un supplice exemplaire. Ce n'est pas assez que le feu expie en public mon offense, j'en serais quitte à trop bon marché; le zèle charitable de ce galant Homme de bien n'a garde de demeurer là; il ne veut point que j'aie de miséricorde auprès de Dieu, il veut absolument que je sois damné, c'est une affaire résolue. (Pléiade II, 192)
>
> *My comedy—though he has not seen it—is diabolical, as is my brain; I am a demon dressed in human flesh and clothing, an impious libertine, worthy of execution and to serve as a public example. A public burning is not enough to expiate my offense (that would be letting me off too lightly); the charitable zeal of this worthy Christian is careful not to stop there: He wants me to receive no mercy from God; he insists that I be damned, and the matter is settled.*

Molière spells out the scandalous lack of Christian charity on the part of one of France's priests who seeks not to save souls but rather to damn them. In the same petition, Molière also suggests, if disingenuously, that were it not for the pamphlet, he might have been able to bear the silencing of *Tartuffe*, safe in the knowledge that he had the king's support:

> Bien que ce m'ait été un coup sensible que la suppression de cet Ouvrage, mon malheur pourtant était adouci, par la manière dont Votre Majesté s'était expliquée sur ce sujet; et j'ai cru, SIRE, qu'elle m'ôtait

tout lieu de me plaindre, ayant eu la bonté de déclarer qu'elle ne trouvait rien à dire dans cette Comédie qu'elle me défendait de produire en public. (Pléiade II, 192)

> *Although the silencing of this work was a real blow to me, my misfortune was alleviated by Your Majesty's explanation of this matter; and I believed, Sire, that you relieved me of all grounds for complaint by your kindness in saying that Your Majesty found nothing wrong with this same play that you forbade me to produce in public.*

In this way, Roulé's attempt both to praise and—indirectly—to influence the king backfired spectacularly, as it provided Molière with the pretext to attempt to influence the king in a different direction. Where Roulé's account of Louis's response to the play is clearly farfetched and belongs to the realm of fantasy, Molière dares, in a far more measured piece of writing, to counter it by stating explicitly that the king had found nothing wrong with the play. While this is, as far as we know, perfectly true, Molière's phrasing and syntax surely hint also at the injustice of the king finding nothing wrong with a play that he nonetheless insisted on banning from public performance.

Indeed, in a strikingly outspoken passage, Molière, addressing the king directly, spells out his understanding of how a king who saw nothing wrong in the play could have been convinced to impose such a ban:

> On a profité, SIRE, de la délicatesse de votre âme sur les matières de Religion, et l'on a su vous prendre par l'endroit seul que vous êtes prenable, je veux dire par le respect des choses saintes: les Tartuffes sous mains ont eu l'adresse de trouver grâce auprès de Votre Majesté; et les Originaux enfin ont fait supprimer la Copie, quelque innocente qu'elle fût, et quelque ressemblante qu'on la trouvât. (Pléiade II, 192)

> *They have taken advantage, Sire, of the sensitivity of your soul with regard to matters of religion, and they have succeeded in influencing you via the only possible means—I mean your respect for all things sacred. The Tartuffes have secretly and cunningly managed to gain Your Majesty's favor, and now the originals have had the copy withdrawn, no matter how innocent it was nor how true its likeness.*

The extent to which Louis's legitimacy and authority as (Christian) monarch was dependent on a theologically based theory of kingship and therefore on a reciprocal and mutually dependent relationship with the Church has already been established, and in that sense

Molière is absolutely right to comment on the king's sensitivity with regard to matters religious. Indeed, it is precisely his "extrême délicatesse pour les choses de la religion" (Pléiade I, 597) (*extreme sensitivity toward religious matters*) that, according to the official account of *Les Plaisirs de l'île enchantée* (see what follows), motivated the ban in the first place. The playwright is also right to observe that religion is the only possible means (or at least the most effective means) to make the king act in a way that runs counter to his own personal views. If Louis XIV is answerable only to God, then arguments that invoke the one authority higher than his own have the best chance of success in convincing him to do something against his own inclination. In the struggle for influence in 1660s France, God was the most persuasive weapon, and in order to keep God on his side, Louis XIV had to ensure that the Church remained in as stable a state as possible. Although Molière's assessment here is accurate, to remind the king of his vulnerability in this regard may not have been politic.

Molière then ventures on to more perilous and less accurate ground when he draws a parallel between Louis's court and the plot and characters of his own play. We have seen that Molière's deliberate conflation of opponents of the play with hypocritical zealots (by calling them "Tartuffes") is an ingenious rhetorical strategy aimed at keeping if not God on his side then at least the moral high ground and, with it, he hopes, the king. But according to this logic, Louis XIV as a victim of their cunning is likened to Orgon the dupe. Molière is suggesting nothing less than the fact that Louis XIV has been taken in by the influential *dévots* around him. And by likening the nameless *dévots* to the likes of Roulé (writing, for instance, of being "exposé tous les jours aux insultes de ces Messieurs") (Pléiade II, 193) (*exposed every day to the insults of these men*), Molière's argument becomes more forceful still. While it is inconceivable that Molière would be so imprudent as to seek to insult the king, the playwright's audacity is remarkable. On the other hand, it pales in comparison with Roulé's quite extraordinary impudence, a fact that perhaps holds a clue as to why the playwright felt emboldened to speak out in this manner in the first place.

Molière had begun his petition by introducing a dimension into the debate that had not been mentioned in any of his earlier controversies (such as that provoked by *L'Ecole des Femmes* the previous year), although it is a common feature in the history of theatrical controversy—namely, that comedy has a moral function to "corriger les Hommes, en les divertissant"[27] (Pléiade II, 191) (*correct men while entertaining them*). Here Molière sets up his play as a useful attack

on the common vice of hypocrisy and vigorously defends it against the charge of the possibility of confusing "le bien avec le mal" (*good and bad*); Molière claims that he has remained entirely respectful of the *vrais dévots* and that he has instead portrayed a "véritable et franc Hypocrite" (Pléiade II, 192) (*real and obvious hypocrite*). He complains, however, that his precautions have come to nothing, since the play has been attacked despite his enjoying the support of the greatest and most enlightened king on earth and of the papal legate and the majority of prelates. We note that Molière is attempting to counter what he claims are the complaints of the Tartuffes with the approbation he has received from other churchmen (although we know that Chigi was hardly *dévot* in his behavior) together with the king. The extent to which the reference to Chigi's approval is disingenuous has already been discussed, and it is certainly misleading on Molière's part to suggest that Roulé knew of it, since the chronology of events makes this impossible. Likewise, it is surely an exaggeration to claim that the majority of prelates were openly in support of the play.

Molière brings the petition to a close by claiming that the best way for him to respond to and purge himself from Roulé's calumny would be to perform the play and thereby demonstrate its innocence to a wider public. At the end, Molière places the ball firmly back in Louis's court and, with a paraleptical flourish, claims to be able to leave the matter with the king given that "les Rois éclairés comme Vous, n'ont pas besoin qu'on leur marque ce qu'on souhaite, ils voient comme Dieu ce qu'il nous faut, et savent mieux que nous ce qu'ils nous doivent accorder" (Pléiade II, 193) (*enlightened kings like [him] do not need us to spell out our wishes; like God, they see what we need and know better than we do what they should grant us*). Of course Louis XIV does not need to be remotely enlightened to divine the nature of Molière's request, since it has been stated perfectly clearly here (and many times in person). What is more interesting is the fact that the conventional image of the enlightened king sits in this document alongside the Orgon-king fashioned by Molière in an attempt to jolt Louis XIV into a change of heart and mind. Although the petition did not lead to an immediate lifting of the ban, it cannot have left the king entirely unmoved, and we know that it did have an effect elsewhere. The *Annales* of the Company of the Holy Sacrament indicate that at a meeting on September 14, 1664, "on résolut de faire exhorter une personne de capacité de ne rien écrire contre la comédie de *Tartuffe*, et l'on dit qu'il valoit mieux l'oublier que de l'attaquer de peur d'engager l'auteur à la défendre" (*Annales* 235) (*[they] decided to beseech a person of high standing not to write anything against* Tartuffe,

saying that it was better to forget it than to attack it, for fear of inciting the author to come to the play's defence). It is widely understood that the person of high standing was none other than Conti, who was then composing his *Traité de la comédie et des spectacles*; this would certainly account for the otherwise surprising absence of any reference to *Tartuffe* in a treatise that was written during (and at least partially inspired by) the controversy. What is even more interesting is the potential influence attributed to Molière's attempts at defending the play. Clearly the Company acknowledged the rhetorical (if not always factual) power of the playwright's arguments, and it is at this point that the Company appears to have dropped out of the controversy altogether.

Péréfixe and Port-Royal, Summer 1664

As the Company's influence faded, the newly incumbent Archbishop Péréfixe (whose appointment as archbishop had only recently been confirmed by Rome, owing to the tensions following the Créqui affair) was trying to assert his own influence on the reign. It was suggested earlier that Péréfixe may have been a driving force behind the 1664 ban on *Tartuffe*. In the summer of 1664, at the same time that Roulé ranted and Molière pleaded, Péréfixe made some very concrete moves toward attempting to resolve the Jansenist debacle. In particular, he was keen to tackle the small number of recalcitrant nuns at Port-Royal who continued to refuse to sign the famous formulary condemning the five propositions from *Augustinus*. According to Racine, the king's confessor Annat was constantly reproaching Péréfixe for being too indulgent of these nuns (*Abrégé* 204).

One of the principal primary sources detailing these events is Racine's *Abrégé de l'histoire de Port-Royal*, written in the 1690s and left incomplete at the time of his death. Although Racine was by this time in his life reconciled with the Jansenists by whom he had been educated (and who had disapproved of his former career as a playwright), the account is not as biased as one might expect. Racine initially describes Péréfixe in the following terms:

> C'était un prélat beaucoup plus instruit des affaires de la cour que des matières ecclésiastiques, mais au fond très bon homme, fort ami de la paix, et qui eût bien voulu, en contenant [*sic*] les jésuites, ne point s'attirer les défenseurs de Jansénius sur les bras. Il cherchait donc des biais pour satisfaire les uns et les autres. (*Abrégé* 199)

> *A prelate, he was far better informed about courtly matters than ecclesiastical ones, but deep down he was a very good man, a man who sought peace and who would really have liked, when restricting*[28] *the Jesuits, not to have ended up with the Jansenists on his back. He looked for the means to satisfy both parties.*

In the wake of the edict of April 29, 1664, demanding that bishops collect signatures from all ecclesiastics within their diocese, Péréfixe devised what he seems genuinely to have thought would offer an acceptable solution to the nuns relying on a casuistical distinction between human faith and divine faith. On June 8, he published a mandate requiring that the nuns sign out of human faith (which demanded full submission to his authority) and the following day duly appeared at Port-Royal to collect their signatures. In the course of what turned out to be a nine-day stay, Péréfixe met with each of the nuns individually and found them to be more resistant and more resilient than he had expected. The meetings were recorded by the nuns (but not by Péréfixe) shortly thereafter.[29] They have been scrupulously analyzed by Kostroun, who offers a fascinating account of the literary and rhetorical strategies adopted by these extraordinary women.[30]

Kostroun reads the Port-Royal scandal in terms of competing and coincidental claims of papal infallibility and monarchical absolutism. In a particularly significant interview with one nun on June 13, 1664, a floundering Péréfixe said at one point, "Hé mais, ma fille, vous sçavez bien qu'une même chose peut être dite en différentes manières" (Kostroun, "Formula" 515n129) (*But oh, my child, you know perfectly well that the same thing can be stated in more than one way*). By admitting that language and meaning are slippery, Péréfixe had inadvertently recognized the potential cracks in his own argumentation. Furthermore, Kostroun writes of Péréfixe's "unreasonable behavior" (*Feminism* 150) during the interviews and of how, according to the nuns' reports, his attitude varied between the conciliatory and the outright aggressive. The archbishop's temper was notorious.[31]

The power of casuistry and verbal coercion having failed him, Péréfixe resorted to a more physical form of persuasion and returned to Port-Royal on August 26 accompanied by a substantial retinue that included "plus de deux cents archers, dont une partie investit la maison, et l'autre se rangea, le mousquet sur l'épaule, dans la cour" (Racine, *Abrégé* 205) (*more than two hundred archers, half of whom took over the house, while the other half lined up, their muskets on their shoulders, in the courtyard*). Péréfixe dispersed the nuns, and Racine paints a pitiful portrait of their devastation. However, Racine also writes, "L'objet, à

mon avis, le plus digne de compassion, c'était l'Archevêque lui-même qui, sans avoir aucun sujet de mécontentement contre ces filles, et seulement pour contenter la passion d'autrui, faisait en cette occasion un personnage si peu honorable pour lui, et même si opposé à sa bonté naturelle" (*Abrégé* 206) (*In my opinion, the person most worthy of our pity was the archbishop himself, who, having no personal disagreement with these girls, found himself on this occasion playing such a dishonorable role and one that was so opposed to his natural goodness, all in order to gratify the fervor of people other than himself*). Racine seems eager to attribute the greatest blame in this matter to prominent Jesuits such as Annat. Meanwhile, Péréfixe was allegedly very agitated during the proceedings and "de la plus grande douceur passant tout à coup au plus violent emportement" (Racine, *Abrégé* 206) (*would suddenly shift from the greatest gentleness to the most violent rage*). Racine also condemns Péréfixe's actions (*Abrégé* 208–9) and demonstrates how the archbishop violated procedure and imposed his will by force. The nuns filed an appeal against Péréfixe and in their report "emphasized Péréfixe's violence and disrespect for the law. For those familiar with the current debates over Jansen, Péréfixe's tyranny over these nuns served as an image of the doctrine of papal infallibility [and perhaps also monarchical absolutism] in action" (Kostroun, *Feminism* 164). The archbishop was, however, able to use his influence to have the case taken to the Royal Council and quashed.[32]

On the very same day that Péréfixe evicted the nuns from Port-Royal (August 26, 1664), Molière was to have made what would have been the first documented private reading of *Tartuffe* at the home of a Jansenist sympathizer, possibly the duchesse de Longueville or Mme de Sablé. The event is also documented by Racine, who, in a letter dated May 10, 1666, narrates how and why the reading was aborted:

> C'était chez une personne qui en ce temps-là était fort de vos amies; elle avait eu beaucoup d'envie d'entendre lire le *Tartuffe*, et l'on[33] ne s'opposa point à sa curiosité. On vous avait dit que les jésuites étaient joués dans cette comédie; les jésuites, au contraire, se flattaient qu'on en voulait aux jansénistes. Mais il n'importe: la compagnie était assemblée; Molière allait commencer, lorsqu'on vit arriver un homme fort échauffé qui dit tout bas à cette personne: "Quoi, Madame? vous entendrez une comédie, le jour que le mystère de l'iniquité s'accomplit? ce jour qu'on nous ôte nos Mères?" Cette raison parut convaincante: la compagnie fut congédiée; Molière s'en retourna, bien étonné de l'empressement qu'on avait eu pour le faire venir, et de celui qu'on avait pour le renvoyer.[34]

> *It was at the home of somebody who at the time was very friendly toward you; she very much wanted to hear* Tartuffe *read, and nobody stood in the way of her curiosity. You have heard that the Jesuits feature in this play; the Jesuits on the other hand flatter themselves that it is the Jansenists who are mocked. Whatever the case, the group was assembled; Molière was about to begin, when a breathless man arrived who quietly informed our host: "What, Madam? You would listen to a comedy the day that the mystery of iniquity is fulfilled? This day when our Mothers are evicted?" This argument seemed convincing; the group was dispersed, and Molière, taken aback by the haste with which he had been summoned and the haste with which he had been sent away again, left as well.*

If the coincidence in dates is precisely that, there is a clear causal link between news of Péréfixe's harsh treatment of the nuns and the annulment of the projected reading of *Tartuffe*. To an extent, this anecdote offers a microcosm of the larger problem surrounding the *Tartuffe* affair—namely, that when the Jansenist controversy was raging, it was unwise, or in this case inappropriate, to indulge in the reading of a play, particularly one that was in itself controversial.

Condé and Other Supporters

We have seen that two of Molière's attempts at private readings of his play were canceled at the eleventh hour. There were probably other readings that did take place that year, as well as two full performances of the play: the first on September 25 (in three acts) at Villers-Cotterets for the king's brother, Monsieur,[35] and the second on November 29 (probably in five acts) at Le Raincy, home of Anna Gonzaga (Princess Palatine), for Condé.[36] The respective identities of Molière's benefactors for these two performances and for subsequent private performances of the play before the ban was lifted are significant. While they are all high-ranking individuals, they are also, and in different ways, somewhat at odds with the king. Louis II de Bourbon, prince de Condé (1621–1686), was, as we have seen, a notoriously conspicuous rebel during the Fronde; indeed, the rebellious activities that took place between 1651 and 1653 are known collectively by many historians as the "Condean Fronde."[37] Like his brother Conti, Condé rejected the general amnesty of October 22, 1652. Instead he elected to serve France's acknowledged enemy, Spain (against whom he had won a famous victory at Rocroi for France on May 19, 1643), and on November 17, 1652, he became leader of the Spanish army in the war against France. Seven years later, Condé's rehabilitation

was to prove one of the most contentious parts of the Treaty of the Pyrenees, which signaled an end to the long war. Condé had to make a full apology to Louis XIV, beg his forgiveness, and leave himself at the king's mercy; the king would then recognize him again as a prince of the blood, nullify his status as a traitor, and restore all his possessions and positions, except that he was now to be governor of Burgundy and Bresse instead of Guyenne (Lossky 58). Condé had thus embodied "l'archétype de l'inconstance aristocratique" (*the archetype of aristocratic disloyalty*); his submission now represented the moment at which the era of the domesticated nobility was beginning (Béguin 18).

Condé did not rebel again and would be reappointed as a military commander in 1667 and serve the king faithfully and effectively in battle during the conquest of the Franche-Comté in 1668. Yet he also represented a more modest and subtle challenge to Louis's pursuit of absolutism by means of the alternative court that he established at Chantilly and where he demonstrated a degree of magnificence that appeared to overlook the exclusive pretentions of the king (Béguin 19). As Louis XIV began work on transforming Versailles from a relatively modest hunting lodge into a spectacular château where he could stage his *gloire* and domesticate the nobility, Condé began to embellish his château at Chantilly, even taking on some of the same artists, including Le Nôtre (formerly on Fouquet's payroll), who designed the new gardens but could only make his way to Chantilly on the rare occasions when the king's back was turned (see Béguin 331–32). And as Louis XIV and Colbert began in earnest to exploit cultural patronage as a means of establishing royal authority, Condé, too, supported the work and welfare of a variety of individuals, many of whom were nonconformist in their outlook. As Katia Béguin notes, the simultaneous appearance of a form of state sponsorship that was reputed to be hegemonic and an autonomous artistic outfit at Chantilly necessarily calls into question the success of Louis XIV's political agenda (328). Her observation whereby royal power tolerated this this kind of parallel authority more than it sought to suppress it (20) suggests a somewhat uneasy truce that allowed Condé more freedom than, for instance, Fouquet. But where Fouquet represented both a genuine political and symbolic threat to absolutism, Louis XIV was able to restrict the political influence of Condé and all the princes of the blood by excluding them from his Royal Council. Moreover, Condé's symbolic capital lay precisely in his status as a notorious rebel who had yielded to the young Louis's authority. Since Condé was temperamentally incapable of ever becoming a Versailles lapdog, it was no doubt

wise to allow him just enough independence to preserve him in a state of formal obedience. But in this regard his position was unusual. As Béguin puts it, "le Grand Condé jouit sans conteste de cet avantage singulier, qui l'autorise à protéger les critiques ou les indifférents politiques et religieux comme les refusés du savoir ou de l'art officiel" (392) (*the great Condé alone benefited from a singular advantage that allowed him to protect critics or those who were politically or religiously indifferent as the rejects of official knowledge or art*).

Rey has noted that both Condé and Conti, as former students of the Jesuits, were far better educated in matters cultural than Louis XIV (Rey and Lacouture 13), and we know that Condé was very eclectic in his interests and intellectual preferences. On the question of Condé's influence in the cultural sphere, in the foreword added by Boileau when publishing the *Epître I, au Roi* in 1669, Boileau explains that Condé had objected to his including, in a work addressed to the king, the fable of the judge who, instead of attempting to meet out justice, eats an oyster. Boileau puts it thus:

> Je me suis rendu à l'autorité d'un prince, non moins considérable par les lumières de son esprit que par le nombre de ses victoires. Comme il m'a déclaré franchement que cette fable, quoique très bien contée, ne lui semblait pas digne du reste de l'ouvrage, je n'ai point résisté; j'ai mis une autre fin à ma pièce, et je n'ai pas cru, pour une vingtaine de vers, devoir me brouiller avec le premier capitaine de notre siècle.[38]

> *I surrendered to the authority of a prince whose critical insights are no less great than the number of his victories. Since he had declared quite openly that this fable, although very well written, did not seem to him to be on a level with the rest of the work, I did not resist. I added a new ending to my work, for I did not think it wise, for the sake of twenty-odd lines, to fall out with the greatest military leader of the century.*

Ranum is probably right to downplay the political overtones of this anecdote and to emphasize what it reveals about Condé's influence as "an arbiter of literary taste in the 1660s" and that "authors still had to reckon with far more than Louis, Colbert, and Chapelain in their bids for patronage."[39] But, as Béguin has noted, Condé's notorious inclination toward religious tolerance (of Jansenists and Huguenots) attracted those who were persecuted for their faith, just as his own libertinage had made him seek out scientific and philosophical outlaws (362). His own curiosity did not sit well with increasing religious and political censure, and he became increasingly interested in religious

controversy, offering hospitality to "une pensée hétérodoxe, étouffée, critique ou incrédule" (Béguin 361, 381) (*outlooks that were heterodox, stifled, critical, or incredulous*). This is not to say that to request, as he did several times in the course of the controversy, that Molière performing *Tartuffe* constituted an act of rebellion per se, but Condé's irreligion was always implicitly threatening to the status quo. As Béguin concludes, Condé's countercourt reflects above all "un parti pris ennemi de la censure, et sans doute, une divergence d'esprit plus qu'une critique radicale des decisions fondamentales de la monarchie" (386) (*a stand against censorship and no doubt an alternative point of view rather than a radical critique of the monarchy's fundamental decisions*). At the very least, Condé was anticonformist in his artistic choices. The private performance of *Tartuffe* at the Hôtel de Condé in Paris in 1668 was perhaps the most daring and provocative of those that Condé arranged, given that it flew in the face of Archbishop Péréfixe's threat of excommunication (see what follows).

The one that took place on November 29, 1664, was not Molière's first private performance for Condé. Indeed, Molière's troupe had been the first to be invited by Condé to stay at Chantilly in Autumn 1663, when they were paid 1,800 *livres* for a six-day visit during which they performed half a dozen plays (see La Grange 1947, 60). And on December 10, 1663, Condé had invited both rival troupes (that of the Hôtel de Bourgogne and Molière's troupe, based at the Palais-Royal) involved in the bitter *querelle de L'Ecole des femmes* to perform in sequence all the relevant plays at the festivities marking the engagement of his son, the duc d'Enghien, to Anne de Bavière. In so doing, Condé was offering his guests the best theatrical entertainment available and simultaneously engaging with the biggest theatrical controversy since that provoked by Corneille's *Le Cid* in 1637 while refusing to side with one troupe over the other.[40] Although Boursault dedicated his anti-Molière piece, *Le portrait du peintre ou la contre-critique de l'Ecole des femmes* to Enghien, and although another enemy of Molière, Montfleury, from the Hôtel de Bourgogne, had gone on in January 1664 to publish his *Impromptu de L'Hôtel de Condé*, there is no doubt that Condé's support of Molière during the *Tartuffe* controversy was unfailing.

Anna Gonzaga, Princess Palatine, also boasted a somewhat checkered past. Indeed, it was alleged that she and Condé had, with the abbé Bourdelot, tried to burn a piece of the true cross (Béguin 380–81). During the Fronde, the princess had acted as an intermediary between the princes and the court, though as a friend of the cardinal de Retz she was always to be considered with some suspicion.

Formerly married to Edouard de Bavière, she had been a widow since March 1663 and now divided her time between her house in Asnières, the château of Chantilly, as a guest of the Condé family, and the château of Raincy.

Of course Philippe d'Orléans, known as Monsieur, and his first wife, Henriette d'Angleterre, known as Madame, who also took a keen interest in the play, were in many ways closer to Louis XIV. However, the relationships were not without significant tensions, as is almost inevitable in the case of a monarch and the individual next in line to the throne. In the course of the *Tartuffe* controversy, one source of tension that arose between Louis and his brother, for instance, was over Monsieur's request in 1666 that his wife be singled out for a special seat with a back when visiting the queen's apartments (Louis XIV 164). As Louis explained to his brother, to accord this privilege would have been inappropriate, as it would have suggested that Madame held a higher rank than she actually did. In his account of the incident, Louis explicitly recalls the Fronde and the dangers of having close powerful relatives who overstep the mark, thereby endowing the request and the debate that it provoked with more import than a mere matter of etiquette or convention. While it would be misleading to claim that Monsieur's or Madame's wish to see *Tartuffe* and to support Molière in his campaign to have the ban lifted constituted anything close to a major act of rebellion, it may well have afforded them the opportunity to make their mark on a playwright of considerable talent who felt himself persecuted by the system. Meanwhile it seems that Louis XIV did not wish to be seen as supporting performances of a play that he himself had banned, and so, when in mid-October Molière's troupe spent twelve days at Versailles at the expense of the Royal Treasury, they gave numerous performances of numerous plays (almost all of them by Molière) but not *Tartuffe*. Indeed it is explicitly stated in the official account of *Les Plaisirs de l'île enchantée* that Louis was denying himself the pleasure of seeing the play, although it is likely that he saw it at Villers-Cotterets, as a guest of his brother.

Middle Stage: 1665–1667

In February 1665, things were moving forward on several fronts: the official published account or *livret* of *Les Plaisirs de l'île enchantée* went on sale; Molière began a performance run of *Le Festin de Pierre* at the Palais-Royal theatre, and Pope Alexander VII issued, following Louis XIV's request, his second anti-Jansenist encyclical, *Regiminis apostolici*, demanding signatures from all French clergy. The *livret* is

significant for at least two reasons: first, because (unlike Marigny's *Relation* of the *fête*[41]) it does actually mention *Tartuffe*, which could easily have been omitted given that the play did not form part of the official festivities; and second, because in its account of the king's view on the matter, it sits judiciously (as we saw in Chapter 2) between the polite but firm condemnation alluded to in the *Gazette* and the outright appreciation of the play that Molière mentions in his first petition:

> Le soir Sa Majesté fit jouer une Comédie nommée *Tartuffe*, que le Sieur de Molière avait faite contre les Hypocrites; mais quoiqu'elle eût été trouvée fort divertissante, le Roi connut tant de conformité entre ceux qu'une véritable dévotion met dans le chemin du Ciel, et ceux qu'une vaine ostentation des bonnes œuvres n'empêche pas d'en commettre de mauvaises; que son extrême délicatesse pour les choses de la Religion, ne put souffrir cette ressemblance du vice avec la vertu, qui pouvaient être prise l'une pour l'autre: Et quoiqu'on ne doutât point des bonnes intentions de l'Auteur, il la défendit pourtant en public, et se priva soi-même de ce plaisir, pour n'en pas laisser abuser à d'autres, moins capables d'en faire un juste discernement. (Pléiade I, 597)

> *During the evening [of May 12, 1664] His Majesty arranged for a performance of a play called* Tartuffe, *by Molière, in which the playwright satirizes hypocrites. Although the play was found to be very entertaining, the king noted such a considerable overlap between those whose true devotion sets them on the path to heaven and those for whom a vain display of good deeds does not prevent them from committing bad deeds as well that his extreme delicacy with regard to matters of religion could not condone this close resemblance between vice and virtue, which could be mistaken one for the other. And although the author's good intentions were not in question, the king nonetheless banned the play from public performance and denied himself this same pleasure in order that it not fall into the hands of those less capable of such discernment.*

The suggestion that true and false religion might become confused was discussed in Chapter 2; here we are concerned with the king's role in the *Tartuffe* affair and the account thereof that he wished to be made known to a wider public. Whereas in the *Gazette* Louis's ban was presented as a matter of national importance, a decision made in the interests of preserving the unity of the Church, here it is ostensibly motivated by a wish to prevent less discerning individuals than he from mistaking the external trappings of *vice* and *vertu*. It would seem, then, that *Tartuffe* was a sufficiently important issue to be dealt

with in this account—but also that its authors sought to downplay the play's significance when relating a set of courtly festivities in a publication aimed at promoting the glory of the young king and the magnificence of the entertainments he was able to offer his court. But this account may in fact have clouded the issue for Molière and his contemporaries as well as for modern scholars and students, for to ban *Tartuffe* owing to the possibility of confusing outward manifestations of true and false religion (whatever the exact nature of their truth or falsehood) makes less sense than to ban it in the interests of the unity of the Church at a time when that unity was under genuine threat. Likewise, to lift a ban made on the basis of an issue that was by that time resolved makes infinitely more sense than to do so with regard to an issue (religious hypocrisy) that is perennial.

What, meanwhile, Molière was trying to achieve by writing and putting on *Le Festin de Pierre* in 1665 is something of an enigma, and one that has exercised critics over the centuries.[42] On the one hand, the story was a popular one in seventeenth-century France: At least three versions were performed in Paris in the decade prior to Molière's, including Dorimond's 1659 version, *Le Festin de Pierre, ou le fils criminel*, and Villiers's 1660–1661 one, as well as an Italian version performed circa 1658. On the other hand, the fact that Molière made his Don Juan not only a self-confessed *libertin* but also, and unlike his predecessors, a religious hypocrite in the final act of the play is clearly a deliberate and provocative choice.[43] According to Claude Bourqui, the Don's feigned conversion and his famous speech in V.2, beginning, "L'hypocrisie est un vice à la mode" (*Hypocrisy is a fashionable vice*), suggested that religious hypocrisy, more than any other sin, was the most culpable of all. The fate of the play is especially intriguing in terms of the censorship that it underwent (changes were made to the text between the first and second performances), its intricate publication history (the play was not published in Molière's lifetime and was known until the nineteenth century in a verse adaptation devised by Thomas Corneille in 1677),[44] and the relative lack of interest or controversy that it provoked. Condé never requested a performance of *Le Festin*. No official pronouncement was ever made against *Le Festin de Pierre*, and Rochemont's *Observations sur une comédie de Molière* are in fact as concerned with *Tartuffe* as with *Le Festin*. We understand that Conti elected to write in his treatise about *Le Festin* because he had been urged to remain silent on the more pressing matter of *Tartuffe*. In that sense, his references to *Le Festin de Pierre* are perhaps, paradoxically, further evidence of its relatively uncontroversial status. Reasons for this may include the fact that *Le*

Festin de Pierre is set in a universe in which God does undeniably exist (see also Chapter 4).[45]

Another reason may be that, while still unable to lift the ban on *Tartuffe*, Louis XIV resisted any pressure to impose an additional ban on *Le Festin de Pierre*.[46] This is suggested in the *Lettre sur les observations d'une comédie du sieur Molière, intitulée "Le Festin de Pierre"* (1665),[47] in which we read that Louis XIV

> savait bien ce qu'il faisait, en laissant jouer *le Festin de Pierre*: qu'il ne voulait pas que les tartufles eussent plus d'autorité que lui dans son royaume, et qu'il ne croyait pas qu'ils pussent être juges équitables, puisqu'ils étaient intéressés. (Pléiade II, 1231)
>
> *knew exactly what he was doing in allowing* Le Festin de Pierre *to be performed: He did not want the Tartuffes to have more authority than he did in his own kingdom, and he did not consider them to be fair judges since they were involved in the affair.*

Whatever the accuracy of these words, the fact that the matter is couched in terms of kingly authority is significant. In the same way that Roulé's *Le Roi glorieux* appears to have provided Molière with a pretext to raise the issue of his forbidden play with the king, it is possible that Rochemont's only somewhat less excessive *Observations sur une comédie de Molière, intitulée "le Festin de Pierre"* (in which, as we have seen, *Tartuffe* is also discussed)[48] may have brought the matter to the king's attention again.[49] And just as Molière had in his first petition pitted himself not against the Church but against the Tartuffes, so here does the author pit Molière against the "tartufles" and Rochemonts, the implication being that there is no conflict between Molière's cause and God's.

Although the ban on *Tartuffe* remained in place, the king continued to invite Molière to perform other material for him at court and made a significant gesture of official support in August 1665. We read in the *Journal des bienfaits du roi*:

> Le roy donne à une troupe de comediens dont Moliere etoit comme le chef une pension de 7.000 livres . . . Ils jouerent plusieurs fois devant le roi et Moliere fit plusieurs comedies pour les divertissements que le roi donnoit à toute la cour et Sa Majesté en fut si contente qu'au mois d'août 1665 elle leur donna une pension de 7.000 livres avec le titre de troupe du roi.[50]

The king awards the troupe of actors led by Molière a pension of 7,000 livres. They have performed several times before the king and Molière has written several comedies for the entertainments offered by the king to his court, and His Majesty was so pleased with the results that in August 1665 he gave them a pension of 7,000 livres and conferred upon them the title of King's Troupe.

La Grange's account of the same event places greater emphasis on the human dimension of the switch from Troupe de Monsieur to Troupe du Roi:

Vendredy 14 aoust [1665] la troupe alla à St Germain en Laye. Le Roy dit au Sieur de Moliere qu'il vouloit que la Troupe doresnavans luy appartinst et la demanda a Monsieur. Sa Majesté donna en mesme tems six mil livres de Pension a la Troupe qui prist Congé de Monsieur luy demanda la continuation de sa protection et prist ce tiltre: la Troupe du Roy au pallais Royal. (La Grange 1947, 78)

Friday, August 14 [1665], the troupe went to Saint-Germain-en-Laye. The king told Molière that he wanted the troupe to belong to him from then on, and he asked Monsieur to agree to this. On the same occasion, His Majesty awarded the troupe a pension of 6,000 livres; the troupe took its leave of Monsieur, while asking for his continued protection, and adopted the title of King's Troupe of the Palais-Royal.

Meanwhile, interest in seeing *Tartuffe* persisted in certain circles. In October 1665, Condé's son, the duc d'Enghien, wrote (using spelling that is eccentric even by the standards of the day) to one of his father's chargés d'affaires in Paris to request a private performance:

Monsieur mon père ira à la Saint-Hubert à Versaille et le lendemain de la Saint-Hubert il ira au Rincy où Madame la Princesse Palatine ira l'attendre. On y voudroit avoir Molière pour jouer la comédie des *Médecins* [i.e., *L'Amour médecin*] et l'on voudroit aussi y avoir *Tartufe*. Parles-luy en donc pour qu'il tiene ces deux comédies prestes et s'il y a quelque rôle à repasser qu'il les face repasser à ces camarades. S'il en vouloit faire quelque difficultés, parles luy d'une manière qui lui face comprendre que Monsieur mon Père et moy en avons bien envie et qu'il nous fera plaisir de nous contenter en cela et de n'y point aporter de difficulté. Si le quatriesme acte de *Tartufe* estoit faict, demandés luy s'il ne le pouroit pas jouer. Et ce qu'il faut lui recommander particulièrement c'est de n'en parler à personne et l'on ne veut point que l'on le scache devant que cela soit faict.[51]

> *For the feast of Saint Hubert, my father will go to Versailles; the following day he will go to Raincy, where the Palatine Princess will await him. They would like Molière to join them to perform* Les médecins *[i.e.,* L'Amour médecin*]; they would also like to see* Tartuffe. *Speak to him about this so that he may have both comedies ready and in case he needs to rehearse any of the parts with his troupe. If he is hesitant in any way, speak to him in such a way that he understands that my father and I wish it and that he will please us by meeting this request without demur. If the fourth act of* Tartuffe *is finished, ask him to perform that. And above all, tell him that he must not speak of this to anybody, as we do not want it known about in advance.*

Given that *Tartuffe* had already been performed for Condé in the same location almost a year earlier, one wonders why Enghien is so keen to urge secrecy in the matter. Yet Condé's interest in the play was no secret, and he was not a man to be afraid of anyone. Perhaps it was a question less of a need for secrecy than of a need not to raise the hopes of the audience members to be treated to this rare spectacle before the performance was confirmed. In any event, we know from La Grange that the troupe went to Raincy on November 8, 1665, by order of Condé and played *Tartuffe* and *L'Amour médecin*.[52]

A few months later, in February 1666, another prominent individual with a penchant for polemic, Christina of Sweden, requested that the text of *Tartuffe* be sent to her in Rome. In a letter to Jacques d'Alibert, the queen's secretary and master of entertainment, de Lionne penned an interesting response:

> Ce que vous me demandez de la part de la Reine touchant la comédie de *Tartuf*, que Molière avoit commencée et n'a jamais achevée, est absolument impossible, et non-seulement hors de mon pouvoir, mais de celui du Roi même, à moins qu'il usât de grande violence. Car Molière ne voudroit pas hasarder de laisser rendre sa pièce publique, pour ne se pas priver de l'avantage qu'il se peut promettre et qui n'iroit pas à moins de vingt mille écus pour toute sa troupe, si jamais il obtenoit la permission de la représenter. D'un autre côté, le Roi ne peut pas employer son autorité à faire voir cette pièce, après en avoir lui-même ordonné la suppression avec grand éclat. Je m'estime cependant bien malheureux de n'avoir pu procurer cette petite satisfaction à la Reine, et j'espère que Sa Majesté me fera la grâce d'être persuadée que dans tout ce qu'Elle m'ordonnera, quand il sera en mon pouvoir, Elle sera obéie avec ponctualité et chaleur. Cependant, je demeure, Monsieur, etc.[53]

> *What you ask me on behalf of the queen concerning the play* Tartuffe, *which Molière has begun but never finished, is absolutely impossible and*

beyond not only my control but even that of the king himself, unless he were to act in an extremely aggressive manner. For Molière would not wish to make his play public in order not to deny himself the financial benefits that he may expect, and that will be at least 20,000 écus *for his troupe, were he ever to be permitted to perform it. Moreover, the king cannot use his authority to have this play performed, having ordered with great ceremony that it be banned. I consider myself most unfortunate not to have been able to satisfy the queen on this matter, and I hope that Her Majesty will do me the honor of believing that in all that she asks, when it is within my power, I will obey swiftly and enthusiastically. However, I remain, Sir, etc.*

As Rey points out, the very fact that, in the middle of a diplomatic crisis following the death of Philippe IV of Spain on September 17, 1665, a former queen and France's minister of foreign affairs should be corresponding about *Tartuffe* is significant.[54] Once again, the question of Louis XIV's power and authority is evoked. The slightly contorted suggestion put forward is that to request that a copy of *Tartuffe* be sent to Christina would be disagreeable to the playwright himself and only within the king's power as an extreme measure. The argument whereby Molière would not relinquish the manuscript prior to the play's eventual performance is certainly valid, but the suggestion that Molière is the obstacle in Christina's way is surely disingenuous. A more credible reason is given with reference to the king's authority, which has already been invoked in order to suppress the play; he cannot therefore invoke the same authority to promote its dissemination. Not yet, anyhow, for, as Louis XIV's *Mémoires* for 1666 attest, he was still troubled by tensions between the clergy and the *parlement* and especially by the ongoing Jansenist problem and the ensuing threat of schism (Louis XIV 199–201).

1667 Performance

It is not our concern here to attempt to document precisely the changes that the original version of *Tartuffe* underwent between 1664 and 1669, except to the extent that any of the changes might have affected the fortune of the play and the power struggles within which it had become embroiled. However, it should be noted that by the time of the single public performance in 1667, the play had been reworked into five acts and the protagonist renamed Panulphe, his costume bestowing upon him, as Molière will point out in his second petition, an unequivocally lay status, thereby making him an imposter more than a religious hypocrite. We know too that Cléante was in

1667 more acerbic and more pugnacious than in 1669 (by which time some of his more biting remarks had been given to Dorine).[55] The circumstances that led to a single performance at the Palais-Royal theatre on August 5, 1667, are impossible to reconstruct with absolute precision, but the essentials are clear enough: Although the Jansenist controversy was still unresolved (and had indeed been fueled by the publication earlier in 1667 of an illegal Jansenist translation of the New Testament in the vernacular; see what follows), the balance of influence at court was slowly shifting away from the *dévot* and toward a more *mondain* outlook following the death of the Queen Mother on January 20 (and that of Conti a month later) and the inclinations of an increasingly self-confident king. Louis XIV had in 1666 taken the highly controversial step of legitimizing the daughter that he had conceived with Mlle de La Vallière before embarking upon a far more scandalous relationship—a double adultery—with Madame de Montespan. Emboldened, perhaps, by the early successes of the War of Devolution in the Spanish Netherlands and freed from the disapproval of his mother, Louis XIV appears to have given verbal (and, it seems, hasty) permission to Molière to perform *L'Imposteur*, possibly before his departure for Flanders on May 15, 1667, but probably on July 16, 1667, during a brief trip to Saint Cloud to see Madame, who had recently had a miscarriage. It is possible that Louis may even have seen the latest version of the play on this occasion; certainly there appears to have been a private performance of *L'Imposteur* around this time at the behest of Madame. It is to this performance that Brossette's account probably refers:

> Il [Molière] ne laissoit pas de songer aux moiens de trouver le moien de pouvoir jouer sa pièce. Madame, première femme de Monsieur, avoit envie de voir resprésenter le *Tartuffe*. Elle en parla au Roy avec empressement, et elle le fit dans un tems où Sa Majesté étoit irritée contre les dévots de la Cour. Car quelques prélats, surtout M. de Gondrin, Archevêque de Sens, s'étoient avisez de faire au Roy des remonstrances au sujet de ses amours (avec Mlle de Lavallière, Mme de Montespan). D'ailleurs le Roy haïssoit les Jansénistes, qu'il regardoit encore la plupart comme les objets de la comédie de Molière. Tout cela détermina Sa Majesté à permettre à Madame que Molière jouât sa pièce. (*Correspondance* 563–64)

> He continued to think of ways of having his play performed. Madame, the first wife of Monsieur, wanted to see Tartuffe. She spoke about it with some fervor to the king, and she did so at a time when the king was irritated by the dévots *at court. A number of prelates, especially Gondrin, Archbishop*

of Sens, had taken it upon themselves to remonstrate with the king about his love affairs (with Mlle de La Vallière and Mme de Montespan). Furthermore, the king hated the Jansenists, whom he considered to be the principal objects of Molière's satire. And so the king decided to allow Madame to have Molière perform the play.

Whereas in 1664 the *dévots* had sought to use *Tartuffe* as a means of influencing the king and the future direction of his reign, it seems that in 1667 the king used the same play partly as a means of retort against his *dévot* critics. Although Boileau (as reported by Brossette) is deliberately making light of the Jansenist question, the account may offer some insight into how the balance of influence was shifting in Molière's favor: Whereas in 1664 the Jansenist problem was the principal reason behind Louis's ban, in 1667 it may paradoxically have been one reason Louis hastily allowed first a private performance of the play and then what would in the event turn out to be a single public performance of it.[56]

The day after that public performance, one Desfontaines wrote to Hugues de Lionne (who was suffering in bed with a fistula):

> Molière donna hier la première représentation de son *Imposteur*, qui n'est autre chose que *Tartuffe*, qu'il appelle présentement Panulphe. Si Votre Excellence était en état de venir entendre cette pièce, je crois qu'elle y prendrait du plaisir. Molière en donne demain la seconde représentation, mais je crains que ce ne soit la dernière: les petits collets y sont si maltraités que je ne doute point qu'ils fassent tous leurs efforts pour la faire supprimer.[57]

> *Yesterday Molière gave the first performance of his* Imposter, *which is none other than* Tartuffe, *who is now called Panulphe. If your Excellency were able to come and hear the play, I think that you would enjoy it. Molière will give the second performance tomorrow, but I fear that it will be the last because the* petits collets *are so badly treated in it that I have no doubt they will go to great lengths to have the play banned.*

The intervention in fact came even sooner than Desfontaines anticipated, since we know from La Grange (1947, 91) that, in the king's absence, the first president of the *parlement*, Lamoignon, took matters into his own hands and sent a bailiff (and, according to Boileau, some archers) to the Palais-Royal theatre on August 6, 1667, barring entrance to the building. As far as Lamoignon was concerned, the ban on the play had not officially been lifted and was still therefore in place. It was simply his duty to ensure that the ban was upheld.

Second Petition

In the wake of this blow, Molière and his troupe went six weeks without performing at all. Molière wrote a second petition to Louis XIV and, undeterred by the fact that the king was waging war in Flanders, sent two members of his troupe, La Grange and La Thorillière, to deliver it.[58] The petition begins with the admission that it is "une chose bien téméraire . . . que de venir importuner un Grand Monarque au milieu de ses glorieuses Conquêtes" (Pléiade II, 193) (*evidence of great audacity to importune a great monarch in the midst of his glorious conquests*), and the fact that Molière does so is both evidence of his desperation and an indication, perhaps, that the play's fate is not unrelated to greater matters of state. Molière immediately sets up the stakes as being those of authority and power, asking rhetorically, "Qui puis-je solliciter contre l'autorité de la Puissance qui m'accable, que la source de la Puissance et de l'Autorité, que le juste Dispensateur des ordres absolus; que le Souverain Juge, le Maître de toutes choses?" (Pléiade II, 193) (*To whom can I appeal against the authority and power that is crushing me, save to the very source of power and authority, the just dispenser of absolute commands, the sovereign judge and master of all things?*). At the same time that Molière respectfully acknowledges the legitimacy of Lamoignon's (temporal) authority and power, he reminds Louis that the king's power is of a different nature altogether and that the former pales into insignificance in comparison with the latter. The implication is of course that Lamoignon's lesser authority and power is somehow in conflict with Louis's greater authority and power and that the king's support of the play should trump Lamoignon's opposition to it. From Lamoignon's point of view, this makes little sense given that we assume he believed himself to be carrying out the king's wishes by enforcing the same king's ban. If, however, we understand the king to have given Molière verbal permission to perform *L'Imposteur*, the playwright's logic is irrefutable: Who is Lamoignon to counter kingly consent?

Molière goes on to spell out the modifications that he has made to the play, notably regarding Panulphe's status as a man of the world, and some adjustments that he has made to the text in the case of anything "que j'ai jugé capable de fournir l'ombre d'un prétexte aux célèbres Originaux du Portrait que je voulais faire" (Pléiade II, 193) (*that [he] considered capable of providing the famous models for the portrait that [he] wished to make with the slightest pretext*). He surmises that "la Cabale s'est réveillée aux simples conjectures qu'ils ont pu avoir de la chose. Ils ont trouvé moyen de surprendre des Esprits,

qui dans toute autre matière font une haute profession de ne se point laisser surprendre" (193) (*the cabal has risen up in response to mere conjectures that its members have made about the affair. They have found the means to take by surprise minds that in any other situation are careful not to be caught out*). Whereas it was Louis XIV whom Molière portrayed as having been taken in by the Tartuffes in his first petition, here it is Lamoignon (about whom Molière is careful to say nothing openly insulting, stating rather that he is "un pouvoir qui doit imposer du respect" (194) [*a source of power that demands respect*]). Molière then alludes to the fact that all he could do in the face of Lamoignon's obstruction was invoke the permission granted by the king to perform the play, "dire que Votre Majesté avait eu la bonté de m'en permettre la représentation" (194) (*to say that Your Majesty had had the kindness to permit the performance*). To this he adds the devastatingly logical argument whereby "je n'avais pas cru qu'il fût besoin de demander cette permission à d'autres, puisqu'il n'y avait qu'Elle seule qui me l'eût défendue" (194) (*[he] had not thought it necessary to obtain permission from anybody else, since it was [His] Majesty alone who had forbidden it*).

Molière then takes aim at his alleged enemies, whom he will once again label as Tartuffes.[59] He develops the idea of Lamoignon and other "véritables Gens de bien" (*truly good people*) being "d'autant plus prompts à se laisser tromper, qu'ils jugent d'autrui par eux-mêmes" (*all the more inclined to be taken in because they judge others by their own standards*)—surely something of a back-handed compliment—and states overtly, "Je ne doute point, SIRE, que les Gens que je peins dans ma Comédie, ne remuent bien des ressorts auprès de Votre Majesté" (Pléiade II, 194) (*I do not doubt, Sire, that those whom I depict in my comedy are trying to pull strings in order to influence Your Majesty*). The uncomfortable suggestion is that the king is thus implicated among the decent folk who are taken in and held up as an object of *dévot* machinations. As he pursues his defensive attack, Molière refers instead, though obliquely, to the wisdom of Condé, who observed that the *dévots* allowed far less decent plays than *Tartuffe/L'Imposteur* pass without comment because "celles-là n'attaquaient que la Piété et la Religion, dont ils se soucient fort peu; mais celle-ci les attaque, et les joue eux-mêmes, et c'est ce qu'ils ne peuvent souffrir" (194) (*those plays merely attacked piety and religion, for which they care very little, but this one attacks them and makes a mockery of them, something they cannot bear*).[60] Molière then goes on to make a new and interesting point whereby the scandal of the play lies elsewhere and that "tout Paris ne s'est scandalisé que de la défense qu'on en a faite" (194) (*the

whole of Paris is scandalized only by the ban). If Louis's principal goal in banning *Tartuffe* was to avoid scandal, then this is potentially a highly persuasive argument, although Louis had uppermost in his mind the need to avoid scandal among leading churchmen, whereas Molière is referring to a more *mondain* public. Nonetheless, it is possible that Louis's former strategy was beginning to unravel. As in the previous petition, Molière puts the onus back on the king but threatens to abandon writing comedies if the Tartuffes have the upper hand. He asks for the king's protection against their venomous rage and asks to be able to "faire rire le Monarque qui fait trembler toute l'Europe" (194) (*make the same king laugh who makes the whole of Europe tremble*). The petition did not, however, have the desired effect. La Grange recorded the outcome of the trip to Flanders by noting simply that "Sa Majesté nous fist dire qu'à son retour a paris Il feroit examiner la piece de Tartuffe et que nous la jouerions" (1947, 91) (*His Majesty informed us that he would, on his return to Paris, have* Tartuffe *examined and that we would perform it*). While this somewhat ambiguous response gave some cause to hope, it did not provide the unequivocal endorsement that Molière no doubt wished for.

Meeting with Lamoignon

Meanwhile, according to Brossette, Molière sought the help of Madame, who, as we have seen, played a key (if indirect) role in lifting the ban in the first place. She seems to have been willing to confirm the veracity of the alleged verbal permission that had recently been granted by the king:

> Le Roi étant parti, Molière, en suite de la permission du Roy, fit représenter son *Tartuffe* le 5 aoust 1667, et le promit encore pour le lendemain. Mais Monsieur le président le défendit le même jour . . . Molière porta ses plaintes à Madame, qui voulut faire savoir à Monsieur le premier président les intentions du Roy.
> M. Delavau, l'un des officiers de Madame . . . s'offrit d'aller parler à Monsieur le premier président de la part de son Altesse Roiale. Madame le chargea d'y aller, mais il gâta tout, et compromit Madame avec M. de Lamoignon, qui se contenta de dire à Monsieur Delavau, qu'il savoit bien ce qu'il avoit à faire, et qu'il auroit l'honneur de voir Madame.
> M. le premier président lui fit en effet une visite trois ou quatre jours après, mais cette princesse ne trouva pas à propos de lui parler de *Tartuffe*: de sorte qu'il n'en fut fait aucune mention. (*Correspondance* 564)

> *In the king's absence and with his permission, Molière performed his* Tartuffe *on August 5, 1667, and was proposing to do so again the next day. But Monsieur the president forbade it the same day. Molière complained to Madame, who wanted to convey the king's intentions to Monsieur the first president.*
>
> *M. Delavau, one of Madame's officers, offered to go and speak with the first president on behalf of her Royal Majesty. Madame bade him go, but he ruined everything and compromised Madame in the eyes of M. Lamoignon, who contented himself with saying to M. Delavau that he knew what he had to do and that he would be pleased to meet with Madame. The first president did indeed come to see Madame three or four days later, but the princess did not see fit to discuss* Tartuffe *with him, and no mention was made of it.*

His efforts to rally effective support from Madame having failed, Molière (who was presumably still awaiting a response from the king) took up Boileau's offer for them to meet with Lamoignon in person. Brossette's account continues:

> Un matin, nous allâmes trouver M. de Lamoignon, à qui Molière expliqua le sujet de sa visite. Monsieur le premier président lui répondit en ces termes: Monsieur je fais beaucoup de cas de votre mérite: je say que vous êtes non-seulement un acteur excellent, mais encore un très habile homme qui faites honneur à votre profession, et à la France votre pays: cependant avec toute la bonne volonté que j'ay pour vous, je ne saurois vous permettre de jouer votre comédie. Je suis persuadé qu'elle est fort belle et fort instructive, mais il ne convient pas à des comédiens d'instruire les hommes sur les matières de la morale chrétienne et de la religion: ce n'est pas au théâtre à se mêler de prêcher l'Evangile. Quand le Roy sera de retour, il vous permettra, s'il le trouve à propos, de représenter le *Tartuffe*, mais pour moy, je croirois abuser de l'autorité que le Roy m'a fait l'honneur de me confier pendant son absence, si je vous accordois la permission que vous me demandez. (*Correspondance* 565)
>
> *One morning we went to find M. Lamoignon, to whom Molière explained the purpose of his visit. Monsieur the first president responded in the following terms: Monsieur, I set great store by your merit; I know that you are not only an excellent actor but also a very talented man and a credit to your profession and to your country. However, despite all the goodwill that I bear toward you, I cannot permit you to perform your play. I am convinced that it is well crafted and most instructive, but it is not for actors to instruct men on matters pertaining to Christian morality and religion. It is not for the theatre to preach the gospels. When the king is back, he will*

allow you, if he sees fit, to perform Tartuffe, *but for my part I would be abusing the authority that the king has done me the honor of bestowing upon me if I were to grant your request.*

We note that Lamoignon gives two different reasons for his refusal to grant Molière his request: First, he expresses a very clear personal opinion on the matter, whereby the theatre is not an appropriate venue or form for religious instruction. He therefore accepts the idea that the theatre can instruct as it entertains but rejects the precept in the case of matters religious. He then hides behind the temporary nature of the authority that the king has, he claims, left in his hands, refusing to agree to lift a ban that he clearly believes still to be in place. The first is a matter of principle; the second, a matter of practicality. Neither has anything specifically to do with the finer points of *Tartuffe* or, in its 1667 incarnation, *L'Imposteur*. Interestingly, between the two sits the suggestion that the king might indeed hold a different opinion on the matter, that Lamoignon and the king might not share the same view on the question of religion in the theatre. And it is this particular objection that seems to have confounded the playwright:

> Molière, qui ne s'attendoit pas à ce discours, demeura entièrement déconcerté, de sorte qu'il lui fut impossible de répondre à Monsieur le premier président. Il essaia pourtant de prouver à ce magistrat que sa comédie étoit très innocente, et qu'il l'avoit traitée avec toutes les précautions que demandoit la délicatesse de la matière du sujet: mais quelques efforts que pût faire Molière, il ne fit que bégaier et ne put point calmer le trouble où l'avoit jeté Monsieur le premier président. Ce sage magistrat l'ayant écouté quelques momens, lui fit entendre, par un refus gracieux, qu'il ne vouloit pas révoquer les ordres qu'il avoit donnez, et le quitta en lui disant: Monsieur, vous voyez qu'il est près de midi, je manquerois la messe si je m'arrêtois plus longtems.
> Molière se retira, peu satisfait de lui-même, sans se plaindre pourtant de M. de Lamoignon, car il se rendit justice. Mais toute la mauvaise humeur de Molière retomba sur Monsieur l'Archevêque (de Péréfixe) qu'il regardoit comme le chef de la cabale des dévots qui lui étoit contraire. (*Correspondance* 565)

> *Molière, who was not expecting this response, was so utterly taken aback that he was unable to respond to Monsieur the first president. However, he tried to prove to the magistrate that his comedy was entirely innocent and that he had taken all the necessary precautions required by such delicate subject matter. But for all his efforts, Molière could only stammer and was unable to regain his composure. This wise magistrate, having listened to*

him for a few minutes, made it clear by his gracious refusal that he did not want to revoke the orders that he had already given. He left Molière, saying "Monsieur, you see that it is nearly midday; I will miss mass if I stay here any longer."

Molière retired, dissatisfied with himself, but he did not complain about Lamoignon, who had justified his actions. All Molière's ill feeling was directed at Monsieur the Archbishop Péréfixe, whom he considered to be at the head of the dévot *cabal that conspired against him.*

Molière's insistence in his second petition on a *dévot* conspiracy, though rhetorically interesting, seems unwarranted in 1667 given the nature and context of Lamoignon's intervention (assuming, that is, that Lamoignon did not know about the verbal permission, as appears to be the case). However, it gains at least some credibility in the wake of Péréfixe's extraordinarily high-handed intervention on August 11, 1667.

Péréfixe's Decree

Lamoignon appears to have acted in this affair not as first president of the Parisian *parlement*, but rather as Louis XIV's deputy during his absence. Whatever the case, Lamoignon's move to suppress *L'Imposteur* was a legal matter, made in the name of temporal power and authority. In supplementing, not to mention trumping, Lamoignon's orders, Archbishop Péréfixe brought down on Molière and his play the additional and more complex weight of ecclesiastical power and authority. In his formal *Ordonnance de Monseigneur l'archevêque de Paris* of August 11, 1667, to be posted on the walls of Paris and read out from its pulpits, Péréfixe provided the first official, written document condemning the play.[61] Péréfixe explains that he is acting at the behest of his "Promoteur," the chair of the Assembly of the Clergy. The arguments leveled against the play are probably much the same as those the archbishop put forward in 1664, whereby it is

> une Comédie très dangereuse et qui est d'autant plus capable de nuire à la Religion, que sous prétexte de condamner l'hypocrisie, ou la fausse dévotion, elle donne lieu d'en accuser indifféremment tous ceux qui font profession de la plus solide piété, et les expose par ce moyen aux railleries et aux calomnies continuelles des Libertins. (Pléiade II, 1168)

> *a very dangerous play that is all the more likely to cause harm to religion owing to the fact that, while claiming to condemn hypocrisy, or false devotion, the play provides grounds to accuse indiscriminately all those who*

profess the most steadfast piety and thereby exposes them to the continual mockery and slander of the libertines.

Péréfixe's line on the question of true and false devotion was discussed in Chapter 4. What is interesting here is the suggestion that true religion will be exposed to mockery, for, following from Molière's suggestion in his second petition that the true scandal of *Tartuffe-L'Imposteur* lies with the ban itself, it will be seen below that Péréfixe's heavy-handed response to *L'Imposteur* would indeed turn out to be an object of mockery:

> Nous, sachant combien il serait en effet dangereux de souffrir que la véritable piété fût blessée par une représentation si scandaleuse et que le Roi même avait ci-devant très expressément défendue. Et considérant d'ailleurs que dans un temps où ce grand Monarque expose si librement sa vie pour le bien de son Etat, et où notre principal soin est d'exhorter tous les gens de bien de notre Diocèse à faire des Prières continuelles pour la conservation de sa Personne sacrée, et pour le succès de ses Armes; Il y aurait de l'impiété de s'occuper à des spectacles capables d'attirer la colère du Ciel; Avons fait et faisons très expresses inhibitions et défenses à toutes personnes de notre Diocèse, de représenter, lire ou entendre réciter la susdite Comédie, soit publiquement, soit en particulier, sous quelque nom et quelque prétexte que ce soit, et ce sous peine d'Excommunication. (Pléiade II, 1168–69)

> *In view of how dangerous it would be to allow true piety to be wounded by such a scandalous performance, and given that the king himself has already explicitly banned it—considering, moreover, at a time when this great monarch is so freely exposing his person for the good of his state and when our principal aim is to exhort all good people within our diocese to pray continually for the conservation of his holy self and for his success in arms—it would be impious to busy ourselves with spectacles that are capable of inciting the wrath of heaven. For these reasons, we have banned and do ban all people from our diocese from performing, reading, or hearing read the aforementioned play, in public or in private, under any name or pretext, and this under threat of excommunication.*

Alongside the familiar argument about true and false devotion and the reminder that the play had been unambiguously forbidden by the king (we assume that Péréfixe, like Lamoignon, was unaware of the verbal permission given to Molière), Péréfixe adds a new reason to condemn *Tartuffe* in the form of the current war and the king's active participation therein. Although Péréfixe would have condemned *Tartuffe*

(and, as we read at the end of the *Ordonnance*, all plays like it) on the basis of its irreverent content alone, he also suggests that such a ban is particularly appropriate in certain contexts. We note that Péréfixe makes no mention of the Jansenist affair.

The weight of the threat of excommunication, meanwhile, raised the stakes of the controversy substantially. The very act of coming into contact with the play has become a matter of personal salvation, with Péréfixe urging his clergy to convey to their parishioners how important it was not to attend the performance or reading of this or any play like it. And the blanket ban meant that nobody under Péréfixe's jurisdiction was exempt under any circumstances, including, of course, Louis XIV himself. The threat of excommunication was not to be made lightly, but Péréfixe was to resort to it once again later that same year. The New Testament of Mons, a translation into the vernacular by Le Maistre de Sacy, in collaboration with Antoine Arnauld and Pierre Nicole, had begun to circulate clandestinely in Paris in the second half of 1667.[62] The anti-Jansenist attack on the translation was inaugurated by one père Maimbourg, whose sermons advised against the work but served only to publicize it further. In September 1667 a strategic plan was devised in response to the Jansenist New Testament involving representatives of the Church and of the king. On November 18, 1667, Péréfixe threatened excommunication to all in possession of this bad book in terms that were very similar to those still hanging over *L'Imposteur*. This was followed four days later by a writ from the Council of State. However, the acute seriousness of the threats, while no doubt putting the fear of God into some, undermined their reception by others, and, unsurprisingly, Péréfixe's extravagance attracted more criticism than the more measured terms of the state authorities.

The parallel between the two events was picked up by at least one contemporary, who wrote:

> Molière est consolé de la rigueur extrême
> Dont on avait usé envers son bel esprit:
> Qui censura *Tartuffe*, a censuré de mesme
> La parole de Jésus-Christ.[63]

> *Molière may take consolation for the extreme rigor*
> *With which his talents were met:*
> *For he who censored* Tartuffe *has likewise censored*
> *The word of Jesus Christ.*

However, the threat of excommunication hanging over *L'Imposteur* appears to have dwindled at about the time that Péréfixe issued the same threat with regard to the offending New Testament—partly because so many people had already bought copies of the latter and because the second threat was, in practice, unenforcable. The abbé Jean Deslions wrote in his journal for November 29, 1667, an account of his meeting with the abbé of Saint-Geneviève:

> J'ay appris que l'ordonnance de M. de Paris [Péréfixe] contre le nouveau Testament de Mons, étoit reçuë de tout le monde avec mépris et indignation.
>
> *I have learned that Péréfixe's decree against the New Testament of Mons was received by all with scorn and indignation.*

He understood that

> l'archevesque ne tiendroit pas longtemps sa rigueur sur cette ordonnance et qu'il en arriveroit comme de Tertuffle de Molière, que l'on a vû deffendre cet été sur peine d'excommunication, et qu'on recommence à jouër à présent sur une permission de bouche que M. de Paris s'est relaché de donner sur la prière de quelques Puissances. (cited in Dieudonné, 102–3)
>
> *the archbishop will not hold out for long on this decree, and the same thing will happen as it did for Molière's Tartuffe, which was banned this summer on pain of excommunication and is being performed again on the basis of verbal permission reluctantly granted by Péréfixe in response to a request from certain authorities.*

The suggestion is that by this time Péréfixe was already informally allowing individuals to see or hear the play in private. Given the nature of the obstacle to be overcome and Péréfixe's own high status, the certain authorities putting pressure on the archbishop must surely have been no lesser figures than Louis XIV and his representatives.

The *Avis de Baluze*

If Péréfixe's pronouncements were mocked by some, Louis XIV was in no position to ride roughshod over them. As the most Christian king and as a member of Péréfixe's diocese, Louis undoubtedly took the threat of excommunication seriously and understood that this had

become the greatest obstacle to the public performance of the play. It also constituted a threat to his own authority. With a view to reasserting his kingly authority in this and other matters, Louis appears to have asked Colbert, with the help of his librarian, an expert in ecclesiastical matters and a theologian from the Sorbonne, one Etienne Baluze (1630–1718), to look into the matter.[64] Baluze, a doctor in canon law, who had been secretary to Marca, Archbishop of Toulouse between 1654 and 1662, had only a few months earlier entered Colbert's service as a librarian. Baluze was asked to pronounce on the question of whether or not Péréfixe was acting legitimately when he threatened to excommunicate those who performed, read, or heard recited, in public or in private, Molière's *Tartuffe*. Baluze's response is very interesting:

> Ces peines ecclésiastiques sont d'une très grande considération, lorsqu'elles sont justes et canoniques. Mais il faut que pour estre réputées canoniques on ait observé toutes les formalités en tel cas requises; les anciens Pères et les Conciles ayant en toutes occasions recommandé aux Pasteurs de ne lascher pas l'excommunication témérairement et inconsidérément.
>
> Il reste donc à sçavoir si cette excommunication a esté décernée canoniquement et si l'Eglise peut se mesler de cette sorte de choses. Il semble d'abord qu'on n'a pas observé toutes les formes, puisque M. de Paris ne décerne pas cette excommunication avec pleine connoissance de cause, mais sur une simple plainte de son Promoteur . . . Il semble qu'il falloit déclarer qu'on avoit eu la pièce en main, qu'on l'avoit exactement examinée, et que, par l'examen qui en avoit esté fait on avoit reconnu qu'elle estoit grandement préjudiciable au salut des âmes. (Baluze 125)

> *These ecclesiastical penalties are very commendable when they are just and canonical. But in order to be considered canonical, all the required procedures must have been followed, for the ancient fathers and the councils have always advised pastors not to threaten excommunication recklessly or inconsiderately.*
>
> *It remains to be determined whether or not this threat of excommunication was issued canonically and if the Church is authorized to intervene in such matters. It appears that procedure was not followed entirely, for M. Paris issued the threat not in full knowledge of the facts but rather in response to a simple complaint on the part of his superior. It seems that he should have declared that he had access to the play, that he had examined it in detail and, following such an examination, had concluded that it was deeply prejudicial to the salvation of souls.*

Péréfixe has thus failed to follow correct procedure. Later on, however, Baluze raises more fundamental issues relating to jurisdiction:

> La Comédie est un divertissement public, permis par les princes dans tous les Estats de la Chrestienté, et qui se donne dans des lieux destinés pour cela, et esloignés des églises et des lieux sacrez, et dans des temps qui ne sont pas ordinairement destinés pour la célébration des devoirs chrestiens. Ainsy l'Église ne peut pas se mesler d'empescher cette sorte de divertissemens, encore moins le peut elle par l'employ des peines canoniques et des excommunications. Et quand il se rencontreroit des cas où les comédies iroient à de tels excez qu'on ne pourroit pas s'en taire, les Evesques ne doivent rien faire témérairement, mais s'adresser aux Princes pour faire cesser les scandales par leur auctorité; et si elle ne peut pas suffire, l'Eglise peut prescher contre ces désordres, exhorter les fidèles de n'assister point à ces actions, leur en représenter l'horreur. (126)

> *The theatre is a form of public entertainment permitted by kings in all states across Christendom and performed in locations designed for that purpose, far from churches and holy places and at times that are not ordinarily destined for performing Christian duties. In this way, the Church may not prevent such entertainments; still less may it do so by means of canonical penalties or excommunication. And if it happens that certain plays are so excessive that it is impossible to remain silent on the matter, bishops must do nothing hastily; rather they must speak to their kings in order that they may put an end to the scandal by their kingly authority. If this fails, the Church may preach against these offenses, describing their horrors and exhorting the faithful not to attend such performances.*

By aligning princely (i.e., kingly) authority with legal authority, and separating this political sphere from that of the Church, Baluze strengthens the case against ecclesiastical authority. In extreme cases, when an ecclesiastic might have good reason to speak out, Baluze makes it clear that a vertical hierarchy exists within which even bishops (and archbishops) must recognize the superior authority of the monarch. Bishops may preach against particularly worrisome plays if they see fit, but only the king can act to suppress this type of scandal. In other words, Péréfixe has overstepped the limits of his authority and encroached upon that which rightly belongs to his monarch alone.

The archbishop's decision to invoke the threat of excommunication, Baluze suggests, has in fact done considerable damage to the cause:

Et si les temps sont assez bien disposez pour qu'on puisse user des derniers remèdes sans scandale et qu'on prévoye que la peine d'excommunication ne sera pas suivie du mespris des chrestiens, on peut en user dans les occasions où les choses saintes seroient ouvertement et impudemment tournées en ridicules. (Baluze 126)

If the times were sufficiently well disposed toward these extreme remedies to endure them without complaint, and if one could be sure that the threat of excommunication would not provoke scorn among Christians, it could be used in situations where holy matters were openly and brazenly mocked.

Baluze here acknowledges that it is within an archbishop's purview to threaten excommunication under extreme circumstances when matters religious are openly mocked—and that, of course, is what Péréfixe would claim to have been the case. However, Baluze suggests that the effect of Péréfixe's extraordinary measure is to have provoked the scorn of Christian believers. In a religious rendering of Molière's account of how the ban was received in Paris, the scandal even among Christians is now Péréfixe's decree and not the play itself. For Molière to make this point would have had little impact on the archbishop or any other *dévot* who saw fit to campaign against the play. But for a respected theologian to do so at the behest of the king, secure in the wake of the kingly authority that he has just reasserted, was another matter entirely.

FINAL STAGE: 1669
Peace of the Church

With Péréfixe's decree discredited, the principal obstacle to the definitive lifting of the ban remained what we understand to have been the original one: the Jansenist controversy. This too was moving toward a resolution. According to Kostroun, it was Louis XIV's attempts to discipline Nicolas Pavillon, Bishop of Alet, who had, in a letter dated August 25, 1664, made a bold critique not of papal infallibility but of Louis XIV's wish to exert unchecked royal power in affairs of the Church, that had set in motion the events that would eventually lead to what is known as the Peace of the Church (or the Peace of Clement IX) in 1669 (Kostroun, *Feminism* 175–77, 182). When Louis XIV sought the pope's help in disciplining Pavillon and three other bishops who had come to his defense (François de Caulet, Bishop of Pamiers; Henri Arnauld of Angers, brother of Antoine; and Chouart de Buzenval of Beauvais), this sparked a rebellion among other French

bishops and prominent members of the Church who had until this point cooperated with the king. As the possibility of schism loomed large, and his push toward absolutism was openly challenged, Louis was obliged to negotiate not only with the pope but also with the bishops and others who refused to condemn Jansen (Kostroun, *Feminism* 182).

The peace was facilitated by Pope Clement IX, who had succeeded Alexander VII in 1667. The extraordinarily delicate negotiations were conducted in secret, and two individuals are notable for having been excluded from them: père Annat, Louis's Jesuit confessor; and Archbishop Péréfixe. The Peace of the Church rested on a linguistic fudge. As Sedgwick explains, "a letter to the pope that was to be signed by the four recalcitrant bishops was drafted. In the letter, the bishops declared their desire to end the troubles that afflicted the Church and expressed their apologies for having contributed to these troubles. They agreed to circulate in their dioceses new pastoral letters requiring signature, accompanied by a vaguely worded statement implying mental reservations as to the question of fact" (137). The nuns at Port-Royal would thus agree to sign the new formulary out of obedience but were permitted to imply a degree of uncertainty with regard to whether or not the propositions did in fact appear in Jansen's *Augustinus*.[65] The letter was drawn up in August 1668, and the bishops signed the relevant documents in September that year. The proposition was received in France by a writ from the Council of State on October 23, and Antoine Arnauld was received by the king at Saint Germain the following day. Following some last-minute diplomatic reassurance confirming the sincerity of the bishops' intentions, the pope finally validated the Peace of the Church on January 19, 1669, and sent two briefs back to the French king that together indicated his acceptance of the new status quo. The first was a letter of reconciliation addressed to the four formerly rebellious bishops, and the second was a letter of congratulation addressed to three of the principal mediators: the Archbishop of Sens and the Bishops of Châlons and of Laon. The courier arrived bearing the two briefs in Paris on February 1, 1669, and the papal nuncio, Bargellini, delivered them to Louis XIV on February 3 (see Dieudonné 240–41). Louis may even have lifted the ban on public performances of *Tartuffe* that same day, for the play finally began its extraordinarily successful performance run at the Palais-Royal theatre two days later, on February 5.

Performance and Publication

Protected by the formal authorization of the king, Molière appears to have reverted in the third and final version of his play to the original dress and name of his eponymous hypocrite. Although, as we have seen, the character of Cléante was more biting in 1667 than in 1669, it is likely that the Tartuffe character was more provocative in his final incarnation. Certainly, Molière's third petition to the king (which includes a request, couched in typically satirical terms, that his doctor be granted a canonicate in the Chapelle Royale at Vincennes) is provocative as well as triumphant.[66] In his second paragraph, in which he refers to the lifting of the ban on his play, Molière writes about "la grande résurrection de *Tartuffe*, ressuscité par vos bontés" (*the great resurrection of* Tartuffe, *resuscitated by your goodness*) and, in the event that his current request is granted, of "trop de grâces à la fois" (Pléiade II, 195) (*too much grace in one go*).[67] Not content simply to revel in having won his five-year battle to be permitted to perform the play in public, Molière cannot resist, in the relatively secure position in which he now finds himself, baiting the *dévots* with his unconcealed irreverence. Given his blasphemous use of the terms *résurrection* and *ressuscité* in a sentence in which *Tartuffe* is likened to the risen Christ on Easter Day, the reader is invited to doubt the sincerity with which Molière had previously claimed to have had no provocative intention in writing the play. Whatever Molière's intention in writing *Tartuffe*, it would seem that in the wake of the Peace of the Church, and now safe in the unqualified support of the king, he dared to goad all *dévots*, true and false, by speaking out in this manner.

The publication of the 1669 text of *Tartuffe* followed its first performance remarkably quickly, appearing on March 23 that same year. The fact that it appeared with the publisher, Ribou, but at the playwright's expense (and, of course, to the playwright's benefit) is also noteworthy. This first edition included a preface by Molière in which he reviews the whole controversy,[68] while the three petitions were to appear for the first time in the second edition, published by Ribou, this time at the bookseller's expense, on June 6. Much of the preface restates what had already been included in the first and second petitions. The tone is both triumphant and bitter as Molière hammers home once again his argument that opponents of the play are those hypocrites who featured in it. He implies that he was surprised by their power and states that they had proven to be the most powerful group that he had put on stage so far in his career. The playwright implicitly likens all his opponents to the fanatical Roulé and expresses

his particular regret at the fact that these hypocrites are able to "jeter dans leur parti de véritables Gens de bien, dont ils préviennent la bonne foi, et qui par la chaleur qu'ils ont pour les intérêts du Ciel, sont faciles à recevoir les impressions qu'on veut leur donner" (Pléiade II, 92) (*enlist to their cause some truly good people, prejudicing the good faith of these people whose enthusiasm for heaven's best interests makes them very impressionable*). The playwright claims that "c'est aux vrais Dévots que je veux partout me justifier" (92) (*it is* vrais dévots *everywhere whom I wish to convince*), a claim that was discussed in Chapter 4, alongside his opposition of a *méchant homme* (*bad man*) and a *véritable homme de bien* (*truly good man*). He addresses the question, raised by Lamoignon (but, interestingly, here attributed to "ces Messieurs"), of the place of religion in the theatre and insists on the theatre's didactic function and on the particular corrective power of ridicule: "On souffre aisément des répréhensions; mais on ne souffre point la raillerie. On veut bien être méchant; mais on ne veut être ridicule" (93) (*We can easily bear to be reprimanded, but we cannot bear to be mocked. We are willing to be wicked, but we do not wish to be ridiculous*). Molière revisits the question of the inclusion of sacred terms in the play, which, he claims, are unavoidable when dealing with a subject such as this, and defends himself against his use of "une Morale pernicieuse" (93) (*a pernicious morality* [i.e., Tartuffe's casuistry]), concluding that *Tartuffe* must be sanctioned, or all comedies condemned.

Molière speaks out against the current tendency to attack the theatre in general but rightly reminds the reader of the fact that the Church is not united in its blanket condemnation thereof. Invoking the authority and approval of the ancients, Molière insists on the usefulness of the theatre while admitting that it, like everything else (including religion), is open to abuse on occasion. Molière claims that he seeks to defend only the right kind of theatre. Suggesting that man needs occasional entertainments, Molière insists that there is nothing better than the theatre to fulfil that need. He ends the preface with a word from a great prince on the comedy *Tartuffe*. The great prince is not, significantly, Louis XIV. Rather, it is Condé, who had offered the playwright unwavering support over the previous five years and whose cutting observation about Molière's detractors seems to have struck a real chord with the playwright. According to Molière's second rendering of this anecdote (the first was in the second petition), when the king asked why the same people who are creating a scandal over *Tartuffe* say nothing about *Scaramouche Ermite*, the prince replied, "C'est que la Comédie de Scaramouche joue le Ciel, et la Religion,

dont ces Messieurs-là ne se soucient point; mais celle de Molière les joue eux-mêmes. C'est qu'ils ne peuvent souffrir" (Pléaide II, 96) (*Scaramouche's play features heaven and religion, for which these gentlemen care not a jot, but Molière's play features them, and this is something they cannot bear*).

Conclusion

Molière's insistence to the end on portraying opponents of his play as religious hypocrites is a clever strategy, but a disingenuous and misleading one. While it is true that in 1664 the zealous Company of the Holy Sacrament sought to suppress his play, the pressure exerted on Louis XIV to put in place the ban on public performances almost certainly came from more official sources—notably, his acknowledged advisor and former tutor, Péréfixe. More important than the source of the ban, however, is the argument behind it, and the account given in the *Gazette* on May 17, 1664, offers the most compelling explanation—namely, the need to uphold religious unity at a time when the Church faced a genuine threat of schism. The problem with *Tartuffe*, then, lay not so much with the form or content of the play itself as with the controversy that its being performed might have provoked within the Church. This crucial point is never at any moment addressed by the playwright, not because he was unaware of it (though he almost certainly did not accept its validity), but because, as an argument, it was irrefutable. Whether or not the anticipated harmful impact of allowing public performances of *Tartuffe* to take place was accurately judged is another matter, and one that can never be known. There is some reason to suggest that the substance of the controversy by 1667 lay not with the play at all but with Péréfixe's heavy-handed response to it. The archbishop's threat of excommunication, while no doubt taken seriously by the strictly devout, discredited his campaign among a broader audience, including moderate *mondains* who understood the delicacy of the situation. It also vexed the king, who perceived in Péréfixe's pronouncement an encroachment on his own superior authority. Baluze's pronouncement and the resolution of the Jansenist debacle freed Louis XIV to assert his kingly authority by lifting the ban on *Tartuffe*. As Ranum puts it, "Molière's triumph was the King's as well" (*Paris* 248).

Péréfixe, on the other hand, lost both his struggle against Jansenist resistance (in the sense that he played no part in its resolution) and that against Molière's play. Indeed, it is interesting to note that the archbishop lost out to two such contrasting ideologies: to Molière,

who, in Péréfixe's eyes, represented a libertine tendency; and to the rigorist Jansenists, who were in turn ideologically opposed to all theatre. As the Jansenist controversy raged on during the mid- to late 1660s, other aspects of Louis XIV's reign were changing and developing too. It was seen in Chapter 2 that the question of the king's love affairs was not unrelated to the controversy and that *Tartuffe* was indirectly bound up with a *dévot* wish to curb the young king's penchant for adultery. Whereas in 1664 Louis XIV was involved with the unmarried Louise de La Vallière and Molière's *La Princesse d'Elide* spoke out in favor of a young prince in love (scandal enough), by the time of Molière's *Amphitryon*, first performed on January 13, 1668 (and dedicated to Condé), Louis XIV was defiantly involved in a more scandalous relationship still, with Mme de Montespan, whose husband was still very much alive. The death of the Queen Mother in January 1666 is significant too, though it may have allowed the king more freedom with regard to his love affairs than it did with regard to Molière's play, for we know that she disapproved of the former and can only speculate whether or not she disapproved of the latter. As the king's image was more securely established, thanks in part to Colbert's skill at propaganda, as well as to the success of the military campaign in the Franche-Comté (attributed to Condé, as well as to Louis XIV) and the ensuing peace with Spain, so the king became more confident and better able to assert himself in the face of those seeking to influence him. With the Company of the Holy Sacrament well and truly dissolved and the Jansenist debacle resolved (for the time being), Louis was now able to indulge his *mondain* tendencies by lifting the ban on *Tartuffe*. On this matter, at least, he could now act independently and with absolute authority.

Conclusion

In the course of this study, I have argued that the extraordinary controversy provoked by Molière's *Tartuffe* turned on questions of content and, above all, context. While the content of the play was undoubtedly controversial in and of itself, it is the politico-religious context in which the play appeared that led to a full-blown controversy. I have also argued that what is commonly known as the *Tartuffe* controversy was brought about by a wish to avoid fueling a more dangerous, religious controversy (although, as we have seen, theatre had a role to play in contemporary religious polemic, just as the debates over Molière's play were sometimes couched in fundamentally religious terms).

The reason that is commonly cited to account for the *Tartuffe* controversy is the fact that the play deals with religion and particularly with the phenomenon of religious hypocrisy. While Molière's satirical treatment of such a theme was unlikely to please the devout, this was insufficient in and of itself to necessitate a ban on public performances of the play. Hypocrisy was a phenomenon as old as religion itself, and one that was regularly denounced not only by satirists but also by *dévot* preachers themselves, including Bossuet and Bourdaloue. The repeated allegation used to attack the play (and to justify the ban in 1664), according to which performances of *Tartuffe* were liable to lead to the confusion of true and false religion, is an interesting but highly problematic one. We have seen that while Molière was right to assert that no attentive audience member could possibly mistake Tartuffe for a sincerely devout individual, the greater problem lay rather with the genuine possibility that a more accomplished hypocrite than the theatrical and at least partially comical Tartuffe might be mistaken offstage for the real thing. The real-life *vrai dévot* is externally indistinguishable from the accomplished *faux dévot*, for what distinguishes the two is not in fact their acts but rather something invisible and known only to God. This is why Tartuffe must be a *(faux) faux dévot*, a flawed *faux dévot* who gives himself away.

I have suggested that a deeper, if perhaps subtler, problem lay not with Tartuffe's hypocrisy but with the absence in the play and play world of any credible Christians and, above all, with the fact that the type of morality put forward by Cléante as an alternative to Tartuffe's hypocrisy is not one of religious sincerity but that of the religiously lukewarm (at least in his case) *honnête homme*. The fact that the play ends with a commendation of Valère, who is "généreux et sincère" (V.7.1962) (*generous and sincere*) but who is also, as Orgon observed in II.2.525, no churchgoer, alongside Molière's description in his preface of Cléante as the "véritable homme de bien" (*truly good man*) (Pléiade II, 92), clearly indicates what future lies ahead. No longer a question of sincerity versus hypocrisy, we are faced instead with a question of competing worldviews. This in turn sheds light on Molière's own failure to distinguish between religious hypocrisy and religious zealotry, both of which he associated with the blanket term *faux dévot*. The *vrai dévot*, then, in addition to running the risk of being confused with or tainted by the *faux dévot*, also runs the far greater risk of being substituted in his privileged position as moral exemplar by the *honnête homme* (and his opposite number, the *méchant homme*). While there is scope for the *honnête homme* to embrace orthodox religion, there is also considerable scope for him to distance himself from it; most significant of all is the fact that the stakes at play have shifted dramatically, as questions of individual salvation are no longer uppermost. The threat of hell and the promise of heaven allowed the Church and its representatives to hold considerable sway over people from a variety of social backgrounds; as people became more concerned with the here and now, the balance of power shifted dramatically. While appearing to be concerned with religion, Molière's *Tartuffe* in fact promoted a morality more concerned with the dynamics of social interactions between human beings than with matters spiritual. It was this uncomfortable juxtaposition and the clear endorsement of one over the other that was particularly jarring.

The *Tartuffe* controversy is thus inseparable from the context of 1660s France and particularly from what I have termed the struggle for influence among competing groups or tendencies eager to shape the new reign of the young Louis XIV. The fact that members of the Company of the Holy Sacrament took it upon themselves to attempt to suppress the play even before its first performance at court is indicative of how important the theatre question was, both inherently and symbolically. The fact that *Tartuffe* was singled out for special treatment in this way is in turn indicative of the play's uniqueness—a uniqueness that owes as much to its courtly premiere during *Les Plaisirs de l'île*

enchantée as to its supposedly religious theme. From May 12, 1664, *Tartuffe* became inextricably bound up with what were perceived by the *dévots* as being the pleasure-seeking demonstrations of a manifestly sinful yet rhetorically heroic king, who appeared to be undermining the possibility of a reign firmly grounded in Christian principles. In a sense, Louis's ban on public performances of *Tartuffe* in 1664 may be seen as a practical attempt to recoup some of the Christian credibility that the king had lost, symbolically, at the same *fête* at which the play received its première. I have also argued that *Tartuffe* was banned by Louis XIV because it was controversial and not because it was intrinsically morally suspect. While many *dévots* strongly disapproved of the content of the play, it was its *effects* that were feared above all: While the *dévots* feared that the reputation of the Church would be tarnished by Molière's portrayal of religious hypocrisy (and zealotry), Louis XIV understood that any further controversy relating to matters religious should be avoided for as long as the Jansenist controversy raged on. The moment the Peace of the Church was confirmed in 1669, the ban on public performances of *Tartuffe* was lifted by a still sinful but more authoritative Louis XIV. It should not be assumed that the play was no longer controversial in certain circles; rather, the lifting of the ban indicated that the politico-religious situation in France had changed sufficiently for any controversy that the play might yet provoke to represent a relatively insignificant threat to the stability of the country. This change in context is the most important factor in the lifting of the ban; any changes in the play's content are of secondary importance, and there is reason to believe that the most controversial elements of the play—notably, Tartuffe's status as a lay director who was semiecclesiastical in appearance—were reinstated by 1669. With the play's publication in 1669, its basic content was fixed.

The *Tartuffe* Controversy in Québec (1694)

If the question of *Tartuffe's* official content was now resolved,[1] the play was of course destined to be performed in a variety of different sociopolitical contexts. Meanwhile, the antitheatrical debate endured, and when in 1694 the abbé Caffaro argued that the theatre was not inherently sinful and could be reconciled with religious principles, Bishop Bossuet responded with his hard-hitting *Maximes et Réflexions sur la comédie*.[2] In the same year, *Tartuffe* enjoyed its greatest number of performances (14) in Paris since 1670, and the governor of Québec sought to present an amateur production of the same play in the French colony, precipitating a micro *Tartuffe* controversy.[3] The

colonization of Canada was in many respects a religious enterprise, and in order to preserve the religious purity and unity of the colony, neither Huguenots nor Jews were permitted to settle there. Whereas the Counterreformation represented an attempt to re-Christianize (old) France, New France was thus ripe for Christianization, although the form of Christianity being proposed was broadly the same. However, this did not prevent divergent opinions from emerging with regard to the direction in which the colony should be moving. Where in France we identified an opposition between, broadly, the more *mondain* and the more *dévot* tendencies, alongside hints of deep secularism, in Canada opinion was also divided on the question of whether or not the colony should be ascribed a primarily mercantilist (and Gallican) or a primarily missionary (and Jesuit) purpose (Salomon 102–3). The powerful presence of the French military as well as the absence of any professional theatre companies also played a role in the Québecois controversy.

The governor general at the time was the comte de Frontenac, described by Vincent Grégoire as a "grand mondain" (257) (*notorious man of the world*), who in winter 1693 arranged for amateur performances of Corneille's *Nicomède* and Racine's *Mithridate* to take place at the military base at the Château Saint-Louis. Although the Bishop of Québec, Jean de La Croix-Chevrières de Saint-Vallier, was a known antitheatricalist, these performances appear to have passed without incident. Frontenac then proposed that Molière's *Tartuffe* be performed for the carnival season in 1694, and rehearsals of the play were duly begun.[4] Rumors of an upcoming production of Molière's famously controversial play reached Saint-Vallier, who asked Frontenac for an explanation. Frontenac's response included the devastatingly simple justification "Puisqu'il se joue à Paris" (*Because it is performed in Paris*).[5]

The zealous Saint-Vallier could not remain silent on the matter and set about an anti-*Tartuffe* campaign. On January 10, 1694, the abbé Glandelet preached a sermon warning against the dangers of the theatre. On January 16, the bishop issued two mandates forming a two-pronged attack on *Tartuffe* via its potential audience and its most culpable actor: These were, respectively, the *Mandement au sujet des comédies* (*Mandate on the subject of the theatre*) prohibiting attendance at *Tartuffe* or at any play like it,[6] and the *Mandement sur les discours impies* (*Mandate on impious speech*), in which the bishop denounced the amateur actor and military seaman Jacques Mareuil, who was to perform the role of Tartuffe.[7] Grégoire has noted how the terms of the bishop's mandates recall those of Péréfixe's similarly draconian

decree of 1667 (252). Mareuil, by all accounts, was inclined to lead a disorderly life. Following the mandate against blasphemy, he was refused entry into all churches and barred from receiving the sacraments, with immediate effect. There followed a legal battle between Mareuil (who, as a member of the French military, was supported by Frontenac) and the bishop. In vain, Mareuil professed his Christian credentials and complained to the Sovereign Council about the bishop's inquisitorial leanings and his abuse of power. However, the actor-marine was eventually found guilty on October 14, 1694, and incarcerated. In the meantime, prior to Mareuil being sent to prison, it appears that Saint-Vallier had paid Frontenac 100 *pistoles* to call off the proposed performance of *Tartuffe*.[8] Mareuil was thus condemned on the basis of his participation in rehearsals of a play that was never even performed. But above all, it seems that he was condemned on the basis of his rowdy recidivism that was antithetical to the type of behavior (and by implication beliefs) that the Church of New France was so eager to promote. On November 29, after Saint-Vallier had returned to France, Frontenac declared himself arbiter in the matter and succeeded in liberating Mareuil from prison. Mareuil then proceeded to make further mischief, even performing "some impious acts on the bishop's doorstep."[9] When news of the affair reached Versailles, Mareuil was summoned back to France, where Saint-Vallier was also to plead his cause; only Frontenac remained, as before, in Québec. In the end, all parties were reprimanded by the authorities in Old France, but it was the bishop who, like Péréfixe thirty years before him (both in his harsh treatment of the nuns of Port-Royal and in his propensity to excommunicate), was seen to have overstepped the mark more than anybody else. Saint-Vallier was asked to resign, but he refused and was eventually permitted to return to New France on the understanding that he avoid future confrontations (Grégoire 263).

According to Salomon,

> deux conceptions du catholicisme s'affrontent à Québec en 1694 comme à Paris en 1664, toutes deux départies par l'apparition de *Tartuffe*. Pour l'évêque de Saint-Vallier comme pour le curé Roullé une représentation de *Tartuffe* eût été anathème; pour la société des jeunes gens la pièce était un agréable divertissement. (114)

> *two conceptions of Catholicism collided in Quebec in 1694, just as they had done in Paris in 1664, divided over the performance of* Tartuffe. *For the Bishop of Saint-Vallier, as for the priest, Roulé, the performance of*

Tartuffe *would have been anathema, while for the younger members of society it was simply a pleasant entertainment.*

While he is right to highlight the question of religious outlook, and while the bishop represents the rigorist *dévot* wing and Frontenac can be said to represent something close to an extreme *mondain* position, the unruly Mareuil is more problematic. He is certainly no *honnête homme*, though he may have had something in common with Don Juan, both pre- and postconversion, for Mareuil claimed in his defense to be an observant Christian. However, the catalog of apparently uncontested accusations against him hardly suggests a wish to lead the kind of life that would have been considered Christian even by the more lax or liberal wing of the Church. Above all, Mareuil was considered a problem, and the proposed performance of *Tartuffe* seems to have provided the bishop with an excuse to nail him. The military colonial context also lends an intriguing additional dimension to the affair, for while the Church was the undisputed official authority on matters moral, she was dependent on the military for both the establishment and preservation of that authority. And while Québec was considered an extension of France, the colony was in some obvious ways very remote from the ultimate authority and influence of Versailles.

In both the original *Tartuffe* controversy and the 1694 one in Québec, there were three main protagonists: in the first instance, these were the playwright, the king, and the archbishop; in the second, they were the governor general, a member of the French military with a penchant for amateur dramatics (as well as a level of hooliganism that bordered on the professional), and the bishop. In both instances the high-ranking ecclesiastic was initially effective and influential but ultimately seen to have abused his authority, notably by threatening excommunication. While Louis XIV was cautious in the deployment of his perfectly legitimate power, Frontenac was only able to obtain Mareuil's release by overstepping his. Where Molière was caught in a struggle for influence that extended far beyond the reach of his play, Mareuil had personally displeased his bishop. The *Tartuffe* controversy of 1664–1669 became a matter of state—a testing ground for the struggle for influence and a pawn in the great Jansenist controversy; in 1694 the play was caught up in a more local, personal drama that also bore marks of a less involved but equally interesting struggle for influence.

The Québecois bishop's ability to influence the local council was eventually trumped by the Versailles authorities, but as far as we know,

this was achieved with no direct intervention from the king. Salomon asks rhetorically, "Quelle transgression Frontenac eût-il commise en montrant une pièce autorisée par Louis XIV depuis un quart de siècle?" (114) (*What sin would Frontenac have committed by putting on a play that had been authorized by Louis XIV for a quarter of a century?*). But that is to assume that the situation in France had not changed since 1669, whereas we have already seen that Louis-Apollo had by the early to mid-1680s become more emphatically the most Christian king. By 1694 Louis XIV, now in his 56th year, was accused no longer of sexual or sensual excess but of an excessive adherence to the external trappings of piety and even of excessive piety *tout court*.[10] So while the 1664–1669 controversy found a pro-*Tartuffe* pleasure-seeking Louis XIV obliged to ban public performances of the play until the Jansenist controversy had been quelled and until he had established a firmer grip on France, 1694 coincided with a pious Louis who was now rather disinclined toward the theatre but who allowed good sense to prevail in this instance.

Perhaps the most important lesson to draw from the 1694 *Tartuffe* affair is that the play had not lost its ability to provoke controversy. Given Molière's own casting of himself and his play as persecuted victims of abusive or misguided authority, it is no surprise that *Tartuffe* has acquired considerable symbolic capital as an agent of anything from slight provocation to outright rebellion. As one might expect, *Tartuffe* enjoyed considerable popularity during the French Revolution, although the *rex ex machina* was of course problematic, and the playwright was considered by some revolutionaries to be inseparable from the corruption of the ancien régime.[11] At some fundamental level, however, the play has always succeeded in retaining its satirical bite, even in contexts where it is not remotely controversial. The subject of religious hypocrisy is of eternal and enduring interest, and that of religious fanaticism is an object of particular fascination to a modern public, as was seen in the Introduction to this book. Molière's *Tartuffe* is thus both timeless and inextricably bound up in its early performance (or nonperformance) history. Paradoxically, the unique context of 1660s France bestowed upon Molière's play some polemical and political overtones that were not necessarily present in the text but that have proven extraordinarily productive to theatre directors over the centuries and across the world. In that sense, the controversy served his satire well. Molière spent five years fighting to bring his *Tartuffe* to the theatre-going public; his goal has been achieved with a level of success that outstrips anything the playwright could possibly have imagined.

Notes

Introduction

1. Yale University Press opted not to include reproductions of the offending images in a book on the very controversy that the images had provoked for fear of provoking further violence. See Jytte Klausen, *The Cartoons that Shook the World*, New Haven: Yale University Press, 2009.
2. See Jacob Véronique, "A chacun son Tartuffe," *L'Express*, October 12, 1995, accessed June 18, 2012, http://www.lexpress.fr/informations/a-chacun-son-tartuffe_610166.html.
3. Barry James, "Spotlight Is on the Link of Religion and Power," February 8, 1996, accessed June 18, 2012, http://www.nytimes.com/1996/02/08/opinion/08iht-edbarry.t.html.
4. Michael Billington, "Review of 'Tartuffe,' Arcola Theatre," *The Guardian*, December 11, 2004, accessed June 18, 2012, http://www.guardian.co.uk/stage/2004/dec/11/theatre.
5. Nicholas de Jongh, "Tartuffe Is No Turkish Delight," *The London Evening Standard*, December 13, 2004, accessed June 18, 2012, http://www.standard.co.uk/arts/theatre/tartuffe-is-no-turkish-delight-7383303.html.
6. Throughout this study I am using the generic term *dévot* simply to denote individuals committed to the program of Catholic reform. The specific terms *vrai* and *faux dévot* will be discussed in Chapters 2, 3, and 4.
7. For a useful overview of trends in Molière criticism since 1990, see Noël Peacock, "Molière: état présent," *French Studies* 61: 1 (2010): 64–72.
8. François Rey and Jean Lacouture, *Molière et le Roi: L'affaire Tartuffe*, Paris: Seuil, 2007.
9. Herman Prins Salomon, *Tartuffe devant l'opinion française*, Paris: Presses Universitaires de France, 1962.
10. Salomon rightly points out, for instance, that ecclesiastical works should be used for more than just a (necessarily vain) attempt to find models for Tartuffe: "On y trouve aussi l'écho des émotions que *Tartuffe* suscita au XVIIe siècle. La connaissance de celles-ci jettera peut-être des clartés nouvelles sur l'histoire de la pièce" (169) (*We find in these ecclesiastical works evidence of the emotions that* Tartuffe *aroused*

in the seventeenth century. Our knowledge of these emotions will perhaps shed new light on the history of the play). This is an approach that I gladly develop in the course of the present book.

11. Robert McBride, *Molière et son premier* Tartuffe: *genèse et évolution d'une pièce à scandale*, Durham: Durham Modern Languages Series, 2005.
12. Francis Baumal, *Tartuffe et ses avatars: De Montufar à Dom Juan*, Paris: Nourry, 1925.
13. Francis Baumal, *La Genèse de Tartuffe: Molière et les dévots*, Paris: Editions du livre mensuel, 1919.

Chapter 1

1. In Paul Bénichou, *Morales du grand siècle*, Paris: Gallimard, 1948, it is suggested that the *Tartuffe* controversy is precisely "un épisode du discrédit progressif de la morale chrétienne entre la Renaissance et l'Encyclopédie" (276) (*an episode in the gradual decline of Christian morality between the Renaissance and [Diderot's] Encyclopedia*).
2. See Henry Phillips, *Church and Culture in Seventeenth-Century France*, Cambridge: Cambridge University Press, 1997, 105. As Phillips observes in his conclusion, "the failure of the state to integrate fully Tridentine decrees in law meant that the Church started from a weak position since the Church's influence in the secular space was thereby institutionally much reduced" (299).
3. Jean Calvet, *Essai sur la séparation de la religion et de la vie: Molière dans le drame spirituel de son temps*, Paris: Nizet, 1980. It is perhaps significant that Molière's Orgon was uncorrupted by the Fronde but has been corrupted by the Counterreformation. All quotations from Molière's plays (and, where appropriate, related seventeenth-century texts) are taken from Molière, *Œuvres complètes*, ed. Georges Forestier, Claude Bourqui et al., 2 vols., Paris: Gallimard, 2010, hereafter referred to as "Pléiade." The earlier Pléiade edition of Molière, *Œuvres complètes*, ed. Georges Couton, is referred to as "1972 Pléiade."
4. I use the word, as Roger Mettam does, in the neutral sense of the term: "The word is used here without its modern overtones of factiousness, intrigue and the pursuit of selfish aims by unscrupulous means, although such undesirable characteristics might be present on occasion. Here it is intended as a description of a social group, whose members have banded together in order to further their own best interests, and whose methods, while undoubtedly opportunist, might be perfectly legitimate and legal. It was a commonplace of French society in this period that individual ambition was best advanced by associating with others who had similar or complementary goals" (1). Roger Mettam, *Power and Faction in Louis XIV's France*, New York: Blackwell, 1988.

5. As Wolf has observed, "minority governments had long since been the 'opportunity' for the 'great ones' who wished to reverse the centralizing tendencies of the royal authority; and in the 1640s the 'great ones' were joined by the regular officials of the kingdom (members of the sovereign courts and the municipal and provincial officials) who resented and feared the rising power of the king's council and its agents. The Fronde really started almost as soon as Louis XIII closed his eyes. Beaufort and the 'important ones' plotted to murder Cardinal Mazarin; parlement refused to register the edicts of the council; Condé demanded special favors for his son as soon as that young man won victory for the king's arms; the boy king *had* to hold a *lit de justice* and listen to the tense speeches" (113). John B. Wolf, "The Formation of a King," in *Louis XIV and the Craft of Kingship*, ed. J. C. Rule, Columbus: Ohio State University Press, 1969, 102–31.
6. Calvet hinted at this when he observed that "derrière cette querelle de théâtre, il y avait une grande bataille morale et même, en un sens, politique" (55) (*behind this theatrical quarrel there lay a great moral and even, in a sense, political battle*).
7. The outline of Conti's biography is taken from the *Dictionnaire de biographie française*, vol. 9, Paris: Letouzey, 1961, 538–39. The details regarding Conti's involvement in the Company of the Holy Sacrament are taken principally from the *Annales de la Compagnie du Saint-Sacrement par René de Voyer d'Argenson*, ed. Henri Beauchet-Filleau, Marseille: Saint-Léon, 1900.
8. See 1972 Pléiade I, 996.
9. The Fronde is commonly divided by historians into two parts: the Parliamentary Fronde (1648–1650) and the Princely Fronde (1650–1652). However, Rule, among others, divides the Frondes into three components: the Parlementary or Old Fronde (August 1648–March 1649); the Princely or New Fronde (March 1649–February 1651), in which interests of nobility of robe and sword were joined; and the Condéan Fronde (February 1651 to 1653) (16). John C. Rule, "Louis XIV, Roi-Bureaucrate," in *Louis XIV and the Craft of Kingship*, ed. J. C. Rule, Columbus: Ohio State University Press, 1969, 3–101.
10. Orest Ranum, *Paris in the Age of Absolutism*, New York: Wiley, 1968 (203–4).
11. The *Avis d'Etat à la Reine* (1649) and *La vérité toute nue* (1652), for instance, both urged the dismissal of Mazarin. See Alexander Sedgwick, *Jansenism in Seventeenth-Century France: Voices from the Wilderness*, Charlottesville, VA: University Press of Virginia, 1977 (61–64), for a discussion of the possibility that these two pamphlets were written by the Jansenist Arnauld d'Andilly.
12. Of the many Mazarinades, the most important, if not the most original, was Claude Joly, *Recueil de maximes véritables et importantes pour l'institution du roy, contre la fausse et pernicieuse politique du cardinal*

Mazarin, prétendu surintendant de l'éducation de sa majesté, Paris: [np], 1652.
13. Joseph de Voisin, *La défense du traité de Monseigneur le Prince de Conti, touchant la comédie et les spectacles ou la réfutation d'un livre intitulé "dissertation sur la condamnation des théatres,"* Paris: Coignard, 1671 (419).
14. He was to be a crucial figure in the Jansenist controversy in the 1660s (see Chapter 5).
15. Cited in Pléiade I, lxxxi.
16. See *Church and Culture*, 4–8, 16, and passim.
17. Jean Racine, *Abrégé de l'histoire de Port-Royal*, ed. Alain Couprie, Paris: Table Ronde, 1994 (102–3).
18. Throughout the *Abrégé*, Racine suggests that Louis XIV was heavily influenced by Marca and especially by Annat in his treatment of the Jansenists. According to Racine, Annat would not even hear anyone speak favorably of the Jansenists (156). Briggs, meanwhile, writes of the Jesuits having had Annat "as first their controversialist, then their man in power as confessor to the king after 1653, determined to seize on every opportunity to discredit the supporters of strict Augustinianism" (223). Robin Briggs, *Communities of Belief: Cultural and Social Tension in Early Modern France*, Oxford: Clarendon Press, 1989.
19. For a very helpful introduction to the Company, see Alain Tallon, *La Compagnie du Saint-Sacrement (1629-1667)*, Paris: Cerf, 1990. Tallon proposes a more positive account of the Company than the majority of critics. For another account, see Gustave Michaut, *Les Luttes de Molière*, Paris: Hachette, 1925. See also Raoul Allier, *La Cabale des dévots, 1627–1666*, Paris: Colin, 1902, repr. Geneva: Slatkine, 1970, and, for its relevance to the *Tartuffe* controversy, Francis Baumal's two volumes, *Tartuffe et ses avatars* and *La Genèse de Tartuffe*.
20. Tallon notes that, while this was indeed true of 1660s France, the Company had been making this claim since its foundation (110).
21. See also Baumal, *Tartuffe* 103, where he suggests that Mazarin was more upset by the cabal than the Fronde and even that Conti was more dangerous when he converted than when he participated in the Fronde.
22. Phillips observes that "the Compagnie's aim was in many ways to police the sacred in the social space" (*Church and Culture* 21).
23. Indeed, according to Ranum, "the upper clergy led the campaign against the Company of the Holy Sacrament" (*Paris* 244).
24. Charles Dufour, *Mémoire pour faire connoistre l'esprit & la conduite de la Compagnie establie en la ville de Caën, appellée l'Hermitage*, Caen: [np], 1660 (np).
25. *Lettres choisies de feu M. Guy Patin*, Paris: Jean Petit, 1692 (490).
26. Ranum writes that for all his claims to have softened the blow as much as possible, "Lamoignon may well have played the part of Judas, since

the *arrêt* was accepted without a struggle, though he could have brought the Parlement to oppose Mazarin" (*Paris* 245).
27. See Georges Lacour-Gayet, *L'Education politique de Louis XIV*, Paris: Hachette, 1898 (9–11). Lacour-Gayet's remains the most complete account of Louis's education to date.
28. See Lacour-Gayet 22–93 (ch. 2) for an account of the most important of these treatises. The final section of his chapter (78–93) deals not with treatises that proposed an exemplary kingly education but rather with those that warned against the flaws of the education that Louis was likely to receive at the hands of Mazarin. One in particular— *Catéchisme royal* (1645) by Péréfixe's brother-in-law (Fortin de la Hoguette), was rather forceful with regard to France's financial problems, the misery of the people, the need for peace, and so on. It was felt to be too ambitious and forthright, and Mazarin had the book withdrawn (see Lacour-Gayet 42–51).
29. There is a fairly detailed biography of Le Vayer in La Mothe Le Vayer, *Lettre sur la comédie de l'imposteur*, ed. Robert McBride, Durham: University of Durham, 1994 (157–67), hereafter referred to as "La Mothe, *Lettre*."
30. See La Mothe, *Lettre* 161, and Molière, L'Imposteur *de 1667, prédécesseur du* Tartuffe, ed. Robert McBride, Durham: Durham Modern Languages Series, 1999, 8–9, hereafter referred to as "L'Imposteur."
31. Ruth Kleinman, *Anne of Austria, Queen of France*, Columbus: Ohio State University Press, 1985 (198); see also Lacour-Gayet 14–15.
32. Lacour-Gayet wonders if having Andilly as his tutor would ultimately have changed Louis XIV's attitude toward the Jansenists and concludes that it probably would not have (16). The strength of anti-Jansenist feeling was probably insurmountable, particularly given the powerful Jesuit influence at court, mentioned earlier. But the question is moot, really, since this is precisely why Andilly was not appointed in the first place.
33. Later, of course, the chosen candidate would be deeply involved in the Jansenist controversy. See Chapter 5.
34. Kleinman writes that, "having eliminated the other candidates for political, religious, or personal reasons, Mazarin and the queen settled on Hardouin de Péréfixe, who had served in the late Cardinal Richelieu's household and was therefore a safe, dependable man. Admittedly he was not brilliant, although he was conscientious about fulfilling his duties" (198).
35. Letter to the duc de Mercœur, 1651 (cited in Lacour-Gayet 142).
36. Andrew Lossky, *Louis XIV and the French Monarchy*, New Brunswick: Rutgers University Press, 1994 (67). See Chapter 5 for further discussion of Péréfixe's character.
37. The source for this information is, alas, unreferenced.

38. Hardouin de Péréfixe, *Histoire du Roy Henry le Grand*, Amsterdam: Elzevier, 1661.
39. Louis XIV, *Mémoires de Louis XIV*, ed. Jean Longnon, Paris: Tallandier, 1978 (32–33).
40. It was not uncommon for bishops to reside outside their dioceses, although this was precisely one of the ecclesiastical abuses that the French Reform movement sought to eliminate.
41. La Mothe, *Lettre* 162–63, 165.
42. This is to overstate the case somewhat, as Péréfixe was not fervently antitheatre. As will be seen, he provided Anne of Austria with a theological justification for the theatre in 1647.
43. These are *La Géographie du prince* (1651); *La Rhétorique du prince* (1651); *La Morale du prince* (1651); *L'Economique du prince* (1653); *La Politique du prince* (1654); *La Logique du prince* (1655); and *La Physique du prince* (1658).
44. Although ghost written, Louis XIV's *Mémoires* were composed in close consultation with the king and may, for the purposes of the present study, be considered a reliable account of what he wished to convey at the time of writing.
45. The trial lasted over two years. When the sentence of banishment was finally pronounced, the king, who was disappointed with the result, had it commuted to life imprisonment. Meanwhile, Louis XIV appropriated Molière, Lully, Le Brun, and Le Nôtre for his own projects at Versailles.
46. In one of the best-known contemporary treatises on kingship—Jean-François Senault, *Le Monarque ou les devoirs du souverain*, Paris: Lepetit, 1661—we read that "[le souverain] ne souffre point de nouveauté dans la Religion" (135) (*the sovereign does not tolerate any novelty in matters of religion*).
47. Annat had become Louis's confessor in 1653 following a tip-off in a letter to Mazarin from Rome indicating that Mazarin was perceived as being too tolerant of Jansenism and that père Annat was returning to France from Rome and should be shown due consideration. See Antoine Adam, *Du mysticisme à la révolte: Les jansénistes du XVIIe siècle*, Paris: Fayard, 1968 (205–6n1).
48. The link between piety and politics was of course a given in contemporary views on kingship. Senault, for instance, explains how "la Pieté est le fondement de la Politique" (125) (*piety is the cornerstone of politics*).
49. Here too, Louis overlaps with Senault, who, on the question of individual piety, distinguishes between *l'Affection* (which is internal and seen only by God) and *l'Action* (which covers external ceremonies and visible relationships between human beings). The first of these is hard to know but reliable in its authenticity; the second is easier to know but less reliable (140–41).

50. This is in marked contrast with Senault, who condemns dance (one of Louis's favorite activities), which, he claims, leads to sexual licentiousness (234) and all types of theatre (241–42).
51. Emmanuel Chill, "*Tartuffe*, Religion, and Courtly Culture," *French Historical Studies* 3 (1963): 151–83 (162).
52. François-Hédelin d'Aubignac, *La Pratique du Théâtre*, ed. Pierre Martino, Paris: Champion, 1927 (330).
53. It is interesting to note that when it was founded in 1666 (i.e., during the *Tartuffe* controversy), the Académie Royale des Sciences was not allowed to discuss religion, politics, or, indeed, any sort of controversy (*Church and Culture* 181). As Phillips observes, this strategy of exclusion would in fact compound the Church's problems with regard to its role in society.
54. Antoine Godeau, *Poésies chrestiennes d'Antoine Godeau*, Paris: Le Petit, 1660 (464).
55. Mme de Motteville, *Mémoires de Madame de Motteville sur Anne d'Autriche et sa cour*, ed. M. F. Riaux and M. Sainte-Beuve, 4 vols., Paris: Charpentier, 1855 (I, 304).
56. Kleinman concludes that, while undoubtedly intimate, Anne's relationship with Mazarin was not sexual in nature. While we can never be sure, it is clear that the relationship was a source of scandal and gossip and the subject of further admonishments from Vincent de Paul, among others (166, 170, 232).

Chapter 2

1. For an interesting account of some of the vagaries of seventeenth-century conceptions of religious hypocrisy (including, even, some good uses to which it could be put), see Georges Couton, "Réflexions sur *Tartuffe* et le péché d'hypocrisie, *cas réservé*," *Revue d'Histoire littéraire de la France* 69 (1969): 404–13.
2. Part of this chapter is a reworked version of an article, reproduced here with kind permission: Julia Prest, "Troublesome Sensual Appetites or Who Is the Real *faux dévot*?" in *Nourritures: Actes du 40ᵉ congrès annuel de la North American Society for seventeenth-Century French Literature*, ed. Roxanne Lalande and Bertrand Landry, Biblio 17, Tübingen: Gunter Narr, 2010: 253–63.
3. Jerry Lewis Kasparek, *Molière's* Tartuffe *and the Traditions of Roman Satire*, Chapel Hill: North Carolina Studies in the Romance Languages and Literatures, 1977 (54).
4. *The Fabrication of Louis XIV*, New Haven: Yale University Press, 1992 (137).
5. Most notably, for the present discussion, by Georges Couton in his posthumous book, *La chair et l'âme: Louis XIV entre ses maîtresses et Bossuet*, Grenoble: Presses Universitaires de Grenoble, 1995.

6. Forestier and Bourqui claim that the account was "rédigée sans doute par Charles Perrault sous le contrôle de Colbert" (Pléiade I, 1394) (*no doubt drawn up by Charles Perrault under Colbert's supervision*). First published in 1664 but bearing the date 1665, it is reproduced in full in Pléiade I, 519–99.
7. Reproduced in Pléiade II, 1168–69.
8. Couton says it was delivered after 1670 ("Réflexions" 411). Salomon argues at length in favor of the date being 1691 (88–97). All references to Bourdaloue are taken from Louis Bourdaloue, *Œuvres complètes de Bourdaloue*, ed. prêtres de l'immaculée-conception de Saint-Dizier, 4 vols., Paris: Guérin, 1864.
9. Père Coustel, *Sentimens de l'Eglise & des SS Peres pour servir de discussion sur la Comedie et les comediens*, Paris: Coignard, 1694.
10. This is reproduced in Pléiade I, 519–99, with the full text of *La Princesse d'Elide* featuring between accounts of the second and third days. Forestier and Bourqui call the account a "compromis de façade . . . destiné à masquer les vraies raisons de politique religieuse qui avaient entraîné l'interdiction de la pièce" (Pléiade II, 1361) (*a face-saving compromise intended to mask the real politico-religious reasons behind the ban on the play*).
11. For an interesting interpretation of the power dynamics at play here, see Jean-Pierre Cavaillé, "Hypocrisie et Imposture dans la querelle du *Tartuffe* (1664–1669): La *Lettre sur la comédie de l'imposteur* (1667)," *Les Dossiers du Grihl, Les dossiers de Jean-Pierre Cavaillé, Libertinage, athéisme, irréligion. Essais et bibliographie*, 5, accessed July 8, 2012, http://dossiersgrihl.revues.org/292; DOI: 10.4000/dossiersgrihl.292.
12. He continues, with reference to the theatre and specifically, it would seem, to Molière's *Festin de Pierre*, "pour faire une espèce de diversion dont le libertinage pût profiter, en concevant et faisant concevoir d'injustes soupçons de la vraie piété, par de malignes représentations de la fausse. Voilà ce qu'ils ont prétendu, exposant sur le théâtre et à la risée publique un hypocrite imaginaire, ou même, si vous voulez, un hypocrite réel, et tournant dans sa personne les choses les plus saintes en ridicule, la crainte des jugements de Dieu, l'horreur du péché, les pratiques les plus louables en elles-mêmes et les plus chrétiennes" (II, 236) (*to create a kind of entertainment from which libertinage might benefit, by casting and arousing unfair suspicion on true piety by cunning representations of false piety. This is what they have tried to do by presenting in a piece of comic theatre an imaginary hypocrite, or if you prefer, a real hypocrite, and by ridiculing through his character the most holy things, including a fear of God's judgment, an aversion to sin, and the most laudable and Christian acts*).
13. The same problem was being debated in more free-thinking circles in the seventeenth century as well. Among others, Le Vayer engaged with

the question in a number of his writings. In *De la Vertu des Payens*, he wrote, for instance, that "le vice et la vertu se brouillent quelquefois de telle sorte, qu'on voit des hommes fort vicieux faire de très bonnes actions; et d'autres au contraire qui en commettent de très méchantes, bien qu'ils soient d'ailleurs dans l'exercise de beaucoup de vertus" (cited in Robert McBride, *The Sceptical Vision of Molière: A Study in Paradox*, London: Macmillan, 1977, 50) (*vice and virtue sometimes get confused to the point where we see really wicked men committing good deeds and, conversely, wicked deeds being committed by people who are otherwise very virtuous*). Jean-Luc Robin, meanwhile, has put forward the possibility of a scientific (or quasi-scientific) dimension to the detection of hypocrisy. He argues, for instance, that Elmire's strategy for unmasking Tartuffe is scientific, and that this takes place within the context of another scientific experiment within the play: that undertaken by the king. See *"Experimentum periculosum*. L'expérience cruciale d'El(o)mire," Biblio 17: 168 (2006): 261–72.

14. *Second sermon pour le 11ᵉ dimanche de carême*. Jacques-Bénigne Bossuet, *Œuvres complètes de Bossuet*, ed. F. Lachat, 31 vols., Paris: Vivès, 1862–1875 IX, 112–33 (124). All quotations from Bossuet except those from the 1662 "Carême du Louvre" series are from this edition, hereafter referred to simply as "Bossuet."

15. The *faux dévot* who convinces *himself* that he is sincere also features in Bossuet, *Sermons: Le Carême du Louvre 1662*, ed. Constance Cagnat-Debœuf, Paris: Gallimard, 2001 (214–15). All quotations from this sermon series are from Cagnat-Debœuf's edition, referred to as "*Le Carême*."

16. "L'hypocrisie, dit ingénieusement saint Augustin, est cette ivraie de l'Evangile, que l'on ne peut arracher sans déraciner en même temps le bon grain. Laissons-la croître jusqu'à la moisson, selon le conseil du père de famille, pour ne nous point mettre en danger de confondre avec elle les fruits de la grâce, et les saintes semences d'une piété sincère et véritable" (*Sur l'hypocrisie* II, 234) (*Hypocrisy, says Saint Augustine ingeniously, is the chaff of the Gospels that cannot be uprooted without the wheat. Following the father's advice, let it therefore grow until harvest in order that we avoid the risk of confusing it with the fruits of the holy spirit and with the holy seeds of a sincere and true piety*).

17. H. Gaston Hall reminds us of the "aphrodisiac quality of the exercises hypocritically evoked" by Tartuffe when he mentions his scourge and his hair shirt. Hall also notes that François de Sales in his *Introduction à la vie dévote*, the most widely read devotional guide of the day, warns of such dangers in his chapter on "mortification extérieure." H. Gaston Hall, "Some Background to Molière's *Tartuffe*," *Australian Journal of French Studies* 10 (1973): 110–29 (121).

18. A similarly ironic and almost contemporaneous use of the word *dévotement* is found in Claude Joly's account of religious hypocrites, in which

he complains how "on médite pieusement, on déchire dévotement" (*they meditate piously, they tear each other apart devoutly*). Cited in Michaut, *Luttes* 117.

19. See Marc Escola, "Vrai caractère du faux dévot: Molière, La Bruyère, Auerbach," *Poétique* 98 (April 1994): 181–98.
20. Of course, such discrepancies are also part of a moliéresque comic tradition that stretches back at least as far as his discussion of the multilayered *vraies* and *fausses précieuses*. In his preface to *Les Précieuses ridicules*, Molière addresses the controversial question of satire and degrees of remove when he writes that "les véritables précieuses auraient tort de se piquer lorsqu'on joue les ridicules qui les imitent mal" (*true* précieuses *would be wrong to take offense when we depict the ridiculous individuals who are only a poor imitation of them*).
21. Larry Riggs identifies the pleasure Tartuffe takes in speaking as another of his sensual appetites (51–52). See "Molière's 'Poststructuralism': Demolition of Transcendentalist Discourse in *Le Tartuffe*," *Symposium* 44: 1 (1990): 37–57.
22. For a discussion of Elmire's techniques, see Julia Prest, "Elmire and the Erotics of the ménage à trois in Molière's *Tartuffe*," *Romanic Review* 102 (2011): 129–44. See also Gilles Declercq, "Equivoques de la séduction. Elmire entre honnêteté et libertinage," Biblio 17: 181 (2009): 73–127.
23. Pierre Le Moyne, *De l'art de régner*, Paris: Cramoisy, 1665 (51). A similar sentiment is expressed by Garaby de la Luzerne in a satirical ditty in his *Sentiments Chrestiens, politiques, et moraux. Maximes d'estat, et de Religion*, Caen: Yvon, 1654: "Pour rendre le succez facile / De quelqu'importante action, / Le pretexte le plus utile / Est celuy de Religion. / Qu'un Politique est bien adroit / Quand il met Dieu de la partie; / Et pour authoriser son droit / Qu'il prend le Ciel à garantie" (85) (*In order to guarantee the success of some important event, the most useful pretext is religion. A cunning politician has God on his side and invokes heaven to legitimize his claim*).
24. See *La chair* for an account of some of the key incidents.
25. Abby Zanger, *Scenes from the Marriage of Louis XIV: Nuptial Fictions and the Making of Absolutist Power*, Stanford: Stanford University Press, 1997 (14). Zanger suggests that Louis XIV's scandalous relationship with Marie Mancini prior to his marriage (but following a life-threatening illness) "may have been utilized or even staged by Mazarin in order to demonstrate to the country that the king's body was once again in good working order" (30).
26. See Francis Assaf, *La Mort du roi. Une thanatographie de Louis XIV*, Biblio 17: 112, Tübingen: Gunter Narr, 1998, Part I ("le corps du roi").
27. As Couton explains, the principal individual with the right to warn and even, in extremis, to discipline the king was his Jesuit confessor.

Between 1654 and 1670, this position was occupied by François Annat, who was followed by Jean Ferrier (1670–1674) and then, after a hiatus of a few months following Ferrier's death, François de La Chaise (1675–1709). The king's last confessor was Michel Le Tellier (1709–1715). Depending on where the court was at any given time, others who might have been in a position to invoke such authority included the parish priest of Saint-Germain-l'Auxerrois, which encompassed the Louvre where the king traditionally heard his Easter sermon; the Archbishop of Paris; the priest of the parish of Fontainebleau, where Louis was occasionally in residence, as well as the Archbishop of Sens, diocesan of Fontainebleau; possibly also the Grand Almoner, Cardinal Barberini, and the first Almoner, the abbé de Coislin (*La chair* 61–62).

28. For an interesting analysis of his techniques, see Constance Cagnat-Debœuf, "Un sermon en anamorphose: le discours au roi dans le *Carême du Louvre*," in *Lectures de Bossuet, Le Carême du Louvre*, ed. Guillaume Peureux, Rennes: Presses Universitaires de Rennes, 2001: 111–28.

29. Jacques Morel suggests that the famous begging scene in *Le Festin de Pierre* is a criticism of the same scandal of inequality and thus of hypocrisy. See "A propos de la 'scène du pauvre' dans *Dom Juan*," *Revue d'histoire littéraire de la France* 72 (1972): 938–44 (944).

30. Jean-Marie Apostolidès, "Le Spectacle de l'abondance," *Esprit créateur* 19: 3 (1981): 26–34 (27). See also Jean-Marie Apostolidès, *Le roi-machine: Spectacle et politique au temps de Louis XIV*, Paris: Minuit, 1981.

31. Couton notes that both Mme de Montespan's cuckolded husband and Louis's future second wife, Mme de Maintenon, drew on the story of King David in their attempts to make Louis understand what he was doing (see *La chair* 90, 185–86). Senault, meanwhile, gives David as an example of a great and pious king. He admits that David was an adulterer and a murderer but insists on his great repentance, which eventually earned him forgiveness (*Monarque* 158).

32. According to Phillips, the contrition-attrition controversy reached its height in the first half of the seventeenth century; Richelieu himself had written in favor of attrition, and the Jansenist favoring of contrition placed them in opposition to him. Louis XIII reportedly lost sleep over the Jansenist preference for contrition (Phillips, *Church and Culture* 271). Ranum gives a slightly different take on the matter, whereby the attritionist position was that "sincere repentance over one's sins, when joined with absolution, sufficed as preparation for communion," while "the Jansenists insisted that in addition to love of God, there must be something of an ethical-psychological cleansing of the sinner before he be allowed to take communion" (*Paris* 125).

33. In a recent biography of Louis XIV, Anthony Levi concludes that Louis cannot have believed that his behavior, although sinful, would actually

lead to damnation, despite the Church's clear teaching on the matter. He makes the same argument about Anne of Austria and Mazarin (whom he firmly believes to have been Louis's father) (130, 234). Anthony Levi, *Louis XIV*, New York: Carroll and Graf, 2004.

34. This passage (re)appears almost verbatim in the *Troisième sermon pour le dimanche de la passion*. Bossuet IX, 415-37 (434).
35. See Kathleen Wine, "Honored Guests: Wife and Mistress in 'Les plaisirs de l'île enchantée,'" *Dalhousie French Studies* 56 (Fall 2001): 78-90 (78).
36. Earlier in the century (and in a different context), Ergaste in Benserade's *Iphis et Iante* had offered an even stricter take on the matter, claiming that "un péché d'ignorance est toujours un péché" (III.3) (*a sin committed in ignorance is still a sin*).
37. Although her analysis is lacking nuance, Béatrix Dussane is not wrong when she insists on some of the parallels between Bourdaloue's and Molière's repeated condemnation of religious hypocrisy. Béatrix Dussane, "Molière et Bourdaloue," *Revue universelle* 38: 12 (September 1929): 641-56.
38. Wine has noted the similarity between Bossuet's description of "quiconque a bu de cette eau . . . est tout changé par une espèce d'enchantement; c'est un breuvage charmé qui enivre les plus sobres" (141) (*anyone who has drunk this water is bewitched by it; it is a magic potion that touches even the most sober and upright*) and the descriptions of Louis's 1664 *fête*. See "*Le Tartuffe* and *Les Plaisirs de l'Ile enchantée*: Satire or Flattery?" in *Theatrum Mundi*, ed. Claire L. Carlin and Kathleen Wine, Charlottesville, VA: Rookwood, 2003: 139-46. Another of Bossuet's prophetic references is to "maisons superbes" (*superb houses*) and "jardins délicieux" (*delightful gardens*) (188).
39. Cardinal Chigi, *Relation et observations sur le royaume de France (1664)*, ed. E. Rodocanachi, Paris: Leroux, 1894 (9).
40. The full program of *Les Plaisirs de l'île enchantée* was published for the first time by Ballard in 1664, although the printed date is 1665. See Pléiade I, 1402-5 for further details on publication.
41. The *fête* may also have constituted a more private ripost to Fouquet, for it was alleged that the surintendant had formerly made romantic overtures to Louise de La Vallière (Couton, *La chair* 30, 38).
42. Couton tells of how Colbert arranged for the birth to take place in secret and for the child to be passed off as the illegitimate offspring of other parents (*La chair* 59). The birth of a second child in January 1665 and subsequent children after that attracted more attention (59-60).
43. The first reference to the idea, according to Rey, is found in Voltaire, who is unreliable with regard to the details of La Vallière's participation in the *fête* (see Rey and Lacouture 71).

44. The official account of the *fête* informs us that the verses in praise of Marie-Thérèse and Anne of Austria were written by the président du Périgny (Pléiade I, 597).
45. For Wine, the tension is supported by the *fête*'s combination of elements from both epic and romance; epic ensures the continuity of identity through marriage, while romance denotes a loss of identity through disorder. "The fête strives to assimilate gallant error to the identity of a hero who has already accomplished his dynastic marriage" ("Honored Guests" 80).
46. It is important to note the prominence of Molière and his troupe in these festivities, particularly when one considers that none of the other major theatrical troupes in Paris was invited. See the official account for further details of the troupe's involvement.
47. The Princess's cousins are already persuaded of the virtues of falling in love. Cynthie notes that "vivre sans aimer n'est pas proprement vivre" (II.1.366) (*to live without loving is not to live at all*), while Aglante opines that "cette passion est la plus agréable affaire de la vie, qu'il est nécessaire d'aimer pour vivre heureusement, et que tous les plaisirs sont fades s'il ne s'y mêle un peu d'amour" (II.1) (*love is the most agreeable activity in life; it is essential to love in order to live happily, and all of life's pleasures are dull without a little bit of love thrown in*). In Pléiade, the editors note that this type of plot had been gaining in popularity over recent years in *mondain* circles, where it was considered good form to condemn indifference to love and to celebrate love's irresistible nature (I, 1398).
48. The fact that this point of view is exposed by the venerable and wise Arbate, a character whom Molière added presumably for that very purpose, gives it greater weight than in Moreto's original, in which the equivalent speech is given to the more comical Moron figure.
49. My reading differs somewhat from that of Wine, who comments that "*La Princesse d'Elide* casts a shadow over the king's future efforts to introduce his bastards into the line of succession" ("Honored Guests" 87).
50. Molière's later play, *Amphitryon* (1668), in which Jupiter is portrayed as a selfish pleasure-seeker, has been widely interpreted as an apology for Louis XIV's developing relationship with Mme de Montespan. The lines that are most frequently cited to support this theory are uttered by the character of Jupiter himself, who notes that "un partage avec Jupiter, / N'a rien du tout, qui déshonore: / Et sans doute, il ne peut être que glorieux, / De se voir le Rival du Souverain des Dieux. (*Amphitryon* III.10.1898–1901) (*to share [a wife] with Jupiter is in no way shameful, and no doubt it is honorable to find oneself rival to the king of the gods*). More than *La Princesse d'Elide*, *Amphitryon* is, in its allusions to kingly liaisons and by the standards of the day, quite bold in its attitude toward marital infidelity and in its eroticism.

51. Isaac de Benserade, *Benserade. Ballets pour Louis XIV*, ed. Marie-Claude Canova-Green, 2 vols., Toulouse: Société de littératures classiques, 1997 (II, 607). On the dangers of Louis's weaknesses being revealed in this way, even in the relatively contained forum of court ballet, see Julia Prest, "Conflicting Signals: Images of Louis XIV in Benserade's Ballets," in *Culture and Conflict in 17th-century France and Ireland*, ed. Sarah Alyn Stacey and Véronique Desnain, Dublin: Four Courts Press, 2004: 227–41.
52. For an interesting reading of this stanza, see Wine, "Honored Guests" 80–81.
53. *Journal d'Olivier Lefèvre d'Ormesson*, ed. M. Chéruel, Paris: Imprimerie Impériale, 1861 (148). Ormesson also tells the story of the hapless duc de Mazarin, who, in the same year, unwisely took it upon himself to inform the king of the scandal caused by his relationship with La Vallière (Ormesson 274–75).
54. Louis XIV wrote in his *Mémoires* for 1661 that "à son égard [celui de Dieu], l'extérieur sans l'intérieur n'est rien du tout, et sert plutôt à l'offenser qu'à lui plaire" (Louis XIV 82–83) (*in God's eyes, the exterior without the interior is nothing and serves rather to offend him than to please him*).
55. Tartuffe is a (nondenominational) lay spiritual director, whereas a confessor was a Jesuit cleric. The king's confessor was expected to act as his spiritual director. The urgency of the need to choose one's guides carefully applies to both lay and clerical directors.
56. Pierre Le Moyne, *La Dévotion aisée*, Paris: Sommaville, 1652; repr. Paris: Cottin, 1668 (197–98).
57. La Vallière gave birth to another of Louis's children on October 2, 1667: Louis, who was officially recognized in February 1669.
58. Under Bossuet's guidance, and following some highly delicate negotiations, La Vallière finally retired to a Carmelite convent in April 1674.
59. *Lettres de Bossuet*, ed. Henri Massis, Paris: Tallandier, 1927 (79–82).
60. See Georges Guitton, *Le père de la Chaize, Confesseur de Louis XIV*, 2 vols., Paris: Beauchesne, 1959 (I, 73).
61. Mme de Montespan had first attempted to retaliate by seeking to discredit the bishop; however, her informants were unable to find any basis for scandal in his life, whereupon she sought to buy his silence with the offer of a cardinal's hat. Bossuet remained unyielding. See Couton, *La chair* 123–24; and Augustin Gazier, *Bossuet et Louis XIV (1662–1704)*, Paris: Champion, 1914, 74.
62. Longnon detects a similar concern in Louis XIV's *Instructions au duc d'Anjou* (1700), in which he "voulait détourner Philippe V des liaisons amoureuses" (Louis XIV 283n2) (*wanted to discourage Philippe V from indulging in amorous liaisons*).
63. Longnon explains that the fragment exists in both draft and reworked (but incomplete) form (Louis XIV 257n24).

64. At the time that the 1667 *Mémoires* were written (according to Longnon, the *Mémoires* for the years 1666 to 1668 were written "au moment même" [*at the time*] [Louis XIV 12]), Louis was shifting his erotic attachment from La Vallière to Mme de Montespan.
65. The pragmatic reason is referred to by some of Louis's contemporaries, too. See Jean-Christian Petitfils, *Louise de La Vallière*, Paris: Perrin, 2011, which reports that in 1665 Louis asked his ministers to confront him if any woman was exerting too much power over him, promising that he would get rid of her within a day (144).
66. The 1682 edition (edited by La Grange and Vivot) of Molière's complete works informs us that of the Exempt's 41 lines, 20 were cut from performance. Brossette, meanwhile, narrates how Boileau had encouraged Molière to change the ending of the play and notes that the playwright had changed the portion in which the king is praised but that when the king heard the new version, he in turn encouraged Molière to change it back. See Auguste Laverdet, ed., *Correspondance entre Boileau-Despréaux et Brossette*, Paris: J. Techener, 1858 (516).
67. For an interesting account of how Molière's constructed Louis cannot be taken seriously, see P. Muñoz Simonds, "Molière's Satiric Use of the Deus Ex Machina in *Tartuffe*," *Educational Theatre Journal* 29: 1 (March 1977): 85–93. See also Francis L. Lawrence, "*Tartuffe*: A Question of *honnête* behavior," *Romance Note*s 15: Supp 1 (1973): 134–44. Lawrence wonders how to interpret the ending of the play and asks, "What credit can actually be given the King for seeing through the hypocrisy of a crude impostor who has fooled only Orgon and Mme. Pernelle?" (143).
68. The term is used by Couton in *La chair* (169) and attributed to Georges Mongrédien. It refers to the particularly intense series of royal liaisons that took place in the late 1670s and into 1680, involving, among others, Mme du Ludres, Mme de Soubise, and Mlle de Fontanges, the last of whom died in 1681 shortly after giving birth to the king's child. These relationships came to be viewed as particularly sordid because they became entangled in the unfolding of the Affair of the Poisons. For an accessible yet scholarly account of the latter, see Anne Somerset, *The Affair of the Poisons: Murder, Infanticide and Satanism at the Court of Louis XIV*, London: Weidenfeld and Nicolson, 2003.
69. Guitton, who is keen to defend La Chaise from any charges of laxism, offers the explanation "parce qu'il n'avait pas l'évidence que le pénitent manquât de la sincerité suffisante" (I, 74) (*because there was no evidence that the penitent was not sincere enough*).
70. *Correspondance générale de madame de Maintenon*, ed. Théophile Lavallée and Laurent Angliviel de La Beaumelle, 4 vols Paris: Charpentier, 1865 (I, 313).
71. According to Bernard Vogler, Ferrier, who was the king's confessor between 1670 and 1674, "s'est montré suffisamment indépendant

pour refuser plusieurs fois la communion au roi adultère" (391) (*showed himself to be sufficiently independent to refuse the adulterous king communion on several occasions*). "La dimension religieuse dans les relations internationales en Europe au XVIIe siècle (1618–1721)," *Histoire, économie et société* 10: 3 (1991): 379–98 (391).

72. According to Sedgwick, Annat "resigned this position to protest the king's illicit relations with Louise de La Vallière" (*Jansenism* 81), but this appears to be based on an anonymous and somewhat unreliable manuscript, *Histoire des amours*.
73. *Mémoires complets et authentiques du duc de Saint-Simon sur le siècle de Louis XIV et la Régence*, ed. M. Chéruel and A. Régnier, 20 vols., Paris: Hachette, 1856 (VII, 46).
74. *Mémoires du marquis de Sourches sur le règne de Louis XIV*, ed. Michel Chamillart et al., 13 vols., Paris: Hachette, 1882 (I, 209n2).
75. The other great preacher of the age, Bourdaloue, was also quite vocal with regard to unpalatable subjects. Mme de Sévigné noted on March 29, 1680, that Bourdaloue "frappe toujours comme un sourd, disant des vérités à bride abattue, parlant contre l'adultère à tort et à travers" (II, 887) (*Bourdaloue continues to shout at the top of his voice, loudly proclaiming the truth, and condemning adultery left, right and center*). Marquise de Sévigné, *Correspondance*, ed. Roger Duchêne, Pléiade, 3 vols, Paris: Gallimard, 1972–78.
76. *Correspondance de Madame, Duchesse d'Orléans*, 2 vols., Paris: A. Quantin, 1880 (I, 57).
77. Robin Briggs, on the other hand, writes that "for the church there were actually disadvantages in the change from the young king who allowed the performance of *Tartuffe* and abstained from the sacraments because of his double adultery with Mme de Montespan to the elderly *dévot* of Versailles. The latter demanded more and interfered more, rarely to good effect" (216).

Chapter 3

1. One notable exception is Claude Bourqui, who draws on the sermons of both Bossuet and Bourdaloue in his analysis of *Le Festin de Pierre*. See *Polémique et stratégies dans le* Dom Juan *de Molière*, Biblio 17: 69, Paris: PFSCL, 1992 (62–75).
2. "Lettre aux deux apologistes de l'auteur des Hérésies imaginaires" in Pierre Nicole, *Traité de la comédie et autres pièces d'un procès de théâtre*, ed. Laurent Thirouin, Paris: Champion, 1998: 265–72.
3. Individuals who have hinted at the importance of zealotry in the equation by drawing our attention to the question of rigorism, fundamentalism, or excess include John Cairncross, who wrote that "*Tartuffe* est, sans aucun doute, une satire du rigorisme et non pas seulement de l'hypocrisie" (18) (Tartuffe *is, without doubt, a satire of rigorism*

and not just a satire of hypocrisy); René Pommier, who observes that "[la pièce] est directement dirigée contre le rigorisme et contre ce qu'aujourd'hui on appellerait l'intégrisme" (11) (*the play is a full-frontal attack on rigorism and on what would today be called fundamentalism*); and Constant Coquelin, who wrote that "Molière a vu que la dévotion, même sincère, lorsqu'elle va à l'excès peut devenir un danger pour la famille" (55) (*Molière saw that even sincere devotion, when excessive, can pose a threat to the family*). *Molière bourgeois et libertin*, Paris: Nizet, 1963; *Etudes sur* Le Tartuffe, Paris: SEDES, 1994; and "Tartuffe," bound holograph c.1884, Maria H. Dehon Polk Collection of Constant Coquelin, Beinecke Rare Book and Manuscript Library GEN MSS 453 (Box 2, folder 25).

4. See Julia Prest, *Theatre under Louis XIV: Cross-Casting and the Performance of Gender in Drama, Ballet and Opera*, New York: Palgrave, 2013, 28–30. The complete cast list for the 1669 performances of *Tartuffe* is known (but not that of earlier performances) thanks to the *Gazette*. The suggestion that Mme Pernelle was always played by a male actor in Molière's lifetime is supported by the fact that the role was taken over by André Hubert (who had previously performed the part of Damis) upon Louis Béjart's retirement in 1670. While Mme Pernelle's limp may have disappeared at this point, neither her dress nor her falsetto (and the comic effects thereof) did.

5. Indeed, this is confirmed by Dorine, who identifies first one neighbor, Daphné, and her husband as particular culprits (and, as it happens, hypocritical ones) in such matters (I.1.103–16) and then Orante (I.1.121–40).

6. This is similar to Garaby's earlier account of the same phenomenon in *Garaby de la Luzerne: Satires inédites*, ed. Eugène de Beaurepaire, Rouen: Espérance Cagniard, 1888. He writes of "le dépit jaloux de Dévotes sans dents, / Pour n'avoir plus de par aux mesmes passetemps, / Et qui, faute d'employ, faisant les preudes femmes, / Des cendres de l'honneur couvrent leurs vieilles flames [sic]!" (60) (*the jealous scorn of toothless devout women who no longer have any part to play in these activities and who, for want of anything to do, take on the role of prude and cover their former passions with a veneer of respectability*).

7. Henri Bergson, *Le Rire: Essai Sur La Signification Du Comique*, Bibliothèque de Philosophie Contemporaine, Paris: Presses Universitaires de France, 1947 (105).

8. Although Salomon makes rather too much of this in his otherwise excellent book, he is right to draw attention to the weight of the issue in the contemporary French reform movement.

9. Salomon has suggested that the comic potential of this moment was enhanced by the discrepancy between the tiny handkerchief proferred by Tartuffe and the vast expanse of breast that it was intended to cover (66n1).

10. Jacques Du Lorens's religious hypocrite is, likewise, one of those "qui n'entendent jamais la Messe qu'à genoux" (*who will only hear the mass on their knees*) We note that he shares other characteristics with Tartuffe: see *Satires de Dulorens*, Paris: Jouaust, 1646; 1869, 7–8.
11. Bourdaloue wrote: "Gardez toutes vos pratiques de dévotion . . . mais avant que d'être dévot, je veux que vous soyez chrétien. Du christianisme à la dévotion, c'est l'ordre naturel; mais le renversement est l'abus le plus monstrueux, c'est la dévotion sans le christianisme" (*Pensées de la vraie et de la fausse dévotion* IV, 373) (*Maintain all your devotional practices, but before you become devout, I want you to be Christian. It is a natural progression to move from Christianity to devotion, but the reverse represents one of the worst abuses possible, devotion without Christianity*).
12. See also 1 Sm 24:14; and 1 Sm 26:20.
13. Tallon has noted a striking similarity between Orgon's words in I.5.278–79 and the supposedly exemplary Renty, about whom it was written, "Il se trouvait, par la divine miséricorde, dans un état de mort si entière, qu'il n'y avait ni anges, ni hommes, ni renversement de sa famille, ni la mort de Madame sa femme ou de ses enfants, bref que, quand le Ciel et la Terre se fussent renversés, qu'il serait demeuré insensible à tout cela" (see Tallon 98) (*He found himself, by divine grace, in such a complete state of annihilation that nothing else could move him, neither angels nor men, nor the disintegration of his family nor the death of Madam his wife nor of his children, not even the end of the world*).
14. See also *Le Festin de Pierre* III.2, in which an exasperated Don Juan, having failed to make him blaspheme, gives money to a beggar anyway, "pour l'amour de l'humanité" (*for the love of humanity*).
15. William Howarth, *Molière, a Playwright and His Audience*, Major European Authors, Cambridge: Cambridge University Press, 1982 (202).
16. See Gérard Defaux, "Un point chaud de la critique moliéresque: Molière et ses raisonneurs," *Travaux de linguistique et de littérature* 18: 2 (1980): 115–32, on mediocrity, in the sense of an avoidance of extremes, being considered a positive quality in the seventeenth century. Defaux writes of François de Sales's *Introduction à la vie dévote* (1609) as "une introduction au juste milieu" (122) (*an introduction to the happy medium*). Of course, even de Sales's *milieu* sits firmly on the side of religion on the worldly-versus-religious spectrum.
17. The zealots in turn would of course consider Le Moyne's position evidence of laxism and therefore of false (because inadequate) devotion. It would seem that everybody is somebody else's *faux dévot*. Indeed, Rochemont turned Molière's own argument back against him, branding the playwright the real hypocrite of the controversy: "Molière est lui-même un Tartuffe achevé, et un véritable Hypocrite" (Pléiade II, 1214) (*Molière himself is an accomplished Tartuffe and a true hypocrite*).

18. François de La Mothe Le Vayer, *Œuvres de François de La Mothe Le Vayer*, 7 vols., Dresden: Michel Groell, 1756–59 (VI, 1, 232).
19. Tallon notes that "cette dichotomie entre un intérieur dévot et un extérieur mondain est reprise et amplifiée par les confrères. Ils y voient non seulement la justification du secret de la Compagnie, mais aussi celle de sa vocation à être dans le monde sans être du monde" (97–98) (*this dichotomy between a* dévot *interior and a* mondain *exterior is taken up and expanded by its members. They use it to justify not only the secrecy of the Company but also its vocation to be in the world but not of the world*).
20. See Chapter 1 for Dufour's comment on the threat to conventional power structures.
21. The poem is reproduced in *Garaby de la Luzerne: Satires inédites* 49–65.
22. The Jansenist Pierre Nicole wrote, "On a veu souvent en ce siecle que les devotions déreglées & établies sur des caprices humains degenerent en illusions fanatiques. L'histoire des Hermites de Caën a esté celebre par tout le royaume, & si l'on avoit fait la recherche qu'on devoit de la Compagnie du S. Sacrement on auroit peut-estre découvert bien d'autres choses de cette nature" (II, 4) (*We have often seen in this century that excessive devotions based on the whim of humans degenerate into fanatical illusions. The story of the Hermitage in Caen was known across the kingdom, and if the necessary research had been undertaken into the Company of the Holy Sacrament, further examples of this nature might well have been found*). *Les Visionnaires, ou seconde partie des lettres sur l'heresie imaginaire*, 2 vols, Liege: Adolphe Beyers, 1667.
23. Bourdaloue warns against six types of devotion, which he then examines in turn: *dévotion fastueuse et d'éclat* (*luxurious, conspicuous devotion*); *dévotion intrigante et dominante* (*scheming, domineering devotion*); *dévotion inquiète et empressée* (*anxious, overattentive devotion*); *dévotion zélée pour autrui sans l'être pour soi* (*dévotion that is zealous with regard to others but not oneself*); *dévotion de naturel et d'intérêts* (*accommodating self-interested devotion*); and *dévotion douce et commode* (*compliant devotion*) (IV, 366–67).
24. Following the example of the editors of the 2010 Pléiade, I refer to the play by its original title throughout this book and to its title character as Don Juan. When citing other critics, I do of course retain their variant spelling and title.
25. For an interesting discussion of *Le Festin de Pierre* in this context, see Bourqui, who argues that Molière treads a strategic and polemical fine line "qui allie violence et sécurité maximales" (60) (*that brings together maximum violence [in Molière's attack] and maximum security [in his defense]*), drawing heavily on "le dynamisme du va-et-vient entre attaque et esquive, offense et alibi" (113) (*the dynamism of the interplay between attack and evasion, offense and alibi*).

26. See Guy Leclerc, "Dom Juan dans la bataille de *Tartuffe*," *Europe* 441–42 (1966): 51–58 (55). Antony McKenna develops this idea in *Molière dramaturge libertin*, Paris: Champion, 2005 (45–71).
27. *Nouvelles conversations de morale*, 2 vols., Paris: Veuve de Sebastien Mabre-Cramoisy, 1688 (I, 21–22).
28. For McKenna, a *vrai libertin* is defined as "un incroyant dont le refus de la doctrine chrétienne s'appuie sur la réflexion philosophique et sur un système de valeurs" (63) (*a nonbeliever whose rejection of Christian doctrine is based on a philosophical position and a value system*).
29. Constant Venesoen, "Dom Juan ou 'la conversion manquée,'" *Revue belge de philologie et d'histoire* 51: 3 (1973): 542–55.

Chapter 4

1. An earlier, shorter version of this chapter was published as an article: Julia Prest, "Where Are the *vrais dévots* and Are They *véritables gens de bien*? Eloquent Slippage in the *Tartuffe* Controversy," *Neophilologus* 96: 3 (2012) [online version] and 97: 2 (2013): 283–97 [print version]. It is reproduced here with the kind permission of Springer Science+Business Media B. V. Research for the article was undertaken with the generous assistance of the Carnegie Trust for the Universities of Scotland.
2. See André Lévêque, "'L'honnête homme' et 'l'homme de bien' au XVIIe siècle," *Publication of the Modern Languages Association of America* 72: 4 (1957): 620–32 (625).
3. See Emmanuel Bury, *L'invention de l'honnête homme 1580–1750*, Paris: Presses Universitaires de France, 1996, for a detailed analysis of the *honnête homme* figure.
4. Abbé de Goussault, *Portrait d'un honnête homme*, Paris: Brunet, 1692, [np].
5. Michel de Marolles, *Mémoires*, 3 vols., Amsterdam: [np], 1755 (III, 75).
6. *Œuvres complètes du Chevalier de Méré*, ed. Charles-H Boudhours, 3 vols., Paris: Fernand Roches, 1930 (III, 101).
7. Myrna Zwillenberg in her search for someone to oppose Tartuffe considers and dismisses in turn Mariane, Damis, Elmire, Dorine, Cléante, and finally even Mme Pernelle. Interestingly, Valère is not even considered (586). "Dramatic Justice in *Tartuffe*," *Modern Language Notes* 90: 4 (May 1975): 583–90.
8. H. Gaston Hall suggests that Orgon could be called a "dévot ridicule" (along the same lines as Molière's *précieuses ridicules*) or a "dévot imaginaire" (recalling Argan, the *malade imaginaire*) (24). *Molière: Tartuffe*, London: Edward Arnold, 1960.
9. Bourdaloue asks rhetorically if having been taken in by hypocrisy is a good excuse before God and concludes that "cette excuse sera l'une

des plus frivoles dont un chrétien se puisse servir" (*Sur l'hypocrisie* II, 242) (*this excuse is one of the most frivolous that a Christian could use*).
10. Interestingly, the abbé de Goussault offers a definition of the *honnête homme* that is also couched in terms of what it is not. His chapters include titles such as "Un honneste Homme n'est point colère," "Un honneste Homme n'est point entesté de son mérite," "Un honneste Homme n'est point flatteur," and so on. See Lévêque 630.
11. The author does not appear to make the fine distinctions between the two terms that I believe Molière does, although his use of *véritable* here may hint at a *mondain* outlook.
12. Lionel Gossman, *Men and Masks: A Study of Molière*, Baltimore: Johns Hopkins Press, 1963 (124).
13. Pléiade II, 1399 n47. See also Jacqueline Plantié, "Molière et François de Sales," *Revue d'histoire littéraire de la France* 72 (1972): 902–927 (915).
14. Michael Hawcroft says simply that they are "people they both know in the play-world" (102). *Molière: Reasoning with Fools*, Oxford: Oxford University Press, 2007.
15. Louis Veuillot, *Molière et Bourdaloue*, Paris: Librairie Catholique, 1877 (161).
16. On the subject of Valère, who is "généreux et sincère" (*generous and sincere*), Suzanne Rossat-Mignod comments, "On voit aisément pourquoi cette morale purement humaine a choqué certains dévots intransigeants" (50) (*We can easily see why this purely human morality shocked certain extremist* dévots). "La portée de *Tartuffe* à la fin du XVIIe siècle," *Europe* 441–42 (1966): 44–51.
17. Francis L. Lawrence also lists critics who believe Cléante to be a model Christian (Lancaster and Michaut) and those who find him worldly (Morent, Adam, and Vedel) (698–99). "The Norm in *Tartuffe*," *Revue de l'Université d'Ottawa* 36: 4 (1966): 698–702.
18. "*Tartuffe*, ou Molière hypocrite," *Revue de l'Histoire Littéraire de la France* 72 (1972): 890-901 (896).
19. Jacques Scherer, *Structures de Tartuffe*. Paris: SEDES, 1966; repr. 1974 (95).
20. Richard Parish, "Tartuf(f)e ou l'imposture," *Seventeenth Century* 6: 1 (Spring 1991): 73–88 (86).
21. The abbé Figuière is thus right to note that "c'est en vain que l'on y cherche un personnage, type de la véritable piété, qui se montre comme l'antithèse et le correctif de tant d'imposture" (33) (*in vain we look for a character who represents true piety and who acts as the antithesis and corrective to such imposture*). *Tartufe, ou L'imposteur*, ed. abbé Figuière, Paris: Poussielgue, 1895. W. G. Moore, meanwhile, claims that Molière has Cléante express "the *artistic* opposite of Tartuffe's exaggerated and false piety" (7, my emphasis). *Molière: A New Criticism*, Oxford: Clarendon Press, 1949; repr. 1962.

22. Phillips observes that "Christian humanism for many seemed to be a contradiction in terms" (*Church and Culture* 300).
23. Only the theatrical hypocrite, like Tartuffe, can display quasi Jansenist rigorism *and* the type of Jesuitical laxist casuistry mocked by Pascal in his *Lettres provinciales*.
24. The line is of course taken from Corneille's *Sertorius* (IV.1), substituting *dévot* for *Romain*.
25. Abbé de Gerard, *Le caractere de l'honneste-homme morale*, Paris: Huré, 1682 (301).
26. His satires were not published in Garaby's lifetime, although they will have circulated in manuscript form. See Chapter 3 of Robert McBride, *Molière*, for more information on Garaby. McBride thinks that Molière must have known the satire in question.
27. It is significant that Garaby (as Cléante will do) mentions the word *cabale*—a clear reference to the work of the Company of the Holy Sacrament.
28. See the *Notice* by Georges Forestier and Alain Riffaud provided in Pléiade II, 1619–50, for further information.
29. See McBride, *Molière* 137–43, for a discussion of Tartuffe's status in 1664, at the end of which McBride concludes that he was probably a lay director, although he would still have worn a costume that denoted religious devotion. See also Chill, who notes that Tartuffe wears "semi-clerical dress and is priestlike without being a priest" (169), noting that the soutane was not peculiar to the clergy (members of the bar and the lower reaches of the magistrature wore similar dress), and that lay members of the Company would have worn a "sombre, priestly kind of habit without imposture" (169n52).
30. Jean-Pierre Camus, *Homélies quadragésimales*, Rouen: Veuve Du Bosc, 1636 (187–88).
31. Couton speculates that Molière changed the line "Pour la gloire de Dieu et le bien du prochain" (*For the glory of God and the good of my neighbor*), which features in the statutes of the Company of the Holy Sacrament, to "Pour la gloire du Ciel et le bien du prochain" (IV.1) (*For the glory of heaven and the good of my neighbor*) at this point in the controversy (1972 Pléiade I, 868).
32. Samuel Chappuzeau, *Le Théatre François*, Lyon: Guignard, 1674 (9–10). D'Aubignac, as we saw in Chapter 1, also commented on this in his response to the *Tartuffe* controversy.
33. *Dictionnaire de l'Académie Françoise*, 3 vols., Paris: Coignard, 1694; and *Dictionnaire universel: contenant généralement tous les mots françois, tant vieux que modernes, et les termes de toutes les sciences*, 3 vols., La Haye: Arnout and Reinier Leers, 1690.
34. *Dictionnaire françois, contenant les mots et les choses, plusieurs nouvelles remarques sur la langue françoise*. Geneva: Widerhold, 1685.

35. Bourdaloue notes in *Sur la vraie et la fausse piété* that "jusque-là que ce qui devrait être un éloge est devenu, par la triste décadence, un reproche; et que le terme d'homme dévot, de femme dévote, qui dans sa propre signification exprime ce qu'il y a dans le christianisme de plus respectable, porte présentement avec soi comme une tache qui en obscurcit tout l'éclat et le ternit" (II, 216–17) (*what ought to be a compliment has been woefully corrupted and is now a reproach; the term* dévot *or* dévote, *which strictly speaking designates what is most respectable within Christianity, now carries with it a stain that conceals all its goodness and tarnishes it*). Gérard Ferreyrolles notes, however, that this tendency predates Molière and that in Pascal, for instance, the word *dévot* already had a negative connotation (8–9). *Molière: Tartuffe*, Études Littéraires 16, Paris: Presses Universitaires de France, 1987.
36. Even after the ban had been lifted in France in 1669, there were further attempts to prevent performances of *Tartuffe* from taking place, including in Québec—see my conclusion.

Chapter 5

1. In "Notice sur la vie et les ouvrages de Molière," *Revue des deux mondes* 21 (January–March 1848): 185–215 (204). See Salomon 71. Rey, on the other hand, credits Sainte-Beuve with being the first to have made the connection (Rey and Lacouture 338).
2. It is likely that the Company had been involved in the attacks against Molière's *L'Ecole des femmes* in 1663, although there is no record of this in the *Annales*. Chill notes that the Company's records were "rudimentary" at this time of particular persecution, which would explain the absence of any reference to Molière's play (153). Several critics have concluded that the prominent magistrate who attempted to impose a ban on the play may have been Guillaume de Lamoignon, "a sympathizer and former member of the Company" (Chill 153n5; see also Cairncross, *Molière* 13, 137), who would reappear in the *Tartuffe* controversy.
3. This fact seems to have been known, since we read in the *Lettre sur les observations d'une comédie du sieur Molière, intitulée "Le Festin de Pierre"* of how "les hypocrites . . . ont cabalé avant que la pièce ne fût à moitié faite, de peur qu'on ne la permit, voyant qu'il n'y avait point de mal" (Pléiade II, 1239) (*the hypocrites, seeing that there was nothing wrong with the play, began their campaign even before it was half completed, for fear that performances would be permitted*).
4. Of course, as the reference to Molière's death nearly ten years later reminds us, the *Annales* were compiled many years after the events that are described and are no doubt colored by the benefits (and disadvantages) of hindsight.

5. See Sedgwick for a useful and coherent overview of French Jansenism. For a fascinating account of the particular case of the rebellious nuns at Port-Royal, see Daniella Kostroun's article, "A Formula for Disobedience: Jansenism, Gender, and the Feminist Paradox," *Journal of Modern History* 75 (September 2003): 483–522, and her book, *Feminism, Absolutism, and Jansenism: Louis XIV and the Port-Royal Nuns*, New York: Cambridge University Press, 2011, hereafter referred to as "Formula" and *Feminism*, respectively.
6. We remember that during the Fronde, Retz had been at the head of a rebellious noble faction that tried to overthrow the government. He had been arrested in 1652 and was considered an ongoing threat, until he finally resigned as Archbishop of Paris in 1662 (a position that he was then holding from exile in Rome).
7. On May 21, 1664, in its description of the festivities of *Les Plaisirs de l'île enchantée*, the *Gazette* does not mention *Tartuffe* at all.
8. It is thought that the first version of the play was called *Tartuffe, ou l'hypocrite*.
9. *La Gazette*, Paris: Bureau d'adresse, 1631–1761, ed. Théophraste Renaudot et al., 1664 (480).
10. Jean Loret, *La muze historique, ou Recueil des lettres en vers à son Altesse Mademoiselle de Longueville*, ed. J. Ravenel and E. D. V. de la Pelouze, 4 vols., Paris: P. Jannet, 1857–1878 (IV, 203).
11. See Paul Sonnino, *Louis XIV's View of the Papacy (1661–69)*, Berkeley: University of California Press, 1966, for an interesting account of the period that concerns us here. Much of the material concerning Chigi is taken from this volume.
12. Louis XIV did at one point support the doctrine of papal infallibility in the interests of attempting to overcome Jansenism, and several theses in support of infallibility were successfully defended at the Sorbonne. See Sonnino ch. 2, ch. 3.
13. For instance, as Sonnino observes (79), from the moment that Alexander issued his bull against the Jansenists, he became dependent on Louis for its enforcement in the event that any bishops should publish the formulary with qualifications (which four of them did).
14. Phillips notes that "the status of the nuncio in France was strictly that of an ambassador who had no powers of enactment, although he was an important channel of communication of Rome's views . . . The nuncio had the authority to protest at the actions of the French authorities" (*Church and Culture* 277).
15. See Sonnino ch. 3 for more details about these.
16. See Lossky 121–22. See also Sonnino ch. 4 for further details of Chigi's legation.
17. Sonnino writes that Chigi arrived in Marseille "toward the middle of May, 1664" (57).

18. Variants are particularly common for this name and include, notably, Roullé and Roulès.
19. Pierre Roulé, *Le roy glorieux au monde*, ed. Paul Lacroix, Geneva: Gay, 1867.
20. *L'Homme glorieux, ou la dernière perfection de l'homme, achevée par la gloire éternelle*, Paris: Gilles Gourault, 1664.
21. These are reproduced in Pléiade II, 1165–67. The most recent Pléiade includes slightly more of Roulé's text than is included in the previous Pléiade edition.
22. Pierre Roulé, *La Sainte Conduite de l'homme en ce monde, ou la vie de salut et méthode salutaire qu'il faut nécesssairement garder au commencement, au progrès et à la fin de la vie pour être sauvé*, Paris: [np], 1662.
23. As we saw in Chapter 2, Turenne did in fact convert to Catholicism in October 1668, thanks in part to Bossuet (and the written works of Nicole). But no thanks, one may safely assume, to Roulé.
24. Given the events to which he refers and the print date of August 1, we know that Roulé must have written the tract around the beginning of Chigi's visit to Fontainebleau at the end of July. Chigi's abortive attempt to hear Molière's play on August 9 therefore postdates the composition of *Le roi glorieux*, and one wonders if Louis's complicity in the attempt was not fueled in part by his anger upon reading Roulé's pamphlet.
25. Cited in *Le Registre de La Grange (1658–1685)*, Paris: Clay, 1876 (x).
26. The first petition is reproduced in Pléiade II, 191–93.
27. This dates back at least as far as Horace and is often known as the *castigat ridendo mores* (*by laughter he chastises behavior*) principle.
28. If *contenant* is a typographical error and what was intended is *contentant*, the translation would read "when contenting the Jesuits."
29. *Divers actes, lettres et relations des religieuses de Port Royal du Saint-Sacrement, touchant la persecution et les violences qui leur ont été faites au sujet de la signature du formulaire*, [np]: [np], 1723–1724.
30. See Kostroun, *Feminism* 149–62, and "Formula" passim. Kostroun suggests, for instance, that in their reports of interviews with Péréfixe in June 1664 (probably composed that summer), the nuns "adopt an innocent, naïve, or extremely earnest tone in their dialogues to discredit and humiliate Archbishop Péréfixe" ("Formula" 501).
31. Boileau noted that "M. de Péréfixe, quoique homme de bien, étoit accoutumé à jurer. Il voulut enfin se défaire de cette méchante habitude: pour cela, il se donnoit la discipline, mais quand il se frappoit trop fort et qu'il se faisoit mal, c'étoit alors qu'il juroit de tout son cœur, à chaque coup qu'il se donnoit: Ha, Jarni! Morbleu! et pis que tout cela" (*Correspondance* 543) (*Péréfixe, although a good man, had a habit of swearing. He eventually wanted to rid himself of this bad habit, and to that end he mortified himself with a scourge. But when he hit himself too*

hard and caused himself pain, he used to swear with all his might with each blow, "Oh, crikey! Bloody hell!" And worse than that). Incidentally, Boileau's account sounds very like Garaby's satirical description of the angry *faux dévot* in his *Les Pharisiens du temps ou le dévot hypocrite*: "Ainsi l'homme bouillant, dont la bile s'allume / Et par mille serments vuide son amertume, / Prévenu bien souvent des premiers mouvements, / Peut encores tout bas jurer entre ses dents / Et pour évaporer le feu de sa colère, / Par les termes moins durs que le dépit suggère, / Convertissant en B. le D. du nom de Dieu, / Lascher encores par fois une bonne Mort Bieu" (*Satires* 62) (*The fiery man whose blood boils and who purges his bitterness with a thousand curses, often warned about it early on, can still swear quietly under his breath, and to dispel his fiery fury, he voices his scorn in less harsh terms, converting "God" into "Dog" and letting out the occasional "Dog's blood"*).

32. According to Racine, copies of the nuns' statements nonetheless made it into public domain, and "ce fut une très sensible mortification pour Monsieur l'Archevêque: en effet, rien ne lui pouvait être plus désagréable que de voir ainsi révéler tout ce qui s'était passé en ces occasions" (*Abrégé* 210) (*it was a very painful form of mortification for the archbishop; indeed, nothing could have been more disagreeable for him than to have made known what had taken place on these occasions*).

33. We remember that Louis XIV made Molière available to Chigi for another abortive attempt at reading his play. Does, perhaps, the *on* (*we*) referred to here also indicate Louis XIV?

34. *Œuvres complètes*, ed. Raymond Picard, Pléiade, 2 vols., Paris: Gallimard, 1964 (II, 28).

35. See McBride, *Molière* 187. Rey suggests that Molière's troupe may have performed *Tartuffe* twice during their week-long stay in Villers-Cotterets in September 1664, as the employee who played the silent role of Flipote was paid twice the amount she had been paid in Versailles and twice what she would be paid for the performance at Raincy (Rey and Lacouture 135).

36. Rey estimates that there were between ten and fifteen people present at this performance, including the Condé family, the Palatine princess, and a few members of her household (Rey and Lacouture 143).

37. Katia Béguin provides a useful chronology of Condé's activities during the Fronde in *Les Princes de Condé: rebelles, courtisans et mécènes dans la France du Grand Siècle*, Paris: Champ Vallon, 1999 (142–44).

38. *Œuvres complètes de Boileau*, ed. Jacques Berriat-Saint-Prix, 4 vols., Paris: Philippe, 1837 (II, 7).

39. Orest Ranum, *The Artisans of Glory: Writers and Historical Thought in Seventeenth-Century France*. Chapel Hill: University of North Carolina Press, 1980 (297).

40. See Huguette Gilbert, "*Les Nopces ducales* et la Querelle de *L'Ecole des femmes*," *Dix-Septième Siècle* 150 (1986): 73–74.

41. Marigny's account is reproduced in Pléiade I, 1143–52.
42. See, in addition to Bourqui, R. Lespire, "Le 'libertinage' de Molière et la portée de *Dom Juan*," *Revue belge de philologie et d'histoire* 28: 1 (1950): 29–58; Jacques Truchet, "Molière théologien dans *Dom Juan*," *Revue d'histoire littéraire de la France* 72 (1972): 928–38; and Venesoen.
43. See Bourqui 80–81. See also Chapter 3 for a brief discussion of Don Juan as *faux libertin* and of his hypocrisy being a consequence of the zealous proselytizing of a series of individuals around him.
44. See Pléiade II, 1619–50, for further details of the play's censorship and publication history.
45. This is also, perhaps, because Don Juan is more of a literary legend and less of a social reality (see Cairncross, *Molière* 21).
46. My interpretation runs counter to that of Lespire, who, having recapped the performance and publication history of the play, asks "De tout cela, que conclure sinon que 'la cabale des dévots' avait triomphé de *Dom Juan* mieux que de *Tartuffe*" (40) (*What are we to conclude from this except that the* dévot *cabale had scored a greater victory with* Dom Juan *than with* Tartuffe*?*).
47. Reproduced in Pléiade II, 1229–41.
48. Reproduced in Pléiade II, 1212–21.
49. Rey suggests that the diatribe is so excessive that it must in fact have been written by one of Molière's supporters or even by Molière himself (Rey and Lacouture 195–96).
50. Madeleine Jurgens and Elizabeth Maxfield-Miller, *Cent ans de recherches sur Molière, sur sa famille et sur les comédiens de sa troupe*, Paris: Imprimerie Nationale, 1963 (409).
51. "Documents inédits: Une lettre du duc d'Enghein demandant le quatrième acte de Tartuffe au Raincy," ed. Georges Monval, in *Le Moliériste* 3 (1881): 193–200 (199). Note the reference to the fourth act of the play.
52. Unlike his references to earlier and later performances of *Tartuffe* for Condé, La Grange does not state the number of acts in the play. See La Grange 1947, 80.
53. *Archives du ministère des Affaires étrangères, Correspondances politiques, Rome*, vol. 174. Reproduced in *Œuvres du cardinal de Retz*, 10 vols., Paris: Hachette, 1882 (VII, 507). This letter is often cited by scholars who believe that the original version of *Tartuffe* was incomplete.
54. Philippe's death opened up the question of Marie-Thérèse's claim to the Spanish succession, which she had renounced only on condition that an impossibly large dowry be paid. The prospect of another war with Spain was particularly distasteful to the *dévots*, because it would once again pit two Catholic countries against one another in an unholy disalliance.

55. For a more detailed summary of the differences between *L'Imposteur* of 1667 and *Le Tartuffe* of 1669, see La Mothe *Lettre*, 145–55.
56. Rey speculates that Condé was present at the public performance of *L'Imposteur* on August 5, 1667, as he was in Paris at the time, having attended Colbert's son's viva voce examination a week earlier (Rey and Lacouture 280).
57. *Archives des Affaires étrangères, Fonds France*, vol. 921, folio 295. Reproduced in *Revue d'histoire du théâtre* (1948–1949) (IV, 263) and cited in Rey and Lacouture 283.
58. The second petition is reproduced in Pléiade II, 193–94.
59. Note that even now that the character is called Panulphe. Molière continues to refer to his opponents as Tartuffes. He is determined to portray any zealous opponent of the play as a religious hypocrite.
60. This observation, attributed to Condé, will feature again at the end of Molière's preface to the published *Tartuffe* in 1669.
61. Péréfixe's decree is reproduced in Pléiade II, 1168–69.
62. See P. Dieudonné, *La paix clementine: défaite et victoire du premier jansénisme français sous le pontificat de Clément IX (1667–69)*, Leuven: Leuven University Press, 2003, 96–104, for details.
63. P. L. Jacob, "Une Epigramme à attribuer," *Le Moliériste* 34 (January 1882), 302–4.
64. "Avis de Baluze," ed. Félix Chambon, in "Document inédit sur Tartuffe, contribution à l'histoire de la pièce," *Revue d'Histoire Littéraire de la France* 3: 1 (1896): 124–26.
65. In fact, the Port-Royal nuns did not sign the formulary until February 13, 1669, at which point they were officially pardoned.
66. The third petition is reproduced in Pléiade II, 195.
67. See 1972 Pléiade I, 1333.
68. The preface is reproduced in Pléiade II, 91–96.

Conclusion

1. This is not to overlook a number of small changes that appeared in different editions of the play or the fact that directors frequently alter a basic text or script to suit the purpose of their particular production. Rather, the important point is that Molière's publication of the play in 1669 resolved the question of which of the versions produced by the playwright between 1664 and 1669 should be considered definitive. It thereby provided a fixed point of reference for any subsequent alterations.
2. *L'Eglise et le théâtre: Bossuet, Maximes et Réflexions sur la comédie*, ed. Ch. Urbain and E. Levesque, Paris: Grasset, 1930, 167–276. It is interesting to note that Bossuet, who had spent the years of the *Tartuffe* controversy attempting not to maintain a ban on the play but to bring the sinful, sensual Louis XIV to a full repentance, roundly

condemns Molière and his work but does not single out *Tartuffe* for particular condemnation.
3. A very useful account of this affair is given in Vincent Grégoire, "La représentation du *Tartuffe* n'aura pas lieu; ou pour une nouvelle 'affaire Tartuffe' à Québec en 1694," in *Lieux de culture dans la France du XVIIe siècle*, ed. William Brooks, Christine McCall Probes, and Rainer Zaiser, Oxford: Peter Lang, 2012, 247–64. Salomon also dedicates a short chapter of his book to "Tartuffe en Nouvelle-France" (102–21). See also Alfred Rambaud, "La querelle du *Tartuffe* à Québec et à Paris," *Revue de l'université Laval* 8: 5 (January 1954): 421–34.
4. Salomon speculates that Frontenac may have been present at a private reading of *Tartuffe* in 1664. Frontenac would certainly have had the opportunity of seeing the play in Paris in the late 1680s, when it became popular once again, and before his return to Canada in 1689 (105).
5. Cited in Grégoire 258. See Gustave Lanctôt, *Histoire du Canada*, 2 vols., *Du régime royal au traité d'Utrecht, 1663–1713*, Montreal: Beauchemin, 1964 (II, 179).
6. Cited in Grégoire 247. *Mandement* dated January 16, 1694, "Au sujet des comédies," in l'abbé C.-O. Gagnon and Mgr H. Têtu, *Mandements, lettres pastorales et circulaires des évêques de Québec*, 4 vols., Quebec: A. Côté, 1887 (I, 303).
7. Salomon speculates that Mareuil may also have been in charge of directing the play (105).
8. Salomon speculates that the governor used the money to recoup what he had already spent on costumes and other sundry expenses in anticipation of the play's performance. He notes that several years later, the bishop asked to be reimbursed by the government for this unanticipated expense (112).
9. Cornelius J. Jaenen, *The Role of the Church in New France*, Toronto: McGraw-Hill Ryerson, 1976 (132).
10. La Bruyère's witty observation in "De la mode" whereby "un dévot est celui qui, sous un roi athée, serait athée" (331) (*a* dévot *is someone who under an atheist king would be an atheist*) only makes sense in the context of a pious Louis. *Caractères*, Paris: Firmin Didot, 1869.
11. See Mechele Leon, *Molière, the French Revolution, and the Theatrical Afterlife*, Iowa City: University of Iowa Press, 2009. See also Salomon ch. IV ("Tartuffe à travers les siècles").

Bibliography

Manuscript

Coquelin, Constant. "Tartuffe." Bound holograph c.1884. Maria H. Dehon Polk Collection of Constant Coquelin, Beinecke Rare Book and Manuscript Library. GEN MSS 453 (Box 2, folder 25).

Early Sources (Pre-1800)

Annales de la Compagnie du Saint-Sacrement par René de Voyer d'Argenson, ed. Henri Beauchet-Filleau. Marseille: Saint-Léon, 1900.
Aubignac, François-Hédelin de. *La Pratique du Théâtre*, ed. Pierre Martino. Paris: Champion, 1927.
Baluze, Etienne. "Avis de Baluze," ed. Félix Chambon, in "Document inédit sur Tartuffe, contribution à l'histoire de la pièce," *Revue d'Histoire Littéraire de la France* 3: 1 (1896): 124–26.
Benserade, Isaac de. *Benserade. Ballets pour Louis XIV*, ed. Marie-Claude Canova-Green. 2 vols. Toulouse: Société de littératures classiques, 1997.
Boileau, Nicolas. *Œuvres complètes de Boileau*, ed. Berrait-Saint-Prix. 4 vols. Paris: Philippe, 1837.
Bossuet, Jacques-Bénigne. *Lettres de Bossuet*, ed. Henri Massis. Paris: Tallandier, 1927.
———. *Maximes et réflexions sur la comédie*, in *L'Eglise et le théatre: Bossuet, Maximes et Réflexions sur la comédie*, ed. Ch. Urbain and E. Levesque. Paris: Grasset, 1930: 167–276.
———. *Œuvres complètes de Bossuet*, ed. F. Lachat. 31 vols. Paris: Vivès, 1862–75.
———. *Sermons: Le Carême du Louvre 1662*, ed. Constance Cagnat-Debœuf. Paris: Gallimard, 2001.
Bourdaloue, Louis. *Œuvres complètes de Bourdaloue*, ed. prêtres de l'immaculée-conception de Saint-Dizier. 4 vols. Paris: Guérin, 1864.
Camus, Jean-Pierre. *Homélies quadragésimales.* Rouen: Veuve Du Bosc, 1636.
Chappuzeau, Samuel. *Le Théâtre François.* Lyon: Guignard, 1674.
Chigi, Cardinal. *Relation et observations sur le royaume de France (1664)*, ed. E. Rodocanachi. Paris: Leroux 1894.
Conti, prince de (Armand de Bourbon). *Traité de la comédie et des spectacles, selon la tradition de l'église.* Paris: Louis Billaine, 1667.

———. *Les devoirs des grands*. Paris: Thierry, 1667.
Correspondance entre Boileau-Despréaux et Brossette, ed. Auguste Laverdet. Paris: J. Techener, 1858.
Coustel, père. *Sentimens de l'Eglise & des SS. Peres pour servir de discussion sur la Comedie et les comediens*. Paris: Coignard, 1694.
Depping, Georg Bernhard, ed. *Correspondance administrative sous le règne de Louis XIV, entre le cabinet du roi, les secrétaires d'état, le chancelier de France*. 4 vols. Paris: Imprimerie nationale, 1850–1855.
Dictionnaire de l'Académie Françoise. 3 vols. Paris: Coignard, 1694.
Divers actes, lettres et relations des religieuses de Port Royal du Saint-Sacrement, touchant la persecution et les violences qui leur ont été faites au sujet de la signature du formulaire. [np]: [np], 1723–1724.
Dufour, Charles. *Mémoire pour faire connoistre l'esprit & la conduite de la Compagnie establie en la ville de Caën, appellée l'Hermitage*. Caen: [np], 1660.
Du Lorens, Jacques. *Satires de Dulorens*. Paris: Jouaust, 1646; repr. 1869.
Enghien, duc de. "Documents inédits: Une lettre du duc d'Enghein demandant le quatrième acte de Tartuffe au Raincy," ed. Georges Monval, in *Le Moliériste* 3 (1881): 193–200.
Furetière, Antoine. *Dictionnaire universel: Contenant généralement tous les mots françois, tant vieux que modernes, et les termes de toutes les sciences*. 3 vols. La Haye: Arnout and Reinier Leers, 1690.
Garaby de la Luzerne, Antoine. *Garaby de la Luzerne: Satires inédites*, ed. Eugène de Beaurepaire. Rouen: Espérance Cagniard, 1888.
———. *Sentimens Chrestiens, politiques, et moraux. Maximes d'estat, et de Religion*. Caen: Yvon, 1654.
Gerard, abbé de. *Le caractere de l'honneste-homme morale*. Paris: Huré, 1682.
Godeau, Antoine. *Poésies chrestiennes d'Antoine Godeau*. Paris: Le Petit, 1660.
Goussault, abbé de. *Portrait d'un honneste homme*. Paris: Brunet, 1692.
Joly, Claude. *Recueil de maximes véritables et importantes pour l'institution du roy, contre la fausse et pernicieuse politique du cardinal Mazarin, prétendu surintendant de l'éducation de sa majesté*. Paris: [np], 1652.
La Bruyere, Jean de. *Caractères*. Paris: Firmin Didot, 1869.
La Grange, Charles Varlet. *Le Registre de La Grange (1658–1685)*. Paris: Clay, 1876.
———. *Le Registre de La Grange. 1659–1685, reproduit en facsimilé avec un index et une notice sur La Grange et sa part dans le théâtre de Molière*, ed. Bert E. Young and Grace P. Young. Paris: Droz, 1947; repr. Geneva: Slatkine, 1977.
La Mothe Le Vayer, François de. *Lettre sur la comédie de l'imposteur*, ed. Robert McBride. Durham: University of Durham, 1994.
———. *Œuvres de François de La Mothe Le Vayer*. 7 vols. Dresden: Michel Groell, 1756–1759.
Le Moyne, Pierre. *De l'art de régner*. Paris: Cramoisy, 1665.
———. *La Dévotion aisée*. Paris: Sommaville, 1652; Paris; repr. Cottin, 1668.

Lettre sur les observations d'une comédie du sieur Molière, intitulée "Le Festin de Pierre" (1665) in Pléiade, II, 1229–41.

Loret, Jean. *La muze historique, ou Recueil des lettres en vers à son Altesse Mademoiselle de Longueville*, ed. J. Ravenel and E. D. V. de la Pelouze. 4 vols. Paris: P. Jannet, 1857–1878.

Louis XIV. *Mémoires de Louis XIV*, ed. Jean Longnon. Paris: Tallandier, 1978.

Maintenon, Françoise d'Aubigné. *Correspondance générale de madame de Maintenon*, ed. Théophile Lavallée and Laurent Angliviel de La Beaumelle. 4 vols. Paris: Charpentier, 1865.

Marolles, Michel de. *Mémoires*. 3 vols. Amsterdam: [np], 1755.

Méré, Antoine chevalier de. *Œuvres complètes du Chevalier de Méré*, ed. Charles-H Boudhours. 3 vols. Paris: Fernand Roches, 1930.

Molière. *L'Imposteur de 1667, prédécesseur du* Tartuffe, ed. Robert McBride. Durham: Durham Modern Languages Series, 1999.

———. *Œuvres complètes*, ed. Georges Couton. 2 vols. Pléiade. Paris: Gallimard, 1972. [Referred to as "1972 Pléiade."]

———. *Œuvres complètes*, ed. Georges Forestier and Claude Bourqui et al. 2 vols. Pléiade. Paris: Gallimard, 2010. [Referred to as "Pléiade."]

———. *Œuvres*, ed. Eugène Despois and Paul Mesnard. 11 vols. Grands Ecrivains de France. Paris: Hachette, 1873–1893.

———. *Œuvres de Monsieur de Molière*, ed. Charles Varlet de La Grange and Jean Vivot. 8 vols. Paris: Thierry, 1682.

———. *Tartufe, ou L'imposteur*, ed. abbé Figuière. Paris: Poussielgue, 1895.

Mongrédien, Georges, ed. *Comédies et pamphlets sur Molière*. Paris: Nizet, 1986.

Motteville, Mme de. *Mémoires de Madame de Motteville sur Anne d'Autriche et sa cour*, ed. M. F. Riaux and M. Sainte-Beuve. 4 vols. Paris: Charpentier, 1855.

Nicole, Pierre. *Traité de la Comédie et autres pièces d'un procès du théâtre*, ed. Laurent Thirouin. Paris: Champion, 1998.

———. *Les Visionnaires, ou seconde partie des lettres sur l'heresie imaginaire*. 2 vols. Liège: Adolphe Beyers, 1667.

Orléans, Charlotte Elisabeth de Bavière. *Correspondance de Madame, Duchesse d'Orléans*. 2 vols. Paris: A. Quantin, 1880.

Ormesson, Olivier Lefevre. *Journal d'Olivier Lefèvre d'Ormesson*, ed. M. Chéruel. Paris: Imprimerie Impériale, 1861.

Pascal, Blaise. *Les provinciales*, ed. Louis Cognet and Gérard Ferreyrolles. Paris: Bordas, 1992.

Patin, Guy. *Lettres choisies de feu M. Guy Patin*. Paris: Jean Petit, 1692.

Péréfixe, Hardouin de. *Histoire du Roy Henry le Grand*. Amsterdam: Elzevier, 1661.

———. *Institutio principis ad Ludovicum XIV*. Paris: Vitré, 1647.

Pléiade. See Molière, *Œuvres complètes*.

Racine, Jean. *Abrégé de l'histoire de Port-Royal*, ed. Alain Couprie. Paris: Table Ronde, 1994.

———. "Lettre aux deux apologistes de l'auteur des Hérésies imaginaires," in Pierre Nicole, *Traité de la comédie et autres pièces d'un procès de théâtre*, ed. Laurent Thirouin. Paris: Champion, 1998: 265–72.

———. *Œuvres complètes*, ed. Raymond Picard. 2 vols. Pléiade. Paris: Gallimard, 1964.

Renaudot, Théophraste, et al., eds. *La Gazette*. Paris: Bureau d'adresse, 1631–1761.

Réponse aux observations touchant "Le Festin de Pierre," de Monsieur de Molière (1665), in Pléiade II, 1222–28.

Retz, Jean François Paul de Gondi de. *Œuvres du cardinal de Retz*. 10 vols. Paris: Hachette, 1882.

Richelet, Pierre. *Dictionnaire françois, contenant les mots et les choses, plusieurs nouvelles remarques sur la langue françoise*. Geneva: Widerhold, 1685.

Rochemont, sieur de. *Observations sur une comédie de Molière intitulée "Le Festin de Pierre,"* in Pléiade II, 1212–21.

Roulé, Pierre. *Le roy glorieux au monde*, ed. Paul Lacroix. Geneva: Gay, 1867.

Saint-Simon, Louis de Rouvroy. *Mémoires complets et authentiques du duc de Saint-Simon sur le siècle de Louis XIV et la Régence*, ed. M. Chéruel and A. Régnier. 20 vols. Paris: Hachette, 1856.

Sales, François de. *Introduction à la vie dévote*. Paris: Lecoffre, 1894.

Scarron, Paul. *Les hypocrites*. Paris: Sommaville, 1655.

Scudéry, Madeleine de. *Nouvelles conversations de morale*. 2 vols. Paris: Veuve de Sebastien Mabre-Cramoisy, 1688.

Senault, Jean-François. *Le Monarque ou les devoirs du souverain*. Paris: Lepetit, 1661.

Sévigné, Marquise de. (Marie de Rabutin-Chantal.) *Correspondance*, ed. Roger Duchêne. 3 vols. Pléiade. Paris: Gallimard, 1972–1978.

Sourches, Louis François de Bouchet. *Mémoires du marquis de Sourches sur le règne de Louis XIV*, ed. Michel Chamillart et al. 13 vols. Paris: Hachette, 1882.

Voisin, Joseph de. *La défense du traité de Monseigneur le Prince de Conti, touchant la comédie et les spectacles ou la réfutation d'un livre intitulé 'dissertation sur la condamnation des théatres.'* Paris: Coignard, 1671.

Modern Sources

Adam, Antoine. *Du mysticisme à la révolte: Les jansénistes du XVII^e siècle*. Paris: Fayard, 1968.

Albanese, Ralph. *Le Dynamisme de la peur chez Molière: Une analyse sociocritique de* Dom Juan, Tartuffe *et* L'Ecole des femmes. Oxford, MS: Romance Monographs, 1976.

Allier, Raoul. *La Cabale des dévots, 1627–1666*. Paris: Colin, 1902; repr. Geneva: Slatkine, 1970.

Apostolidès, Jean-Marie. *Le roi-machine: Spectacle et politique au temps de Louis XIV*. Paris: Minuit, 1981.

———. "Le Spectacle de l'abondance." *Esprit créateur* 19: 3 (1981): 26–34.

Assaf, Francis. *La Mort du roi: Une thanatographie de Louis XIV*. Biblio 17: 112. Tübingen: Gunter Narr, 1999.
Auerbach, Eric. *Mimésis. La représentation de la réalité dans la littérature occidentale*. Paris: Gallimard, 1968.
Barras, Moses. *The Stage Controversy in France from Corneille to Rousseau*. Berkeley: University of California Press, 1981.
Baumal, Francis. *La Genèse de Tartuffe: Molière et les dévots*. Paris: Editions du livre mensuel, 1919.
———. *Tartuffe et ses avatars: De Montufar à Dom Juan*. Paris: Nourry, 1925.
Bazin, A. "Notice sur la vie et les ouvrages de Molière." *Revue des deux mondes* 21 (January–March 1848): 185–215.
Béguin, Katia. *Les Princes de Condé: Rebelles, courtisans et mécènes dans la France du Grand Siècle*. Paris: Champ Vallon, 1999.
Bénichou, Paul. *Morales du grand siècle*. Paris: Gallimard, 1948.
Bergson, Henri. *Le Rire: Essai Sur La Signification Du Comique*. Bibliothèque de Philosophie Contemporaine. Paris: Presses Universitaires de France, 1947.
Billington, Michael. "Review of 'Tartuffe,' Arcola Theatre." *The Guardian*, December 11, 2004. http://www.guardian.co.uk/stage/2004/dec/11/theatre.
Bourqui, Claude. *Polémique et stratégies dans le* Dom Juan *de Molière*. Biblio 17: 69. Paris: PFSCL, 1992.
Briggs, Robin. *Communities of Belief: Cultural and Social Tension in Early Modern France*. Oxford: Clarendon Press, 1989.
Burke, Peter. *The Fabrication of Louis XIV*. New Haven: Yale University Press, 1992.
Bury, Emmanuel. *L'invention de l'honnête homme 1580–1750*. Paris: Presses Universitaires de France, 1996.
Butler, Philip. "Tartuffe et la direction spirituelle au XVIIe siècle," in T. E. Lawrenson, F. E. Sutcliffe, et al., *Modern Miscellany Presented to Eugene Vinaver by Pupils, Colleagues, and Friends*. Manchester: Manchester University Press, 1969: 48–64.
Cagnat-Debœuf, Constance. "L'ironie dans *Le Carême du Louvre*." *Littératures Classiques* 46 (2002): 125–39.
———. "Un sermon en anamorphose: le discours au roi dans le *Carême du Louvre*," in *Lectures de Bossuet, Le Carême du Louvre*, ed. Guillaume Peureux. Rennes: Presses Universitaires de Rennes, 2001: 111–28.
Cairncross, John, ed. *L'humanité de Molière*. Paris: Nizet, 1988.
———. "Impie en médecine." *Cahiers de l'Association Internationale des Etudes Françaises* 16 (1965): 269–84.
———. *Molière bourgeois et libertin*. Paris: Nizet, 1963.
———. *New Light on Molière: Tartuffe, Elomire hypocondre*. Geneva: Droz, 1956.
———. "*Tartuffe*, ou Molière hypocrite." *Revue de l'Histoire Littéraire de la France* 72 (1972): 890–901.

Caldicott, C. E. J. "Le gouvernement de Gaston d'Orléans en Languedoc (1644–1660) et la carrière de Molière." *Dix-septième siècle* 116 (1979): 17–42.

Calvet, Jean. *Essai sur la séparation de la religion et de la vie: Molière dans le drame spirituel de son temps.* Paris: Nizet, 1980.

Cashman, Kimberly. "*Tartuffe* IV, 5: Performance Space as the Locus of Truth," in *Formes et formations au dix-septième siècle*, ed. Buford Norman. Biblio 17: 168. Tübingen: Gunter Narr, 2006: 251–59.

Cavaillé, Jean-Pierre. "Hypocrisie et Imposture dans la querelle du *Tartuffe* (1664–1669): La *Lettre sur la comédie de l'imposteur* (1667)." *Les Dossiers du Grihl, Les dossiers de Jean-Pierre Cavaillé, Libertinage, athéisme, irréligion. Essais et bibliographie.* http://dossiersgrihl.revues.org/292; DOI: 10.4000/dossiersgrihl.292.

Chevalley, Sylvie. "Les Plaisirs de l'île enchantée." *Europe* 441–42 (1966): 34–43.

Chill, Emmanuel. "*Tartuffe*, Religion, and Courtly Culture." *French Historical Studies* 3 (1963): 151–83.

Couton, Georges. *La chair et l'âme: Louis XIV entre ses maîtresses et Bossuet.* Grenoble: Presses Universitaires de Grenoble, 1995.

———. "Réflexions sur *Tartuffe* et le péché d'hypocrisie, *cas réservé*." *Revue d'Histoire littéraire de la France* 69 (1969): 404–13.

———. *Richelieu et le théâtre.* Lyon: Presses Universitaires de Lyon, 1986.

Dandrey, Patrick. *Dom Juan ou la critique de la raison comique.* Paris: Champion, 1993.

Declercq, Gilles. "Equivoques de la séduction. Elmire entre honnêteté et libertinage." Biblio 17: 181 (2009): 73–127.

Defaux, Gérard. "Un point chaud de la critique moliéresque: Molière et ses raisonneurs." *Travaux de linguistique et de littérature* 18: 2 (1980): 115–32.

Dieudonné, P. *La paix clementine: Défaite et victoire du premier jansénisme français sous le pontificat de Clément IX (1667–69).* Leuven: Leuven University Press, 2003.

Dussane, Béatrix. "Molière et Bourdaloue." *Revue universelle* 38: 12 (September 1929): 641–56.

Escola, Marc. "Vrai caractère du faux dévot: Molière, La Bruyère, Auerbach." *Poétique* 98 (April 1994): 181–98.

Fargher, Richard. "Molière and His Reasoners," in *Studies in French Literature presented to H. W. Lawton*, ed. J. C. Ireson. Manchester: Manchester University Press, 1968: 105–20.

Ferreyolles, Gérard. *Molière: Tartuffe.* Études Littéraires 16. Paris: Presses Universitaires de France, 1987.

Gaines, James. "Sagesse avec Sobriété: Skepticism, Belief, and the Limits of Knowledge in Molière." Biblio 17: 147 (2003): 161–71.

———. *Social Structures in Molière's Theater*. Columbus: Ohio State University Press, 1984.
Gaumont, Jean, and L. Chouville. "Ninon, Molière et les Dévots." *Mercure de France* 33: 153 (January 1922): 36–70.
Gazier, Augustin. *Bossuet et Louis XIV (1662–1704)*. Paris: Champion, 1914.
Giesey, Ralph E. *Cérémonial et puissance souveraine. France, XVe-XVIIe siècles*. Paris: Colin, 1987.
Gilbert, Huguette. "*Les Nopces ducales* et la Querelle de *L'Ecole des femmes*." *Dix-Septième Siècle* 150 (1986): 73–74.
Gossman, Lionel. *Men and Masks: A Study of Molière*. Baltimore: Johns Hopkins Press, 1963.
———. "Molière and Tartuffe: Law and Order in the Seventeenth Century." *French Review* 43: 6 (1970): 901–12.
Grégoire, Vincent. "La représentation du *Tartuffe* n'aura pas lieu; ou comme une nouvelle 'affaire Tartuffe' à Québec en 1694," in *Lieux de culture dans la France du XVIIe siècle*, ed. William Brooks, Christine McCall Probes, and Rainer Zaiser. Oxford: Peter Lang, 2012: 247–64.
Guicharnaud, Jacques. *Molière, une aventure théâtrale*. Paris: Gallimard, 1963.
Guion, Béatrice. "L'aigle de Meaux, le cygne de Cambrai et Louis le Grand: Louis XIV devant Bossuet et Fénelon." *Travaux de littérature* 18 (2005): 195–215.
Guitton, Georges. *Le père de la Chaize, Confesseur de Louis XIV*. 2 vols. Paris: Beauchesne, 1959.
Hall, H. Gaston. *Molière: Tartuffe*. London: Edward Arnold, 1960.
———. "Some Background to Molière's *Tartuffe*." *Australian Journal of French Studies* 10 (1973): 110–29.
Hawcroft, Michael. *Molière: Reasoning with Fools*. Oxford: Oxford University Press, 2007.
Herzel, Roger. "The Function of the *Raisonneur* in Molière's Comedy." *Modern Language Notes* 90: 4 (1975): 564–75.
Hoffman, Kathryn. *Society of Pleasures: Interdisciplinary Readings in Pleasure and Power during the Reign of Louis XIV*. New York: St Martin's Press, 1997.
Howarth, William. *Molière, a Playwright and His Audience*. Major European Authors. Cambridge: Cambridge University Press, 1982.
———. "Les Tartuffes de l'époque révolutionnaire," in *Atti del Convegno di studi sul teatro e la Rivoluzione francese*, ed. M. Richter. Vicenza: Accademia Olimpica, 1991: 65–77.
———. "The theme of Tartuffe in Eighteenth-Century Comedy." *French Studies* 4 (1950): 113–27.
Jacob, P. L. "Une Epigramme à attribuer." *Le Moliériste* 34 (January 1882): 302–4.

Jaenen, Cornelius J. *The Role of the Church in New France*. Toronto: McGraw-Hill Ryerson, 1976.
James, Barry. "Spotlight Is on the Link of Religion and Power." *The New York Times*, February 8, 1996. http://www.nytimes.com/1996/02/08/opinion/08iht-edbarry.t.html.
Jaynes, William. "Critical Opinions of Cléante in Tartuffe." *Œuvres et critiques* 6: 1 (1981): 91–97.
Jongh, Nicholas de. "Tartuffe Is No Turkish Delight." *The London Evening Standard*, December 13, 2004. http://www.standard.co.uk/arts/theatre/tartuffe-is-no-turkish-delight-7383303.html.
Judge, H. G. "Louis XIV and the Church," in *Louis XIV and the Craft of Kingship*, ed. J. C. Rule. Columbus: Ohio State University Press, 1969: 240–64.
Jurgens, Madeleine, and Elizabeth Maxfield-Miller. *Cent ans de recherches sur Molière, sur sa famille et sur les comédiens de sa troupe*. Paris: Imprimerie Nationale, 1963.
Kasparek, Jerry Lewis. *Molière's* Tartuffe *and the Traditions of Roman Satire*. Chapel Hill: North Carolina Studies in the Romance Languages and Literatures, 1977.
Klausen, Jytte. *The Cartoons that Shook the World*. New Haven: Yale University Press, 2009.
Kleinman, Ruth. *Anne of Austria, Queen of France*. Columbus: Ohio State University Press, 1985.
Kostroun, Daniella. *Feminism, Absolutism, and Jansenism: Louis XIV and the Port-Royal Nuns*. New York: Cambridge University Press, 2011.
———. "A Formula for Disobedience: Jansenism, Gender, and the Feminist Paradox." *Journal of Modern History* 75 (September 2003): 483–522.
Lacour, Louis. *Le Tartuffe par ordre de Louis XIV*. Paris: Claudin, 1877; repr. Nîmes: Lacour, 1999.
Lacour-Gayet, Georges. *L'Education politique de Louis XIV*. Paris: Hachette, 1898.
Lapommeraye, Henry de. *Molière et Bossuet*. Paris: Ollendorff, 1877.
Lawrence, Francis L. "The Norm in *Tartuffe*." *Revue de l'Université d'Ottawa* 36: 4 (1966): 698–702.
———. "The *Raisonneur* in Molière." *L'Esprit créateur* 6: 3 (1966): 156–66.
———. "*Tartuffe*: A Question of *honnête* behavior." *Romance Notes* 15: Supp 1 (1973): 134–44.
Lecercle, François. "Jeux avec la censure: Molière et la stratégie de l'obscène. A propos de *Tartuffe*, IV, 5," in *La liberté de pensée*, ed. François Lecercle. Poitiers: UFR de langues et littératures, 2002: 157–84.
Leclerc, Guy. "Dom Juan dans la bataille de *Tartuffe*." *Europe* 441–42 (1966): 51–58.
Leon, Mechele. *Molière, the French Revolution, and the Theatrical Afterlife*. Iowa City: University of Iowa Press, 2009.

Lespire, R. "Le 'libertinage' de Molière et la portée de *Dom Juan*." *Revue belge de philologie et d'histoire* 28: 1 (1950): 29–58.

Lévêque, André. "'L'honnête homme' et 'l'homme de bien' au XVIIe siècle." *Publications of the Modern Languages Association of America* 72: 4 (1957): 620–32.

Levi, Anthony. *Louis XIV*. New York: Carroll and Graf, 2004.

Lossky, Andrew. *Louis XIV and the French Monarchy*. New Brunswick: Rutgers University Press, 1994.

McBride, Robert. *Molière et son premier* Tartuffe*: Genèse et évolution d'une pièce à scandale*. Durham: Durham Modern Languages Series, 2005.

———. *The Sceptical Vision of Molière: A Study in Paradox*. London: Macmillan, 1977.

McKenna, Antony. *Molière dramaturge libertin*. Paris: Champion, 2005.

Mercader, Albert. "L'hypocrisie et Tartuffe." *Mercure de France* 156: 605 (September 1923): 289–315.

Mettam, Roger. *Power and Faction in Louis XIV's France*. New York: Blackwell, 1988.

Michaut, Gustave. *Les Luttes de Molière*. Paris: Hachette, 1925.

Mongrédien, Georges, ed. *La Querelle de l'Ecole des femmes*. 2 vols. Paris: Didier, 1971.

———. *Recueil des textes et des documents du dix-septième siècle relatifs à Molière*. 2 vols. Paris: CNRS, 1965.

Moore, W. G. *Molière: A New Criticism*. Oxford: Clarendon Press, 1949; repr. 1962.

Morel, Jacques. "A propos de la 'scène du pauvre' dans *Dom Juan*." *Revue d'histoire littéraire de la France* 72 (1972): 938–44.

Norman, Larry. "Molière, rhapsode et espion: fictions d'auteur dans la querelle de *L'Ecole des femmes*," in *Fiction d'auteur: Le discours biographique sur l'auteur de l'Antiquité à nos jours*, ed. Sandrine Dubel and Sophie Rabau. Paris: Champion, 2001: 185–200.

———. *The Public Mirror: Molière and the Social Commerce of Depiction*. Chicago: University of Chicago Press, 1999.

Parish, Richard. "Tartuf(f)e ou l'imposture." *Seventeenth Century* 6: 1 (Spring 1991): 73–88

Parker, David. *The Making of French Absolutism*. London: Edward Arnold, 1983.

Peacock, Noël. "The Comic Role of the 'Raisonneur' in Molière's Theatre." *Modern Language Review* 76: 2 (1981): 298–310.

———. "Molière: état présent." *French Studies* 61: 1 (2010): 64–72.

Petitfils, Jean-Christian. *Louise de La Vallière*. Paris: Perrin, 1990.

Peureux, Guillaume, ed. *Lectures de Bossuet, Le Carême du Louvre*. Rennes: Presses Universitaires de Rennes, 2001.

Phillips, Henry. *Church and Culture in Seventeenth-Century France*. Cambridge: Cambridge University Press, 1997.

———. "Molière and Tartuffe: Recrimination and Reconciliation." *French Review* 62: 5 (April 1989): 749–63.

Picard, Raymond. "Tartuffe, 'production impie'?" in *Mélanges d'histoire littéraire (XVI^e-XVII^e siècle): Offerts à Raymond Lebègue*. Paris: Nizet, 1969: 227–39.

Pineau, Joseph. *Le théâtre de Molière: Une dynamique de la liberté*. Paris: Lettres modernes Minard, 2000.

Plantié, Jacqueline. "Moliere et François de Sales." *Revue d'histoire littéraire de la France* 72 (1972): 902–27.

Pommier, René. *Etudes sur* Le Tartuffe. Paris: SEDES, 1994.

Prest, Julia. "Conflicting Signals: Images of Louis XIV in Benserade's Ballets," in *Culture and Conflict in 17th-century France and Ireland*, ed. Sarah Alyn Stacey and Véronique Desnain. Dublin: Four Courts Press, 2004: 227–41.

———. "Elmire and the Erotics of the ménage à trois in Molière's *Tartuffe*." *Romanic Review* 102 (2011): 129–44.

———. *Theatre under Louis XIV: Cross-Casting and the Performance of Gender in Drama, Ballet and Opera*. New York: Palgrave, 2013.

———. "Troublesome Sensual Appetites or Who Is the Real *faux dévot*?" in *Nourritures: Actes du 40^e congrès annuel de la North American Society for seventeenth-Century French Literature*, ed. Roxanne Lalande and Bertrand Landry. Biblio 17. Tübingen: Gunter Narr, 2010: 253–63.

———. "Where are the *vrais dévots* and Are They *véritables gens de bien*? Eloquent Slippage in the *Tartuffe* Controversy." *Neophilologus* 96: 3 (2012) [online version] and 97: 2 (2013): 283–97 [print version].

Rambaud, Alfred. "La querelle du *Tartuffe* à Québec et à Paris." *Revue de l'université Laval* 8: 5 (January 1954): 421–34.

Ranum, Orest. *The Artisans of Glory: Writers and Historical Thought in Seventeenth-Century France*. Chapel Hill: University of North Carolina Press, 1980.

———. *Paris in the Age of Absolutism*. New York: Wiley, 1968.

Rapley, Elizabeth. *The Dévotes: Women and Church in Seventeenth-Century France*. Montreal: McGill-Queen's University Press, 1990.

Ravel, Jeffrey S. *The Contested Parterre: Public Theater and French Political Culture, 1680–1791*. Ithaca: Cornell University Press, 1999.

Rey, François, and Jean Lacouture. *Molière et le roi: L'affaire Tartuffe*. Paris: Seuil, 2007.

Riggs, Larry W. "Molière's 'Poststructuralism': Demolition of Transcendentalist Discourse in *Le Tartuffe*." *Symposium* 44: 1 (1990): 37–57.

Robin, Jean Luc. "La chute de la maison Orgon: mercantilisme et économie symbolique dans *Tartuffe*." *Papers on French Seventeenth Century Literature* 29: 56 (2002): 33–46.

———. "*Experimentum periculosum*. L'expérience cruciale d'El(o)mire." Biblio 17: 168 (2006): 261–72.

Rossat-Mignod, Suzanne. "La portée de *Tartuffe* à la fin du XVII^e siècle." *Europe* 441–42 (1966): 44–51.
Rule, John C., ed. *Louis XIV and the Craft of Kingship*. Columbus: Ohio State University Press, 1969.
———. "Louis XIV, Roi-Bureaucrate," in *Louis XIV and the Craft of Kingship*, ed. J. C. Rule: 3–101.
Salomon, Herman Prins. *Tartuffe devant l'opinion française*. Paris: Presses Universitaires de France, 1962.
Saur, Pamela S. "Molière's *Tartuffe*." *The Explicator* 60: 1 (2001): 9–11.
Scherer, Jacques. *Dramaturgies du vrai-faux*. Paris: Presses Universitaires de France. 1994.
———. *Structures de Tartuffe*. Paris: SEDES, 1966; repr. 1974.
Sedgwick, Alexander. *Jansenism in Seventeenth-Century France: Voices from the Wilderness*. Charlottesville: University Press of Virginia, 1977.
Simonds, P. Muñoz. "Molière's Satiric Use of the *Deus Ex Machina* in Tartuffe." *Educational Theatre Journal* 29: 1 (March 1977): 85–93.
Somerset, Anne. *The Affair of the Poisons: Murder, Infanticide and Satanism at the Court of Louis XIV*. London: Weidenfeld and Nicolson, 2003.
Sonnino, Paul. *Louis XIV's View of the Papacy (1661–69)*. Berkeley: University of California Press, 1966.
Spingler, Michael. "The King's Play: Censorship and the Politics of Performance in Molière's *Tartuffe*." *Comparative Drama* 19: 3 (1985): 240–57.
Tallon, Alain. *La Compagnie du Saint-Sacrement (1629–1667)*. Paris: Cerf, 1990.
Thierry, Edouard. "Le Silence d'Elmire: étude sur l'interprétation du rôle dans *Tartuffe*." *Revue d'art dramatique* 12 (1888): 129–38, 193–206.
Thirouin, Laurent. *L'aveuglement salutaire: Le réquisitoire contre le théâtre dans la France classique*. Paris: Champion, 1997.
Tobin, Ronald. "Tartuffe, texte sacré," in *Dramaturgies, langages dramatiques: Mélanges pour Jacques Scherer*. Paris: Nizet, 1986: 375–82.
Truchet, Jacques. "A propos de l'*Amphitryon* de Molière: Alcmène et La Vallière," in *Mélanges d'histoire littéraire XVI^e et XVII^e siècle offerts à Raymond Lebègue*. Paris: Nizet, 1969: 241–48.
———. "Molière théologien dans *Dom Juan*." *Revue d'histoire littéraire de la France* 72 (1972): 928–38.
Venesoen, Constant. "Dom Juan ou 'la conversion manquée.'" *Revue belge de philologie et d'histoire* 51: 3 (1973): 542–55.
Véronique, Jacob. "A chacun son Tartuffe." *L'Express*, October 12, 1995. http://www.lexpress.fr/informations/a-chacun-son-tartuffe_610166.html.
Veuillot, Louis. *Molière et Bourdaloue*. Paris: Librairie Catholique, 1877.
Vogler, Bernard. "La dimension religieuse dans les relations internationales en Europe au XVII^e siècle (1618–1721)." *Histoire, économie et société* 10: 3 (1991): 379–98.

Wine, Kathleen. "Honored Guests: Wife and Mistress in 'Les plaisirs de l'île enchantée.'" *Dalhousie French Studies* 56 (Fall 2001): 78–90.

———. "*Le Tartuffe* and *Les Plaisirs de l'Ile enchantée*: Satire or Flattery?" in *Theatrum Mundi*, ed. Claire L. Carlin and Kathleen Wine. Charlottesville, VA: Rookwood, 2003: 139–46.

Wolf, John B. "The Formation of a King," in *Louis XIV and the Craft of Kingship*, ed. J. C. Rule: 102–31.

Zanger, Abby E. *Scenes from the Marriage of Louis XIV: Nuptial Fictions and the Making of Absolutist Power*. Stanford: Stanford University Press, 1997.

Zoberman, Pierre. "Rhétorique et prédication: *Sur la Prédication évangélique et les sermons sur la parole de Dieu*." *Littératures classiques* 46 (2002): 33–53.

Zwillenberg, Myrna Kogan. "Dramatic Justice in *Tartuffe*." *Modern Language Notes* 90: 4 (May 1975): 583–90.

Index

absolutism, 5, 10, 15, 25, 27–28, 61, 67, 139, 141, 146, 159, 160, 162, 174, 186, 190
Annat, François, 26, 160, 186, 202n18
　as confessor to Louis XIV, 14, 71, 158, 204n47
Anne of Austria (Queen Mother), 9, 14, 19, 20, 26, 31–33, 54, 56, 61–62, 138, 141–42, 172, 190
Apostolidès, Jean-Marie, 49
Arnauld, Antoine (le grand Arnauld), 13, 20, 149, 181, 186
Arnauld d'Andilly, Robert, 20, 85, 201n11
d'Aubignac, abbé, 29–30, 103, 125, 127
authority, 14, 24, 95, 98, 126, 139, 140, 146, 156, 163, 168, 174, 177–78, 179, 181–85, 188, 189, 195, 196–97
　ecclesiastical, 31, 47, 48, 65, 70, 71, 126, 140, 179, 184, 196
　kingly, 3, 5, 15, 21, 27–28, 61, 66–69, 137, 140, 143, 146, 155–56, 159, 160, 162, 168, 170–71, 174, 181, 182, 183–84, 185, 189, 190, 193, 196
　legal, 95, 179, 184
　papal, 26, 143, 146, 159, 160, 222n12

Avignon Festival, 1

Baluze, Etienne, 182–85, 189
Baumal, Francis, 3, 94
Bergson, Henri, 80–81
biblical references, 45, 47, 48, 49–50, 83, 86–87, 91, 97, 99, 109, 120, 209n31, 216n12
Bilis, Serdar (2004 production of *Tartuffe*), 1, 2
Billington, Michael, 2
Boileau, Nicolas, 163
Boileau-Brossette correspondence, 133, 142, 144, 172–73, 176–79, 213n66
Bossuet, Jacques-Bénigne, 40, 46, 48, 58, 59, 64–66, 73, 80, 89, 109
　Carême du Louvre, 4, 47–53
　description of, 47
　on hypocrisy, 62–63, 113
　and Louis XIV, 4, 62, 63, 65, 70
　separates Louis XIV and Mme de Montespan, 65
　and theatre, 29, 63, 128, 193, 226n2
Bourdaloue, Louis, 75, 80, 97–101, 109, 206n12, 221n35
　on adultery, 214n75
　on devotion, 38–39, 40–41, 97, 111–12, 216n11, 217n23

Bourdaloue, Louis (*continued*)
 on hypocrisy, 41, 99–100, 105, 111–12, 113, 207n16, 218n9
Bourdaloue, Louis, (*continued*)
 on zeal, zealotry, 40–41, 86, 97–101, 103–04, 105
Bourqui, Claude, 167, 214n1, 217n25

Calvet, Jean, 7, 117–18
Camus, Jean-Pierre, 117, 126
Chappuzeau, Samuel, 127
Chigi, Cardinal, 53, 146–49, 157
 allusions to by Molière, 147, 148–49
 plans to see *Tartuffe*, 148–49
 visits France, 147–49, 153
Christina of Sweden, 170–71
Ciron, abbé de, 12
Cléante, 87–93, 96, 103–5, 116–17, 118–20, 171–72
 and alternative form of morality, 4, 87, 92–93, 105, 117, 119, 120, 130–32, 134–35, 192
 attempts to describe *vrai dévot*, 4, 90–92
 on distinguishing between true and false devotion, 87–90, 113–14, 116
 names *vrais dévots*, 116–18
 as *véritable homme de bien*, 130–32, 134
Colbert, Jean-Baptiste, 25, 54, 66, 190
Company of the Holy Sacrament, 3, 14–19, 52, 75, 76, 85, 105, 123, 126, 138–39, 141, 149, 158
 Annales of, 14, 15, 17, 18, 19, 47, 94, 138, 142, 157, 221n4
 is made illegal, 18, 133, 140
 scandals in and around Caen, 15–16, 18, 93–97, 112

 secrecy of, 93–94. *See also* Dufour, Charles
 See also *Tartuffe*, banning and unbanning of
Condé, prince de (Louis de Bourbon)
 during the Fronde, 9, 10, 161, 162–64
 is pardoned, 24, 161–62
 and *Tartuffe*, 76, 137–38, 161, 164, 169–70, 175, 188–89
Conti, prince de (Armand de Bourbon), 8–13, 17, 18, 163
 Les devoirs des grands, 11
 during the Fronde, 9–10
 enters the Company of the Holy Sacrament
 in Languedoc, 14
 in Paris, 17
 religious conversion of, 12
 and Molière, 9, 10, 11–13
 and *Tartuffe*, 11, 157–58
 Traité de la comédie, 11, 128, 158, 167–68
Corneille, Pierre, 148, 164, 194
Council of Trent. *See* Counterreformation
Counterreformation, 7, 29, 84, 85, 107, 110, 119
 in France, 4, 7, 13, 14, 28, 75, 78, 81, 82, 93, 128, 194
court ballet, 53, 57, 60–61
Coustel, père, 37, 39–40
Couton, Georges, 46, 66, 72, 126

Damis, 77, 85, 86, 90
Deslions, Jean, 182
dévot and *mondain*, tensions between, 2, 4, 7, 15, 27, 32, 36, 53, 58, 60, 61–62, 71, 72, 81–82, 93, 109, 128, 138, 172, 190, 194, 196
dévots, 10, 14, 15, 30, 32, 36, 47, 58, 73, 83, 97, 104, 107, 121, 124–26, 129, 141–44,

156, 172–73, 175, 187, 190, 193, 199n6, 221n35. *See also* Company of the Holy Sacrament; *faux dévot*; *vrai dévot*
Dorine, 42–43, 77–79, 81, 82, 84, 85, 90, 172
Dufour, Charles, 15–16, 94–96

Edict of Nantes, Revocation of, 66, 73, 150
Elmire, 43, 44, 208n22
d'Enghien, duc, 164, 169–70
Escola, Marc, 43, 68, 72–73

false devotion. See *faux dévot*
fanaticism, 1–2, 75, 95, 96, 149, 197. *See also* zealotry
faux dévot, 3, 4, 35–73, 75–105, 110, 112–13, 114, 121–22, 126, 130, 132, 191, 192
(*faux*) *faux dévot*, 43, 68, 191
(*vrai*) *faux dévot*, 43, 73
See also Escola, Marc; *vrai-faux* model
Fouquet, Nicolas, 8, 24–25, 54, 162
Fronde, 8, 9, 10, 23–24, 61, 69, 139, 164, 165. *See also* Condé, prince de; Conti, prince de
Frontenac, comte de, 193, 194, 195–97

Garaby de la Luzerne, Antoine, 96, 121–23
Les Pharisiens du temps, 96–97, 121, 122–23, 134–35, 215n6, 224n31
Sentiments Chrestiens, 121–22, 208n23
Gazette, La, 20–21, 143–44, 146, 166, 189
Gerard, abbé de, 120
Godeau, Antoine, 31
Goussault, abbé de, 108–9, 219n10

Grégoire, Vincent, 194–95
Guardian, The. *See* Billington, Michael

Hawcroft, Michael, 118–19
Henriette d'Angleterre (Madame), 45, 165, 172–73, 176–77
homme de bien, 41, 108–10, 115, 130, 131
honnête homme, 108–10, 119, 122, 130, 131, 192, 219n10
hypocrite, the, 35–73

L'Imposteur, 125–26, 127, 133, 134, 171–73, 174, 178–82
Panulphe, 125–26, 134, 171, 173, 174

James, Barry, 1, 2
Jansenism, 25–26, 108, 139, 140. *See also* Port-Royal
Jansenist controversy, 5, 137, 139–41, 143–44, 146, 161, 171, 172, 173, 181–82, 190, 193. *See also* Péréfixe: and nuns of Port-Royal
Jesuits
 and casuistry, 13–14, 76, 89
 as confessors, 13–14, 70, 139, 208n27
Jongh, Nicholas de, 2

Kostroun, Daniella, 139, 140, 144, 159, 160, 185, 186

La Chaise, François de, 65, 66, 70, 71–72, 213n69
La Croix-Chevrières de Saint-Vallier, Jean de (Bishop of Québec), 194, 195–96
La Grange, Charles Varlet, 169, 170, 173, 174, 176
Lamoignon, Guillaume de, 18, 133, 173, 174, 175, 176–79,

Lamoignon, Guillaume de (*continued*)
188, 202n26. See also *Tartuffe*, banning and unbanning of
La Mothe le Vayer, François de, 19–20, 93, 206n13
as tutor to duc d'Anjou and Louis XIV, 19–20, 22–23
La Vallière, Louise de, 45–46, 49, 50, 55, 56, 57, 60–61, 62, 64, 67, 172, 212n57, 212n58
laxism, 13, 64, 70, 71, 73, 76, 89, 120
Le Moyne, Pierre, 58, 59
La Dévotion aisée, 64, 92–93, 111, 120
De l'art de régner, 44–45
Lettre sur la comédie de l'Imposteur (anon), 23, 116–18, 131–32, 134
Lettre sur les observations d'une comédie du sieur Molière (anon), 33, 102, 114–16, 147–48, 168
London Evening Standard, The. See Jongh, Nicholas de
Longueville, Mme (duchesse de), 9, 10
Loret, Jean, 145–46
Louis XIV, 4, 15, 36, 37, 50, 53–56, 57, 60–61, 64, 65, 70, 129, 140, 141, 146–53, 156, 162, 166, 168–69, 172, 180–83, 186, 193, 197
does not take communion, 62, 65, 72
education of, 19–23
hypocrisy of, 44–47, 70
is refused absolution, 71–72
Mémoires of, 22, 23–28, 53, 66–68, 139, 165, 171, 204n44, 212n54
mistresses of. *See* La Vallière, Louise de; Montespan, Mme de
Molière's petitions to. *See under* Molière, works

See also absolutism; authority: kingly; Fronde; *Tartuffe*: *deus ex machina*; *Tartuffe*, banning and unbanning of

Maintenon, Mme de, 66, 70, 73
Mareuil, Jacques, 194–96, 227n7
to perform role of Tartuffe, 194–95
performs impious acts, 195
Marie-Thérèse (Queen of France), 46, 54, 56, 73
Marolles, Michel de, 109
Mazarin, Cardinal, 10, 11, 15, 18, 19, 20, 21, 22, 24, 32
Mazarinades, 10–11, 201n12
McBride, Robert, 20, 23
Molière et son premier Tartuffe, 3
The Sceptical Vision of Molière, 80–81, 120
Méré, chevalier de, 109–10
Mnouchkine, Ariane (1995 production of *Tartuffe*), 1–2
Molière, works
Amphitryon, 190, 211n50
La Critique de l'Ecole des femmes, 32–33, 141
L'Ecole des femmes, 33
Le Festin de Pierre, 102–4, 123–25, 167–68, 217n25
Don Juan, 102–4, 108, 124, 125, 167
Elvire, 104, 124, 125
Petitions to Louis XIV
First Petition (1664), 76–77, 147, 154–58
Second Petition (1667), 76, 125, 133, 174–76
Third Petition (1669), 187
Preface to *Tartuffe*, 3, 37, 107–8, 113, 126, 127–28, 129–31, 133, 134, 187–89
La Princesse d'Elide, 57–60
Tartuffe. See *Tartuffe*
Montespan, Mme de, 46, 64–66, 71, 72, 172–73, 190, 212n61

INDEX 245

New York Times, The. See James, Barry
Nicole, Pierre, 128, 181, 217n22

Orgon, 76, 77, 87, 103, 113, 131, 200n3
 blindness of, 82, 135
 and the Fronde, 69
 as monomaniac, 81
 on Tartuffe, 82–83, 84, 85–87
d'Orléans, duchesse, 72

Parish, Richard, 119
Pascal, Blaise, 14, 70
Patin, Guy, 16–17
Pavillon, Nicolas (Bishop of Alet), 12, 185
Peace of the Church, 5, 137, 185–86, 187, 193. *See also* Jansenist controversy
Péréfixe, Hardouin de Beaumont de (Archbishop of Paris), 4, 5, 20–23, 26, 27, 28, 32, 137, 142, 150–51, 158–61, 178–79, 186, 189–90, 223n31
 Histoire du Roy Henry le Grand, 21–22, 52
 Institutio principis ad Ludovicum XIV, 21, 22
 and nuns of Port-Royal, 158–61. *See also* Jansenist controversy
 Ordonnance condemning *Tartuffe*. See *Tartuffe*, banning and unbanning of
 and threats of excommunication, 164, 180–82, 183–85, 189, 196
 tutor to Louis XIV, 20–21, 22, 28, 203n34
Pernelle, Mme, 44, 78, 79–80, 113, 116–17, 131, 134, 215n4
Philippe d'Orléans (Monsieur, duc d'Anjou), 19, 22–23, 62, 165, 169
Phillips, Henry, 13, 29, 30–31, 146–47, 200n2, 209n32

Les Plaisirs de l'île enchantée, 53–62, 192–93
 official account of, 37–38, 48, 53, 54, 55, 56, 62, 156, 165, 166–67, 206n10
 as pleasure-seeking, 54, 57, 60, 193
 See also Molière, works: *La Princesse d'Elide*
pleasure, 21, 27, 41, 48, 50, 52–54, 56, 62, 67, 80
Pommier, René, 83, 134
Pope Alexander VII, 146–47, 165–66
Pope Clement IX, 186
 see also Peace of the Church
Pope Innocent X, 139
Port-Royal, 13, 139, 141
 nuns of, 158–61, 186, 226n65
 see also Jansenism; Jansenist controversy
Princess Palatine, Anna Gonzaga, 164–65, 169–70
Protestant question, 22, 27, 139, 150

Québec, *Tartuffe* controversy in, 193–97

Racine, Jean, 194
 Abrégé de l'histoire de Port-Royal, 158–60
 on Jesuits, 14
 on *Tartuffe*, 76, 160–61
Ranum, Orest, 10, 13, 163, 189, 209n32
repentance, 48, 50–51, 62, 63–65, 104, 209n32
Retz, cardinal de (Jean-François Paul Gondi, Archbishop of Paris), 9, 27–28, 139, 164, 222n6
Rey, François and Jean Lacouture, 2, 55, 137, 149, 154, 163, 171
rigorism, 13, 81, 82, 87, 120, 134

Rochemont (pseud.), *Observations sur une comédie de Molière*, 33, 37, 41–42, 147, 167, 168
Rome, France's relationship with, 26, 146–47, 186
Roulé, Pierre, 149–54, 187
 Le Dauphin, 153
 Le Roi glorieux, 149–53, 154, 223n24
Rule, John C., 9

Saint Augustine, 13, 41, 86, 101
Saint-Simon, Louis de Rouvroy, 71–72
Sales, François de, 117, 120, 207n17, 216n16
Salomon, Herman Prins, 3, 115, 137, 194, 195–96, 197, 199n10, 215n8, 215n9
satire, 1, 23, 36, 37, 38–39, 64, 76, 78–79, 81–82, 83, 96–97, 104, 120, 121–23, 141, 152, 173, 187, 197, 208n20
schism, threat of, 25, 45, 137, 140–41, 144, 167, 171, 186, 189
Scudéry, Madeleine de, 102–3
Senault, Jean-François, 45, 58, 59, 204n48, 204n50, 209n31
spiritual directors, 43, 63–64, 69, 73, 75, 97, 126, 149–50, 151–52, 193, 212n55
 scandal of women as, 98
struggle for influence, 3, 5, 7–8, 12, 15, 19, 24, 26, 36, 137, 141, 156, 158, 172, 173, 175, 192, 196

Tallon, Alain, 14–15, 52, 93, 94, 96, 140, 202n20, 216n13, 217n19
Tartuffe, 51–52, 64, 66, 113, 120, 125, 130, 187
 hypocrisy of, 4, 42–44, 52, 69–70, 82, 86, 87, 92, 102, 104–5, 132

 sensuality of, 4, 36, 42–44, 69, 82
 use of casuistry, 43, 64, 71, 76, 188
 zealotry of, 4, 75, 76, 77–87, 104–5
Tartuffe, 62, 124–25
 for characters, see individual names
 deus ex machina, 68–69, 124–25, 197, 213n67
 first performance of, 1, 15, 35, 37, 53, 62, 141
 modern Islamist productions of, 1–2
 performances of during the French Revolution, 197
 private performances and readings of, 146–49, 160–61, 164–65, 169–71, 172–73
 publication of, 187, 193
 references to the Fronde in, 69
 as symbol, 137, 138, 164, 165, 192–93, 197
Tartuffe, banning and unbanning of
 ban on public performances (1664), 37, 62, 68, 141–46, 155, 156, 158, 166–68, 170–71, 189, 191, 193
 Company of Holy Sacrament seeks early ban (1664), 15, 19, 138, 141, 189, 192, 221n3
 final lifting of ban (1669), 72, 137, 167, 185–87, 193
 L'Imposteur is performed (1667), 171–73
 Lamoignon upholds ban (1667), 133, 173, 174–79
 Louis XIV gives verbal permission to perform *L'Imposteur* (1667), 172–77, 180
 meeting between Molière and Lamoignon (1667), 133, 177–79

Molière seeks to have ban lifted, 145–46, 154–57, 165
Péréfixe issues *Ordonnance* (1667), 37, 38, 142, 179–81
Péréfixe relaxes ban, 182
See also Québec, *Tartuffe* controversy in
theatre, 28–32, 41–42, 53, 128, 129, 184, 188, 190, 193
 as battle ground in struggle for influence, 8, 32, 137–38, 184, 192, 196
 and the Church, 29, 30, 128, 180, 184
 inclusion of religion in, 29–31, 125, 127, 144, 177–78, 188, 191
 and moral instruction, 30–31, 156, 178, 188
 as touchstone for devotion, 12–13, 28–29, 128
true devotion. See *vrai dévot*

Valère, 118, 192, 219n16
véritable, as qualifier, 108, 130, 131, 132, 133
véritable homme de bien, 108, 117, 129–33, 134, 135, 175, 188. See also *homme de bien*
Voisin, Joseph de, 11–12
vrai dévot, 87, 88, 90–92, 107–35, 157, 188, 191, 192
 absence of in *Tartuffe*, 4, 42, 118, 124, 127, 134, 192
 invisibility of, 4, 40, 72, 110–12, 114, 115, 134, 191
vrai-faux model, 3, 35, 37–42, 107, 118, 129, 132

Wine, Kathleen, 55, 210n38

zealot, 38, 75–105, 107, 135, 149. See also *faux dévot*
zealotry, 1–2, 13, 75–105, 107, 121, 131, 133. *See also* fanaticism

GPSR Compliance

The European Union's (EU) General Product Safety Regulation (GPSR) is a set of rules that requires consumer products to be safe and our obligations to ensure this.

If you have any concerns about our products, you can contact us on

ProductSafety@springernature.com

In case Publisher is established outside the EU, the EU authorized representative is:

Springer Nature Customer Service Center GmbH
Europaplatz 3
69115 Heidelberg, Germany

www.ingramcontent.com/pod-product-compliance
Lightning Source LLC
LaVergne TN
LVHW011812060526
838200LV00053B/3745